REMARKABLE
GOLF COURSES

Dedication
For Terry Lynch, the Bryson deChambeau of Thames Ditton
and Esher G.C.

First published in the United Kingdom in 2017 by
Pavilion
An imprint of HarperCollins*Publishers*
1 London Bridge Street
London SE1 9GF

www.harpercollins.co.uk

HarperCollins*Publishers*
Macken House
39/40 Mayor Street Upper
Dublin 1
D01 C9W8
Ireland

ISBN 978-1-911595-04-5

A CIP catalogue record for this book is available from the
British Library.

Reprinted in 2018, 2019, 2020 (2), 2021 (2) , 2023 (2), 2024
Reproduction by Rival UK

Printed and bound by GPS Group in Bosnia and Herzegovina

This book contains FSC™ certified paper and other controlled
sources to ensure responsible forest management.

For more information visit: www.harpercollins.co.uk/green

REMARKABLE
GOLF COURSES

— IAIN SPRAGG & FRANK HOPKINSON —

PAVILION

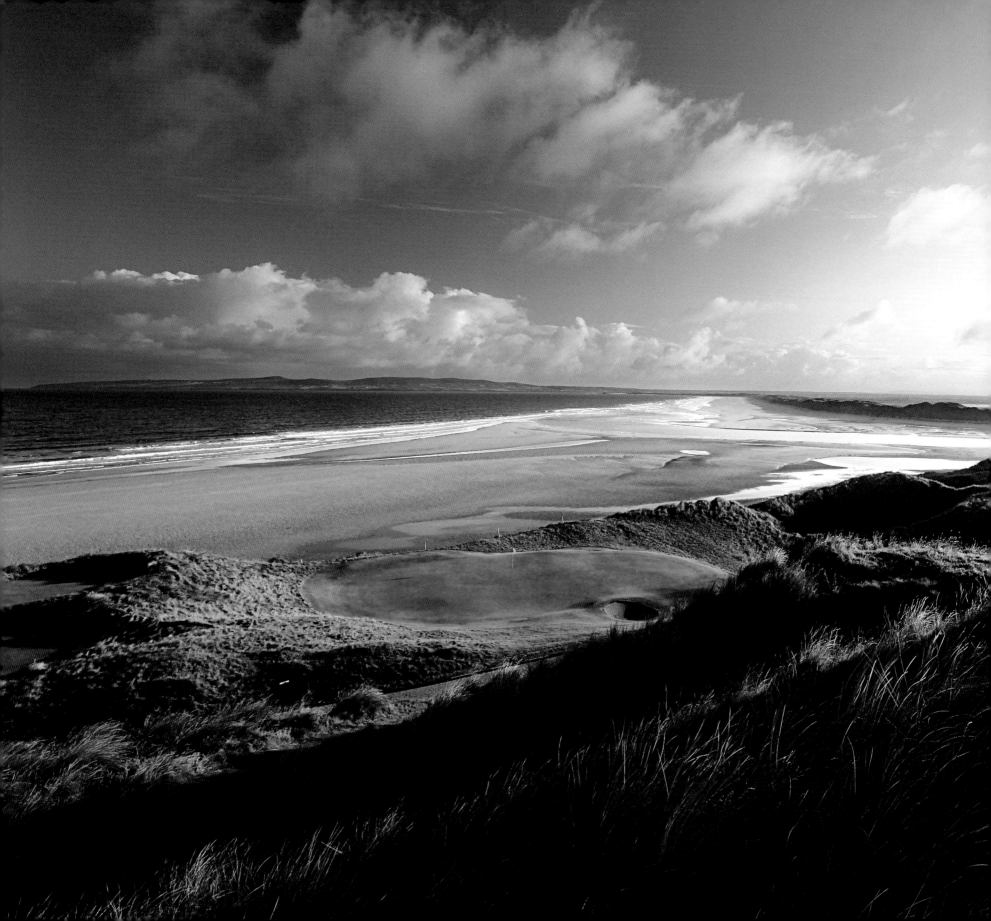

Contents

Introduction	6	Merapi Golf	114
		Mission Hills Resort	116
Abu Dhabi Golf Club	14	Moor Park Golf Club	120
The Addington	16	Naldehra Golf Club	122
Ailsa Championship Course	18	Oakmont Country Club	124
Arikikapakapa	20	The Ocean Course	128
Arrowhead Golf Club	22	The Old Course, Musselburgh	130
Augusta National Golf Club	24	The Old Course, Royal Troon	134
Barnbougle	28	The Old Course, St Andrews	136
Barra	32	Old Head Golf Links	142
The Brabazon	34	Painswick Golf Club	146
Brocket Hall Golf & Country Club	36	Pebble Beach Golf Links	148
Cape Kidnappers Golf Course	38	Pennard Golf Club	150
Championship Course, Carnoustie	40	Pine Valley	152
Championship Course, Machrihanish	44	Prestwick Golf Club	154
Championship Course, Royal County Down	46	Punta Mita Pacifico Golf Course	156
Chicago Golf Club	50	Real Club Valderrama	158
The Church Course	52	The Rise	160
Clearview Golf Club	56	Royal Haagsche Golf and Country Club	162
Club de Golf Alcanada	58	Royal Melbourne Golf Club	164
Coeur d'Alene Resort Golf Course	60	Royal North Devon Golf Club	166
Cypress Point Club	62	RTJ Golf Club	168
The Dunes Golf Resort	64	Rye Golf Club	170
Fuego Maya	66	Sedona Golf Resort	172
Furnace Creek Resort	68	The Severiano Ballesteros Course	174
Green Monkey Golf Course	70	Signature Course	178
Harbour Town Links	72	Stadium Course, Bro Hof Slott	182
The Isle of Harris Golf Club	74	Stadium Course, PGA Catalunya Resort	184
Icelandic Golf	76	Stadium Course, TPC Sawgrass	186
Ile Aux Cerfs	82	Stanley Thompson Eighteen	188
Jack's Point	84	Stoke Park	190
Jade Dragon Snow Mountain Golf Club	86	The Straits Course	192
Ko'olau Golf Club	88	Streamsong Red, Streamsong Blue	194
Kobe Golf Club	90	Taiheiyo Club Gotemba Course	198
La Paz	92	Torrey Pines Golf Club	200
Leaders Peak Golf Club	94	Tralee Golf Club	202
Leeds Castle Golf Course	98	Tromsø Golf Club	206
The Lodhi	100	Upper Course	208
Lofoten Links	102	Ushuaia Golf Club	210
Lost City Golf Course	104	Victoria National	212
Llanymynech Golf Club	106	West Links	214
Lundin Ladies Golf Club	108	West Course	218
Majlis Course	110	Wolf Creek	220
Manele Golf Course	112	Index	222

Introduction

There are two kinds of remarkable golf course. Of the first variety there are tens of thousands, maybe more, and none of them are included in this book. These are the golf courses on which golfers have conquered their demons and put together the round of their life; a round in which all the golfing perils of slice, hook, top, shank and the yips disappear and the final score makes their handicap look like the invention of a rogue and a scoundrel. That course will remain forever remarkable in their eyes, just as the Worcestershire Golf Course in Malvern Wells, England, remains remarkable to me.

But even though the 14th hole of the Worcestershire is a stern test; a blind drive into a valley avoiding the old railway line, and pulling up short of a Swilken-Burn-like brook, it is not enough to make it into the book. Never mind the fact that the contoured, split-level green has rheumy-eyed senior golfers requesting their ashes be spread across it. Never mind that it is in the rainshadow of the Precambrian Malvern Hills that so inspired Sir Edward Elgar. It is simply a beautiful golf course, not a remarkable one.

The remarkable golf courses that have made it into this book include some of the best in the world and regularly jostle for places amongst *Golf Digest*'s top 100. Yet some of them wouldn't come close. They are remarkable for other reasons. The Isle of Barra in Scotland's Hebridean islands might not have much in common with the Himalayan Golf Club in Nepal, but both have greens that are protected from grazing animals by wire fences. To get on the green in Barra, golfers must pass through an old-fashioned 'kissing gate' that prevents the grazing sheep and cattle from wandering across the putting surface. The Himalayan course has gated greens but it also has the unique distinction that it possesses an island green, one that is sited in the middle of a river.

Neither of these two courses are grand in scale, and in a sport where length is often revered

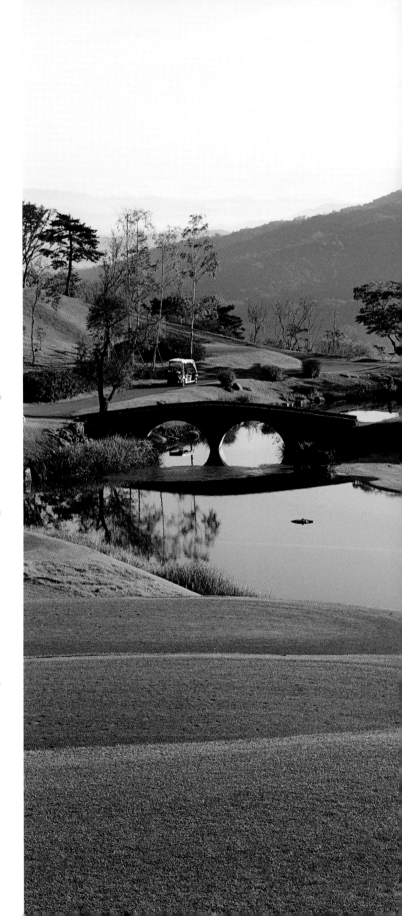

RIGHT: A serene scene at Golf Club Q in Anseong, South Korea, a beautiful course that didn't quite make it into the list of remarkables.

PREVIOUS PAGE: Tralee Golf Club, Republic of Ireland.

we have included one of the longest courses, Jade Dragon in China, which at 8,432 yards is indeed a monster length for 18 holes. The compensating factor is that because it is one of the most elevated golf courses in the world, the atmosphere is thin and balls travel up to 20% further. Never mind the fact that golfers are struggling for oxygen at that elevation, when the shot is made you get a lot more bang for your backswing.

The competitive nature of golfers has long driven golf club owners looking for a unique selling point to claim they have the longest hole in golf. Some have done this simply by extending back tees which have then fallen out of use and rendered the claim invalid. The course at Satsuki in Japan has a 964-yard par seven hole, which has stood the test of time. But in between writing and publishing this book a new challenger could easily take the title.

The world's largest green is said to lie at the end of the 695-yard fifth hole, a par six, at the International Golf Club in Massachusetts, with an area in excess of 28,000 square feet. But given the increasing standards of grass maintenance how hard could it be to let the mower loose and increase the green size to claim that crown? So in this book we have treated the record breakers of golf warily, though with a sneaking admiration for the fourth hole at Kobe in Japan. That is an 188-yard par four and must count as one of the shortest par fours in golf. In contrast, the 19th hole at the Legends Golf & Safari Resort in South Africa is the longest par three at 631 metres. As the number suggests, the hole doesn't form part of the standard round and players need to call on the services of the resort helicopter to get them to the mountaintop tee. Being so far away calls for a large green and though the temptation might have been to create one in the shape of a barn door, the architects have opted for an outline of Africa instead. As golf challenges go it doesn't come much bigger than that.

Golf can be an inspiring game and as the writer P. G. Wodehouse maintained it can also provide some salutary life lessons. "Sudden success in golf is like the sudden acquisition of wealth. It is apt to unsettle and deteriorate the character," is one of his classic lines on the game. He also professed, "to find a man's true character, play golf with him." Wodehouse, more than any novelist in the last 150 years, intertwined golf with his plots and in his many parodies of the English upper classes there is a lot of swishing with a mashie niblick. He played his golf at Royal Addington in Surrey and once gave his home address as one of the bunkers after deciding he spent more time there. Another great British literary figure, former Poet Laureate Sir John Betjeman, is forever linked with the St Enodoc golf course in Cornwall. Apart from its undoubted beauty the course has the rare distinction of having the ancient church of St Enodoc entirely within the bounds of the golf course. Fittingly, Sir John is buried in the graveyard, the shortest of irons away from the course that once rewarded him with "that most unprecedented three" in his celebrated poem *Seaside Golf*.

In the search for remarkable golf courses we have gone to the extremes. Golf is played under the midnight sun in Tromsø, Norway, on the world's most northerly 18-hole course, as it can at the Lofoten Links and the prodigious number of beautiful courses in Iceland. At the other extreme, the Ushuaia Golf Course in Tierra del Fuego, Argentina, is the most southerly golf course in the world. After an energy-draining round, golfers can go back to the clubhouse

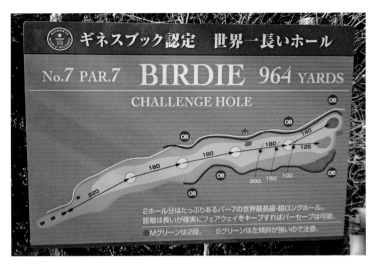

OPPOSITE: A church encompassed by a golf course, St Enodoc in Cornwall, England.

TOP: The hole marker for the most established contender for 'golf's longest hole' in Satsuki, Japan.

RIGHT: The unique river island hole at the Himalayan Golf Club in Nepal.

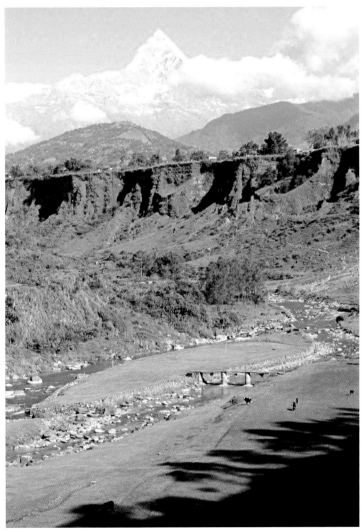

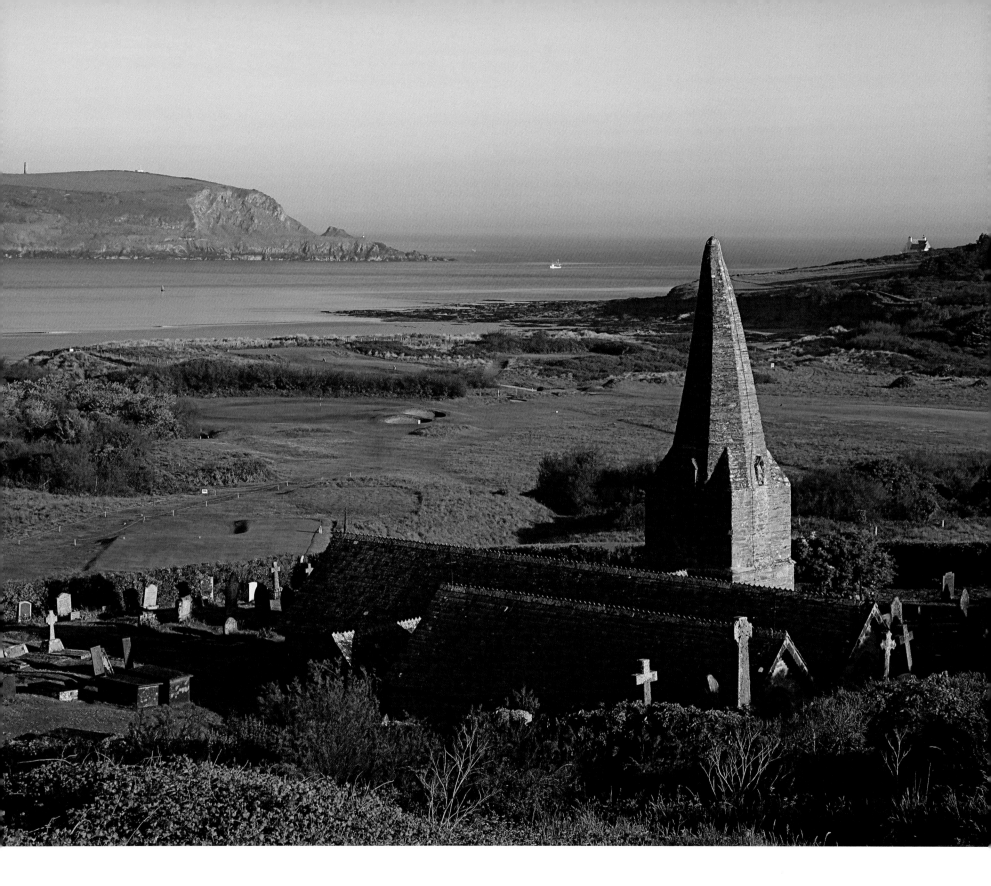

and pick up a penguin, the grilled kind, not the chocolate-covered variety.

The course at Jade Dragon may be high, but La Paz in Bolivia holds the record for the world's highest golf course. In Death Valley, California, golfers ignore the date-scavenging coyotes to play the world's lowest course at 214 feet below sea level. And who says geologists have got no sense of humour? A little further up Death Valley from the aptly named Furnace Creek is the Devil's Golf Course. Anybody packing their clubs and setting off to challenge el diablo will be sorely disappointed as it is the name given to a flat but infinitely craggy surface that even a scratch-playing Beelzebub would find hard to break 100 on.

Slow play may be the curse of the professional game and weekend golf at oversubscribed clubs, but there are some courses where it is no hardship to wait and take in the surroundings. Golf is played against the backdrop of some of the planet's most remarkable scenery. In Sedona, Arizona, two courses have the incredible red sandstone outcrops of Sedona to marvel at, while at the Hornafjörður course in Iceland, the vast Vatnajökull ice cap dominates the horizon. But few can match the jaw-dropping landscape of the Upper Course at Whisper Rock in Arizona. Whatever is marked on your card at the end of the round is incidental to the experience of treading the fairways on what is a truly monumental golf course.

Nature has been involved in shaping golf courses for an aeon or two, but remarkable historical features occasionally make their appearance on the fairways as well. In Britain there is quite a bit of history scattered through the countryside and at Lundin Ladies in Scotland, the circa 4,000-year-old standing stones are unmissable hazards on the second fairway. The Painswick Golf Club in Gloucestershire, England, has made use of Bronze-Age earthworks

originally created as part of an ancient hill fort and incorporated them into several holes. What looks like a Pete Dye- or a Tom Fazio-created mound was actually constructed by a wode-covered ancient Celt, keen on seeing off rival tribes and eventually the Romans. Pennard Golf Club on the Gower peninsular in Wales boasts a relative newcomer compared to these two. Their castle was originally constructed in the wake of the Norman invasion and the initial wooden fort was converted to stone through the thirteenth and fourteenth centuries. Time and erosion has left it a romantic ruin.

All these historical features are managed with care, which leads us to another area of remarkable golf courses, built where land has already been exploited by man. The National Course in Indiana, Streamsong Red and Blue in Florida, and the Green Monkey course in Barbados are all built on former quarries or land that has been strip-mined. They are not alone in reclaiming once derelict land and putting it to good use, but they show the sophistication and degree of invention that golf architects have brought to the modern course layout.

The work of the original golf architects, men like Old Tom Morris of St Andrews and Harry Colt are also celebrated in these pages. Writing an exact chronology of the evolution of golf on the east and west coasts of Scotland can be a contentious exercise (though Old Tom had a hand in both). There are arguments for the Old Course at St Andrews and at Musselburgh being the oldest links. But Musselburgh has the plaque and also the rare distinction of being an extant golf course that was subsequently encircled by a horse racing track – and not one created within. What is certain is that Prestwick on the Ayrshire coast hosted the first Open Championship in 1860 and

RIGHT: A hallowed spit of land where the river Eden meets the North Sea, the site of St Andrews' Old Course.

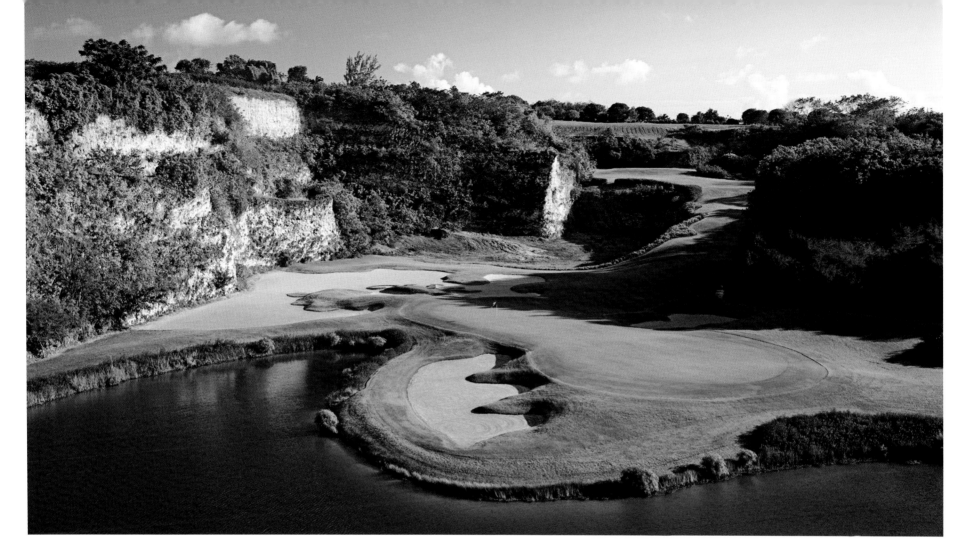

along with neighbours Troon and Turnberry vied with St Andrews, North Berwick and Carnoustie for golfing pre-eminence in the Victorian age.

As to the future, golf is still expanding its territory of influence, even if some of the more traditional courses are struggling. China has seen a rapid expansion in the middle classes and the passion for playing golf has matched the enthusiasm for driving Mercedes and Jaguars. A less predictable destination that is expanding its number of

ABOVE: The Green Monkey Course at Sandy Lane, Barbados.

LEFT: Golf and vulcanology seem to go hand in hand; there are many golf courses near volcanoes, in this case on Big Island, Hawaii, the Francis I'i Brown Golf Course.

courses is Iceland. More people play golf in Iceland per head of population than any other country in the world and should you wish to play golf with a backdrop of volcanoes, fjords, glaciers, geothermal features and get attacked by arctic terns, then it's the go-to destination for golfers. And like their Viking ancestors they're not averse to stirring up a bit of trouble. They have abandoned the strict 18-hole format to their competitions and have vowed to set the number of holes on courses to suit the location and the people who want to play there, which is a remarkable move in itself.

Throughout this book there are many such stories. There is the golf course that has a tee in one country and its putting green in the country

next door (no passport required). There is the course built by one man's determination to combat racial discrimination and play the game he loved, and on a lighter note there is the golf course with the world's most famous 'named hole'. There are many truly beautiful courses that haven't made it into this miscellany. For all these golf challenges there are the trusty top 100s found in golf magazines and on the Internet and whose inclusion on such a list automatically hikes the green fee. Take a trip to the Isle of Barra course, though, and you can play a round for £10 or purchase a life membership for £100. That wouldn't even get you past the fifth hole at Wynn, Las Vegas.

Frank Hopkinson, 2017

Abu Dhabi Golf Club

Sas Al Nakhl, Abu Dhabi, United Arab Emirates

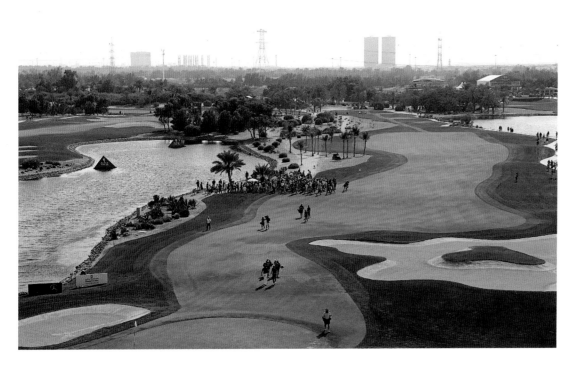

over 162 hectares, the course also features seven saltwater lakes which bring water into play on 10 holes in total.

The front nine is marginally longer than the closing holes and the pros rate the fifth as the biggest challenge on the way out, a 469-yard par four which usually plays into the wind. The fairway is narrow and if you're wayward from the tee and find the rough, there's no chance of reaching the green safely in two.

The 16th is notable for the long stretch of water down the right side of the fairway and right front of green, but it is the long par five 18th which really demands due care and attention. A 567-yarder from the long tees, the closer features a vicious left-to-right dogleg before reaching a putting surface which is patrolled by a liberal scattering of sand traps to the front.

Falconry in the Middle East can trace its history back over 5,000 years and the region's long affinity with hunting with birds is celebrated at the Abu Dhabi Golf Club in the shape of its spectacular falcon-shaped clubhouse.

The falcon is the club's official emblem and the clubhouse was designed on the same theme, the giant raptor's wings forming the concrete roof of the building, while its talons rest on an oversized golf ball. Overlooking the ninth and 18th greens,

the unique construction boasts a fully-equipped gym, swimming pool and squash courts inside but it is the view of its incredible frontage from the course which leaves visitors with their abiding memory of the club.

Opened in 2000 and designed by Peter Harradine, it took nearly a decade of planting, preening and pruning to grow the ornamental trees, palms and shrubs, not to mention the grass of the fairways and greens of the course. Spread

ABOVE LEFT: The view over the ninth green from the roof of the clubhouse during the 2017 Abu Dhabi HSBC Golf Championship.

RIGHT: Henrik Stenson and caddie Gareth Lord walk towards the ninth green and the unique giant falcon. Which other sport has a zoomorphic clubhouse…?

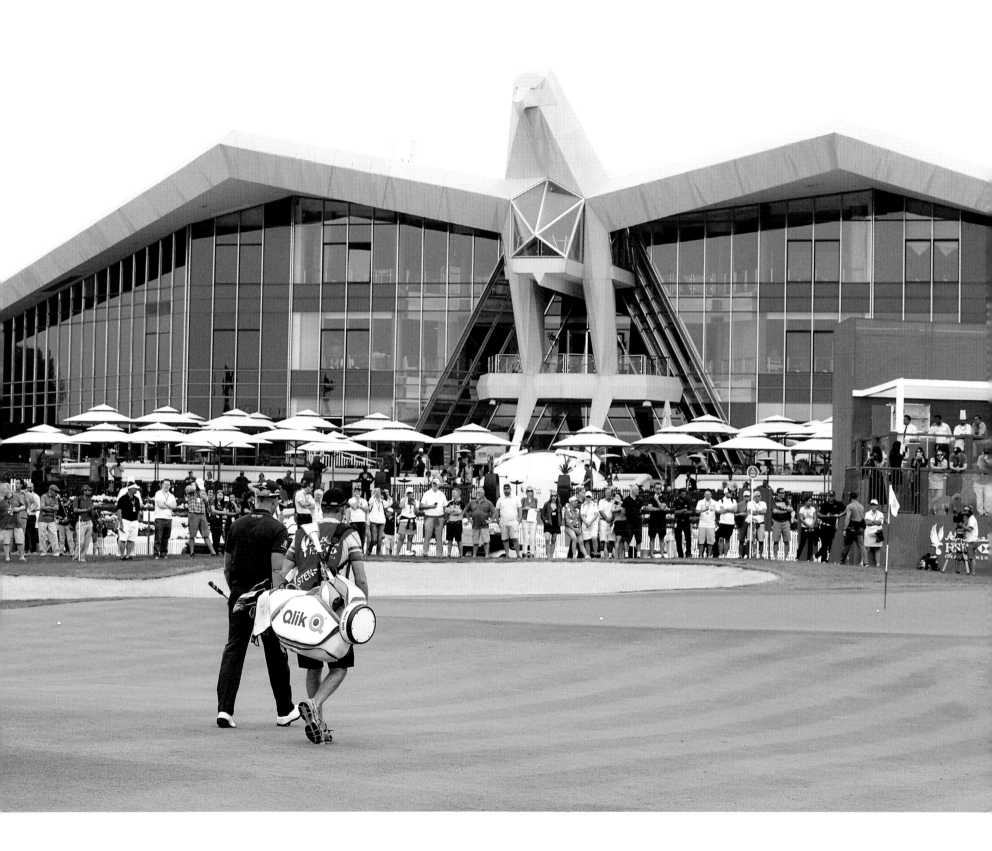

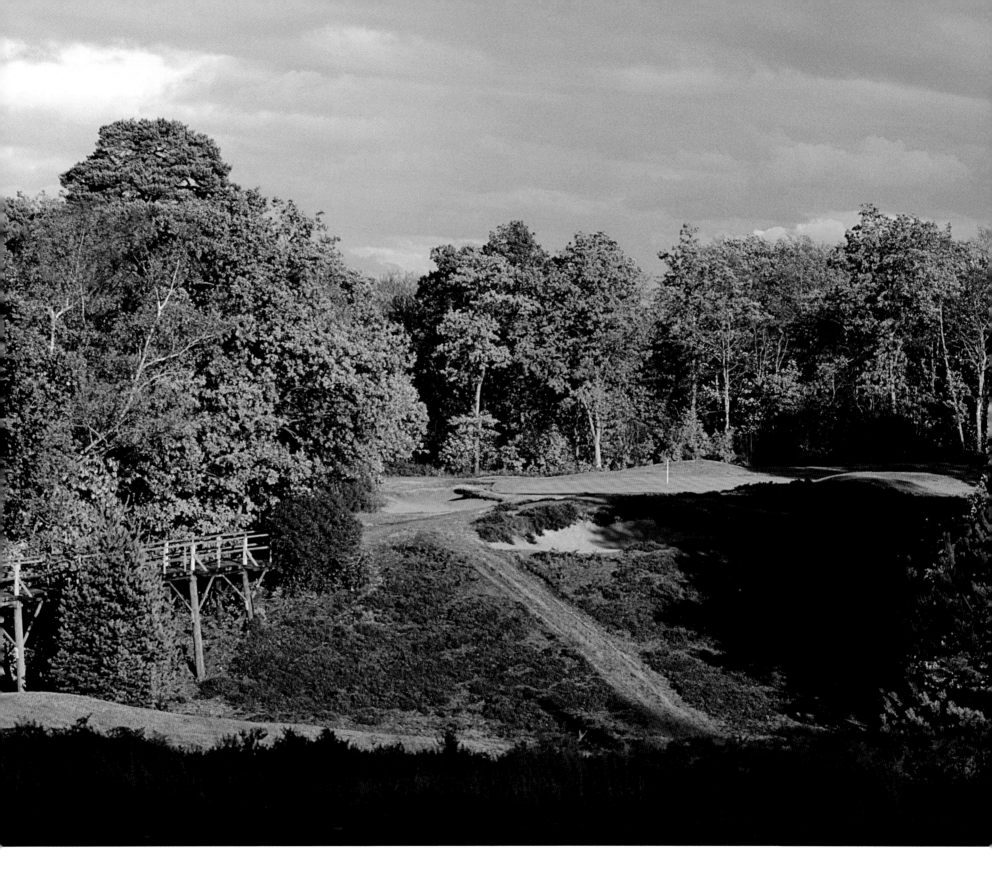

The Addington Golf Club

Surrey, England

For over a century The Addington has offered an oasis of golfing calm not far from the centre of London. The outlines of Canary Wharf and the Shard may still be visible from parts of the course but Addington feels like an altogether more serene place than its noisy metropolitan location.

Designed by noted player J. F. Abercromby, it was opened in 1913 after a syndicate raised £1,000 to begin proceedings. The club has long enjoyed a reputation as one of the most well-heeled in the country as London's great and good travelled out to Surrey for a round. It meant that a chauffeurs' hut was soon required next to the caddies' hut, while in 1937 King George VI became patron, affording the club the temporary title of 'Royal Addington'.

Other notable advocates of Addington include the writer P. G. Wodehouse, who underlined his admiration for the course in black and white in his collection of nine short golfing stories in 1926 entitled *The Heart of a Goof*, signing the preface of the book 'P. G. Wodehouse, c/o the sixth bunker, Addington'. Almost a century later Wodehouse is still the only significant literary figure to have written extensively about golf, most notably his collection of short stories as recalled by 'The Oldest Member' in *The Golf Omnibus*.

Although a fire raised the clubhouse to the ground in 1952, little else over the years has

changed at Addington. Abercromby's unique course set against silver birch, oak, beech and cedar remains relatively untouched and his penchant for par threes is still writ large with six short holes on offer.

The Addington's most acclaimed hole is one of those par threes, the 230-yard 13th with a fiendish slope guarding the front of what is an extremely tight green. "I swear it to be," wrote Henry Longhurst, the celebrated BBC broadcaster, "with the exception of the fifth at Pine Valley, the greatest one-shot hole in inland golf. To see a full shot with a brassie perfectly hit and preferably with a new ball, sail white against the blue sky, pitch on the green and roll upwards towards the flag, is to know the sweetest satisfaction that golf has to offer."

ABOVE LEFT: An Amateurs vs Professionals matchplay from 1934 featuring pro Alf Padgham. In the mid-thirties the Addington was one of the 'in' clubs surrounding London and it became informally known as 'Royal Addington' even before King George VI became the Patron in 1937.

OPPOSITE: The par three 17th hole at the Addington.

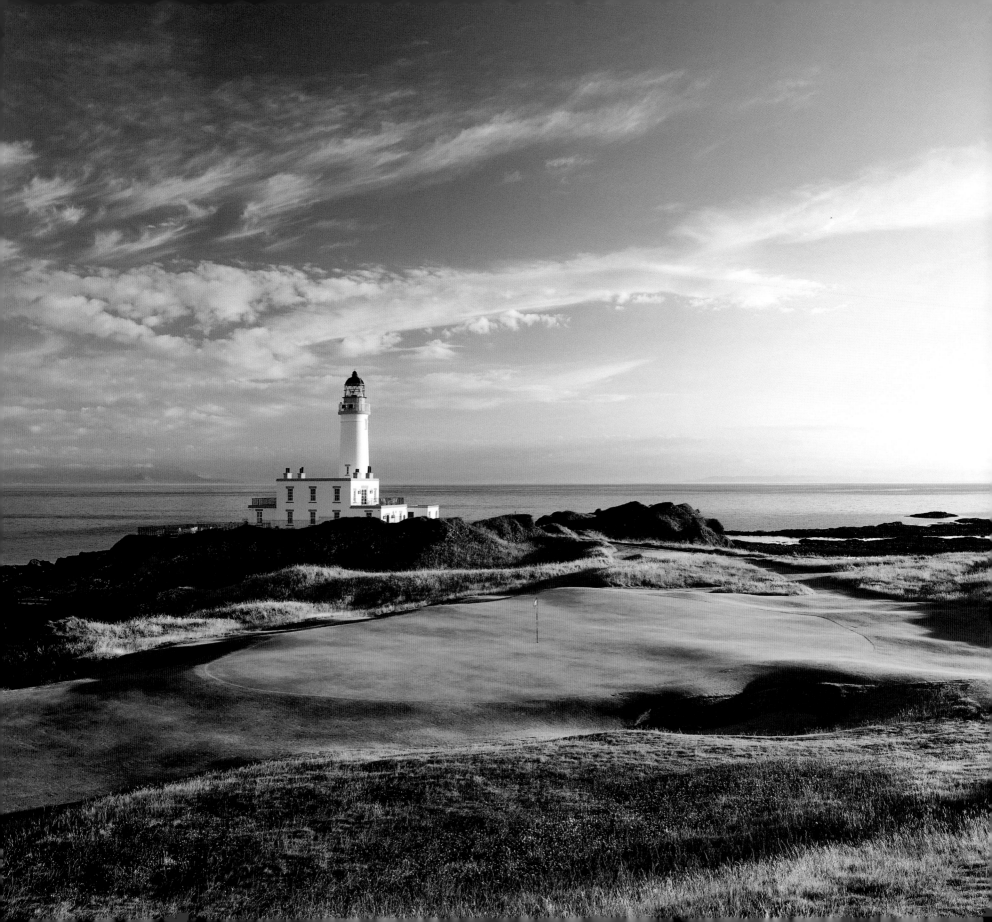

Ailsa Championship Course

Trump Turnberry, Ayrshire, Scotland

Set on a stunning peninsula of land on the Ayrshire coast, with views across the Firth of Clyde to the islands of Arran and Ailsa Craig, the Mull of Kintyre and Ireland, the club was established in April 1902. But it was not until 1909 the Ailsa Course moved to the land it occupies today. The course was named in honour of Archibald Kennedy the 3rd Marquess of Ailsa who commissioned William Fernie of Troon, the winner of the Open in 1883, to lay out the first version of the course.

The world renowned Turnberry Hotel was built on the estate in 1906 to accommodate players of Fernie's original course. It was commissioned by the Glasgow & South Western Railway company and designed by architect James Miller, who had forged his reputation building rail stations in Glasgow, and when the club moved courses in 1909 they did not stray far from Miller's impressive new hotel.

During the First World War, the property was used as an airbase by the Royal Flying Corps while the hotel was pressed into temporary service as a hospital. A stone memorial dedicated to the airmen who gave their lives during the conflict still stands on a hillock overlooking the 12th green. Golf returned to Turnberry after 1918 but the advent of World War II saw the estate once again bow to the war effort with the RAF taking up residence.

The Ailsa was reopened in 1951 thanks to the restorative efforts of designer Mackenzie Ross

and Turnberry's connection with the Open Championship, which had begun at the start of the century with former champion Fernie, was renewed in 1977 when the club staged the tournament for the first time. It proved to be a compelling four days of golf in Ayrshire as Jack Nicklaus and Tom Watson fought out an epic battle. Dubbed the 'Duel in the Sun', Watson clinched it with two birdies on the final two holes.

American presidents dating back to William Taft have escaped the pressures of the Oval Office with a round of golf but none before Donald Trump actually owned their own golf club. The American-billionaire-turned-politician bought Turnberry in 2014 and quickly set about a major overhaul of the club's historic Ailsa Championship Course. None of the 18 holes were untouched in the extensive £200 million redevelopment, which involved significant earthwork to remodel greens and fairways, and was completed by the summer of 2016.

OPPOSITE: A view of the redesigned green on the 248-yard par three ninth hole on the Ailsa Course. Guests at the resort can now rent rooms in the lighthouse.

LEFT: A 1910 poster from the Glasgow and South Western Railway advertising the delights of their Ayrshire resorts including Turnberry where they built the grand hotel (below). Today, only one of them is Trump.

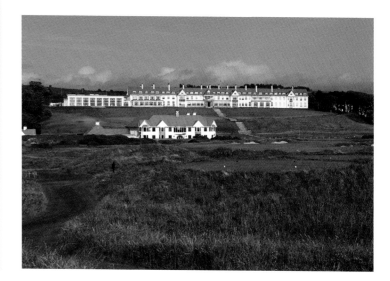

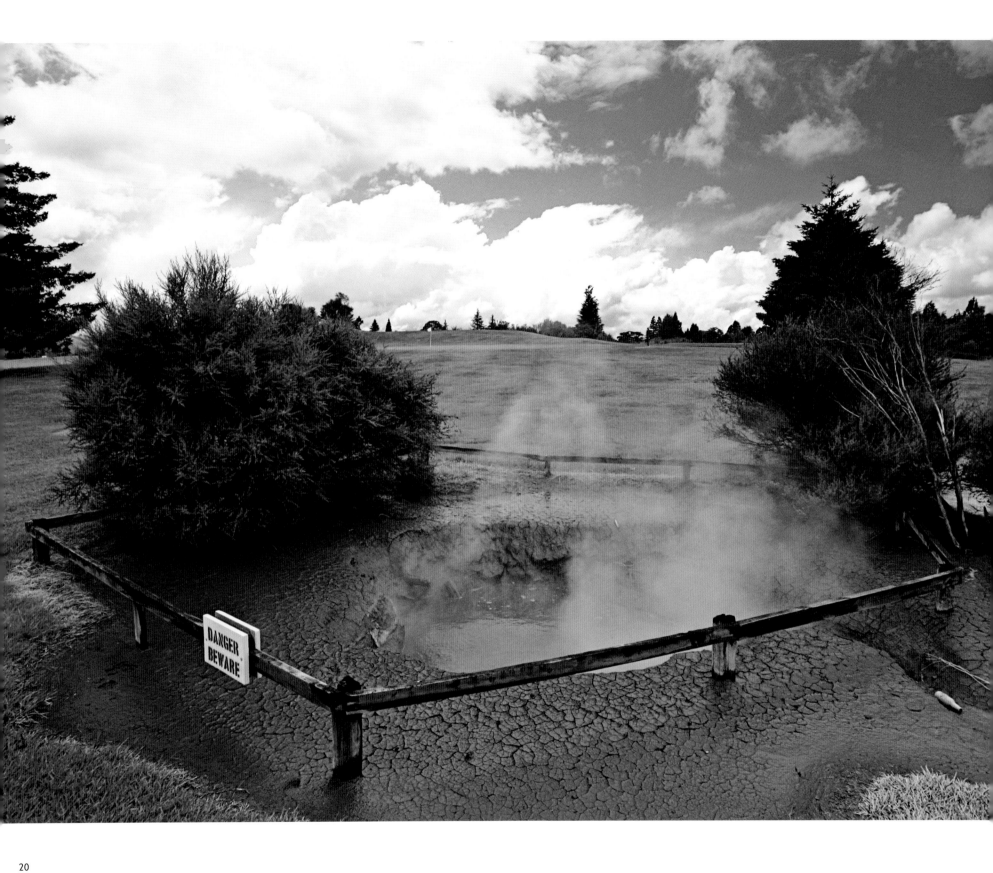

Arikikapakapa

Rotorua Golf Club, Bay of Plenty, New Zealand

Mud is a perennial hazard of winter golf in the northern hemisphere, but at one club in New Zealand, should your ball land in the mud, then retrieving it, cleaning it and replacing it under winter rules might be out of the question. The Maori word 'Arikikapakapa' translates as the gentle sound made by bubbling mud pools, which are a feature of the Rotorua Golf Club. Their par 70 course is located in an area famed for its geothermal activity with steam vents, geysers and hot springs.

Located just outside the village of Whakarewarewa in New Zealand's Taupo Volcanic Zone, the club was founded in 1906 and after three different early locations arrived in Arikikapakapa in 1912. It was extensively remodelled in 1996 but what remained unchanged was the course's peculiar natural characteristics which results in the aforementioned bubbling mud and steam rising from the water hazards.

The ninth hole features a sulphur pool on the right-hand side of the green – an unusual scene which was featured on a New Zealand stamp in the 1990s – while a geothermal crater guards the left of the fairway on the signature, par three

14th. The 15th and 16th holes play across or alongside a lake which emits plumes of steam on chilly winter days. The most feared hole, however, is the par four fifth, a warm creek and enormous tree are two of a number of hazards awaiting the wayward player.

The natural geology of the area certainly lends Arikikapakapa some striking visuals but it also renders it a genuinely all-weather track. The course is built on porous pumice which drains rapidly meaning the fairways and greens are playable remarkably quickly after even the most inclement and heavy downpour.

Since its major overhaul two decades ago the course's unique reputation has increasingly preceded it and in 2015 it was ranked among the top 25 clubs in New Zealand by PGA professionals.

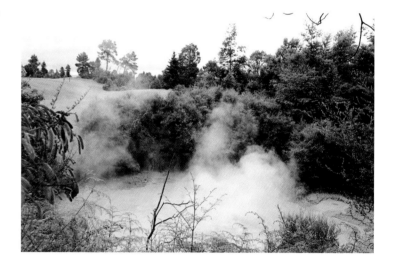

LEFT: The hot bubbling mud pool alongside the ninth hole at Arikikapakapa.

RIGHT: Hot steam rises from the springs behind the clubhouse. The geothermal actvity is generated by the Rotorua Caldera which also powers the nearby Pohutu Geyser at Whakarewarewa.

Arrowhead Golf Club

Colorado, USA

The golf club at Arrowhead was opened as recently as 1972 but its trademark red sandstone formations which stand sentry all along the course have been 300 million years in the making. They serve as both natural hazards and an unmissable photo opportunity.

The land on which Arrowhead now sits once belonged to an Irish immigrant called Henry Persse who visited the area regularly in the 1860s and was so transfixed by its natural beauty, writing about the area in a series of articles for various New York newspapers, that he eventually bought the plot. Persse dreamed of building a holiday resort complete with golf course in Colorado but ambitious plans never came to fruition after he was killed by a streetcar in 1918.

Set in the foothills of the Rocky Mountains in Roxborough State Park near Denver, Arrowhead was designed by the famed father and son team of Robert Trent Jones Sr. and Jr. Out of necessity the duo sculpted a course which weaved its way through the massive rocky outcrops, giving some expansive mountain views as the holes unfolded.

Arrowhead features serious changes in elevation throughout to ask a different question off each tee, while only two of its 18 greens are without a significant risk of finding sand after a wayward approach. The local wildlife meanwhile – most notably deer, elk and foxes – are as ubiquitous as they are potentially distracting. At 6,636 yards from the back tees, the course is long for a par 70, and possesses only three par fives. On a clear day the par three third hole has great views of the Denver skyline.

Today the course is considered by *Golf Digest* as one of the top 75 public courses in the United States.

BELOW: Arapahoe High School golfer Hannah Wood gets in some practice at possibly the most breathtaking driving range in the world.

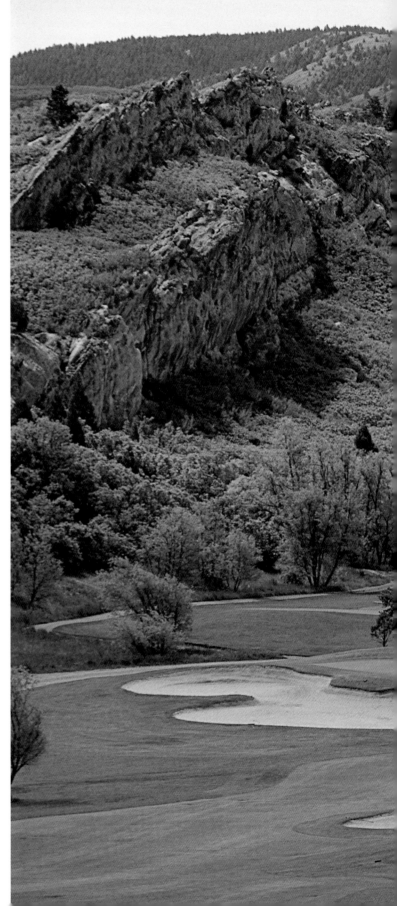

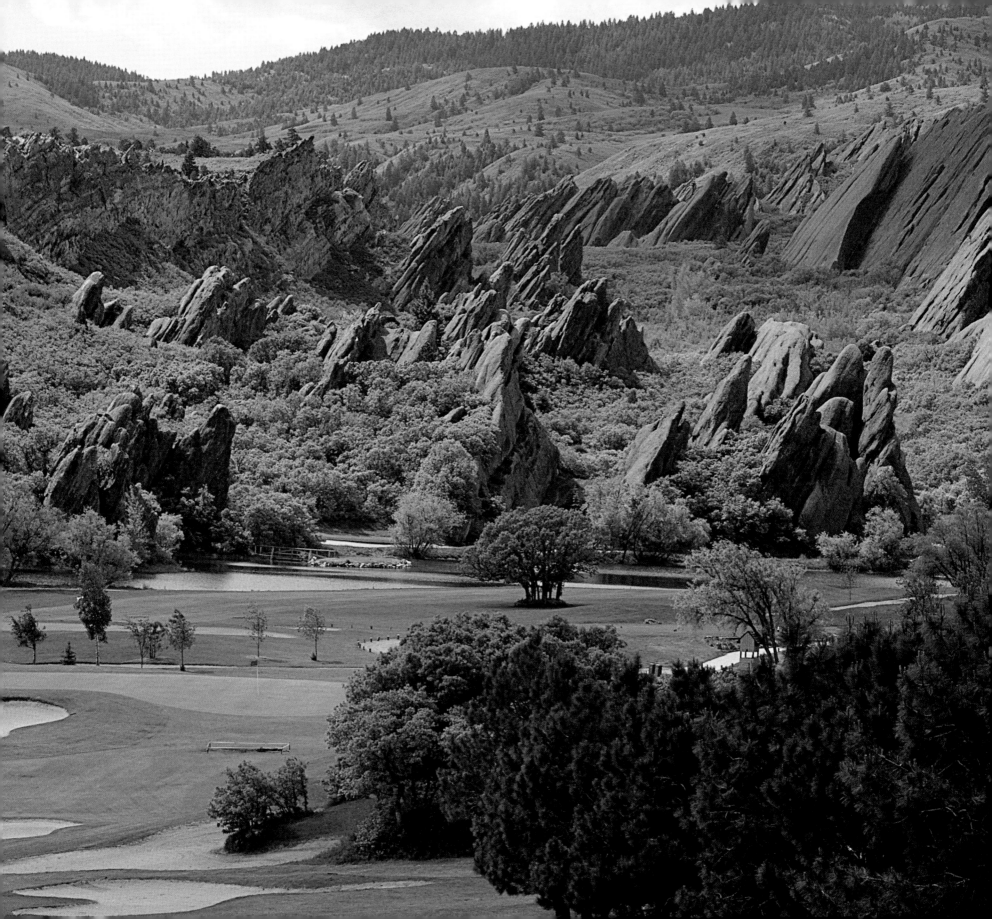

Augusta National Golf Club

Augusta, Georgia, USA

The story of one of the game's most cherished courses began in 1851 when a doctor-cum-horticulturist called Louis Berckmans fled war-torn Belgium and sailed across the Atlantic with his family. They originally settled in New Jersey but in 1857 relocated to Augusta and purchased a 385-acre plot of land. It was here Berckmans and his son Prosper established their Fruitlands Nurseries.

For the next 70 years successive generations of the family grew and sold all manner of plants, but in the 1930s horticulture gave way to sport when Open and U.S. Open champion Bobby Jones came calling in search of a site for his new club. The Berckmans sold up and in January 1933, Augusta opened for business.

The Berckmans may have gone but they have not been entirely forgotten. The Augusta clubhouse is the old family home, while each of the hallowed 18 holes are named after a tree or shrub, harking back to the land's previous incarnation as a nursery. The second hole, for example, is called 'Pink Dogwood', the third

'Flowering Peach', while the 18th is rather more prosaically dubbed 'Holly'.

Plants still dominate Augusta with azaleas, rhododendrons, camellias and redbud liberally sprinkled all along the course which, combined with the dazzling green putting surfaces, create an annual riot of colour which is nearly as spectacular as the golf it hosts when the Masters is in town every April. No other course stages one of the game's four majors on an annual basis and this unique claim to fame

can be traced directly back to Jones, who had unsuccessfully petitioned the USGA to hold the U.S. Open on his new course. They declined, citing excessively hot playing conditions in Georgia for their decision, so Jones staged his own tournament initially known as the Augusta National Invitational. It was renamed the Masters in 1939 and duly assumed the mantle of one of golf's 'big four'.

Hosting an annual major has provided the course with a storied past. The greens are among the

RIGHT: Augusta's trademark rhododendrons and azaleas in bloom behind the 13th green.

OPPOSITE: One of the most familiar holes in golf, the par three 16th at Augusta.

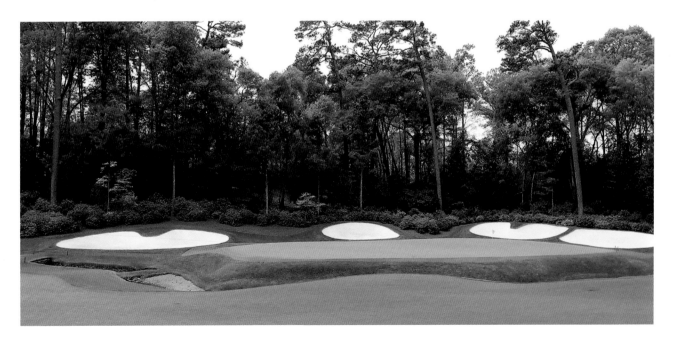

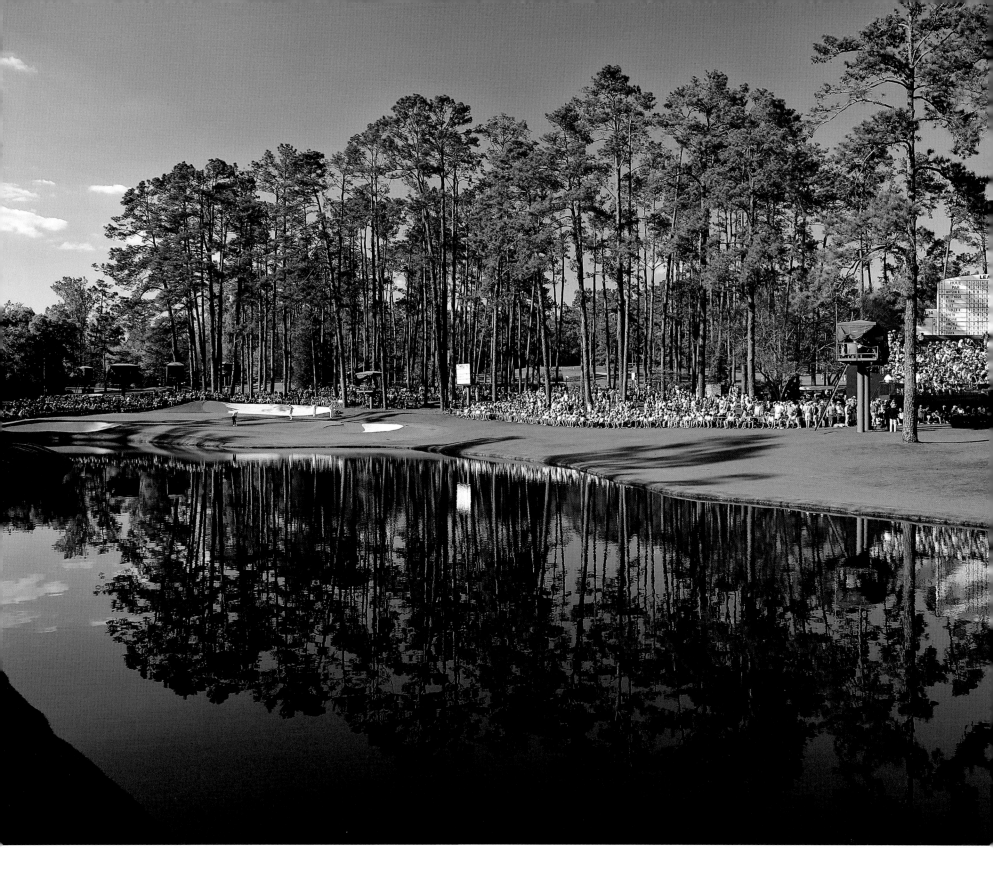

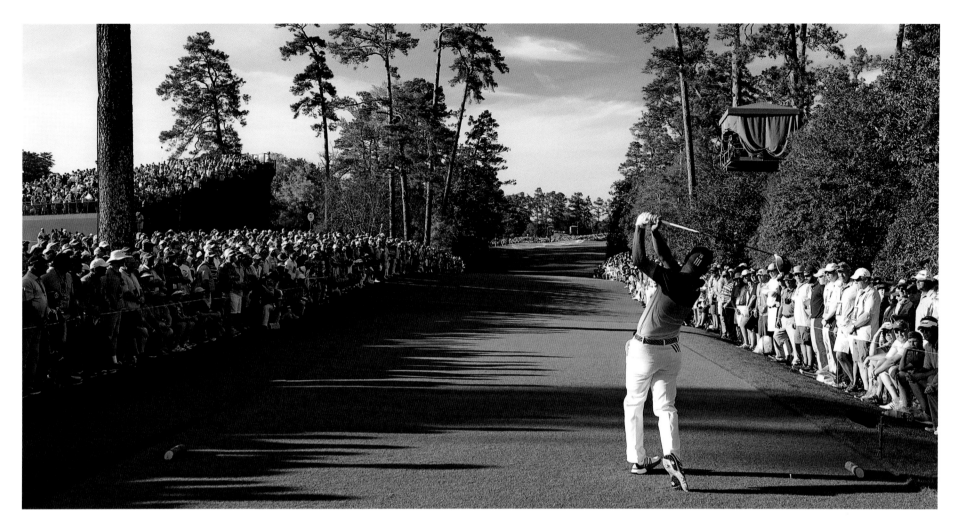

quickest on the planet, frequently rendering even the most accomplished putter mystified by the pace of the surface, and although Augusta has never been overly enamoured by the idea of excessive rough, the fairways have become narrower over the years.

The trickiest stretch of Augusta is 'Amen Corner', a collective phrase which refers to the second shot on the 11th, the full 12th and first two shots on the 13th. The 11th, known as 'White Dogwood', is a monster of a par four at 505 yards and the feared second shot is one which demands enough distance to carry the water guarding the front of the green but enough back spin to avoid the large bunker at the back.

At 155 yards, the 12th is the shortest hole on the course but does not lack teeth with Rae's Creek lying menacingly in wait for those who don't take enough club. The par five 13th is another watery disaster waiting to happen, the creek snaking down the left-hand side of the fairway before cutting to the right to form a natural hazard in front of the green.

The trio of holes were first dubbed 'Amen Corner' by the American sports writer Herbert Warren Wind in an article for *Sports Illustrated* in 1958. Wind explained he had taken the expression from a 1930s jazz song called *Shouting in that Amen Corner*, although jazz buffs have yet to unearth a recording.

The three holes reminded everyone of their potential peril as recently as 2016 when leader Jordan Spieth quadruple-bogeyed the 12th in his final round to hand the coveted Green Jacket to England's Danny Willett.

ABOVE: Sergio Garcia's critical teeshot at the 18th during the final round of the 2017 Masters as he duelled with Olympic champion Justin Rose.

RIGHT: Rae's Creek guarding Jordan Spieth's bogey hole, the par three 12th. In his final round of 2016 he took seven. In 2017 he reduced that to a double-bogey five.

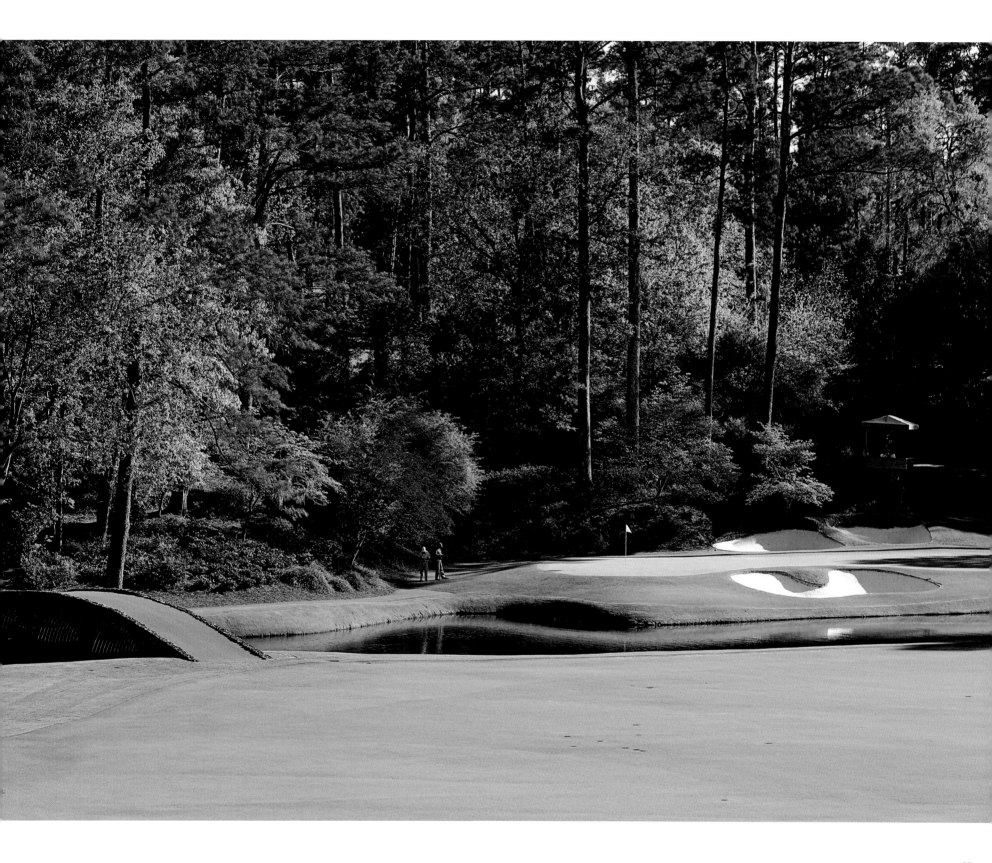

Barnbougle

Tasmania, Australia

For a club to boast one course ranked in the top five in the country is indeed an accolade. To have two separate courses in the top five, makes it an underlined destination on any golfer's bucket list. Barnbougle's two 18-hole courses are The Dunes and Lost Farm respectively, and after the former came in at number two in *Golf Australia's* Top 100 Courses and the latter in fourth, the club were in understandably celebratory mood.

The Dunes is the senior of the two following its opening in 2004 and was a collaborative design effort between Australian Mike Clayton and American Tom Doak, both architects striving to create an Antipodean links challenge reminiscent

of its Scottish forefathers. Their resulting course is one of wide fairways, unforgiving Marram grass, challenging hole layouts ready to ensnare the unsuspecting player and surprisingly rapid greens.

The signature hole of The Dunes is the fourth which features a vast bunker before the pin which is reputed to be the largest sand trap in the southern hemisphere. The par four is a

RIGHT: The headland at Banbougle's Lost Farm course.

BELOW: A lone wallaby surveys The Dunes course at Barnbougle.

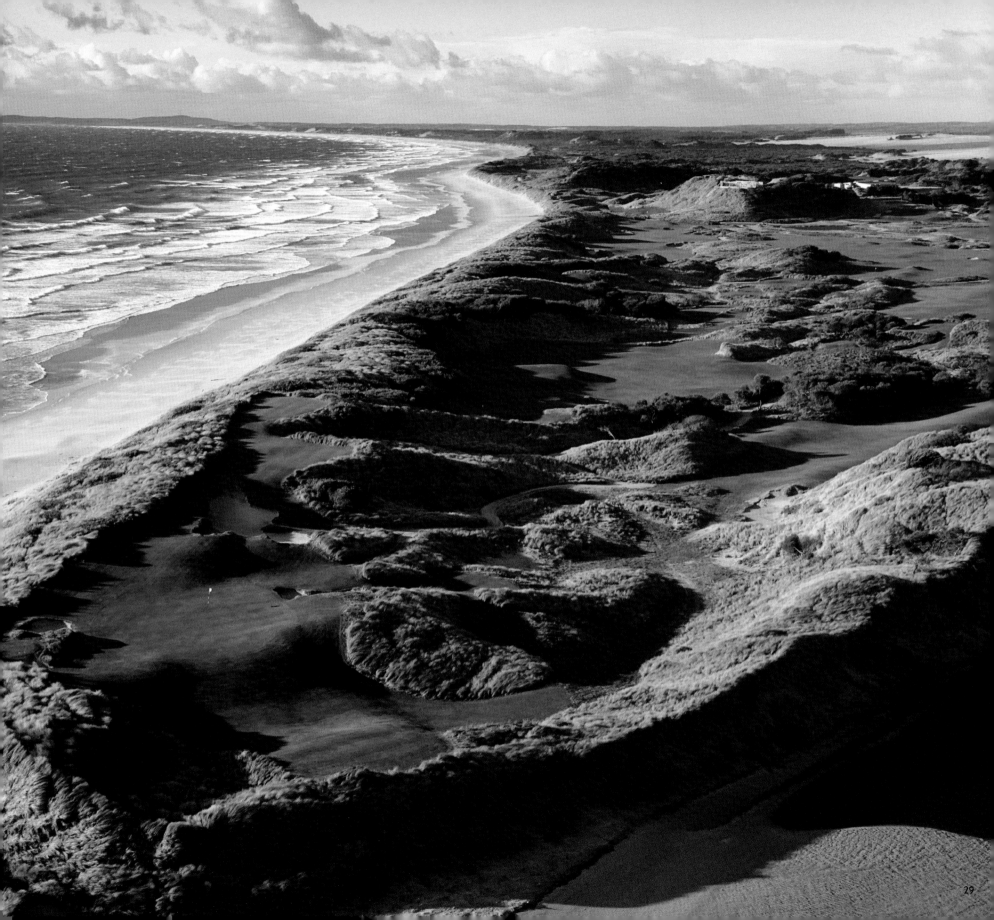

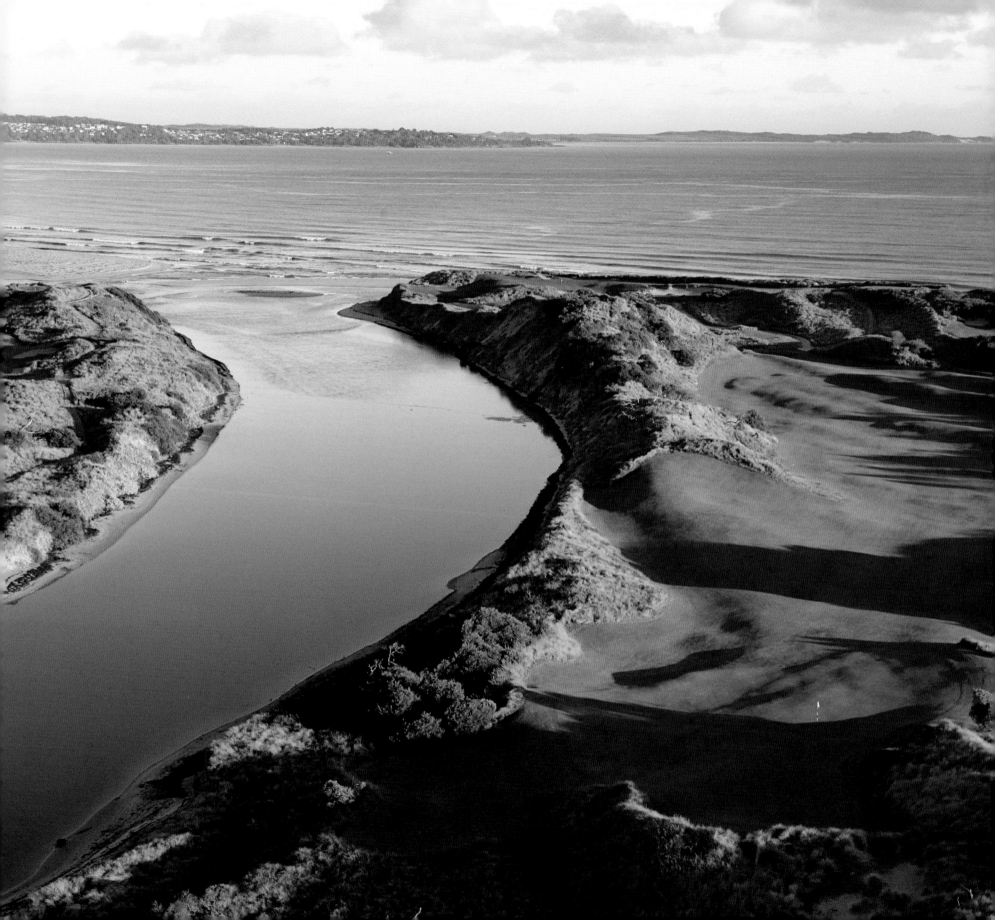

modest 271 metres (296 yards) from the back tees, serving up the conundrum of whether to attempt to carry the vast expanse of sand pit with an initial drive in search of glory or play more cautiously and hope to one-putt for birdie.

Lost Farm is the six years junior of The Dunes and was laid out by Bill Coore and although his offering is no more than a pitching wedge away from its older counterpart, the two adjacent courses are subtly different in character. Not least because Lost Farm features 20 rather than the standard issue 18 holes. The steepness of its inclines among the sand dunes are more significant than its sibling.

Lost Farm achieves its 20-hole status by virtue of the cunning creation of 13a, a short but difficult par three towards an elevated green, and 18a, another short challenge with a big green and extensive bunkering that catches the unsuspecting unawares as they head towards the clubhouse after the 'real' 18th.

OPPOSITE: The Lost Farm course to the right is separated from The Dunes course by the Great Forester River.

RIGHT: The par three 17th green at Lost Farm.

BELOW: Looking from the tee down the fairway at Lost Farm's par three 15th hole, overlooked by the clubhouse.

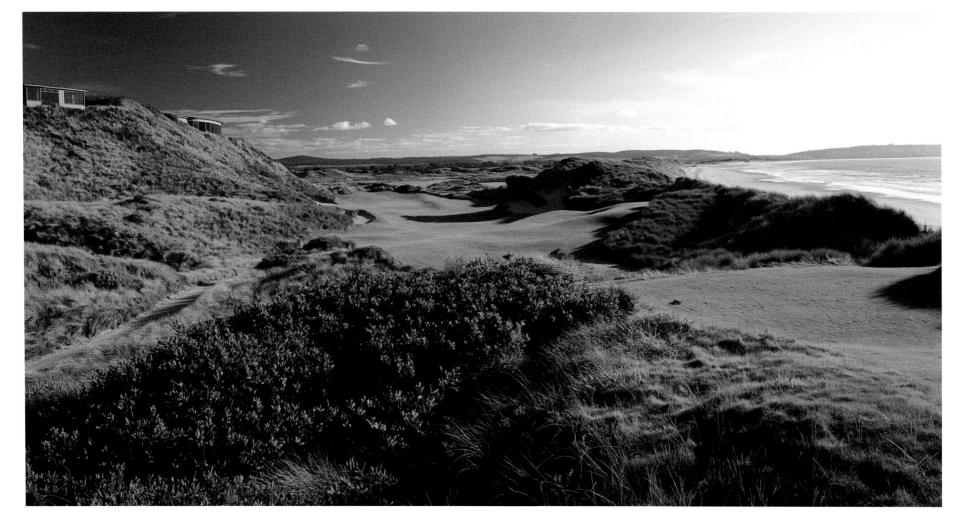

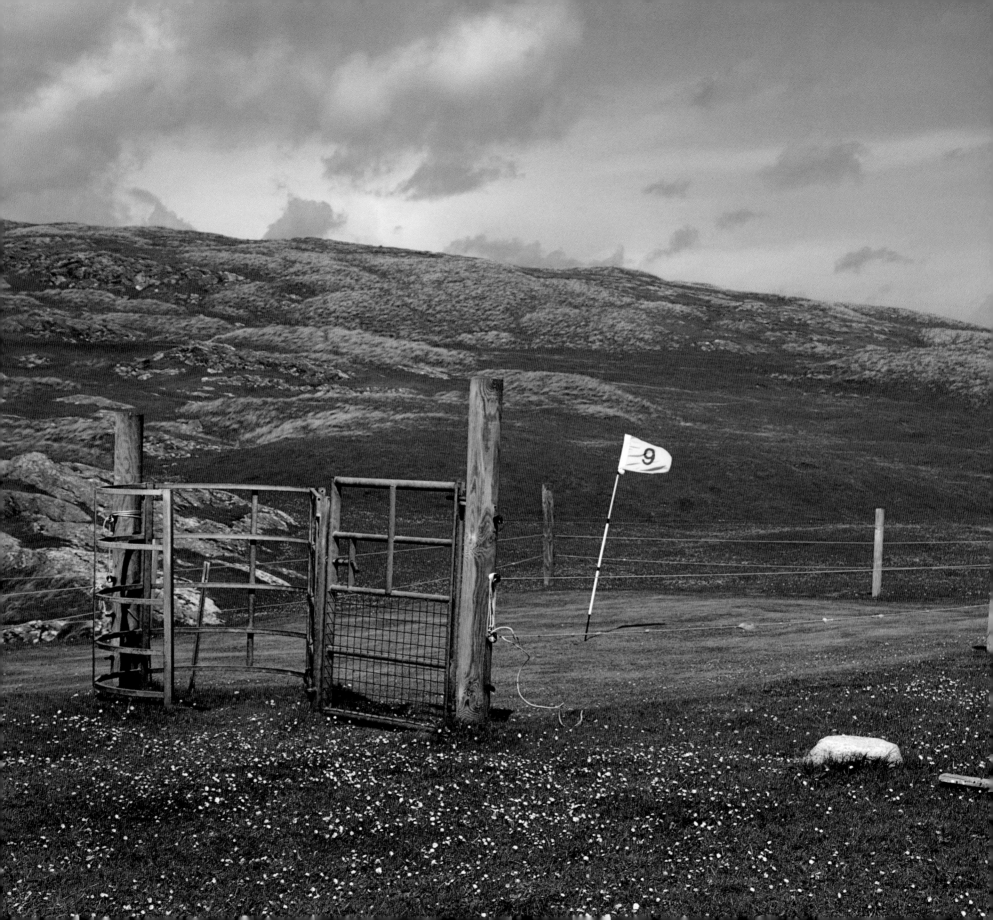

Barra Golf Club

Isle of Barra, Outer Hebrides, Scotland

There are, by conservative estimate, over 2,500 golf courses the length and breadth of the United Kingdom. For the curious golfer in search of a new challenge, many are conveniently sited, but those wishing to sample the remote charms of the Barra Golf Club must be prepared for a rather longer journey to the first tee.

Located on the western shoreline of the Isle of Barra, the course is unquestionably scenic but it is also incredibly remote and while the panoramic views out over the Atlantic are reward enough for those who venture to the island to play, only the locals can play the club's windswept nine holes without first packing a suitcase. Opened in 1992, the course makes full use of the island's natural machair – fertile, low-lying dune pastureland which is typical of the Western Isles of Scotland – to provide a fine surface, but players must be prepared to share the fairways with the local sheep and cattle.

Barra's splendid isolation is both its greatest attraction but also its achilles heel. It has proved a significant challenge to maintain a course on such a far flung island with a resident population of little over a thousand people. Full annual membership is a mere £80, while visitors can tackle the 2396 yards for just £10 deposited in an honesty box.

"It is the most westerly course in Britain and the views are absolutely stunning," explained club spokesman Murdoch MacKinnon in 2016. "It looks out to Barra Head on one side and on the other side towards the Uists; out to the Atlantic on one side and the Minch from the other. Visitors think the views are absolutely magnificent.

"We started in 1992 and we used to have 66 members, but we are down to 15 now and we are struggling. We are very fortunate because the crofting township (of Cleat) allows us to use the land, but it takes about £8,000 a year to keep the course going, with someone to help on the greens, and it is getting harder and harder every year."

Members at Barra nonetheless still harbour ambitions to build a clubhouse and a 2016 social media crowdfunding appeal raised more than £1000 to help take a step closer to making a permanent shelter from the unpredictable Hebridean weather a reality.

LEFT: The opening hole *Bruach Ban* (Fairbank) of the nine-hole course is a challenging 210-yard par three. And that's *before* the wind starts blowing.

FAR **LEFT**: The ninth green.

The Brabazon

The Belfry Hotel & Resort, Warwickshire, England

When the Belfry hosted the Ryder Cup for a fourth time in 2002, more than 120,000 spectators flocked to the Brabazon course over the three days of play to watch Sam Torrance's European side comprehensively recapture the trophy from the USA.

The idea for the course can be traced back to a conversation golf commentator Peter Alliss had in the mid-1970s with PGA director Colin Snape. Alliss tipped him off about an old hotel that was for sale just outside Birmingham that would make an excellent HQ for the organisation. He and design partner Dave Thomas then took an unremarkable tract of farmland and created a course that would go on to host four Ryder Cups.

It was named after PGA President Lord Brabazon and opened in 1977 with a challenge match between Severiano Ballesteros and Johnny Miller, and Tony Jacklin and the redoubtable, pipe-smoking Brian Barnes. Dave Thomas would revisit it in the late 1990s and add a lot more water to the challenge.

Apart from the renowned 18th hole (pictured right), requiring second shots to carry the lake, there is the tempting 301-yard par four 10th which encourages golfers to emulate Seve and drive the green. Failure to make the distance with a suitable fade to the right, ends up in water, and such is the slope and speed of the green that approach shots can easily spin back into trouble as well.

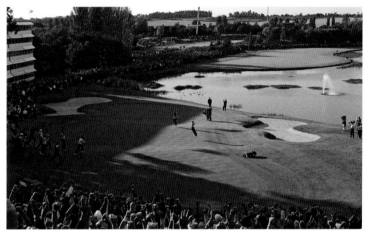

The first time the Ryder Cup headed to the Warwickshire countryside was in 1985. Ominously the USA had won 13 Ryder Cups in succession, a triumphant run dating back to 1959 when the opposition was limited to Britain and Ireland. The Belfry proved an inspirational choice of location for Tony Jacklin's team as they romped to a 16.5 to 11.5 victory. Four years later the two teams drew 14-14 on their return to the club, a result which saw Jacklin's charges retain the title, while the 1993 Ryder Cup produced Europe's only defeat at the Belfry as Tom Watson's team proved too strong for Bernard Gallacher and co.

The 2002 edition of the event, however, was the one which produced one of the most famous moments in Ryder Cup history. Narrowly beaten at Brookline three years earlier, Europe went into the final day's singles tied at 8-8 with the Americans.

Irish debutant Paul McGinley versus Jim Furyk was the ninth pairing of the day and as the rivals prepared to tackle the 18th, Europe needed only a half to lift the Ryder Cup. McGinley was subsequently faced with a 12-footer to achieve just that and the rookie held his nerve superbly to spark wild scenes.

TOP RIGHT: Lee Westwood negotiates the familiar angry duck hazard on the 18th.

RIGHT: Ryder Cup winner and wild swimmer Paul McGinley celebrates with a dip in 2002.

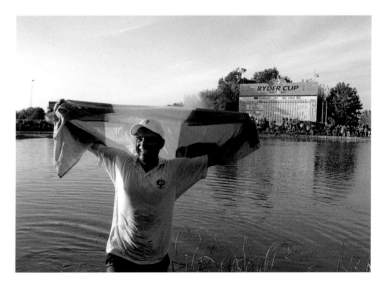

Brocket Hall Golf & Country Club

Hertfordshire, England

At first glance, the historic Brocket Hall and its two acclaimed courses – the Melbourne and the Palmerston, named after two prime ministers and former residents of the house – are the epitome of English rural charm, respectability and understated elegance.

The picture-perfect electric ferry which gently transports players across the River Lea to the 18th green of the Melbourne Course is a quintessentially British delight, while the Palmerston Course, designed by Donald Steel, is lined with glorious 300-year-old woodland. Brocket Hall, set in eighteenth-century parkland, simply oozes style and good breeding. Delve a little deeper, however, and a less seemly, more salacious picture emerges.

Built in around 1760, the house's first walk on the wild side concerned its first resident, Lord Melbourne. His wife Elizabeth had many lovers but she really rubbed salt in the wound by conducting an affair with the Prince Regent under her husband's nose in Brocket Hall itself.

The second Lord Melbourne enjoyed no greater marital fidelity from his spouse Lady Caroline Lamb, who had a well-publicized affair with Lord Byron and who gave the poet the lasting tag of "mad, bad and dangerous to know".

More recently the Hall and its two courses belonged to Lord 'Charlie' Brocket but he was reluctantly forced to lease the entire 500-acre estate to a property consortium on a 60-year deal after falling foul of the long arm of the law in the early 1990s.

A classic car dealer by trade, Lord Brocket ran up huge debts when the market in expensive vintage cars collapsed in 1991 and rather than lose the house, he dismantled three vintage Ferraris and a Maserati, buried the parts in the grounds and put in an insurance claim for £4.5 million. He was sentenced to five years in prison for attempted fraud.

Not all of the disassembled car parts were recovered, which means golfers at Brocket Hall today could be hitting their shots unwittingly standing a few feet away from the bonnet badge of a classic Ferrari 250 Europa GT, or the rear wheel of a Maserati Tipo 61 'Birdcage'.

BELOW: At Brocket Hall the river Lea has been widened into the Broadwater Lake.

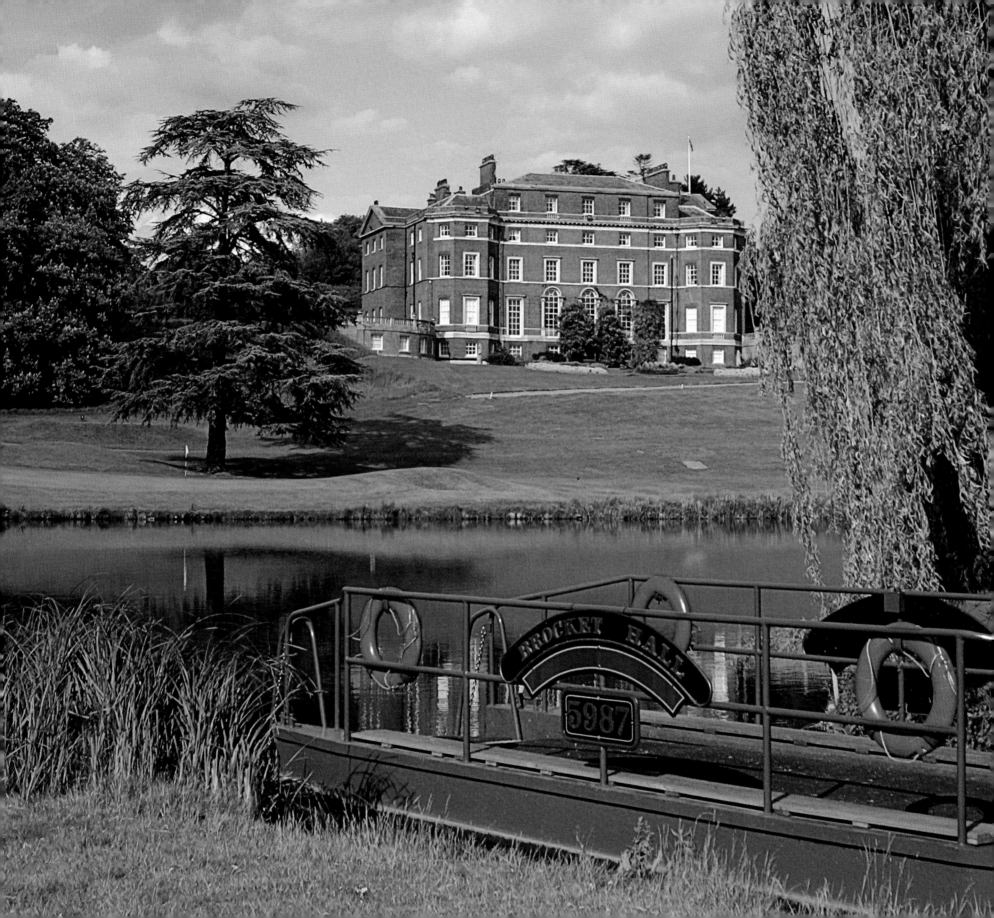

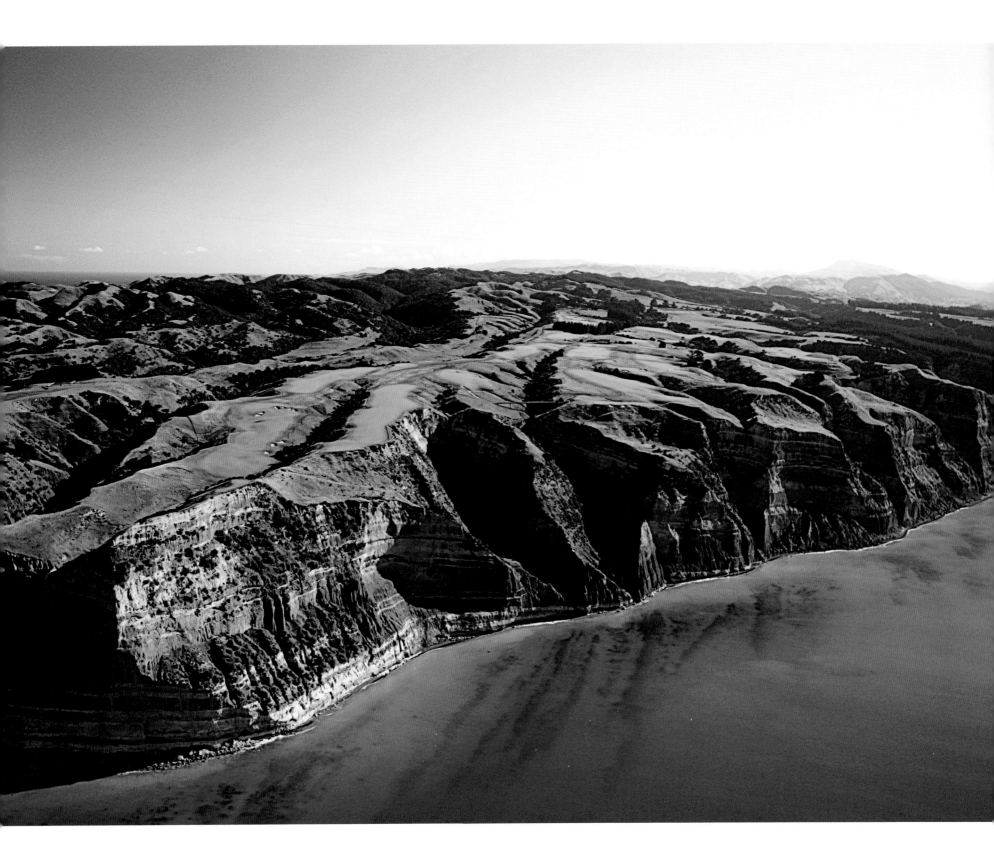

Cape Kidnappers Golf Course

Hawke's Bay, New Zealand

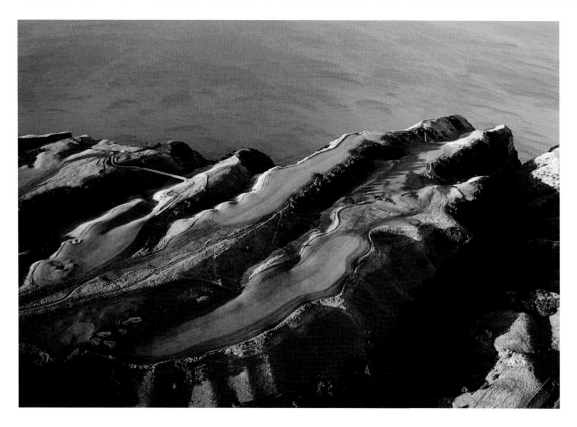

peninsula's gullies, chasms and rugged rock formations.

"The site is not like anywhere else in golf," Doak said. "If it were any bigger or any more dramatic, it would probably be cordoned off as a national park. It's an overwhelming experience to stand up on the cliffs and look out across the waves far below in Hawke's Bay."

Both the area and the club take their unusual name from an eighteenth-century skirmish between Captain Cook and the crew of HMS *Endeavour* when local Maori attempted to abduct one of Cook's servants while he was taking a dip in Hawke's Bay. The would-be kidnappers were sent packing but the name stuck.

The playing surface at Cape Kidnappers is firm and fast, with wind unsurprisingly a near constant factor, while the rough is stubborn and unforgiving. The two most dangerous holes are the sixth and 15th with both providing the opportunity to watch your ball disappear into the South Pacific. It will take a full, agonising 10 seconds for the ball to descend from the course before it is finally embraced by the water below.

Patience is a perennial virtue and one which those who make the long journey to Cape Kidnappers are advised to be mindful of as they draw up to the front gates of the club. Five more miles separate the expectant but weary golfer from the course, and should the local cattle or sheep choose to wander into the road, the final leg of the trip can take half an hour.

The wait, however, has its considerable rewards. Cape Kidnappers' remote location on a headland of the North Island overlooking Hawke's Bay is its greatest asset and with the natural rock promontories jutting dramatically out towards the water, some 500 feet below, the course is breathtakingly panoramic.

Designed by the American architect Tom Doak and opened in 2004, minimalism was the watchword when the original designs were drawn up and the course embraces rather than rides roughshod over the succession of the

ABOVE LEFT: Light rakes across the 13th, 14th, 15th, 16th and 17th holes at Cape Kidnappers in Hawke's Bay.

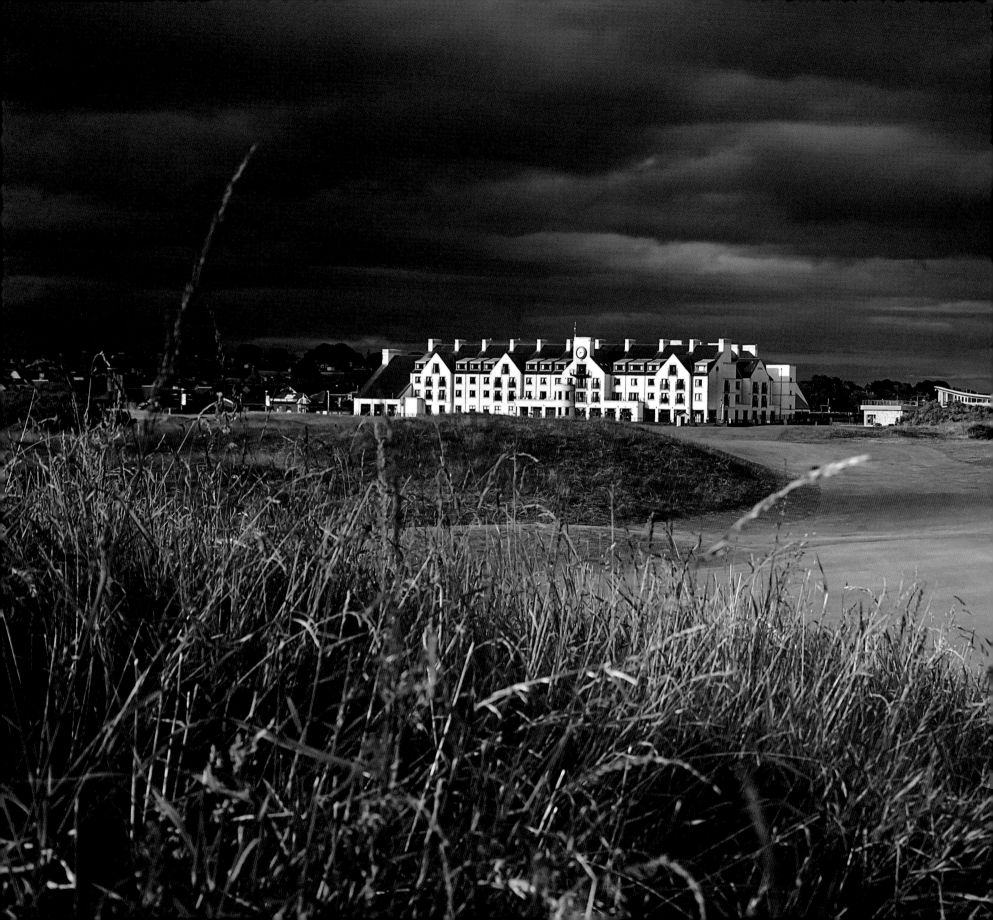

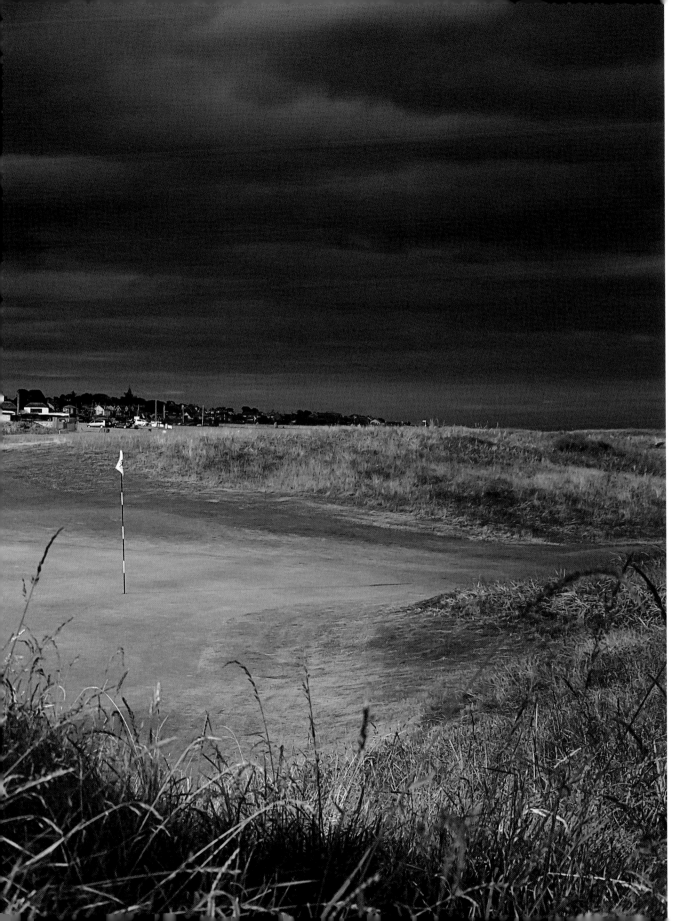

The Championship Course

Carnoustie Golf Links, Angus, Scotland

Originally opened on the east coast of Scotland in 1842 with just 10 holes, Carnoustie expanded to the full 18 a quarter of a century later and from that moment on its unforgiving reputation has preceded it. To no-one's great surprise it is also known as 'Carnasty' by those who have suffered the slings and arrows of not particularly outrageous fortune in the latter stages of the course.

The bunkers guarding the front of the green of the 245-yard, par three 16th are merciless to those who cannot make the distance, while the par four 17th is snaked by the hazardous Barry Burn (more of which shortly), but it is Carnoustie's infamous 18th hole which truly strikes fear into the hearts of the professionals and amateurs alike.

At 499 yards, it's a long par four regardless, but the real problem is the aforementioned Barry Burn, the small river which twists its way towards the green, heads off left and then loops back in front of the putting surface.

A host of players have suffered a watery fate on the 18th hole courtesy of the Barry Burn but none more famously than Jean Van de Velde of France, who was ultimately denied glory at the Open Championship in 1999 after disastrously tangling with Carnoustie's silent assassin.

The Frenchman was three shots clear of the field and only needed to score a six on the final hole to clinch the famous claret jug. He opted for the driver and successfully found terra firma but rather than laying up with his second shot and avoiding the Burn's well-documented threat, he went for bust. His approach hit railings on the grandstand and ricocheted fifty yards backwards and Van de Velde's ball deposited itself in deep rough. There was a palpable sense of inevitably that his third would find the Barry Burn. A brief paddle in the Burn persuaded him it would be folly to attempt to play out, so he took a drop, but he could subsequently muster no better than a triple-bogey seven which condemned the one-time runaway leader to a three-way play-off with Justin Leonard of America and Scotsman Paul Lawrie for the title.

There was no redemption for the Frenchman, however, as Lawrie held his nerve to win the four-hole decider and, cursing the Barry Burn as he packed his bags, Van de Velde departed to ruefully contemplate what has since become known as one of golf's greatest gaffes.

There was further, final round drama on the 18th when Carnoustie staged The Open for a seventh time in 2007. This time it was Ireland's Padraig Harrington who found himself acquainted with the Burn – in his case twice – but in stark contrast to Van de Velde eight years earlier, he was able to recover from the setback of a double bogey six. Harrington's inaccuracy did relegate him to a play-off with Sergio Garcia but a bogey five on his second visit of the day to the 18th was still good enough to clinch the Irishman the title.

Golfers, though, are not the only victims of the voracious Barry Burn and in 2011, as Carnoustie played host to the Women's British Open, the river swallowed up a golf buggy after its driver conspicuously failed to spot the impending hazard.

BELOW LEFT: Jean Van de Velde contemplating his fourth shot from the Barry Burn in 1999.

BELOW: An aerial view of the par five, sixth hole 'Hogan's Alley' on the Carnoustie Championship Course.

RIGHT: Both sinuous and sinister, the Barry Burn snakes round the 18th hole providing a great degree of jeopardy for any misplaced shot.

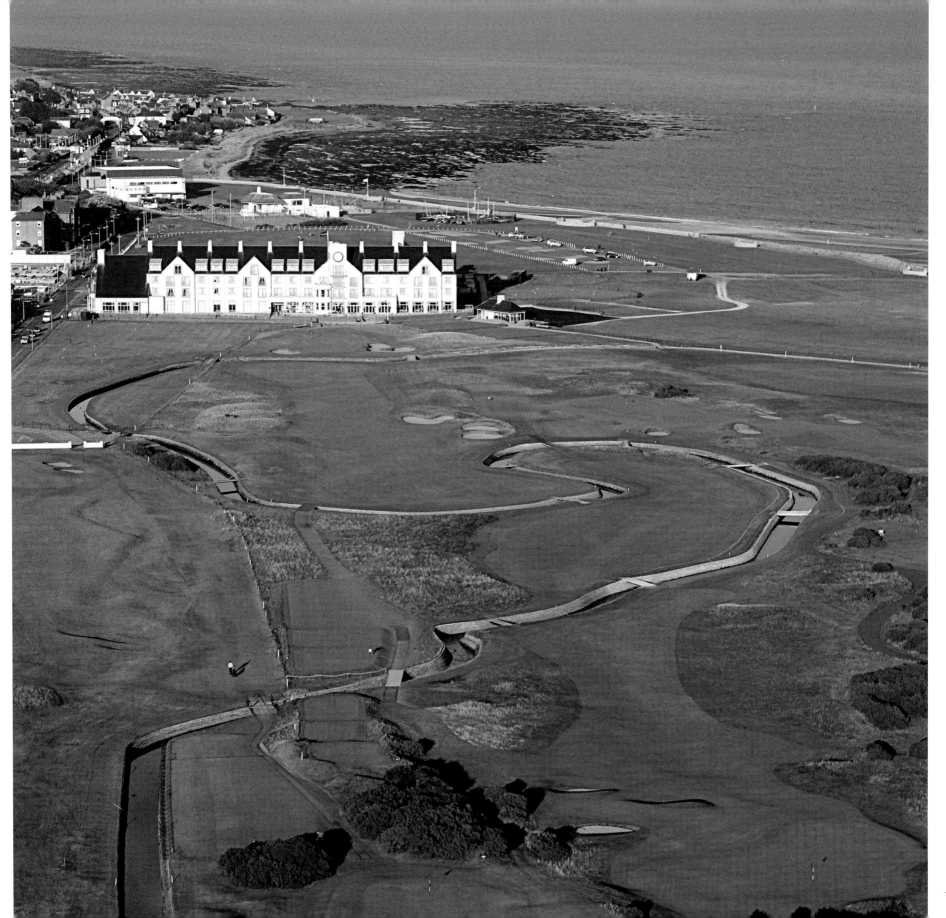

Championship Course

Machrihanish Golf Club, Argyll, Scotland

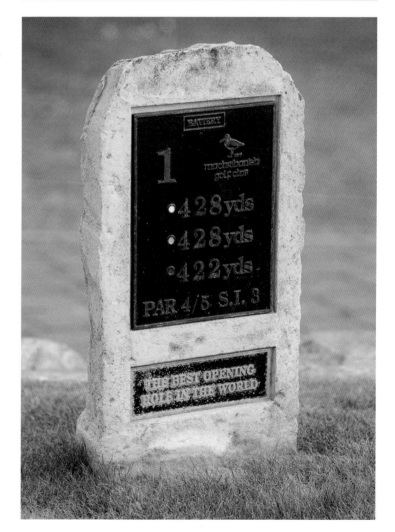

There is a school of thought within golf that a course's most spectacular, eye-catching hole should be its 18th, the pièce de résistance to the 17 holes which have preceded it. Saving the best for last.

When the revered golfer and course designer Old Tom Morris first looked out over the Machrihanish Dunes in 1879, contemplating in his mind's eye an overhaul and expansion of what was then the 10-hole Kintyre Golf Club, he decided to start rather than finish his new course with a bang.

"The Almichty Maun hae had gowf in his e'e when he made this place," Old Tom is said to have exclaimed as he surveyed the scene and the result of his contrary thought process is Machrihanish's majestic 436-yard, (previously 428 yards) first hole, named 'Battery', which many consider to be the finest opener anywhere in the game.

The key to Battery's appeal is the Atlantic Ocean and the beach which separates the fairway from the salt water. Significantly, the beach is considered in play rather than out of bounds and since potentially playing from the sand on the left of the fairway is no more onerous than from one of the four bunkers on the right, many players are emboldened and take on a drive from the elevated tee over the beach rather than playing it safe.

Combined with the panoramic views afforded by the southern tip of the Mull of Kintyre, and the outlines of the nearby islands of Islay, Jura and Gigha, it makes for an unforgettable start to one of Scotland's most popular classic links courses.

Old Tom's original design for the Championship course has largely stood the test of time despite modifications being made in the 1910s and again in the 40s, while the enduring genius of his vision for Machrihanish was recognised when *Golf Digest* named it 91st in its list of the World's 100 Greatest Courses in 2016.

TOP: The 373-yard third hole 'Islay' at the Machrihanish Golf Club.

OPPOSITE: Nobody needed to explain 'risk and reward' to Old Tom Morris, it's all here at 'Battery'.

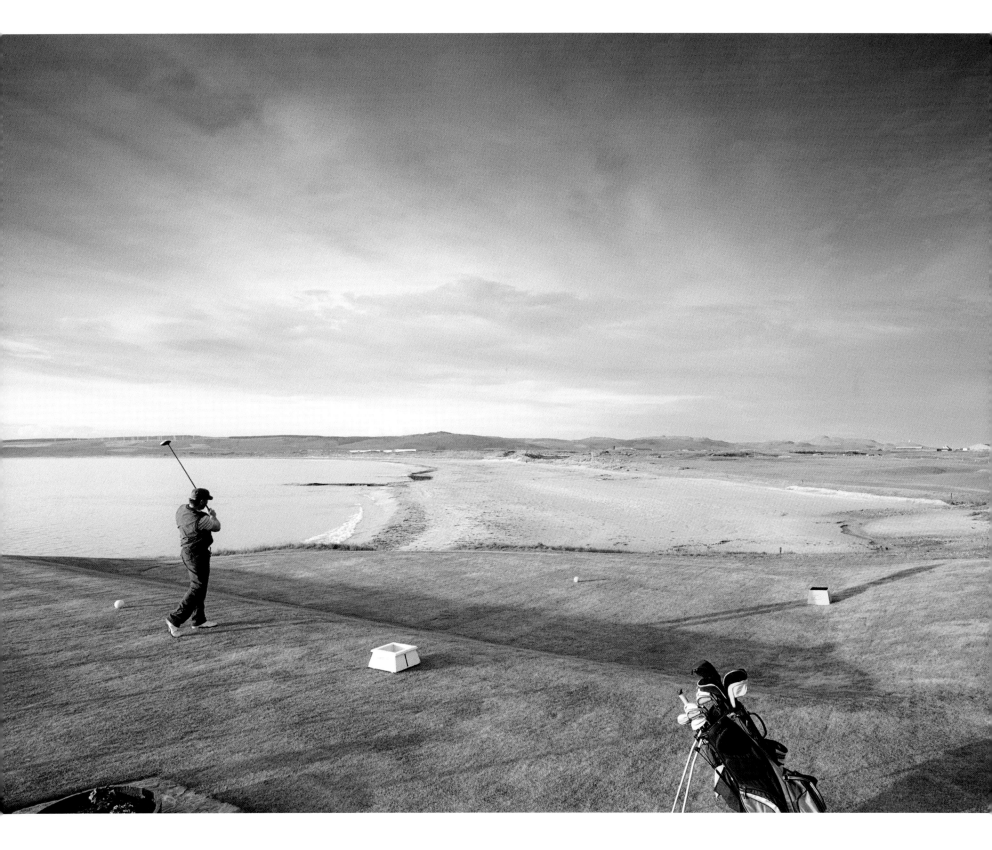

Championship Course

Royal County Down, Newcastle, Northern Ireland

Golf and tourism often go hand in hand. Courses attract visitors, while holiday resorts create opportunities for new clubs, and it is often merely a question of which came first. In the case of Royal County Down, it was tourism first and golf a close second.

The club's origins date back to the emergence of Newcastle as a popular Victorian holiday destination following the completion of a railway line from Belfast to the town on the Irish Sea. The resulting influx of people was a business opportunity too good to miss for a group of Belfast entrepreneurs and they commissioned Scotsman George L. Baillie to lay out nine holes for them in Newcastle.

The course opened in March 1889, catering for locals and holidaymakers alike, but just four months later plans were already afoot for

expansion and the owners called upon the revered Old Tom Morris to head over from Scotland and revamp the course. Which he did for £4. By July 1889, three more holes had been added and by early 1890 the course was the full 18 holes. Such rapid expansion was made possible by adapting the classic links terrain which demanded minimal excavation.

In 1908, the same year as the club received its royal patronage from Edward VII, Harry Vardon made some alterations to the course, but perhaps the most significant year in the club's history was in 1925 when Harry Colt was to be found in Newcastle making further improvements. The result was the creation of

BELOW: Rory McIlroy launches one in the direction of Slieve Donard, the highest peak in the Mourne Mountains, at the 2015 Irish Open.

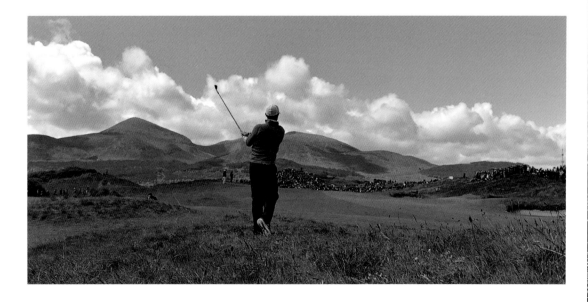

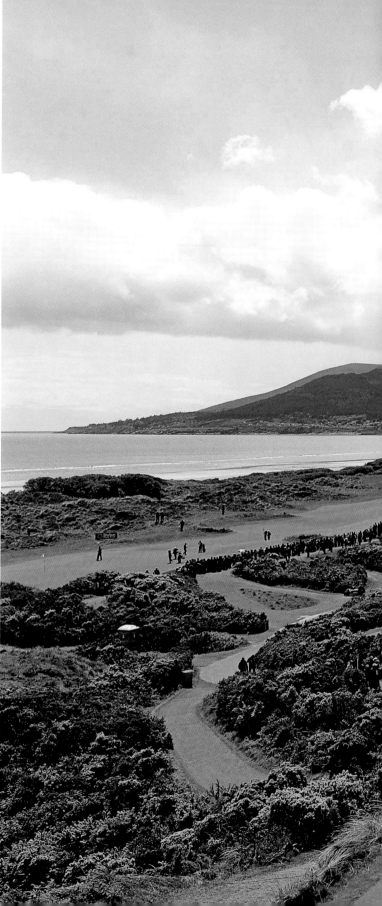

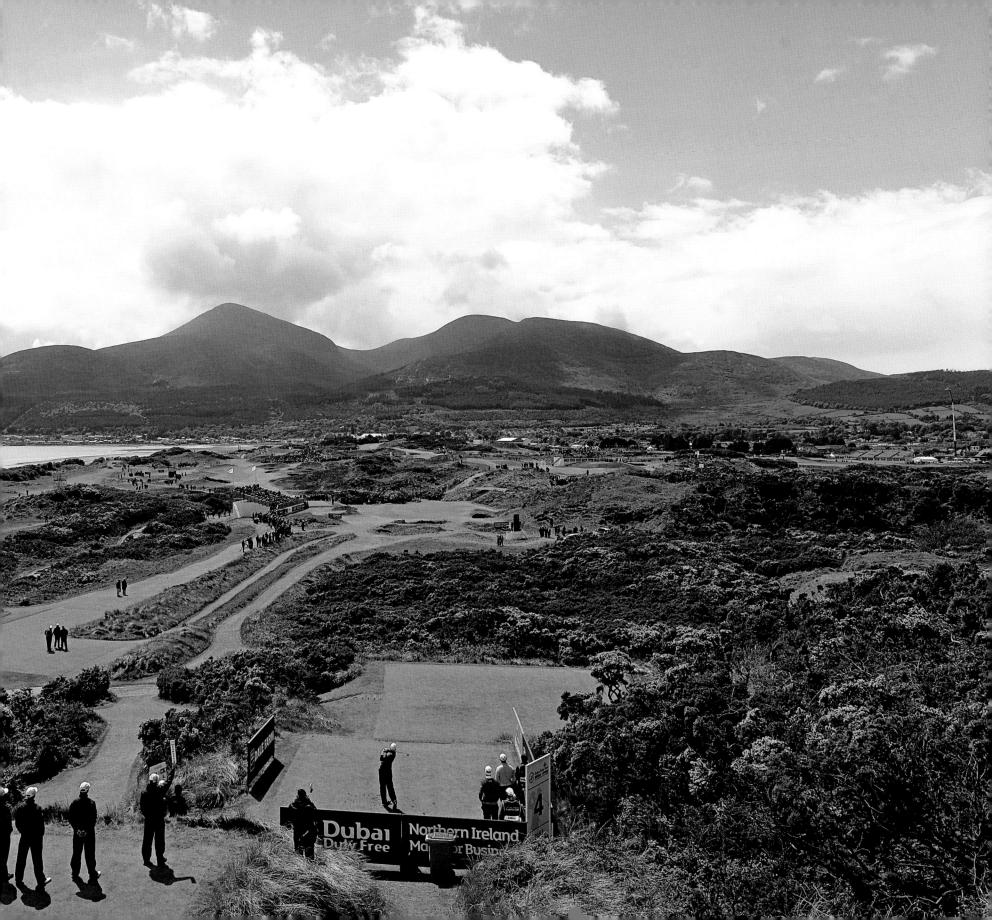

Royal County Down's revered fourth and ninth holes, two of the most photographed holes in Irish golf.

The fourth is a breathtaking par three of 229 yards from the championship tees. The elevated tee affords incredible views of Dundrum Bay and the Mountains of Mourne, but it is the barrage of seven bunkers at the front of the narrow green that players need to keep their eye on. Even if the bunkers are avoided, there are large drop-offs to the left, right and rear of the green awaiting the unsuspecting.

The ninth, providing views of the iconic Slieve Donard Hotel in the distance, is a sizeable par four at 483 yards which begins with a blind tee shot which needs to stay left, close to a large dune to garner the best angle of approach to the green.

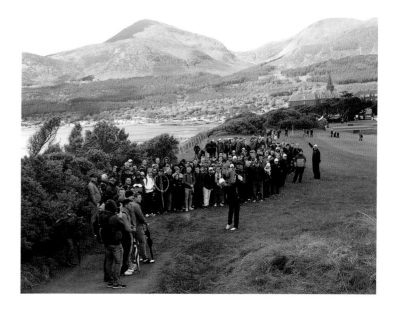

RIGHT: Tommy Fleetwood of England flirts with the out-of-bounds as he plays his second shot to the first hole at the 2015 Irish Open.

BELOW: Padraig Harrington thinks about which club to use on the sixth tee. Beyond is the distinctive tower of the Victorian era Slieve Donard Hotel.

OPPOSITE: Home boy Rory McIlroy of Northern Ireland heads home from the 16th tee. The 2015 Dubai Duty Free Irish Open was hosted by the Rory Foundation.

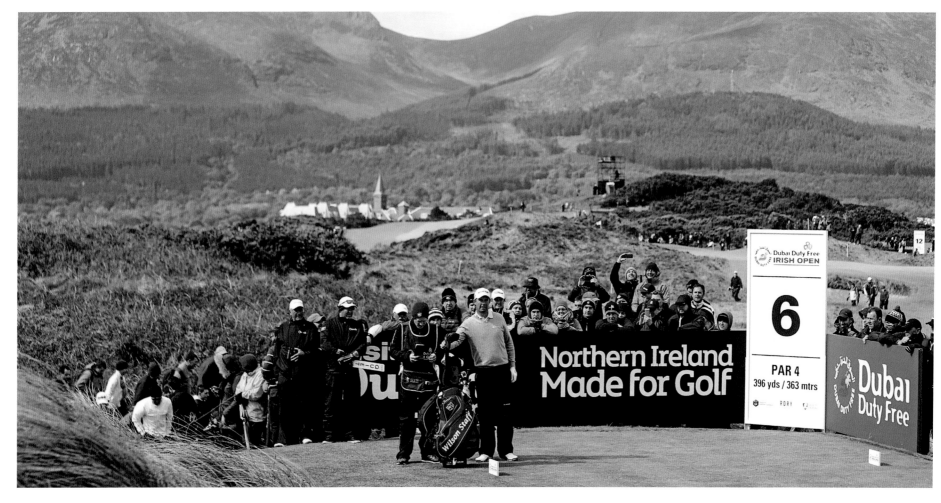

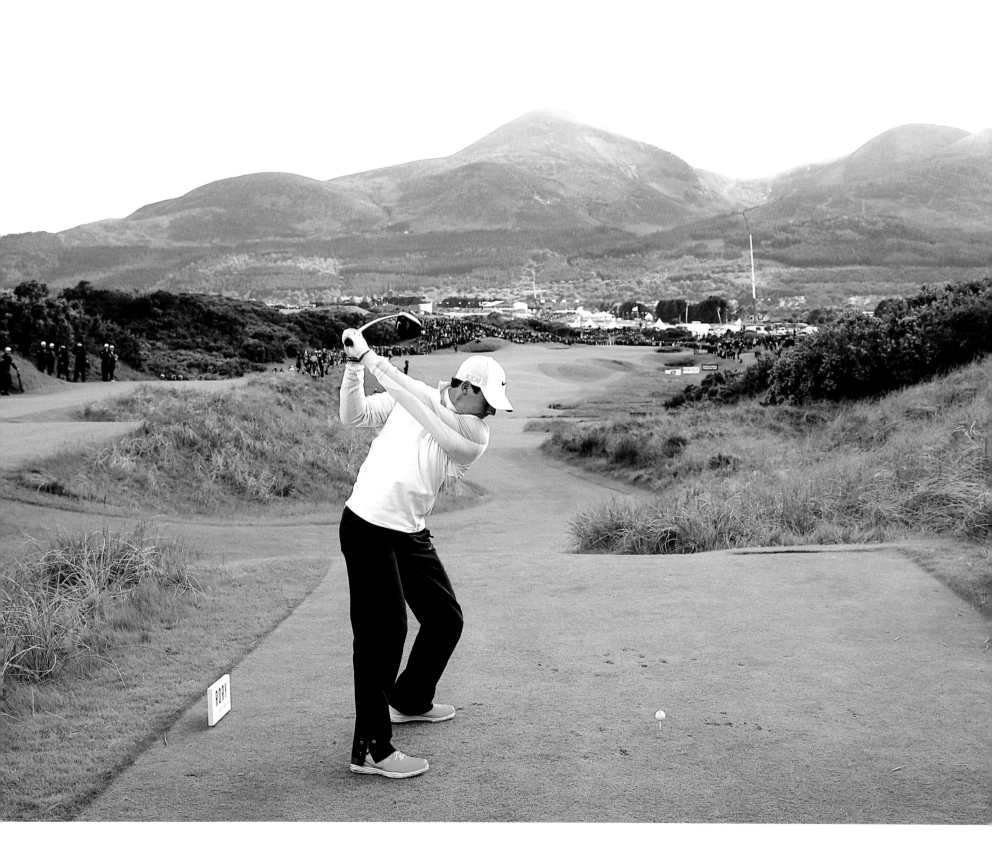

Chicago Golf Club

Wheaton, Illinois, USA

The history of golf in the USA must, by definition, be briefer than that of its European antecedents. The game as we know it was born in Britain and although it was not long before it made the Transatlantic journey and put down deep roots, golf is nonetheless a sporting immigrant in America. The title of the country's oldest 18-hole course is therefore a coveted one and belongs, via a circuitous story, to the Chicago Golf Club.

Today it is still ranked among the top 20 courses in the USA by a number of different publications, but back in the late nineteenth century it was unequivocally No.1.

The driving force behind the creation of Chicago Golf Club was Charles Blair MacDonald, who fell in love with the game when he attended St Andrews University in Scotland as a teenager. When he returned to the States brandishing a set of clubs, he was determined to spread the gospel.

In early 1888 he laid out a few informal holes on lakeside land owned by a friend. The new game from the old world proved to be a hit, and four years later MacDonald raised enough money from golf's new converts to build a nine-hole

track on farmland in Belmont, some 20 miles outside Chicago.

His creation was again extremely popular and as he was to subsequently reveal in his book of 1928 entitled *Scotland's Gift - Golf*, by the spring of 1893 he had successfully expanded the course at Belmont to a full 18 holes. In the summer of the same year, the charter was granted for the Chicago Golf Club.

The story does not end here, however. In 1894 club members demanded an improved 18-hole track and a 200-acre stretch of farmland near the town of Wheaton was purchased for the purpose.

Macdonald himself undertook the links-style design, routing the front nine in a clockwise layout because he was a well-known slicer of the ball and this way he would stay out of trouble. His real genius, though, was to invigorate what was essentially a flat, boring parcel of land and make it a genuine golfing challenge. He achieved this with a judicious sprinkling of bunkers but chiefly with an imaginative sculpting of the greens, featuring many false fronts which demand precise approach shots.

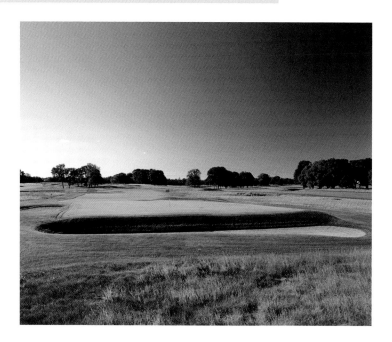

His creation went on to host the U.S. Open in 1897, 1900 and finally in 1911, while more recently it was the venue for the Walker Cup of 2005, as the best amateurs from both sides of the pond did battle.

ABOVE: The 320-yard par four fifth hole at the Chicago Golf Club. Many of the early greens were square.

The Church Course

St Enodoc Golf Club, Rock, Cornwall, England

For some people, golf is a religion, requiring as it does dedication, perseverance and the belief in occasional divine intervention. At St Enodoc Golf Club on the north Cornwall coast, the two forms of worship exist side by side in one of the game's most idyllic settings.

The church of St Enodoc, just outside the village of Trebetherick, near Rock, is surrounded on all sides by the golf course. The only access is by foot across the club's famous fairways and while the local congregation must be wary of ill-directed balls, particularly on Sunday mornings, the church and the course have coexisted amicably for more than a century ever since James Braid laid down the 18 holes in 1907. The church was there first, the oldest parts dating back to the twelfth century. It is named after a hermit called Enodoch, a sixth-century saint from South Wales, who it is believed lived in a cave on which the church was subsequently built.

St Enodoc's location on the edge of the river Camel estuary makes it an ideal place for a links course but the proliferation of sand has not always been the church's friend and from the sixteenth century to the middle of the nineteenth, the building was virtually engulfed by the sand dunes. As a result, it was dubbed locally as 'Sinking Neddy'.

The club's fame is not merely ecclesiastical in

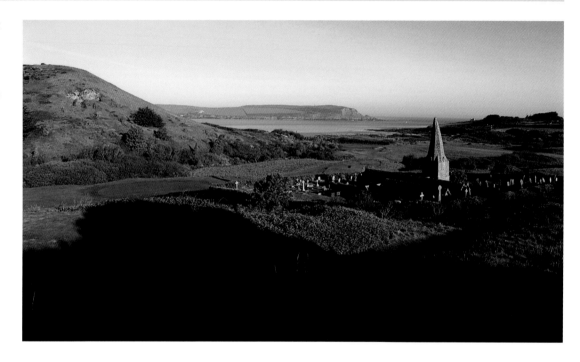

nature, the course is indelibly linked with Sir John Betjeman, the former Poet Laureate who fell in love with St Enodoc. He spent many childhood holidays in Trebetherick and relocated to the village later in life, buying a house close to the 12th hole.

By his own admission, Betjeman was not a great golfer, but he was an enthusiastic member of the club and in 1954 he immortalised St Enodoc when he penned a collection of poems which included *Seaside Golf*, his ode to the 13th hole.

He became an Honorary Member of the club in 1977 until his death seven years later. Fittingly he was buried in the graveyard, his coffin carried the length of the 10th hole in driving rain to the church.

Despite Betjeman's poetic tribute to the 13th, however, the Church Course's two best holes are arguably the sixth and 10th. The former is a

RIGHT: The sixth green is protected by the vertiginous 'Himalaya' bunker.

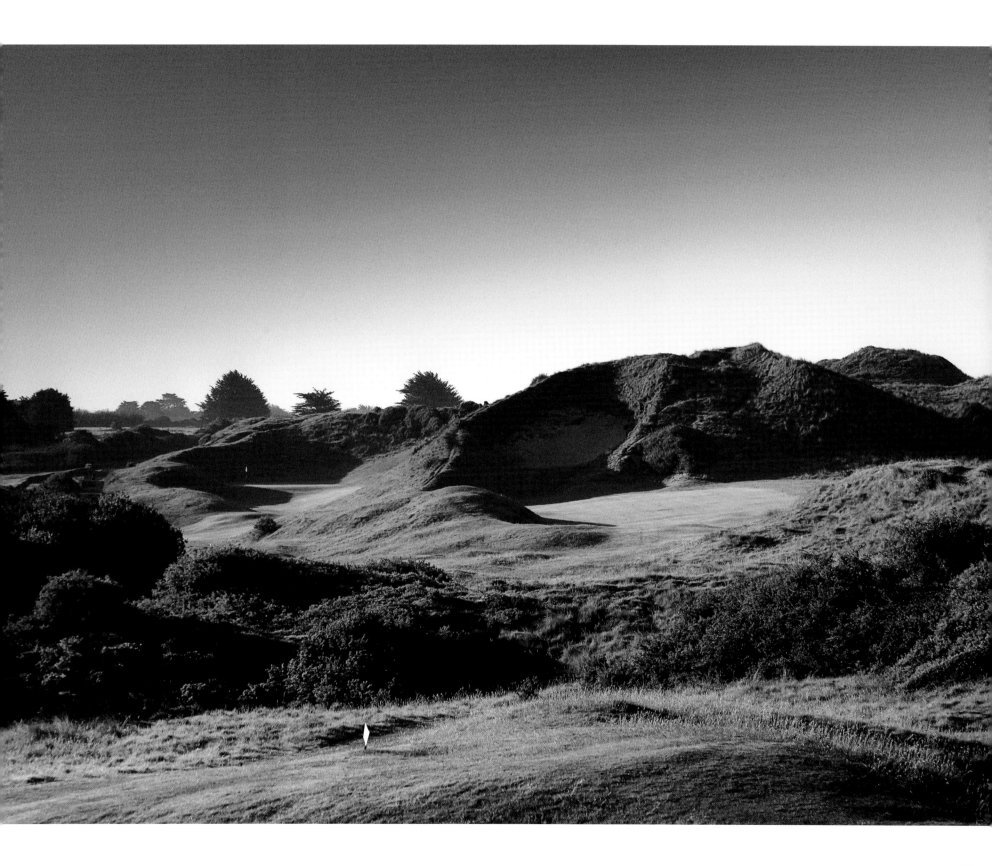

par four which plays 428 yards from the back tee and it is known as 'Himalayas'. It begins benignly enough but an imposing dune hillock with a vast bunker cut into its side that some have likened to a sandy crater, suddenly looms large and obscures the view of much of the green.

The 10th is a glorious undulating challenge of up to 457 yards, the majority of the distance downhill. Trees to the left and rough to the right demand accuracy, but the true beauty of the hole is the sight of the church peering above the tall hedge which surrounds it; players slicing their approach to the green run the danger of striking the stonework. The final word on St Enodoc must go to the man who admired nature and who deplored Slough, and who captured an emotion all of us have felt while playing an unpredictable links course.

> And down the fairway, far along
> It glowed a lonely white;
> I played an iron sure and strong
> And clipp'd it out of sight,
> And spite of grassy banks between
> I knew I'd find it on the green.

An extract from *Seaside Golf* by John Betjeman

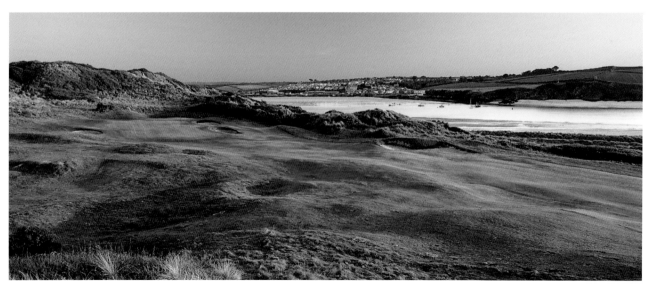

ABOVE RIGHT: The grave of former Poet Laureate Sir John Betjeman, a man who epitomised the phrase 'national treasure' and whose poetry was always better than his golf - apart from the day when he got 'that quite unprecedented three'.

RIGHT: The par five 16th hole with the Camel estuary and the town of Padstow beyond.

OPPOSITE: The par three 15th hole at St Enodoc.

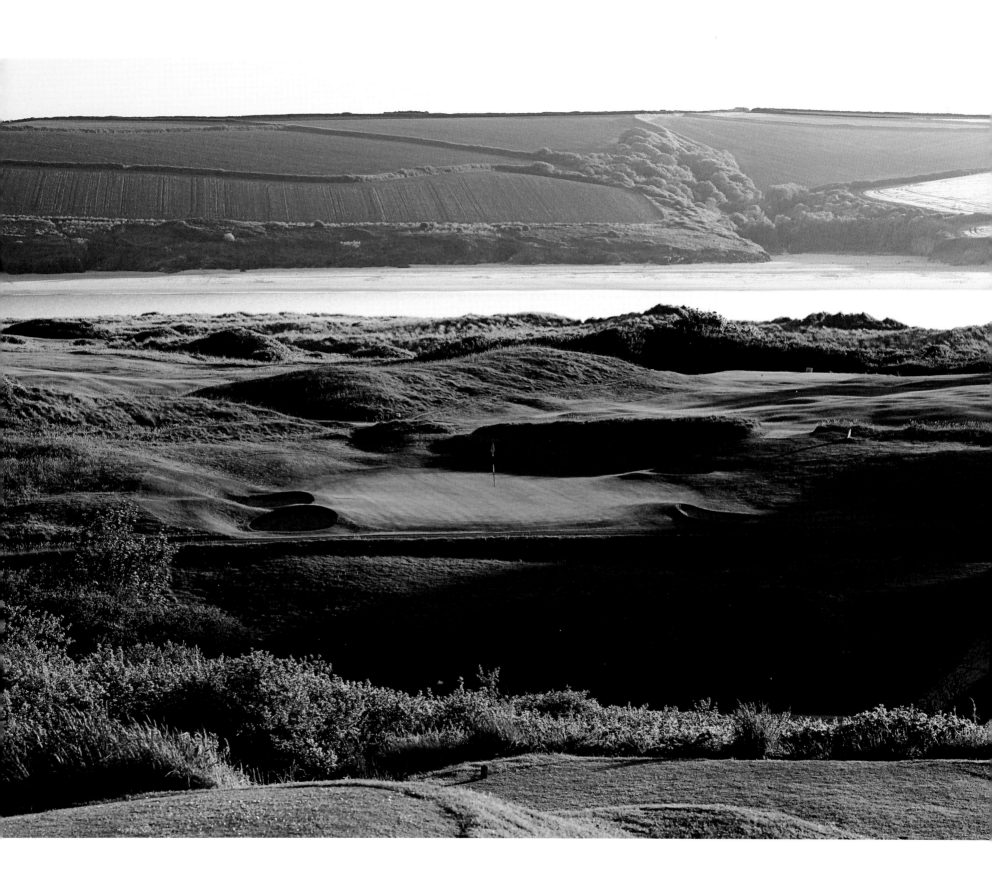

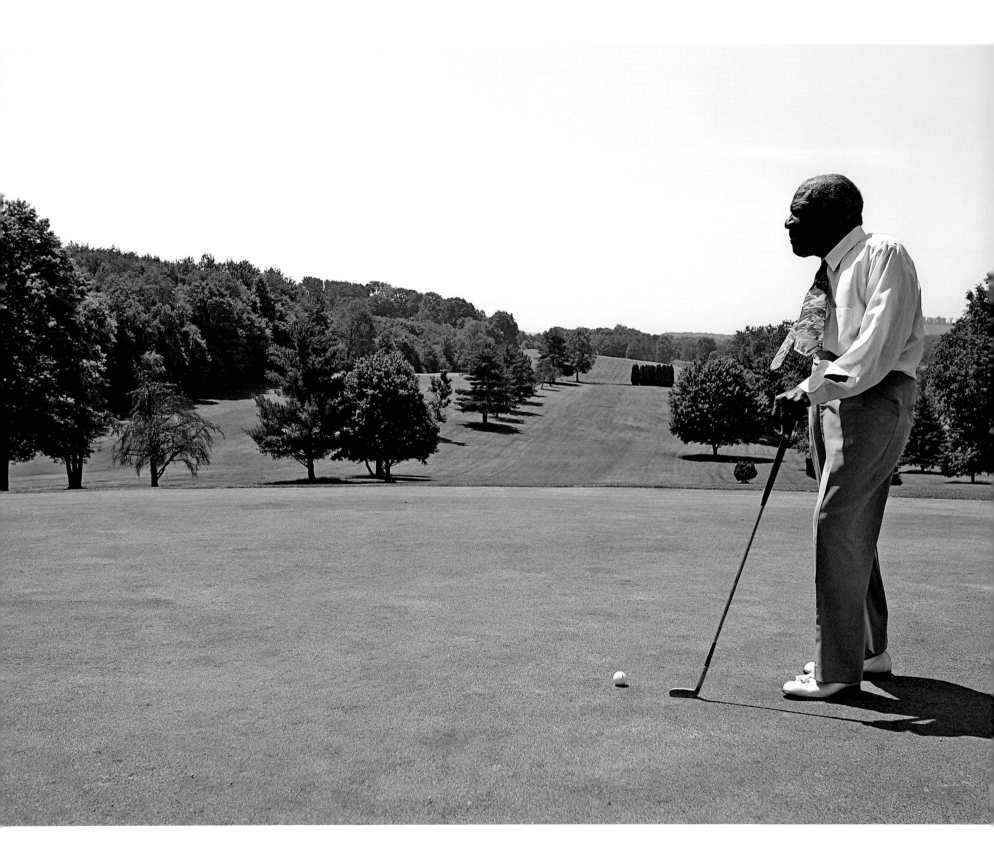

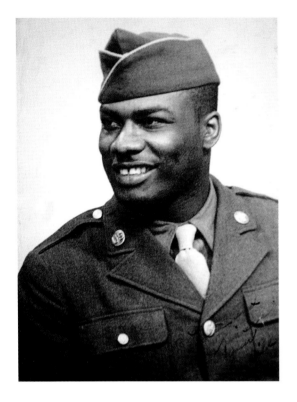

Clearview Golf Club

East Canton, Ohio, USA

There are many clubs over the years which have been founded as the result of an individual's labour of love, a burning desire to build a golf course. Clearview Golf Club would certainly never have been created were it not for the late, indefatigable William 'Bill' Powell. The course was his baby but its story is one of protest and outrage from an ugly era of American history.

A keen high-school golfer, Powell was an African-American who served his country in the Second World War only to return home after the conflict and find himself the victim of racial discrimination and excluded from Ohio's white-only courses.

He determined to build his own. The local bank's refusal to lend him the money required was only a temporary setback and after securing finances from two local African-American doctors and his own brother, Powell bought a 78-acre dairy farm in 1946 in East Canton.

It took him two years to lay out the first nine holes. He landscaped and then seeded his course by hand. He adapted a Jeep to drag a manual mower along the track in lieu of the more advanced grass-cutting equipment which he could not afford, but his considerable toil paid off and in 1948 the first golf course in America to be designed and owned by an African-American was open.

Admirably Powell rejected the prejudice that had been the catalyst for his creation in the first place and his club's policy was everyone, irrespective of race, was welcome to play. "The only color that matters," he said, "is the color of the greens."

In 1978 Clearview was expanded to the full 18 holes. In 1996 Powell was inducted into the National Black Hall of Fame and five years later his course was added to the National Register of Historic Places. In 2009, the same year as his death at the age of 93, he received the PGA Distinguished Service Award, while a plaque commemorating his incredible determination now proudly stands at the tree-lined course he built in rural Ohio.

ABOVE LEFT: 'Bill' Powell served in the USAAF in England during the Second World War.

LEFT: William J. Powell in his nineties. The plaque from the Ohio Historical Society describes his triumph over discrimination. 'Clearview represents the historic postwar era when athletes first broke the color line in American sports.' Jackie Robinson got to play for the Brooklyn Dodgers and William J. Powell built his golf course.

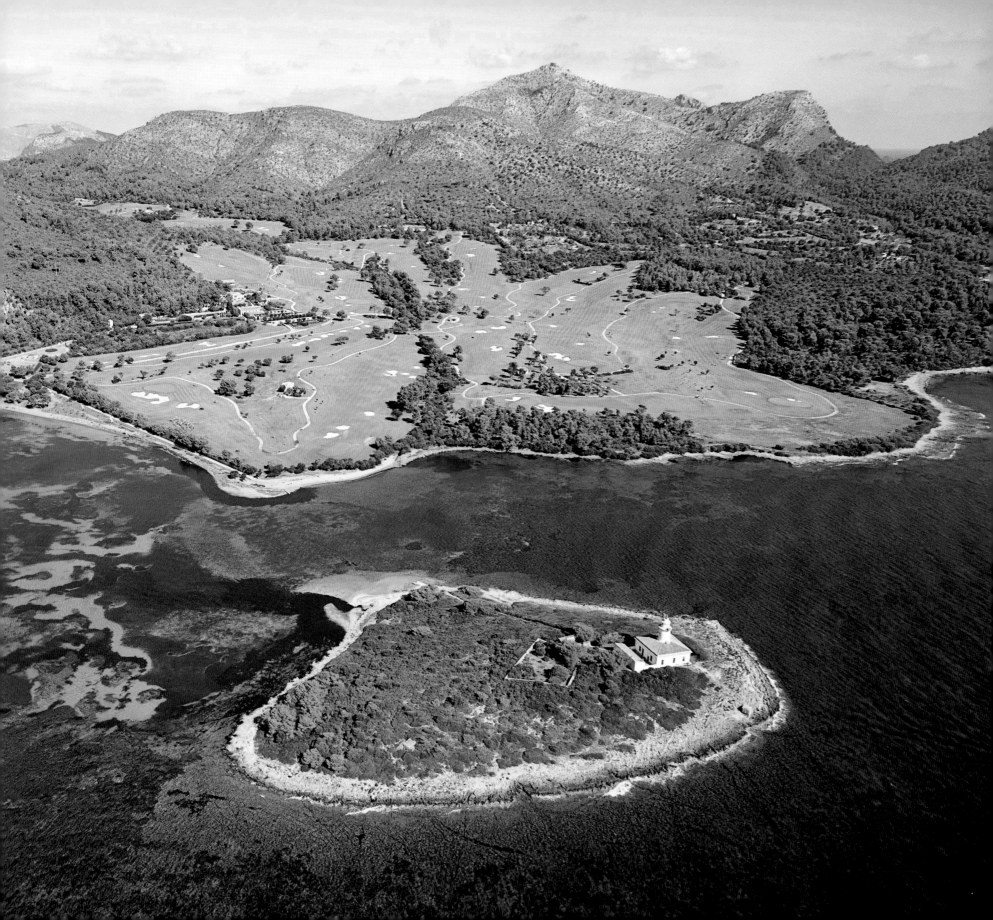

Club de Golf Alcanada

Mallorca, Spain

Nestled on land that sweeps down towards the Bay of Alcudia and framed by the Sierra Lavante Mountains, Club de Golf Alcanada enjoys a stunning Mediterranean setting but the undisputed star of the scene is the whitewashed lighthouse perched on the islet of Alcanada just off the Mallorcan coastline.

Built in the mid-nineteenth century and standing 25 metres tall, the lighthouse is visible from the more elevated sections of Alcanada and although the small uninhabited island on which it sits is not part of the course, it has become so synonymous with the club that it has been adopted as its official emblem.

During the Spanish Civil War three machine gun nests were built on the islet as hostilities raged between 1936 and 1939, while the last of the resident lighthouse keepers left in 1960 following automation.

Designed by the American architect Robert Trent Jones Jr. and opened in 2003, the club takes its name from the area of Mediterranean coastline between Port d'Alcudia and the Cap de Menorca in the north of the island and although it measures a relatively manageable 6,499 metres (7,107 yards) from the longest tees, it is not considered a course for beginners.

The frequent, humid sea breeze comes into play more markedly on the back nine rather than front nine. The best view of the Bay of Alcudia and the lighthouse can be found on the elevated tee on the par five 13th hole, although the 17th and 18th are also well appointed in terms of coastal vistas.

Widely regarded as the best course on Mallorca and, surprisingly, the only one on the island situated on the coast, it's a course with 58 bunkers while only the sixth hole is bereft of a tree-shaped hazard, the long 554-metre (604 yards) 11th in particular with its long, narrow fairway and its phalanx of pine, olive and oak trees particularly challenging. There are four par threes in total, the longest of which is the 17th at 213 metres (232 yards) and its green patrolled by an extensive bunker complex to the left of the putting surface.

BELOW: The picture postcard view of the lighthouse and the ancient, gnarled olive trees that line the fairways of Alcanada have brought it many accolades. A German golf magazine named it the best course in Europe for four consecutive years, up until 2012. Presumably that was the year their timeshare ran out.

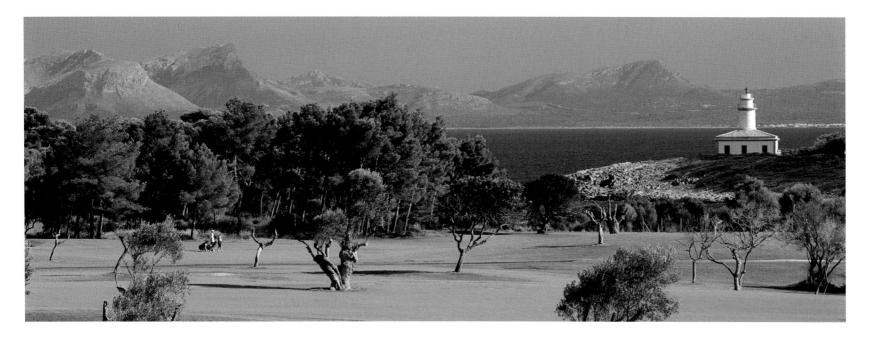

Coeur d'Alene Resort Golf Course

Idaho, USA

Every successful course needs a unique selling point. With increased competition between the top clubs an island green may well be a strong selling point, but these days quite a few clubs can boast them. However only the Coeur d'Alene Resort can move theirs around. Their 14th hole is golf's only moveable, floating green.

The story of how the course came to possess such a unique feature belongs to the resort's founder, Duane Hagadone, a local property and publishing millionaire, who bought the old North Shore Resort in 1983. Hagadone had ambitious expansion plans and after completing a new hotel on the banks of Lake Coeur d'Alene, he turned his thoughts to the creation of a top-class golf course to enhance his resort's reputation and attract visitors.

The innovative concept of a floating green came to him after watching coverage in 1990 of Lee Trevino making a hole-in-one on the island green at PGA West in Palm Springs. The following day inspiration suddenly struck.

"As I sat there with the dog, I looked out on the lake and saw a perfectly round log boom that had been brought in the night before," he said. "A light came on. If they can have an island green in the desert, why can't we have a floating green on Lake Coeur d'Alene?"

The result was the construction of a 2,300-ton raft boasting a 15,000 square-foot green of bluegrass surrounded by two bunkers, four trees and assorted geraniums, complete with a small wooden jetty. Described as golf's "ultimate risk and reward" hole, the manmade island is operated by a twin-drum winch connected to a submerged steel cable controlled by computer, and so the par three can play as short as 65 yards and as long as 210. Players cross the lake courtesy of the small electric ferry dubbed 'The Putter'.

Accuracy off the tee is of course paramount and every year a team of divers is despatched to retrieve the thousands of balls which suffer a watery fate.

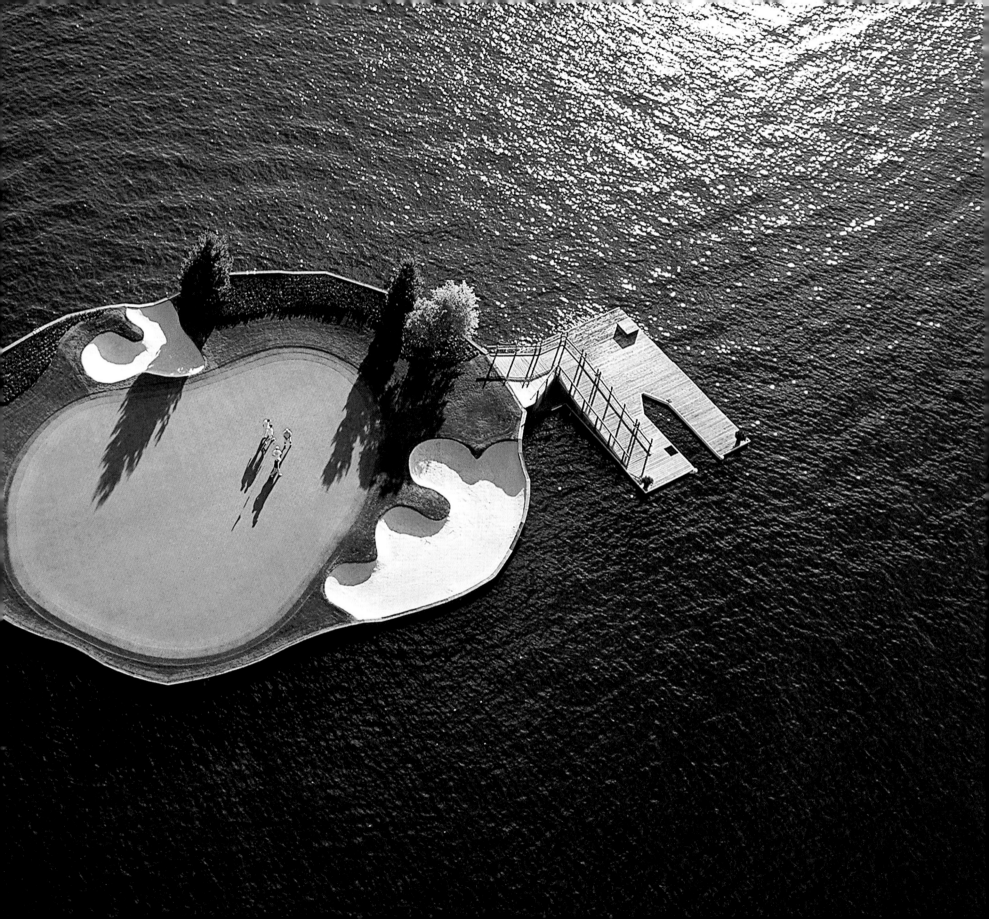

Cypress Point Club

Pebble Beach, California, USA

The origin of the expression 'all good things come in threes' has sadly been lost in the mists of time. The logic of fortune favouring any particular numeral is dubious at best but it is an axiom with which those fortunate to have played the holy trinity of the 15th, 16th and 17th holes at Cypress Point would wholeheartedly agree.

Repeatedly rated as the best trio of closing holes in golf, the three all require significant carries over the Pacific Ocean and when the breeze is stiff and the waves are crashing onto the rocky shore, it is a challenge which has defeated many.

The 15th is a deceptively short par three, a mere 120 yards from the regular tees, but even if the salt water is safely negotiated, five intricately sculpted bunkers encircle the green. The 16th is also a par three but significantly longer at 218 yards and a straight shot at the pin demands both courage and luck, the flight of the ball taking it almost exclusively over the ocean. The fairway of the par four 17th is hemmed in by rocks and water on its right and too much distance with the second shot could yet see the ball swallowed up by the Pacific lurking behind the green.

The course was designed in 1928 by British surgeon-turned-architect Alister MacKenzie in collaboration with Robert Hunter and from the moment he first saw the site on the Monterey peninsula, he was in no doubt of its potential.

"It would be difficult to overestimate the great possibilities of a golf course at Cypress Point," he said. "I am fully acquainted with the world's greatest golf courses and have no hesitation in saying that in the beauty of its surrounding, the magnificence of its sand dunes, its spectacular sea views, its glorious Cypress trees - there is no opportunity of making (a golf course] which should be superior to any other."

Membership of the private club is notoriously expensive and exclusive. There are no set fees, the club simply divides operational costs at the end of each year between its estimated 275 members regardless of what that turns out to be, and it is devilishly difficult to join. "One year they had a big membership drive at Cypress," the comedian and golf club stalwart Bob Hope once said. "They drove out 40 members."

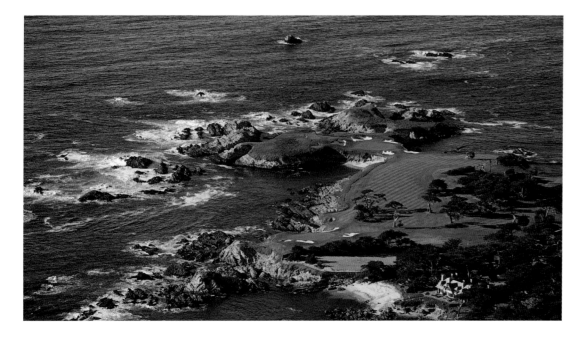

RIGHT: The much-admired 218-yard16th hole at Cypress Point, often regarded as one of golf's hardest holes.

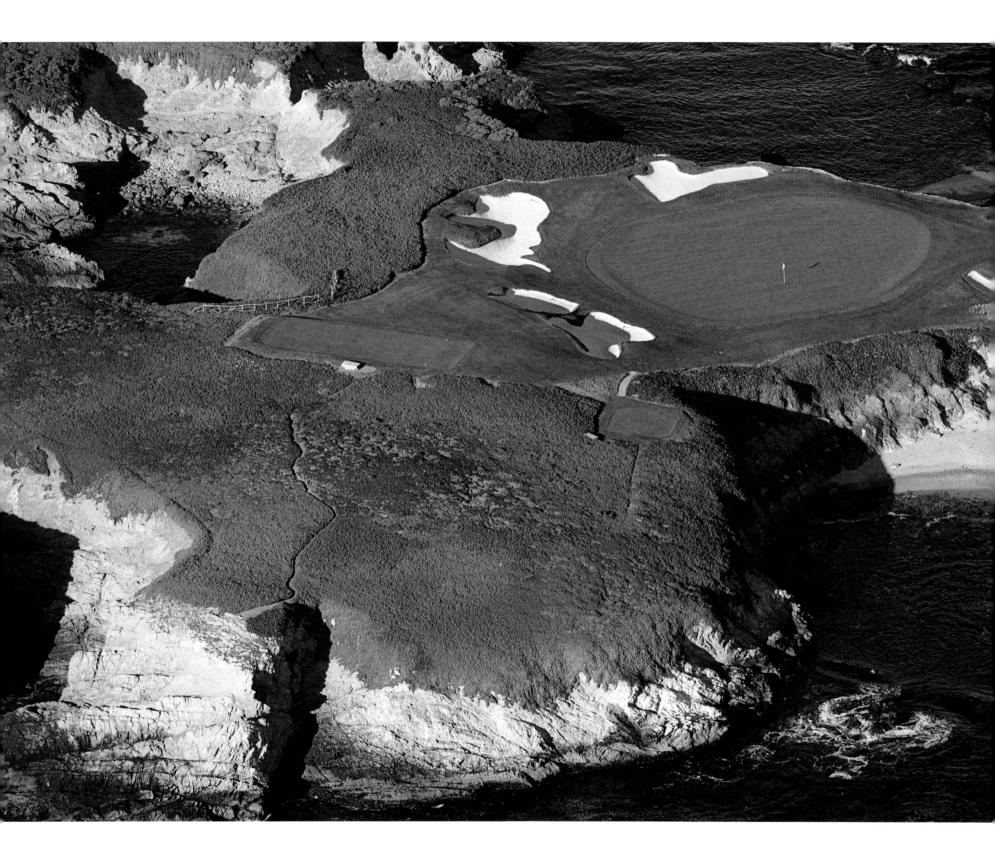

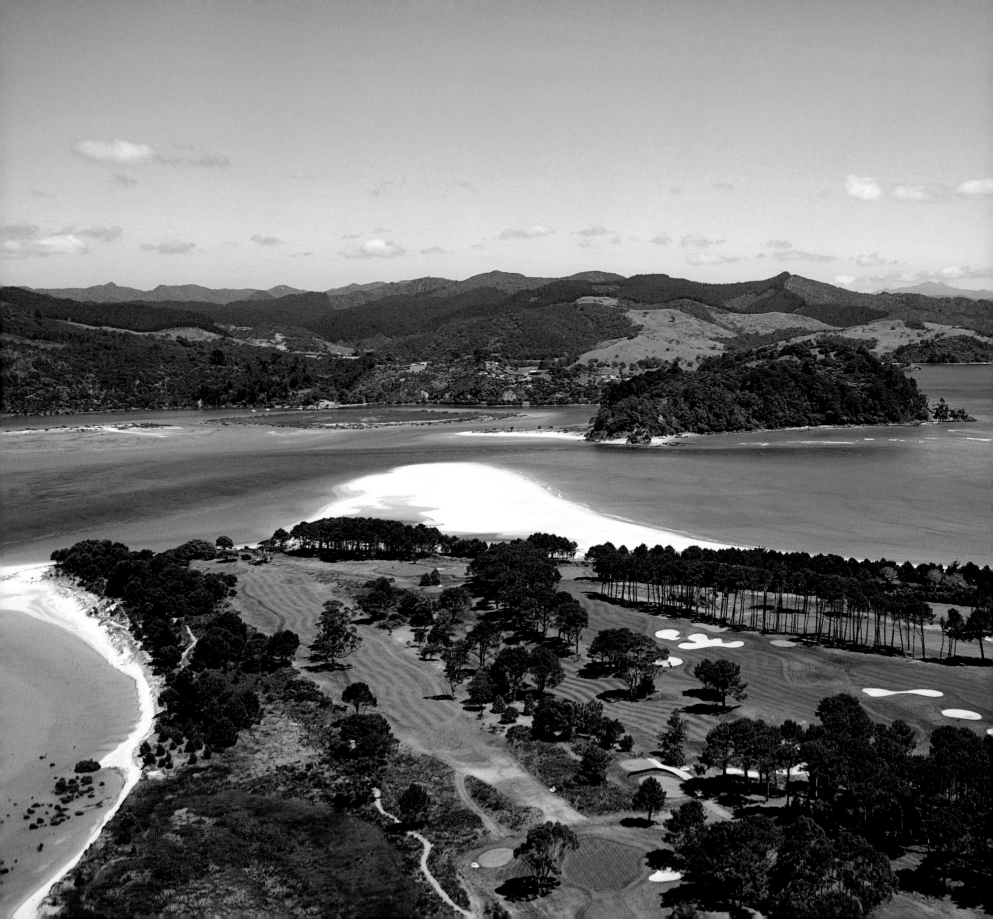

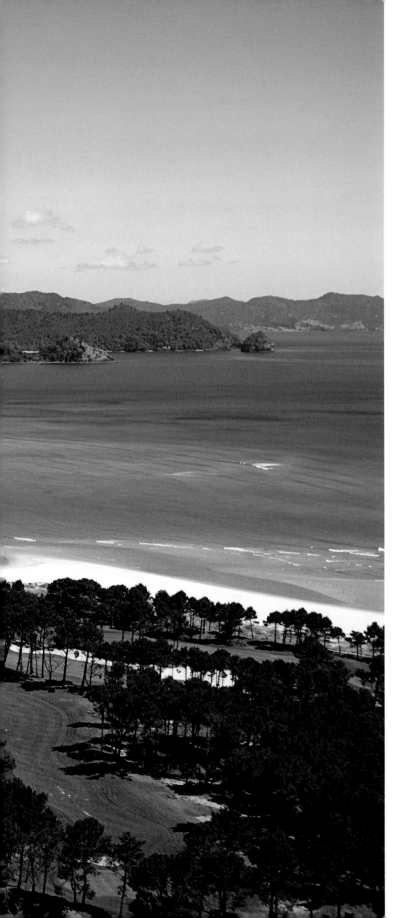

The Dunes Golf Resort

Matarangi, North Island, New Zealand

An overcrowded course is always prominent on a player's list of pet hates but it's unlikely to be an issue should they arrive at the right time of year, for golfers who journey to Matarangi in New Zealand to sample the 18 holes at The Dunes.

A resort town established in 1978, Matarangi has a resident population of just 350 people for most of the year but between the summer months of December and February that number swells to more than 7,000. Many of them head directly to The Dunes to enjoy a round on the sandy Coromandel Peninsula but outside of peak periods, the all-year-round course is gloriously quiet and relaxed.

Laid out against the stunning backdrop of Whangapoua Harbour, the white sand of Matarangi beach and Castle Rock, The Dunes was opened in the 1980s. It was designed by one of New Zealand's golf greats, Sir Bob Charles, and although it only stretches to a modest 6,162 metres (6,738 yards) from the longest tees because of the restricted space on the panoramic peninsula, it is nonetheless a par 73 challenge.

The course's signature hole is the first, a par four which affords uninterrupted views of Mercury Bay from the tee. For those hoping to begin their round without blemish, the 353-metre (386 yards) hole demands a straight drive at all costs.

The third through to the eighth holes all feature water to varying degrees, the par three seventh is the pick of the bunch with its prolonged carry over a substantial, manmade lake.

The mystery of how such a seemingly short course in terms of yardage can be rated a par 73 is solved on the back nine. The 10th is the first of a quartet of par fives on the way home – the others are the 13th, 14th and 17th – and although The Dunes finishes with a par three, it is all about the distance on the closing holes on the very furthest tip of the Coromandel Peninsula.

LEFT AND BELOW: At roughly the same latitude as Auckland on North Island, The Dunes is set between Mercury Bay and Whangapoua Harbour.

Fuego Maya

La Reunion Resort, Guatemala

Golf is not renowned as a particularly perilous pastime. Regular players may suffer the occasional wrist sprain, painful rotator cuff or mysterious back spasm but on the whole, it's regarded as a sport whose middle name is not danger.

Getting struck by lightning is perhaps the biggest natural threat that most golfers will encounter, but in Guatemala there is also the faintest possibility of being struck by a pyroclastic surge - a fast-moving, ground-hugging wave of hot, toxic gases and ash.

The Fuego Maya course in southern Guatemala lies in the ominous shadow of a quartet of volcanoes. Three of them may be extinct but the fourth - the Volcán de Fuego (Volcano of Fire) – certainly is not, the plumes of smoke which issue from it on a daily basis testify to its distinctly active status.

Built on the site of a former coffee plantation and designed by the famed father and son duo of Peter and Perry Dye, Fuego Maya opened in 2009 and offers spectacular views from its elevated position. On a clear day, the Pacific Ocean some 50 miles away is visible, while the 7,302-yard, par 72 course makes full use of the undulating natural landscape and spectacular backdrops.

The signature hole is the 16th, a monster par five which plays just short of 700 yards from the back tees. The short 17th features a waterfall to the right while the closing 18th is a long, downhill par four which has blighted many an otherwise respectable scorecard.

It is, however, the Fuego volcano which dominates the scene and although there has been no major eruption in years, it has been active ever since the Spanish Conquistadors first set foot on the continent over 500 years ago.

In 1932 it spewed out enough ash with enough force to blanket the city of Antigua 11 miles away, while in 2012 it began producing lava, precipitating the evacuation of more than 30,000 people from 17 nearby villages. In 2015 emissions from the mountain of fire prompted the closure of La Aurora International Airport in Guatemala City.

Golfers at Fuego Maya are in truth in little danger of meeting a fiery demise, but few who do play the course fail to give one wary glance up at the volcano at some stage of their round.

Furnace Creek Resort

Death Valley, California, USA

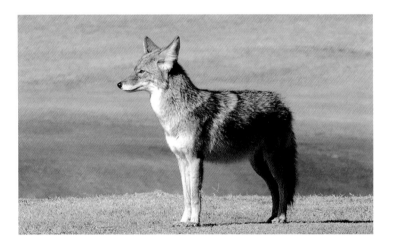

Course designers often seem intent on carving out 18 holes in the most unlikely of locations. Furnace Creek is one such topographical oddity and proof positive that people will build golf courses in the most improbable places.

At 214 feet below sea level, it holds the record as the lowest course on the planet. It also happens to be in Death Valley in the Mojave Desert, which makes it one of the hottest places on earth to hit a ball. Logic dictates Furnace Creek really has no business hosting a golf course.

The original architects of the sundrenched venue were a group of local date farmers who laid out three holes for their own amusement in 1927. Four years later a further six holes were added, while in 1968 noted designer William F. Bell was drafted in to create the back nine. Against all the odds, Furnace Creek now had the full 18 holes.

The course's depressed elevation means players can expect their shots to struggle to fly through the thicker air with, for example, an average five iron travelling 10 to 15 yards shorter than on higher tracks, while the extreme, arid climate – the temperature in Furnace Creek hit a sweltering 56.7 °C (134°F) in 1913, the highest ever recorded on the planet – is a huge challenge for even the fittest of golfers. In a tongue-in-cheek celebration of the extreme conditions, the club held its inaugural 'Heatstroke Open' in 2011, attracting 48 foolhardy entrants.

The greens and fairways, however, are surprisingly green given its location. With an average annual rainfall of just 1.6 inches the resort gets its considerable water requirement from underground springs. When architect Perry Dye overhauled the course in 1997 he installed an irrigation system to exploit this natural resource. On an average day 200,000 gallons irrigate the greens and fairways and the system is capable of delivering a million gallons of water a day during the intensive heat of a Californian summer.

ABOVE RIGHT: Coyotes are a familiar site on the Furnace Creek golf course, the wily ones scavenging dates from under the scattered groves of date palms. They are also adept at removing golf balls from fairways.

RIGHT: Further south in Death Valley is an altogether different 'golf course', named thus because the salt-caked and craggy surface would be too difficult for the devil himself to play on. Even if he used local rules.

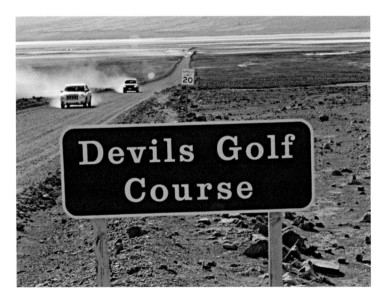

Green Monkey Golf Course

Sandy Lane Resort, Barbados

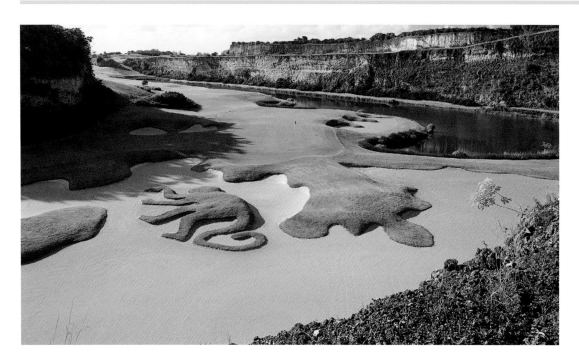

to threaten the putting surface – is dizzyingly difficult.

Players are at least able to call upon cutting edge technology as they lock horns with the course. All the Green Monkey's buggies are equipped with GPS which can beam down pictures of the course from a satellite to the befuddled golfer, as well as calculating exact yardage and highlighting imminent hazards.

The resort itself opened way back in 1933 and over the years has cemented its reputation as a star-studded bolt-hole for the rich and famous after welcoming the likes of T. S. Eliot, Queen Elizabeth, Jacqueline Kennedy and Elton John through its opulent doors over the years.

The presence of local wildlife can lend a certain charm to a course. Bajan green primates are not an indigenous species to Barbados, they were introduced to the Caribbean from West Africa 350 years ago, but such is their proliferation on the island today that the unusual name seemed the obvious choice ahead of the Sandy Lane Resort's golf course in 2004.

Tom Fazio was the Green Monkey's architect and in a strikingly visual nod to the island's mischievous primate population he designed the signature par three 16th complete with an intricate, monkey-shaped grass island in the middle of the bunker at the back of the green.

Carved out of an old limestone quarry and flanked by mature mahogany trees, the Green Monkey is all about dramatic changes in elevation along the rolling fairways and approaches to the greens. At 635 yards, for example, the monster par five ninth is challenge enough, but the 100-foot drop to the green with the third shot – if you are by then close enough

ABOVE LEFT: Grass grows quickly in the warm Barbadian sun, so keeping the grass trimmed on the signature 16th hole monkey is just the kind of challenge a greenkeeper loves.

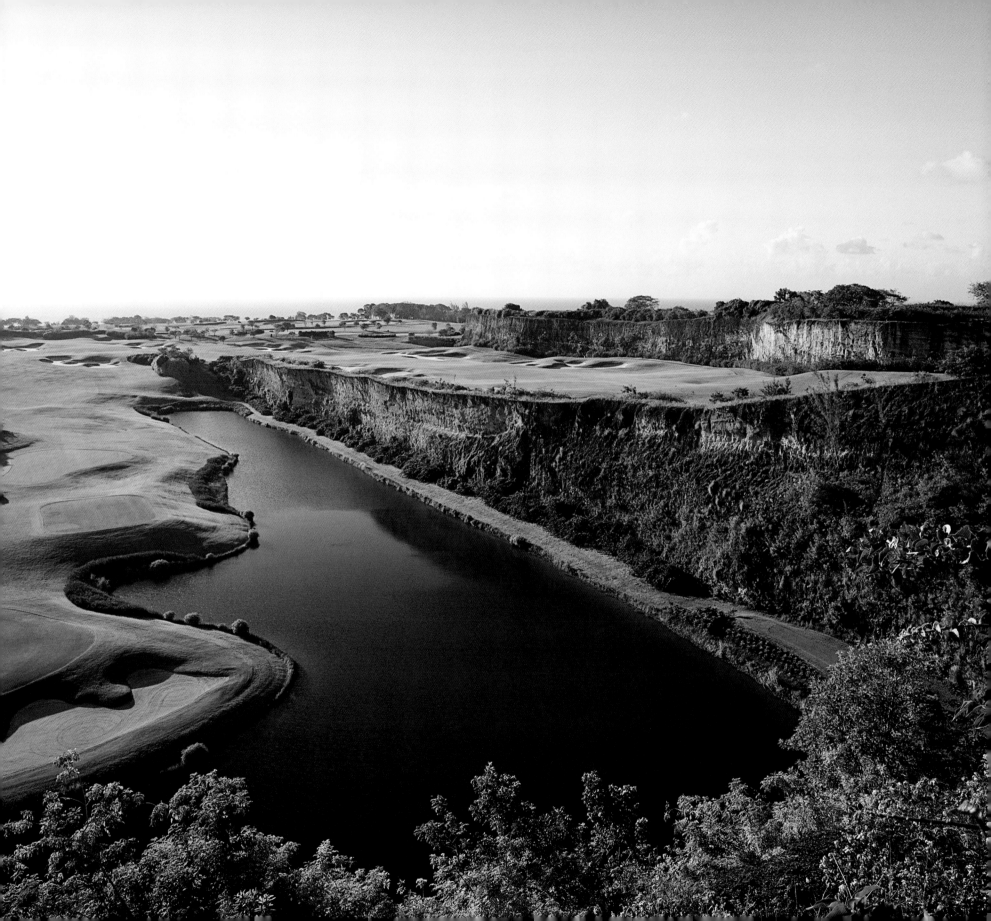

Harbour Town Links

Hilton Head Island, South Carolina, USA

Now that earth-moving machinery is available, and mature, balled-up trees ready to plant, golf architects have two choices. They can opt to mechanically mould the terrain to their vision, or alternatively they can choose to work with the natural characteristics of the landscape. Both approaches have produced some remarkable golf courses. Harbour Town Links' world-renowned 18th hole however is an example of an ongoing struggle between golf and the environment and one which is yet to be definitively resolved.

The intriguing story of the 18th, famous for the red-and-white-striped lighthouse which towers behind the green, began in 1967 when the American designer Henry Cobb was drafted in to work on the Sea Pines Resort. Part of the project was the Harbour Town Links and when Cobb sketched out the original course, his 18th ran adjacent to the 10th hole inland, back towards the clubhouse, a steady if unspectacular conclusion to the course.

Man inadvertently intervened in the shape of a dredging operation in the waters of the adjacent Calibogue Sound, with tons of displaced sand accidentally creating a new, artificial strip of land leading directly towards the lighthouse.

In 1971, when Pete Dye was commissioned to reroute Cobb's original design, he saw an opportunity to create something more memorable and Harbour Town's magnificent closing hole, framed on one side by the Atlantic, and on the other by trees and grand residential property, was born.

Nature probably felt rather cheated but over the years that followed she exacted a slow revenge as coastal erosion nibbled away at the manmade terra firma. The problem became so acute that the resort was forced to act in 2012 with the installation of protective rock revetments and the planting of more than 21,000 marsh grasses to keep the encroaching tidal water at bay.

The result, for now at least, is a victory for man over nature and the chance to tackle the 444-yard, par four masterpiece, but the Calibogue Sound may yet have more to say on the matter in the future.

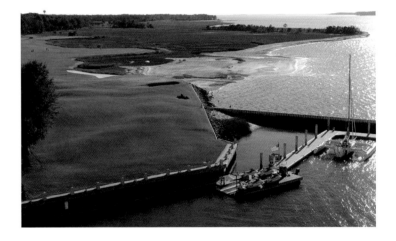

ABOVE RIGHT: The view of Harbour Town's closing hole from the lighthouse.

RIGHT: South African Branden Grace tees off on the 18th hole during the final round of the 2016 RBC Heritage at Harbour Town Links.

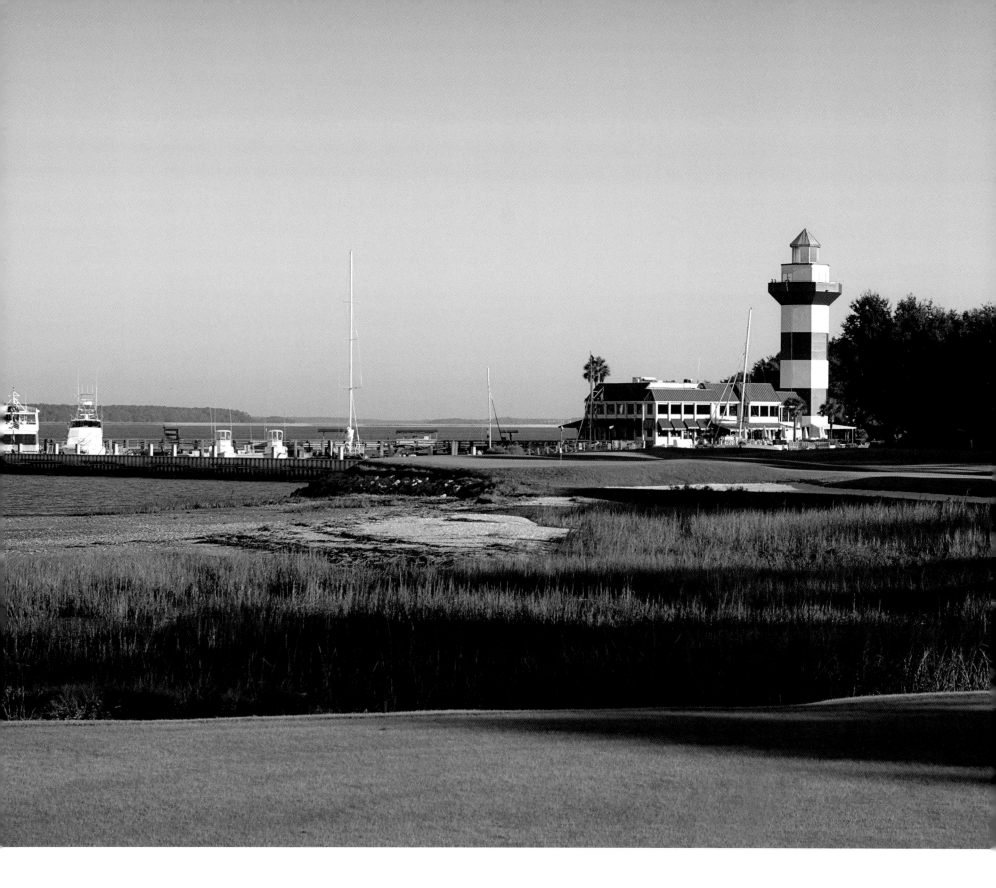

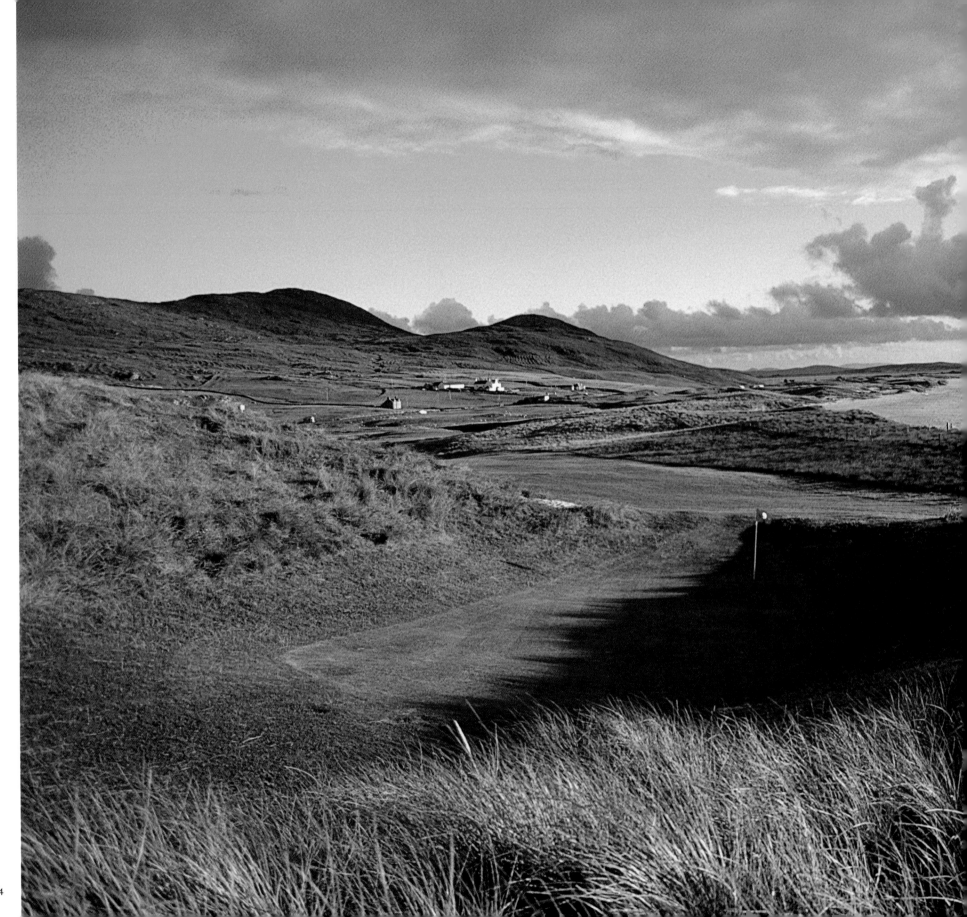

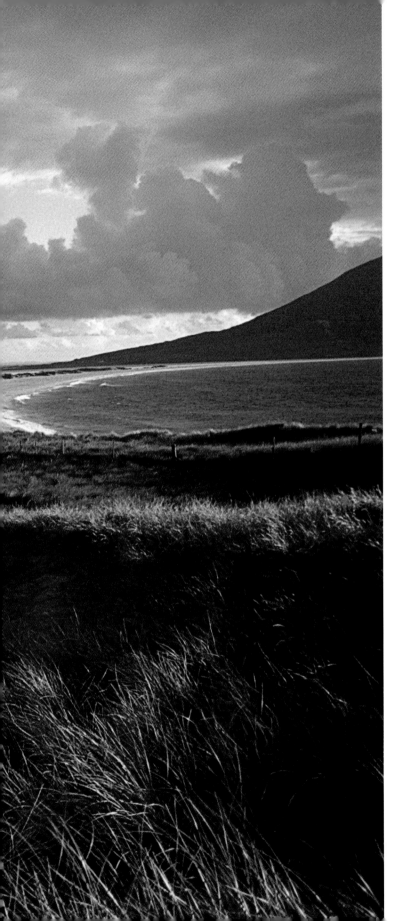

The Isle of Harris Golf Club

Outer Hebrides, Scotland

At first glance, there is precious little to link the remote and rugged nine holes of the Isle of Harris Golf Club off the west coast of Scotland and the Masters at Augusta in Georgia. But if you factor in the island's most famous export and consider that the Masters' coveted reward for the winner is the green jacket, then you have a link. Harris tweed is famous the world over, so what better trophy for the club's open competition than the Harris tweed jacket. Unlike Augusta where second place is rewarded with only a healthy cheque and no item of clothing, on Harris they have a tweed cap for runner-up.

A second Augusta connection comes from a five pound note reportedly recovered from the course's honesty box and signed by green-jacket recipient Nick Faldo. Faldo visited in the early 1990s while getting some links practice ahead of the Open Championship. The note was never cashed and, like the venerated tweed jacket and

tweed cap, has become a trophy which is played for every year.

Bordered by the Sound of Taransay on one side, leading to the Atlantic, and peppered throughout by white beaches, the Isle of Harris Golf Club was founded in 1930 and follows the natural contours of a landscape sculpted by the sea, sand and wind. The greens are relatively compact, frequently nestled in hollows. There may be only nine holes but each is different in character. The first is a par four which measures less than 300 yards but demands a blind tee shot to focus mind and body at the start of a round, while the second hole sees the Atlantic crashing onto rocks on the left of the tee as players prepare to drive. The 495-yard ninth is the only par five on the course and with a tight fairway bounded by long grass, it provides a challenging finish to a unique links experience.

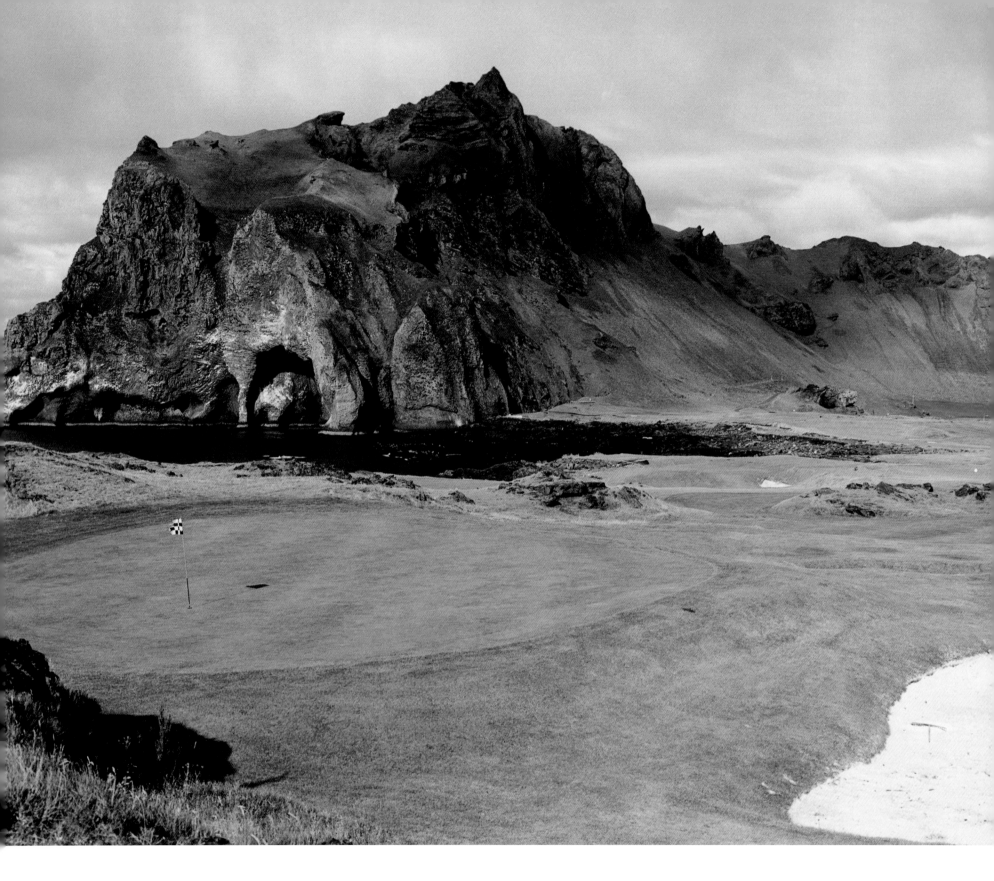

Icelandic Golf

One of the significant reasons that golf was able to develop on Scottish links and has thrived on island courses in Hawaii and Iceland is that they were built on land with marginal use for anything else. In the case of Hawaii and Iceland they both share a recent volcanic history, though not quite the same climate profile.

There are many outstandingly beautiful courses in Iceland, but the most remarkable thing about golf in the land of ice and fire is the number of golf courses per head of population. With 65 courses already built (and more on the way), and an island population of around 330,000, that equates roughly to one golf course per 5000 people. Iceland's equivalent to the Ayrshire coast is the south-west corner near Reykjavik, stretching from Borgarnes to the north, and down to the Vestman Islands in the south-west.

The long-time poster boy for Icelandic golf has been the Vestmannaeyjar Golf Course (pictured left) located on one of the Vestman islands, a 20-minute ferry ride from the mainland. First established in 1938, play was suspended in 1973 when the nearby Eldfell volcano erupted and the island was evacuated. In 1996 and 2008, the course hosted the Icelandic Championship as well as the Scandinavian Championship for Amateurs in 2000. It is also home to the Volcano Open, the annual tournament staged to

commemorate the island's fiery past.

At Ness Golf Club, on the Seltjarnarnes peninsula just outside of Reykjavik, the hazards of playing the nine-hole course are a regular feature. While Florida has its alligators, and the West of Scotland its midges, Ness has some very aggressive arctic terns. Known locally as 'kría' they make the trip from Antarctica to nest in the rough grass around the headland from May to July. Given that the primary golfing season in Iceland is short – May to September – they cannot be avoided and should a shot stray from the

fairway, any golfer going to look for it is likely to be divebombed. To combat this, golfers deploy a golf umbrella or driver as the twenty-first century equivalent of a barrage balloon (as pictured below), but it's just another incentive to hitting the ball straight and keeping it on the fairway.

Apart from the classic scenery that is the backdrop to many of the Icelandic courses there

BELOW: The immensely challenging par five first hole at Brautarholt, named 'Borgarvík'.

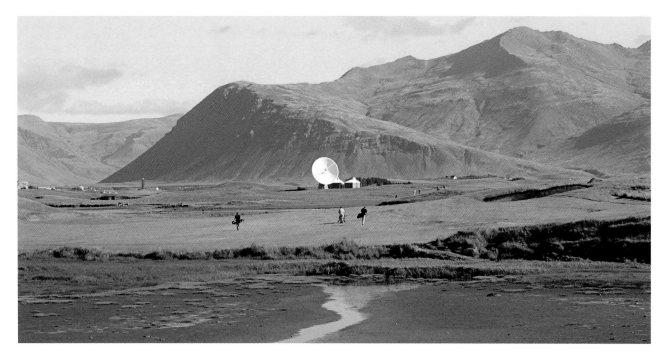

is the phenomenon of playing golf 24 hours of the day and 'night' during the summer months. Like Tromsø and the Lofoten Links, the northerly latitude of Icelandic golf courses allows golfers to book a 4 a.m. tee time. *Golf Digest*'s Oliver Horowitz described taking part in the Arctic Open, held at Akureyri Golf Club in the north. "Playing under the Midnight Sun is like gambling in a casino. Time loses meaning: 3 a.m. comes and goes without warning, and there are only vague biological reminders of passing time, such as feeling hungry and then remembering you ate dinner eight hours ago."

To give further credence to the 'ice and fire' tag, a round at the Hornafjörður Golf Club is played against the backdrop of the Vatnajökull glacier which covers the south-east of the country. The scale of Vatnajökull is immense, it is the largest glacier in Europe and covers around eight per cent of Iceland. There has been a nine-hole golf course at Hornafjörður since 1971, but in the early 2000s it underwent major changes under the guidance of influential golf architect and writer Edwin Roald. Roald's signature flourish was linking the north and south shores of the small cove on Hornafjörður by utilising a small island 130 metres out in the water. The result is an ingenious design which sees players drive off from the island back to the mainland from the fourth tee, only to return to it when it serves as the green for the eighth hole. It's job is not yet done however, the island also hosts the tee for the ninth. Golf may boast a number of island holes, some natural and others man-made, but few are as hard-working as this one.

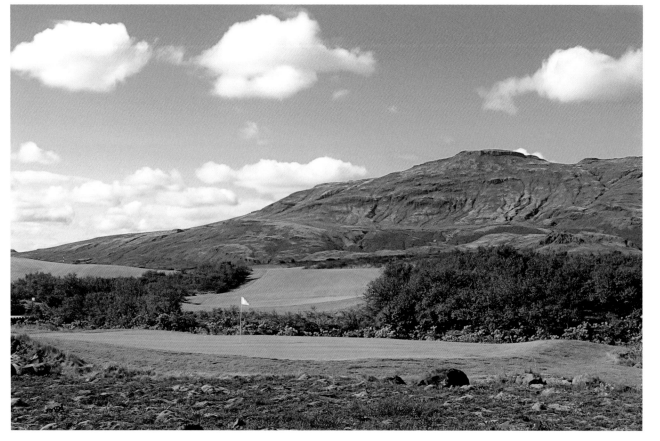

ABOVE LEFT: A view of the fourth fairway at Hornafjörður

RIGHT: The fifth green at Hornafjörður with the massive Vatnajökull glacier beyond. Play is possible on most courses from May to September.

LEFT: Like the Rotorua club in New Zealand, the Geysir golf club has geothermal activity nearby.

This kind of innovative thinking has driven Roald to question the need for making every golf course 18 holes. Nine might be too few, but 18 too many, and his core message is that hole numbers should suit the location and people's available time. The radical shift has been backed by the Golf Union of Iceland who have removed any reference to hole counts from its championship criteria. In a country where 10% of the population play golf and most of the courses are nine holes, it is a compelling argument.

RIGHT: Akureyri Golf Club, Iceland's oldest.

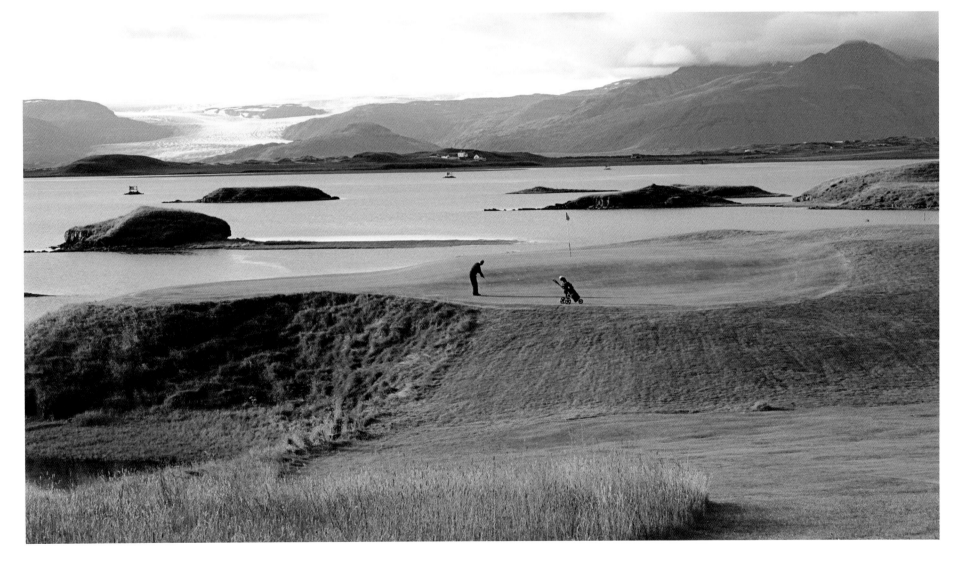

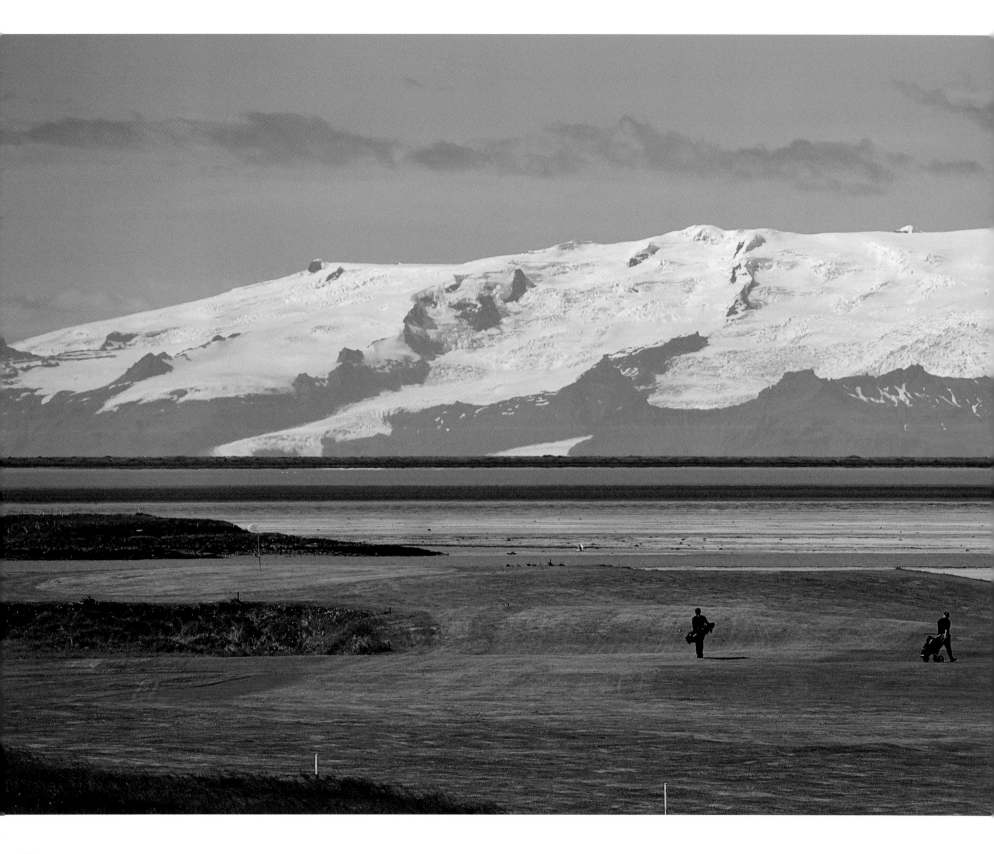

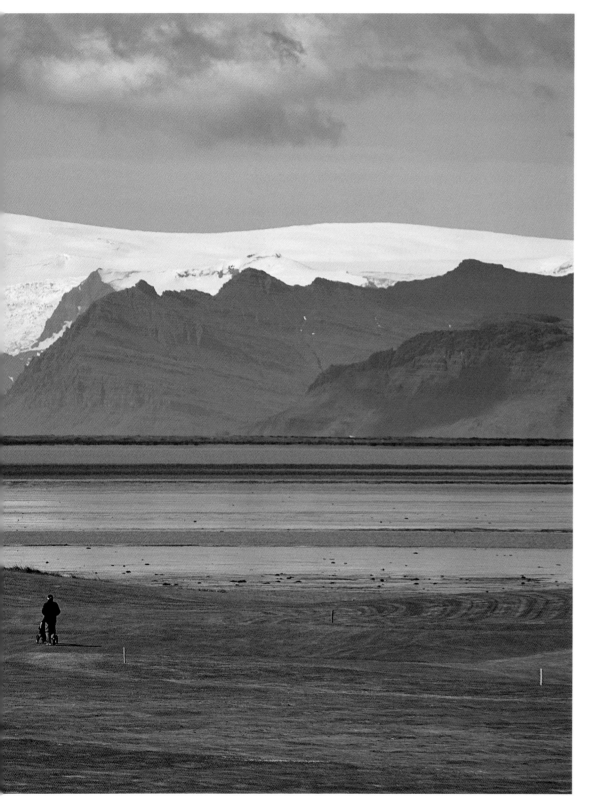

TOP: The expansion of golf on the island continues with these lodges built to attract summer tourists, but the local population are equally engaged with the game.

ABOVE: The dramatic second hole at Hornafjörður.

LEFT: Golfers at the Hornafjörður Golf Club play against the backdrop of the Vatnajökull Glacier and Hornafjörður fjord. The chances of Paul McGinley jumping in after a round are slim.

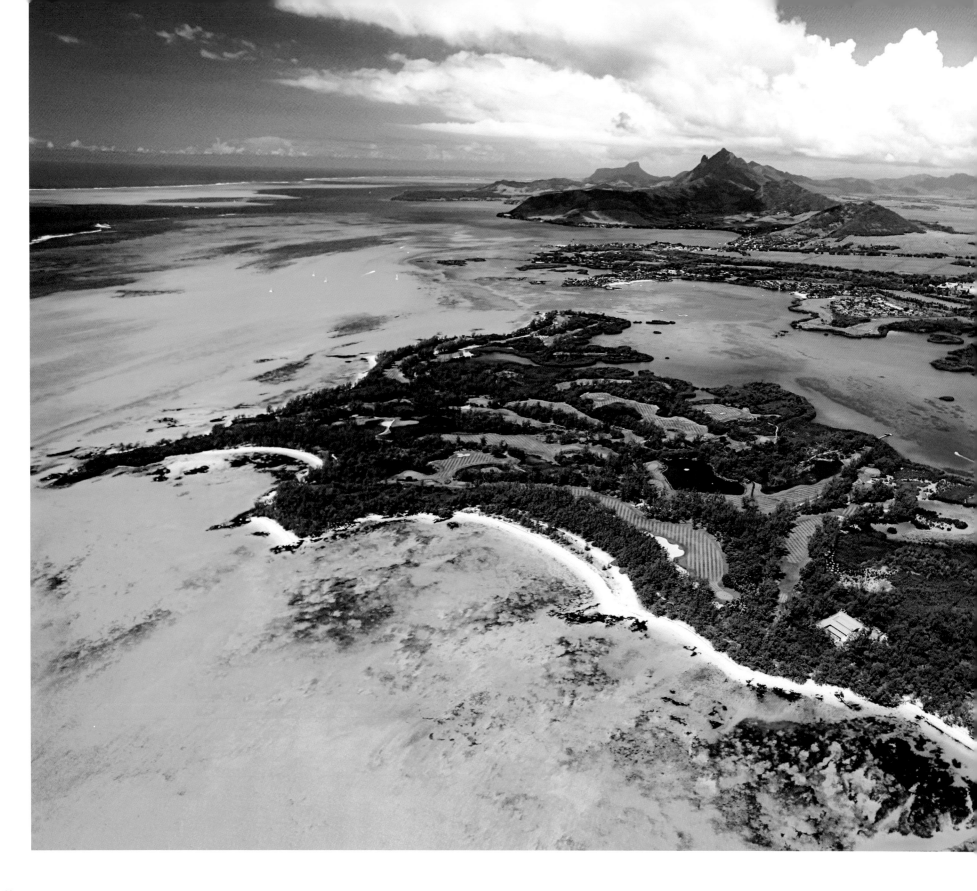

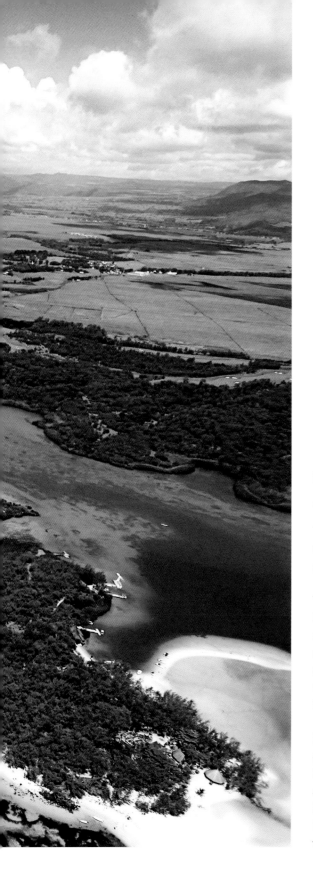

Ile Aux Cerfs

Flacq, Mauritius

There are many island greens, many golf courses on islands, but in the Indian Ocean there is one golf course that is the island.

The Ile Aux Cerfs lies off the east coast of Mauritius. Designed by Bernhard Langer and opened in 2003, the 87-hectare 'Island of Deer' as it translates into English is accessed across a stunning turquoise lagoon, while the course itself covers 38 hectares on the south of the island and is built on the site of a former sugar plantation.

Lush vegetation, bright white sandy beaches, gullies and the course's Salam Seashore Paspalum grass, not to mention the volcanic rock, all contribute to what is a tropical masterpiece, but the constant factor, as the 18 holes unfold, is the view of water; either the lagoon looking towards Mauritius or the Indian ocean on the other side of the narrow island. Surprisingly for a course already so defined by water, there are also nine inland lakes on Ile Aux Cerfs and three of the holes require shots over sea inlets to reach the fairway.

Arguments continue over which is the course's signature hole, with the eighth and the 14th often the last ones standing after long discussion. The eighth is dubbed 'Mangrove Walk' and although it is a seemingly innocuous 143-yard par three, only the most accurate of players will land safely on its elevated green encircled by mangrove trees. The curiously entitled 'Be Right', aka the 14th, is a par four 337-yarder and the dilemma here is whether to go for bust on the drive, risking in the process both water and bunkers, or play it conservatively and lay up.

Jack's Point

Queenstown, New Zealand

The aerial hazards that can potentially confront a golfer on a course are manifold. A wayward ball is the most obvious but players need to be wary of marauding bird life, falling branches and, in extreme circumstances, bolts of lightning.

Players at Jack's Point, near Queenstown on the South Island, are more likely to turn their eyes skyward and encounter hordes of brightly-clad skydivers descending. It's an occupational hazard when the fourth fairway runs close to the grass airstrip operated by a local skydiving company.

The plummeting bodies and their parachutes, however, merely provide another striking visual element rather than a real and present danger to what is a stunning 18 holes sandwiched between the peaks of the aptly named Remarkables mountain range and the clear blue water of Lake Wakatipu.

Opened in 2008, the 6,388-metre (6,986 yards), par 72 course is built on what was high country farmland and the sympathetic touch of local designer John Darby is in evidence all over a course which embraces rather than battles with its natural rocky outcrops, tussock, wetland and indigenous bush. The old farm's heritage stone walls were also preserved to further foster the sense of continuity with the area.

The lake is in play on the fifth through to the eighth holes while the rest of the course is characterised by breathtaking tee shots followed by challenging approaches to the greens. The standout hole is arguably the par three seventh, offering a spectacular, elevated view down towards Lake Wakatipu from the tee.

Both the course and the accompanying 3,000 acres of land take their name from a local Maori called Jack Tewa who enjoyed two claims to fame in nineteenth-century New Zealand. The first was as the man who discovered gold in the area and, secondly, as the heroic saviour of a hapless European traveller who was thrown from a boat on the south of Lake Wakatipu only to be plucked to safety by Jack.

Despite being a relative newcomer as a destination course, Jack's Point has risen rapidly up the golfing ranks and by 2016 it had already ascended to the status of the second best course in New Zealand according to the *Australian Golf Digest*.

RIGHT: The 18th hole and clubhouse at Jack's Point, set within a 3,000-acre nature reserve on the shores of Lake Wakatipu.

BELOW: Another view of the 18th hole. Queenstown is the home of extreme sports in New Zealand, so this is about as calm as it gets.

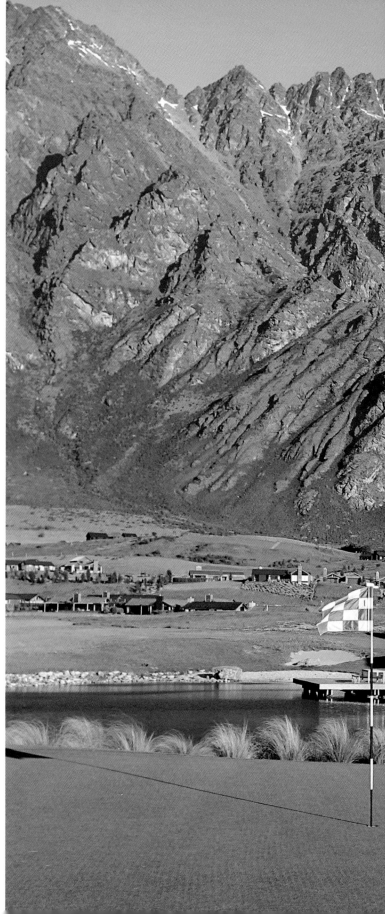

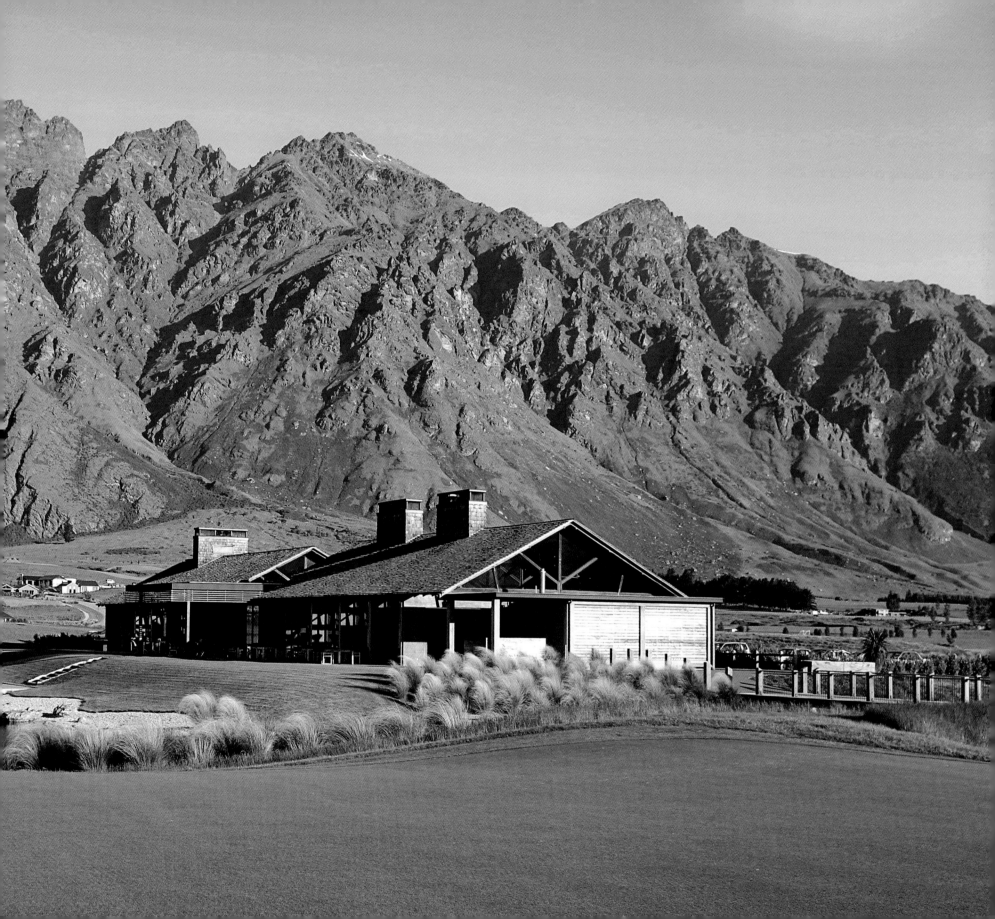

Jade Dragon Snow Mountain Golf Club

Yunnan, China

It is a frequent lament within more conservative golfing circles that the modern game has become obsessed with big hitting. The advances in club technology, they argue, have allowed players to drive further than ever before, courses are getting longer and longer and the game's old adherence to touch and delicacy has been sacrificed on the altar of power and distance.

When Robin Nelson and Neil Haworth sat down to design Jade Dragon Snow Mountain, it is safe to assume they were untroubled by such traditionalist concerns. The pair were evidently devotees of the 'bigger is better' mantra and when they were finished they had created the longest course on the planet, measuring a staggering 8,548 yards from the back tees.

Opened in 2001, everything about the course is epic in scale. Although it is actually set in a valley overlooked by the imposing Jade Dragon Snow Mountain, it is still 10,800 feet above Sea Level, making in the second highest as well as longest 18 holes in the world. The par five fifth hole is 711 yards long, another world record, while all four of the par threes are over 235 yards.

The good news for players fearful of the daunting distances is the thin air at such a high elevation, meaning balls fly an estimated 15 to 20% further. All the club's carts are equipped with oxygen canisters for those afflicted by altitude sickness.

The birth of Jade Dragon, however, was bad news for The Pines at The International Resort in Massachusetts which had proudly boasted the title of world's longest course at 8,325 yards since 1972 but had to begrudgingly step aside when its Chinese rival opened for business.

Another, less serious claimant of the title is the Nullarbor Links in Australia, which is 1,365 kilometres long but doesn't truly measure up as a golf course given that its 18 holes are in fact essentially separate entities scattered along the Eyre Highway on the country's southern coast, the extreme distances between green and the next tee only made possible by car.

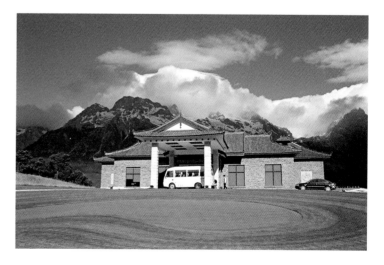

RIGHT: The clubhouse at Jade Dragon is equipped with all the familiar reviving drinks and tinctures for a golfer returning from his gruelling round, plus oxygen for those sent giddy by playing golf on the roof of the world.

Ko'olau Golf Club

Oahu, Hawaii, USA

The vagaries of the weather are an unrelenting factor in golf. As every player knows, the elements can be unpredictable, but few courses can rival the claim of the Ko'olau club in Hawaii, which features three different climate zones within the confines of its 18 stunning holes.

Nestled in lush rain forest in the shadow of the Ko'olau Mountains on the island of Oahu, the course is reminiscent of a scene from Jurassic Park and with its tropical monsoon zone, tropical summer dry zone, and tropical continuous wet zone, the club is as climatically diverse as it is beautiful. Certain parts of the course can receive up to 130 inches of rain per year while others remain in comparison relatively dry.

Designed by American architect Dick Nugent and opened in 1992, Ko'olau embraces its verdant, vertiginous environs rather than fighting back against them and the result is a course which makes the most of its plentiful natural assets. It is also a course widely regarded as not for the faint-hearted.

This is perfectly illustrated by Ko'olau's 18th hole, a 476-yard par four which tests the nerve of even the most accomplished player. The drive off the tee has to carry over a cavernous ravine. The approach also needs enough distance to avoid a second, slimmer strip of the same ravine and even if the ball flies true and straight, there is a long bunker protecting the front of the green.

Ko'olau's reputation as one of the game's greatest challenges now precedes it and legend has it the course record for lost balls in a single round currently stands at 63. There have even been unconfirmed tales of balls being pilfered by mongooses, an invasive species on the island.

The experts however have no doubt how formidable Ko'olau really is. CNN Travel, for example, ranked it third in its list of the world's 10 toughest courses in 2012, only below Kiawah Island and Carnoustie, while NBC Sports included the club's fiendish 18th on its list of 50 of the game's hardest holes.

BELOW: There is only one water hazard at Ko'olaua, but the dense jungle makes up for it. From the back tees there are 14 drives that require carries and for an errant, high handicap golfer that may require a lot of balls.

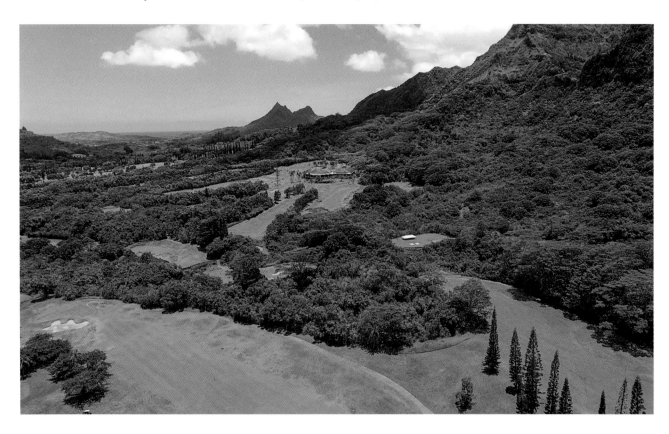

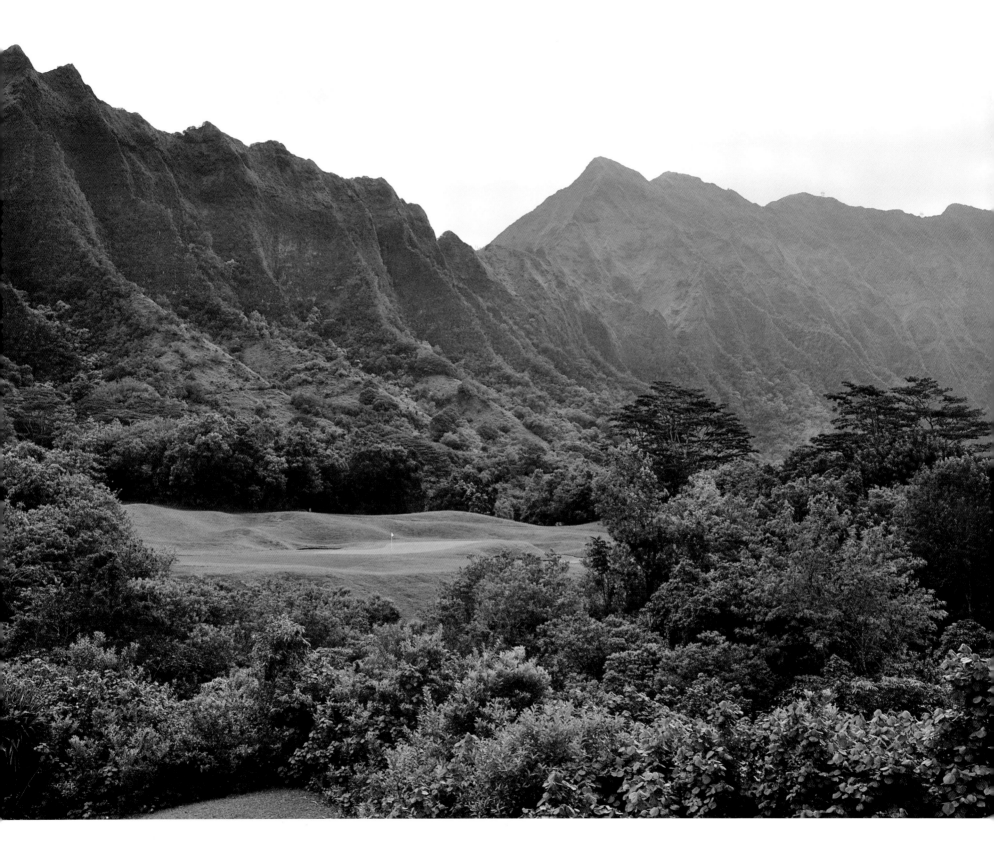

Kobe Golf Club

Rokkosan-Cho Ichigatani, Nada-ku Kobe, Japan

Historically speaking Japan was a very closed society, not influenced by the West. But in the early twentieth century the Land of the Rising Sun made a significant sporting import when an English businessman by the name of Arthur Hesketh Groom established the first ever golf club in the country.

Built on the slopes of Mount Rokko and opened in May 1903, Kobe Golf Club was initially only nine holes, predominantly played by British expats and a sprinkling of Germans, Americans and French. Nevertheless its inauguration paved the way for an explosion in the game's popularity and the estimated 2,350 clubs which modern Japan has today.

The course was designed by two of the club's founding members, Scotsmen by the name of Adamson and McMurtie. As the club's reputation grew, the make-up of the membership changed dramatically. By 1926 local Japanese outnumbered the foreigner contingent by 98 to 83.

Kobe's mountainous terrain precludes the use of golf buggies and club rules dictate that players can only take eight clubs out on the course with them so as not to unduly burden caddies who often have to haul four bags around the 18 holes. At 4,049 yards, par 61, it is far from a long course – there are no par fives. In fact the course must have one of the shortest par four holes in golf, the third hole, 'Bishop's', is only 188 yards from the back tees.

Each hole has its own nickname. Some are prosaic, such as 'Shorty' for the 131-yard 17th or 'Long Valley' for the par four 12th – but others are rather more evocative. The 15th, for example, is known as 'Groom's Putt' in tribute to Arthur Groom, while the fourth is dubbed 'Styx' after the river of Greek mythology and a nod to the stream which once ran under the tee.

LEFT: Kobe Golf Course was carved out of the slopes of Mount Rokko with views across to the 'inland sea'.

RIGHT: Kobe has inspired its newly built neighbour, the Rokko Kokusai Golf Club which hosts the Suntory Ladies Open.

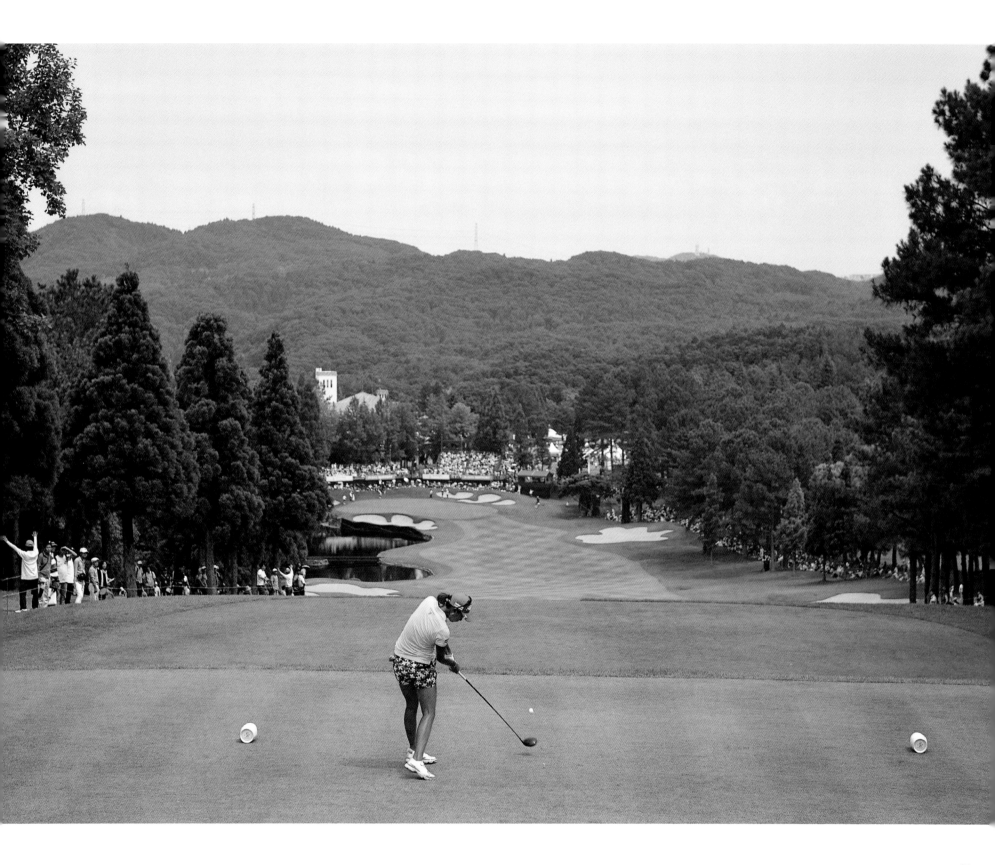

La Paz Golf Club

Pedro Domingo Murillo, Bolivia

There are many spectacular courses around the world said to be capable of taking the breath away from the unsuspecting golfer, but in the case of La Paz Golf Club in Bolivia it is literally true given its elevated location.

'El Campo de golf mas alto del mundo' ('The highest golf club in the world') proudly states the club's signage and with the most elevated parts of the course a staggering 11,000 feet above sea level, it is a claim which brooks no argument now that a rival course has gone out of business.

Until the mid 1990s the Tuctu Golf Club in the Morococha province of Peru held the title at 14,300 feet above sea level. The course was infamous for inducing nose bleeds in those foolhardy enough to make the climb but has since been abandoned, giving La Paz its place in golf's record books.

The air is so dizzyingly thin in the foothills of the Andes that newcomers are advised to spend a few days acclimatising to the conditions before tackling the 6,600-yard course, but while debutants may struggle with 'soroghe' – the word used by locals to describe the feeling of breathlessness – the physical effort is offset by the extra distance gained off the tees with drives flying an estimated 18% further in such a rarefied atmosphere.

Perched on the edge of a vast canyon 20 minutes outside the capital city, the course was carved out of the sandstone in 1912 by British engineers who were working for the Bolivian Railway Company and is a beguiling mix of harsh rock, native cacti and incongruously green fairways.

The standout hole is the 12th. Players have to traverse two bridges just to get to the island tee box and the weather-pitted sandstone which surrounds it is more akin to a lunar landscape than a golf course. The drive off the tee demands a 180-yard carry over a 60-foot gorge and the balls that litter the depths below are testament to those who have failed to successfully make the distance, despite their extra 18%.

RIGHT: Marta Mamani, an indigenous Aymara, hits a drive during a round at La Paz golf club. It would be an interesting proposition for clubs around the world to impose a dress code based on that country's national dress. And hardly more ludicrous than some of the ones currently in place at some clubs.

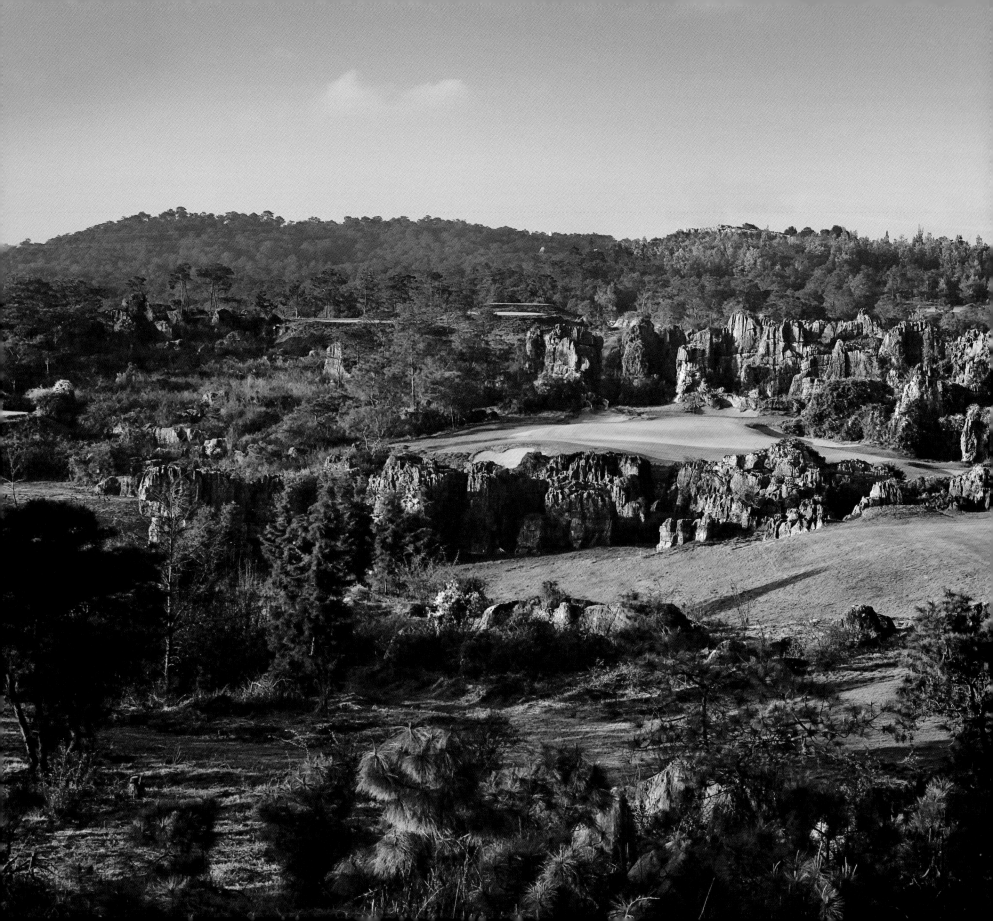

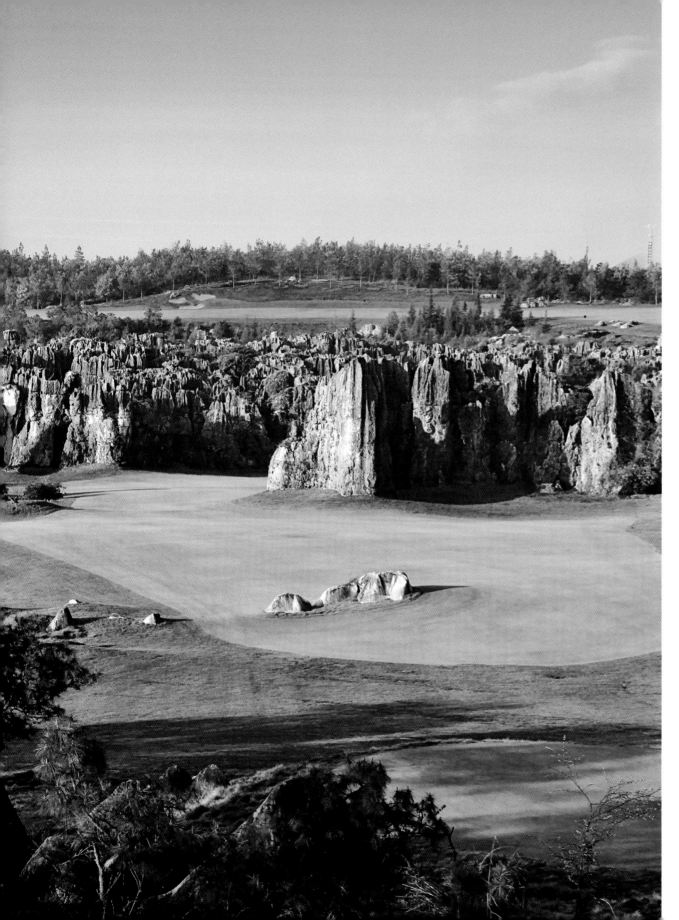

Leaders Peak

Kunming Stone Forest, Yunnan, China

Building a new golf course is never an overnight project. Irrespective of how conducive the natural terrain, or generous the budget for construction, it takes time to create 18 holes and it is invariably a matter of years rather than months for the finished article to finally emerge.

The most striking element of the Leaders Peak course in the Stone Forest was some 270 million years in the making. Limestone aggregations at the bottom of a shallow sea in the Permian geological period were raised up over millions of years and the process of erosion began. The exposure to wind and rain, weathered the limestone stacks into tree-like shapes and so it got its name, the Stone Forest.

The course that was built through these spectacular outcrops first opened in 2009 but even the final phase of its creation was not a rapid one. The area had been designated a UNESCO World Heritage Site just two years earlier, which meant large areas of the stone patchwork could not be bulldozed into shape and had to be either sculpted by hand-powered hammer or incorporated into architect Brian Curley's design. It was nothing if not painstaking work.

Stone Forest's prehistoric monoliths not only lent his stunning course an undeniable visual edge but also an intriguing strategic challenge. Players who strayed off course, or tried to cut corners, suffered wildly unpredictable ricochets.

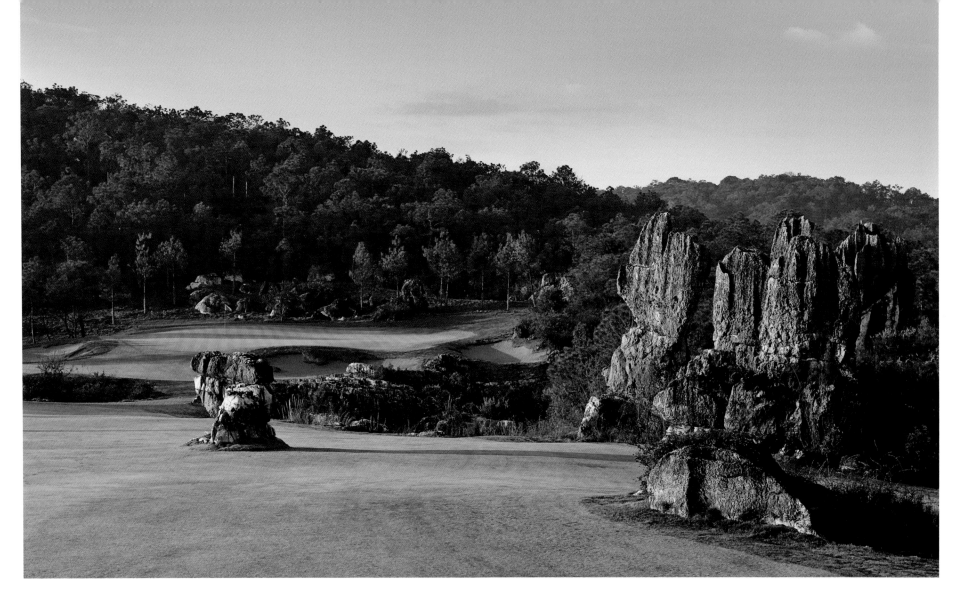

Curley's attention to detail in designing the course was faultless and the bunkers were even filled with grey rather than brighter sand in an effort not to draw the eye from the course's millennia-weathered limestone leviathans.

Stone Forest was closed in October 2016, but the visual legacy of a stunning integration of landscape and golfing challenge remains.

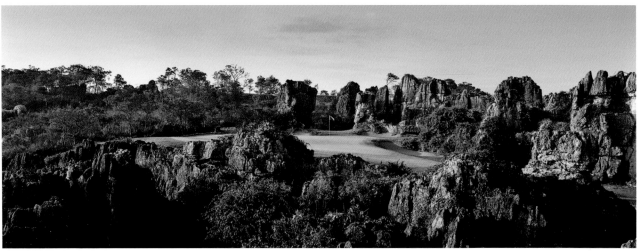

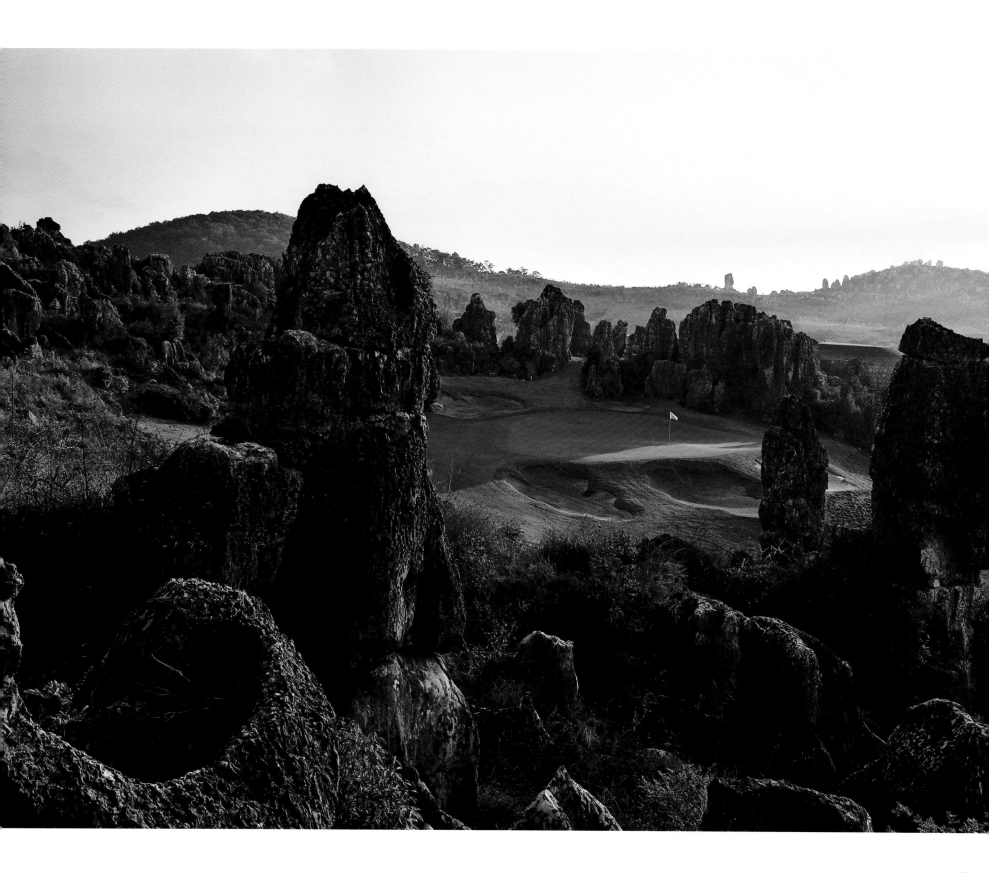

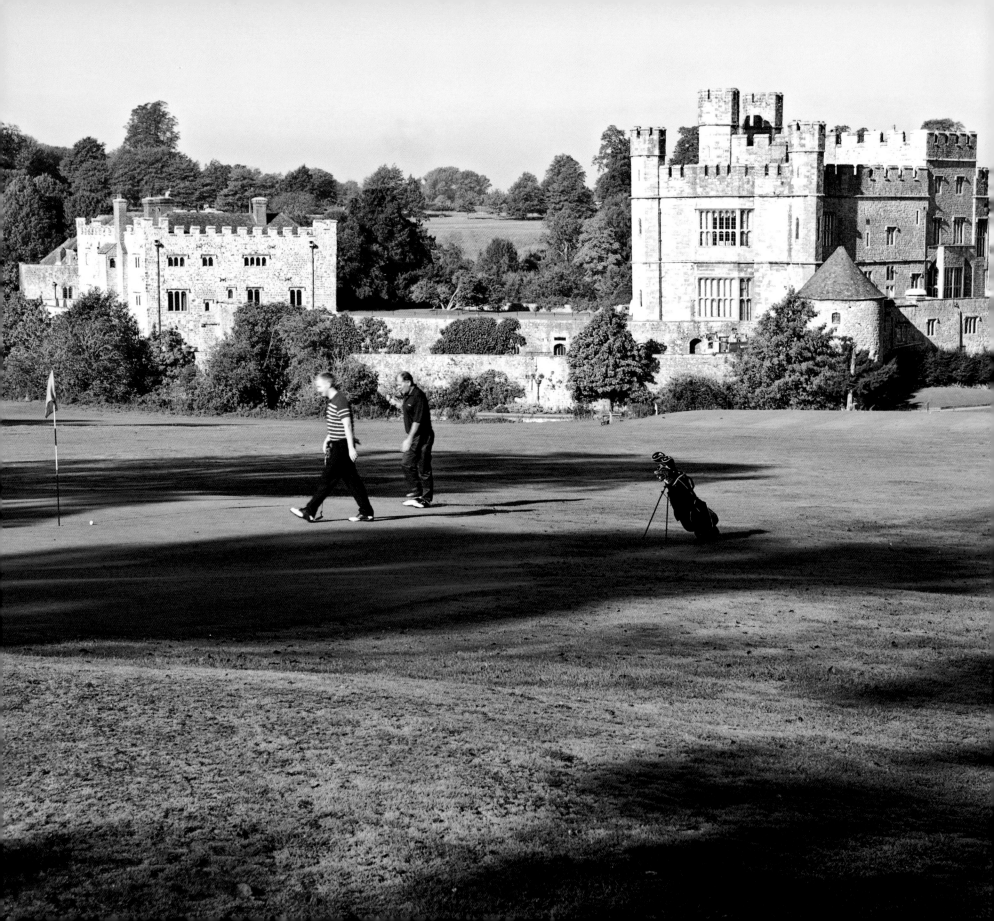

Leeds Castle Golf Course

Kent, England

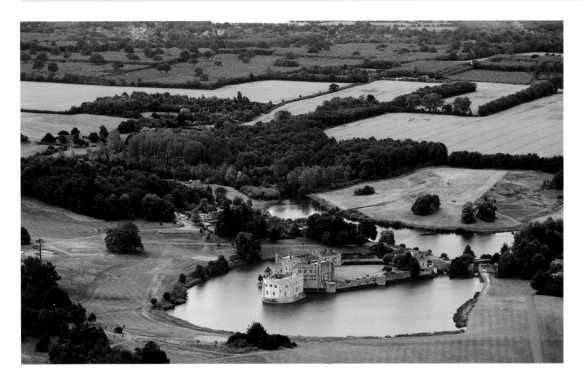

Manmade water hazards are ubiquitous on golf courses all over the world. Some date as far back as the late nineteenth century when the game's popularity exploded, but they are mere newcomers compared to the water in play at the par three sixth at Leeds Castle, which is nearly 900 years old.

The water in question is the castle's much-photographed moat, fed by the River Len, and although the nine-hole course itself is twentieth century in construction, the ancient water hazard has been part of the fortifications since the first stone was laid.

There has been a castle at Leeds in Kent from the early twelfth century. In the thirteenth century it became a favoured haunt of King Edward I, while three centuries later Henry VIII installed his first wife Catherine of Aragon in the fortress before he became tired of her inability to provide him with male heirs, incurred the wrath of the Catholic Church and divorced her. The current castle building is largely nineteenth century in construction and hence has never withstood a good besieging.

Divorce and Leeds Castle were reacquainted in the 1930s when its then owner, Arthur Wilson Filmer, parted ways with his wife Lady Baillie. She got the castle in the settlement and in 1931 instructed designer Sir Guy Campbell to build her nine holes on her newly-acquired 500-acre parkland estate. Lady Baillie bequeathed Leeds to a charitable trust on her death in 1974 and the castle and the course, 2,843 yards and par 34, were opened to the public two years later.

In 1978 it was the venue for a historic meeting between the Egyptian Foreign Minister Mohammed Ibrahim Karmel and Israeli Foreign Minister Moshe Dayan ahead of the famous Camp David Accord, while in 2004 former Prime Minister Tony Blair hosted Northern Ireland peace talks inside the castle walls. It has sadly gone unrecorded whether either group of politicians took time out for a cheeky little nine holes on the Leeds course, and there is no footage of any politician saying to newsmen, "now watch this drive", a quote made famous by President George W. Bush after a press briefing on the golf course about the war on terror.

ABOVE: The moat at Leeds Castle is visited by flocks of geese throughout the year and they occasionally become the victims of stray drives. Which raises the thorny question: Is it good etiquette to shout "Fore!" to warn large birds?

The Lodhi

Delhi Golf Club, Delhi, India

Anglophile historians have long argued for the positive legacy left by the British Raj in India, not least the railways, the language, the civil service infrastructure and the rule of law. The Delhi Golf Club and the beautiful 18 holes of the Lodhi course could credibly be added to the list.

The story of the course began in 1928 when the British moved the capital from Calcutta (Kolkata) to Delhi. The city's head of horticulture, a keen amateur player from Scotland, was instructed to begin work on a new course and he chose an area of thick bush between the tomb of the sixteenth century Mughal Emperor Humayun and Delhi's Babarpur estate.

The chief horticulturist however had an ulterior motive for his choice of site. He was as keen an amateur archaeologist as he was a golfer and hoped to unearth long-lost artefacts as construction of the new course unfolded, but his dreams of discovering buried treasure ultimately came to nothing.

The Lodhi Golf Club, as it was originally known, was nonetheless born. Membership peaked during the Second World War when Delhi was awash with Allied officers, but by 1948 this had dwindled to only 80 signed-up players and the club was only saved when the Indian Government agreed to lease the land back to the membership at incredibly generous rates.

The walled area of the club includes a large number of Mughal archaeological remains such as the famous Lal Bangla, two tombs built from red and yellow sandstone, believed to contain the graves of the mother and daughter of the dynasty's sixteenth Emperor, Shah Alam II. The seventh green is adjacent to the Barakhamba (or '12 pillars'), a fourteenth century tomb to an unknown occupant.

There are some who believe striking any of these ancient monuments brings bad luck and a spurious tale to lend weight to the story can be gleaned from a curious incident during the 1968 Indian Open when Australian Stan Peach showed an inadvertent lack of respect and hit the Barakhamba with an ill-judged shot in his final round. Initially it seemed his waywardness had actually proved fortuitous, his ball ricocheting improbably off the stonework and to within inches of the pin for an easy birdie on the seventh. Peach was now sitting on a six shot lead, but after his ball's impact with the historic mausoleum, the Australian's game imploded and he was eventually beaten to the title by his Japanese rival Kenji Hosoishi.

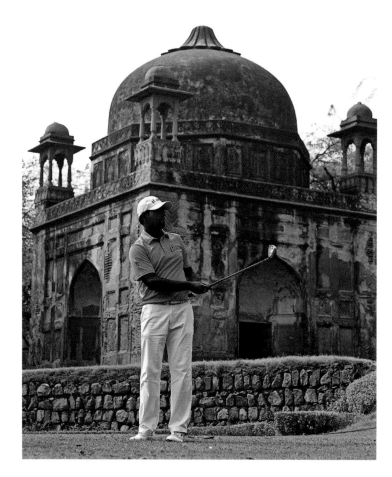

ABOVE RIGHT: Soren Kjeldsen of Denmark plays a shot during the first round of the Hero Indian Open in 2015.

RIGHT: The tombs and mauseleums dotted around the course have fared much better than Nizamuddin railway station which previously occupied a site on the 13th fairway and has entirely disappeared.

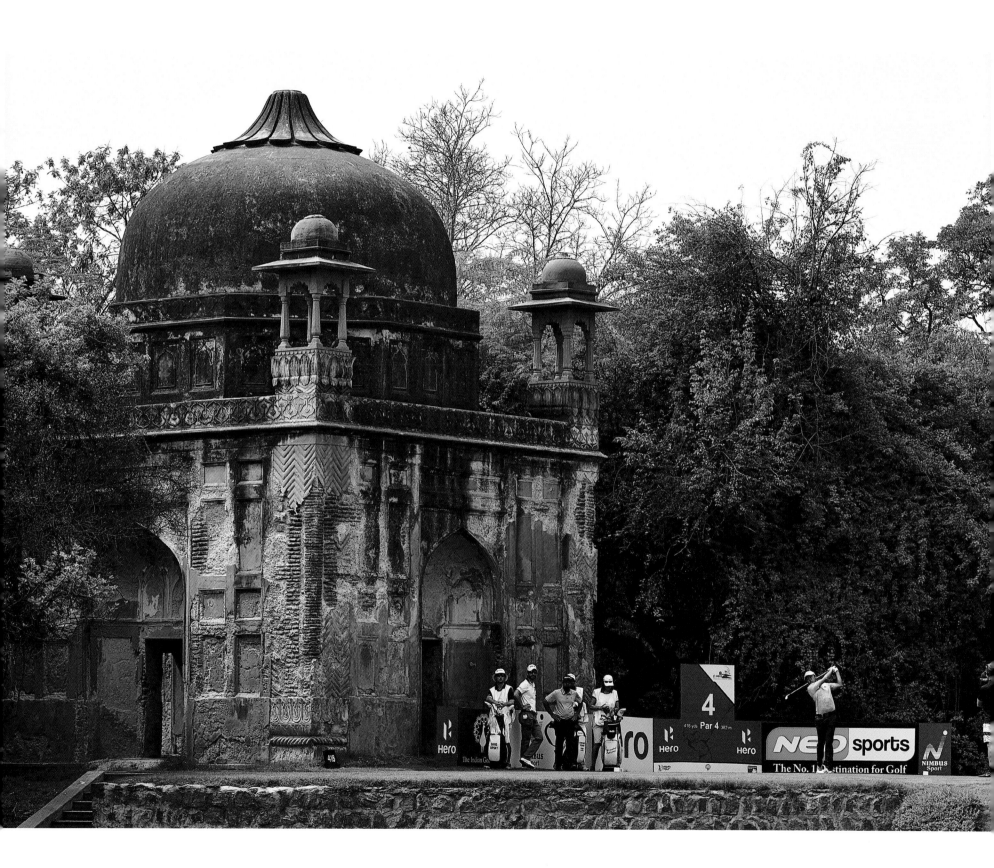

Lofoten Links

Gimsøysand, Norway

Located 100 miles inside the Arctic Circle in the Lofoten archipelago is the island of Gimsøya. The 46-square-kilometre island has a population of around 200, and at Gimsøysand, its own unique golf course. Lofoten Links is undeniably eye-catching, with its ocean views and sandy beaches, but the real attraction is the potential for nocturnal play courtesy of the endless sun in the summer months.

From the end of May until late July, darkness is a stranger to the course thanks to the phenomenon known as the midnight sun, while from the end of August through until mid-October players venturing out in the evening or beyond can experience the fabled Northern Lights in all their glory.

Golf has been played at Lofoten since 1998 when the original six-hole course was opened. Six became 18 in the summer of 2015 and since the expansion, the Links have become particularly popular with the more ornithologically oriented golfer given the proliferation of seabirds in the area including oystercatchers, cormorants, curlews and sea eagles.

Each of the holes is individually named and the first – 'Tore Hjort' pays tribute to the location's Viking heritage. Hjort was a famed tenth century chieftain who features in the Viking sagas and who historians believed hailed from nearby. Two tombs from the era are visible from the course and although they cannot be definitively identified as Hjort's final resting place, the course nonetheless remembers the revered Norse warrior.

The first hole itself is typical of the challenge presented by Lofoten. A par four measuring 301

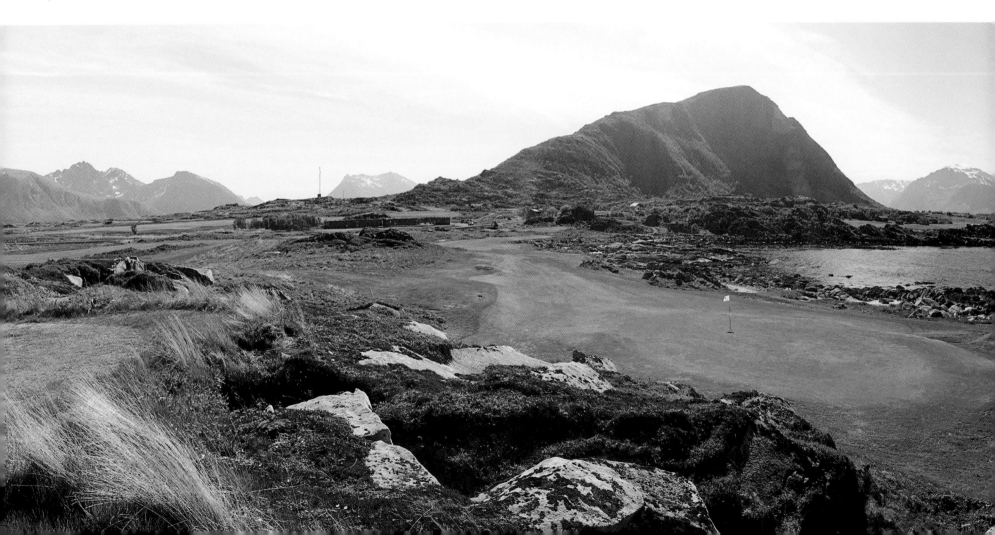

metres (329 yards) from the long tees, players must be aware of the sea all along the left-hand side of the fairway with their first shot, while rocks on the left and one of the aforementioned Viking graves on the right come into play on the second shot. The green is slightly elevated, falling down towards the water, to complete what is an intriguing, if frequently chilly, opening hole.

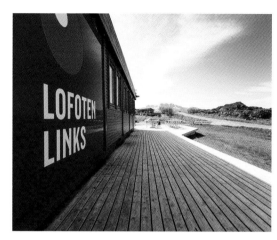 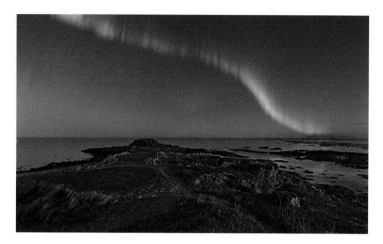

FAR RIGHT: Apart from golf under the midnight sun, Lofoten is a perfect location to watch the Northern Lights.

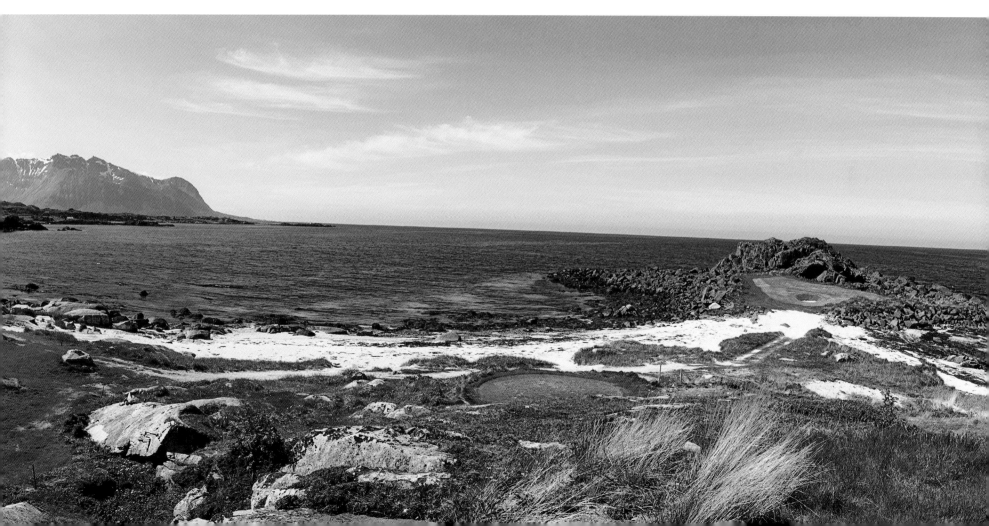

Lost City Golf Course

Sun City, South Africa

Golf's more gung-ho players are fond of holes, according to the vernacular, with teeth. Until 1992 it was purely a metaphorical expression but since the construction of the Lost City course, it has assumed a distinctly more alarming and perilous meaning.

The source of danger can be found on the par three, 198-yard 13th, which could prove very unlucky indeed. The cluster of nine large bunkers guarding the elevated green-shaped-like-the-African-continent are not the problem, it's the 38 Nile crocodiles in the pond to one side of the putting surface that unsuspecting players really should be wary of.

"Entry to the crocodile enclosure is strictly prohibited," a sign rather needlessly warns Lost City's clientele. "Do not attempt to retrieve golf balls from the croc pit. Please refrain from throwing objects at the crocodiles."

The resident reptiles, some of which measure up to two metres, are an unusual talking point back in the clubhouse, but even their unexpected presence cannot overshadow what is a magnificent course in its own right, set in 100 hectares of arid and rocky African bushveld.

Designed by South African golf's original favourite son, Gary Player, Lost City offers expansive fairways covered in hardy Kikkuyu grass, mountainous areas and small patches of desert, while the front nine of the course is separated from the closing holes, which adjoin the Pilanesburg Game Reserve, by a series of lakes.

Lost City was built following the success of its older sibling, the Gary Player Country Club, also in the Sun City resort, but over the last 20 years has forged its own reputation as one of South Africa's finest courses.

The 13th aside, Lost City's best holes are the par three third which demands a lofted shot off the tee and over a substantial water hazard, and the par four ninth with its cascading water from the waterfall in front of the Zimbabwean Ruins-themed Clubhouse.

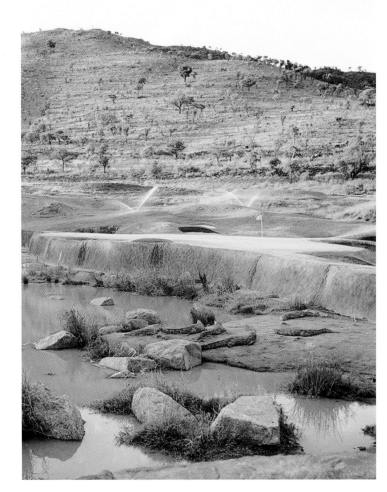

RIGHT: Water is a familiar hazard on a golf course, but Lost City goes one further by adding crocodiles to make the area truly out of bounds.

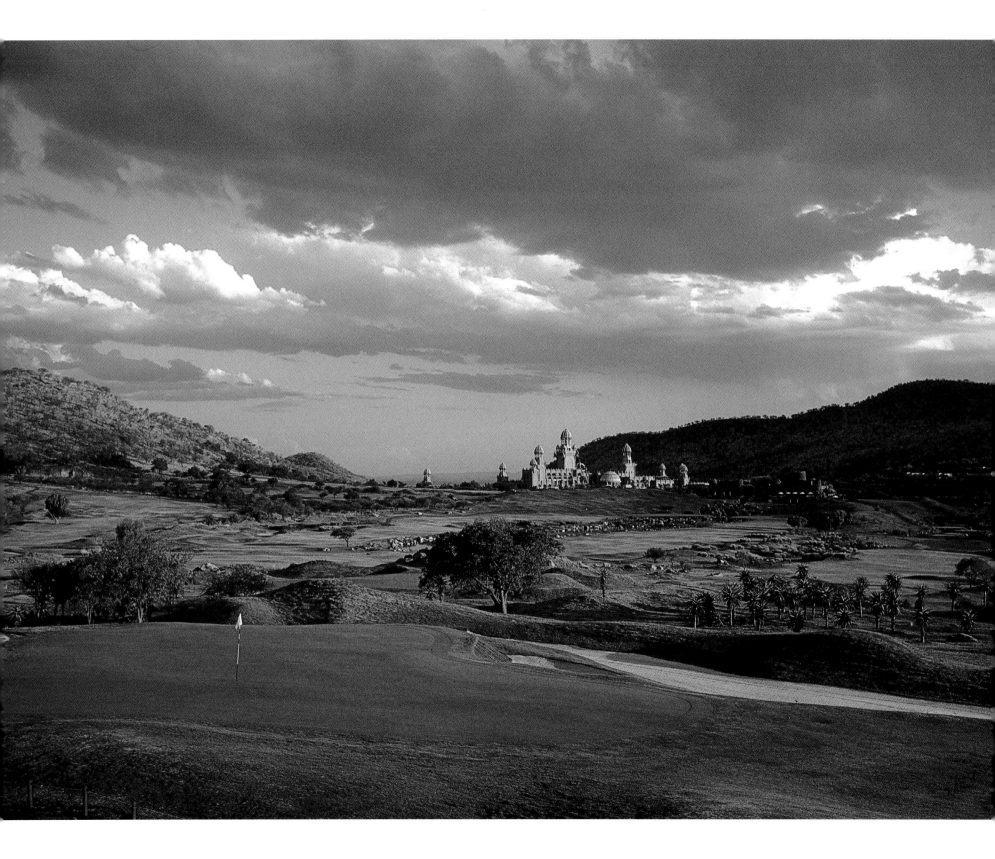

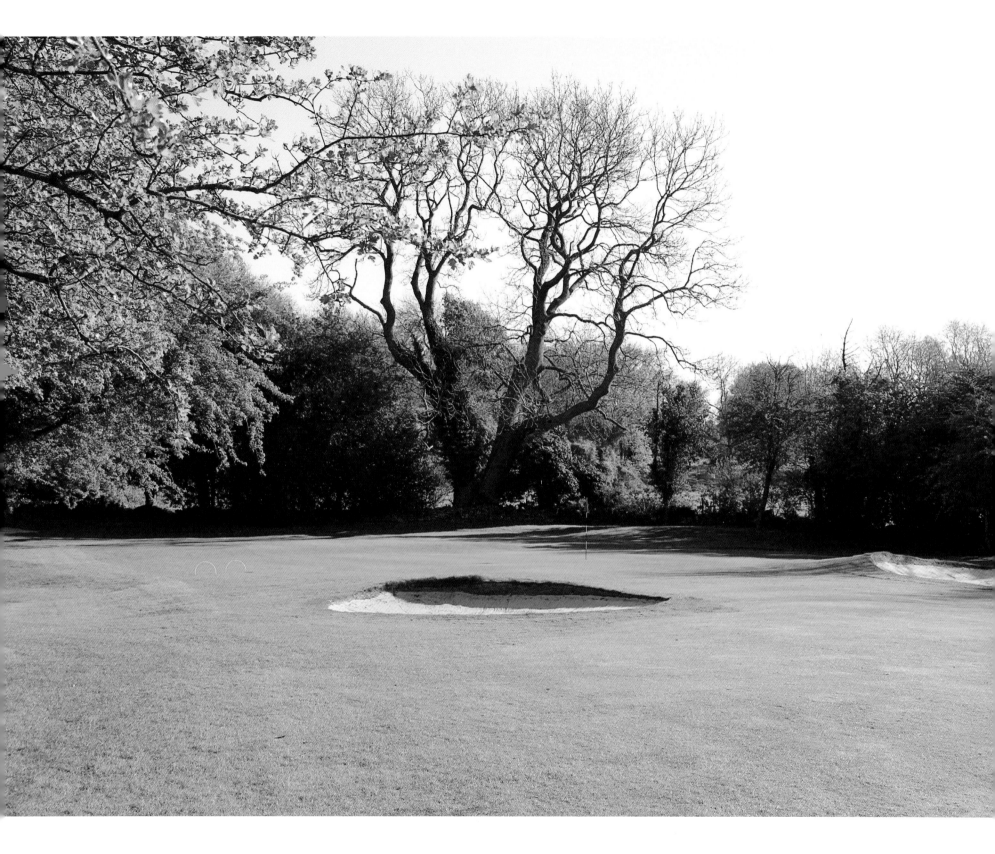

Llanymynech Golf Club

Montgomeryshire, Wales/Shropshire, England

Many golfers have dusted off their passports and ventured abroad to sample new golfing experiences. However at the Llanymynech Golf Club in Wales it's possible to visit another country during a round of golf without any need for a passport. The course straddles the Wales-England border, which means members and visitors alike can step foot in two different countries during the same round. It's a unique, cross border claim to fame which makes Llanymynech the most international of all clubs.

Founded in 1933, the course sits on Llanymynech Hill on the site of a Bronze-Age copper mine. It was originally only nine holes but was subsequently expanded to the full 18 and today is a par 70, playing 6,036 yards from the long tees.

The first three holes are exclusively on Welsh soil but it is on the fourth where the course strays into England. 'Drive in Wales', 'Putt out in England' proudly proclaims the two signs on the tee and players do indeed begin the dogleg, 340-yard par four in one country only to finish it in another. The fifth and sixth holes are wholly in England but by the time players have reached the seventh tee, they are back in the Principality, where they remain for the rest of their remarkable round.

The village of Llanymynech (which means 'Church of the Monks' in Welsh) mirrors the golf course's geographical split personality with the Anglo-Welsh border running through much of the main street. There was once a pub called The Lion which was built directly on the boundary line and thirsty golfers frequenting the premises after their 18 holes had a choice of a pint in one of the two bars which were in Shropshire (England) or, if fancy took them, they could have a drink in the third bar which was in Montgomeryshire (Wales).

The golf club's most famous son is Ian Woosnam who honed his skills on the cross-border course before going on to win The Masters at Augusta in 1991 and captain Europe to Ryder Cup glory 15 years later at the K Club.

ABOVE RIGHT: The entirely English fifth green. On the right is the sixth tee overlooking the par three sixth.

RIGHT: Golfers heading from the sixth green to the seventh tee are greeted by the sign 'Welcome to Wales'.
Golffwyr pennawd o'r chweched gwyrdd i'r seithfed tî yn cael eu cyfarch gan yr arwydd 'Croeso i Gymru'.

OPPOSITE: The fourth green resides in England while the fourth tee (top right) is in Wales. Many clubs claim to be 'international', but surely Llanymynech has the greatest claim to the title.

Lundin Ladies Golf Club

Fife, Scotland

Golf's relationship with the fairer sex has become something of a cause célèbre in the modern era. Patriarchal bans on female members at clubs have sparked vociferous public outcry and finally forced some offending institutions, most notably the R&A in 2014, to revise their policies.

As the name of the club suggests, however, members of Lundin Ladies have never had to endure such outrageous gender inequality and since it was formed in the late nineteenth century, it has proudly stood as a standard bearer for female golf.

It was established in 1890 as a separate entity from the Lundin Golf Club, making it the oldest extant ladies golf club in the world, and formally constituted the following year. The new club initially used land known as Massney Braes by the beach at Largo Bay, but it was a short-lived arrangement.

In 1909 a permanent home was found in the nearby Standing Stanes Park and a nine-hole, 2,409-yard course was laid out. Plans to expand to 18 holes were thwarted by the First World War and the urgent need to use the extra land for farming, and in 1922 the club definitively decided to remain a compact nine-hole affair.

Today the course is a tight challenge with a burn which comes into play on the sixth, seventh and ninth holes while the rough is a major factor on the third and fourth. An alternative set of tees allow members to double up and play the front nine a second time around and complete a full 18.

The signature hole is the 262-yard, par four second which features a curious hazard in the shape of three ancient stone megaliths in the middle of the fairway. The trio of sandstone pillars are around 4,000 years old and make for a highly unusual obstacle.

The original constitution of Lundin Ladies makes for interesting reading, stating as it does that "the club shall consist of Lady members, Honorary members, Gentlemen Associates and children over the age of seven," meaning that while men cannot be fully paid up members, they can nonetheless play on the course's nine holes, a generosity of spirit sometimes absent in golf.

RIGHT: Looking like a cross between modernist sculptures and the stones of Easter Island, Lundin's Bronze-Age Standing Stanes are one of the oldest man-made hazards in golf.

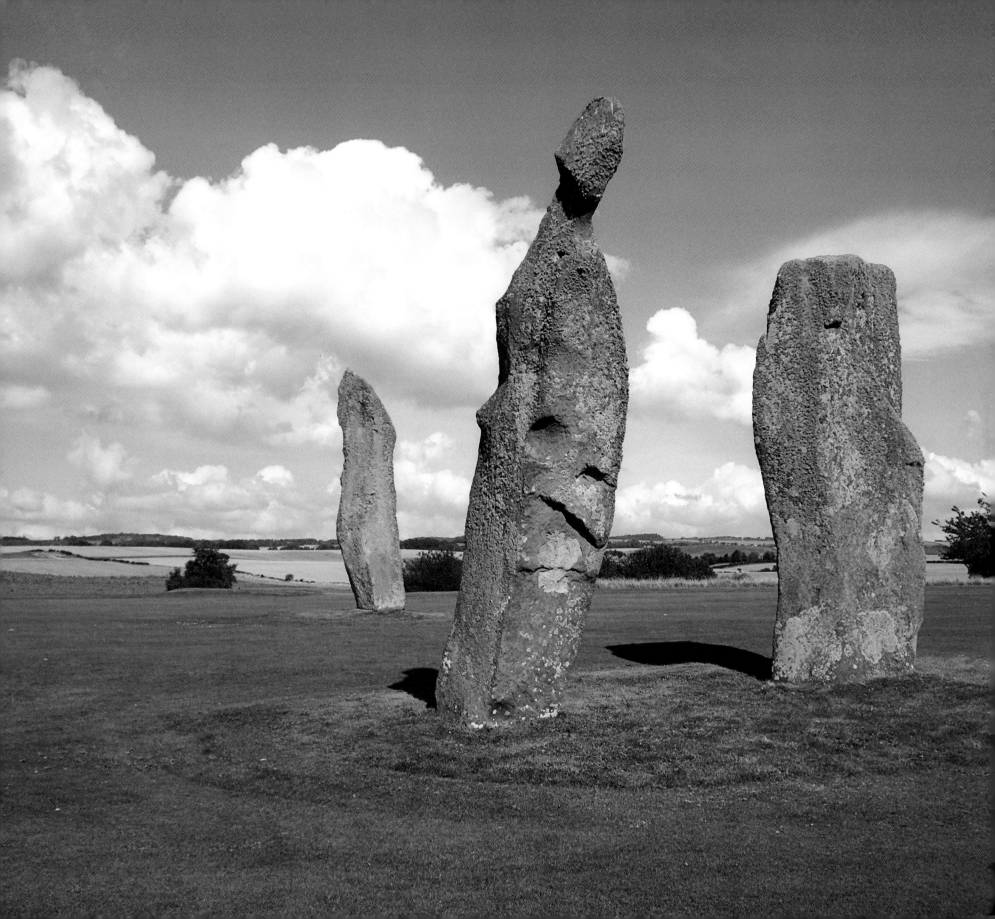

Majlis Course

Emirates Golf Club, Dubai

The chance to play in the imposing shadow of skyscrapers is not one afforded to every golfer given the traditional space limitations of the urban environment, but the Majlis is a course that defies this convention with its stunning vistas of the precipitous Dubai skyline.

Taking its name from the Arabic word for 'meeting place', Majlis was born in 1988 when Sheikh Mohammed bin Rashid Al Maktoum donated land on the edge of the city for the construction of the Middle East's first ever full-grass course, and mindful of his caveat that the indigenous desert flora was to be undisturbed, work began on the historic development.

American architect Karl Litten was commissioned to lay out the 18 holes and within a month of opening, Majlis was staging its first major tournament, the Pan-Arab. Within a year it became the home to the prestigious Dubai Desert Classic, sanctioned by the European PGA.

As with all of Dubai's large-scale investments in recent decades, the course was designed to attract worldwide attention and Majlis and the Classic have done just that, with Seve Ballesteros, Ernie Els, Tiger Woods and Rory McIlroy amongst those to have lifted the trophy since its inauguration. Els still holds the tournament record with the 11-under-par 61 he shot in 1994.

Surprisingly, given its arid surroundings, nine of the Majlis' 18 holes feature water to a greater or lesser extent. The course's most challenging hole is the long, 459-yard par four eighth. It would be testing enough without the dogleg halfway down the fairway and the uphill contours, but even if players get to the green in two, the undulating green makes three putting a frustratingly familiar outcome.

RIGHT: Chelsea Pezzola of the United States plays her second shot on the par five 13th hole during the 2016 Omega Dubai Ladies Masters.

LEFT: Sergio Garcia hits his second shot on the eighth hole on his way to winning the Omega Dubai Desert Classic in 2017. Many golf courses vie for possession of the 'world's biggest bunker' and at Pine Valley in New Jersey they have 'Hell's Half Acre'. However many of the desert golf courses are set in one giant bunker, this one being the Arabian Desert.

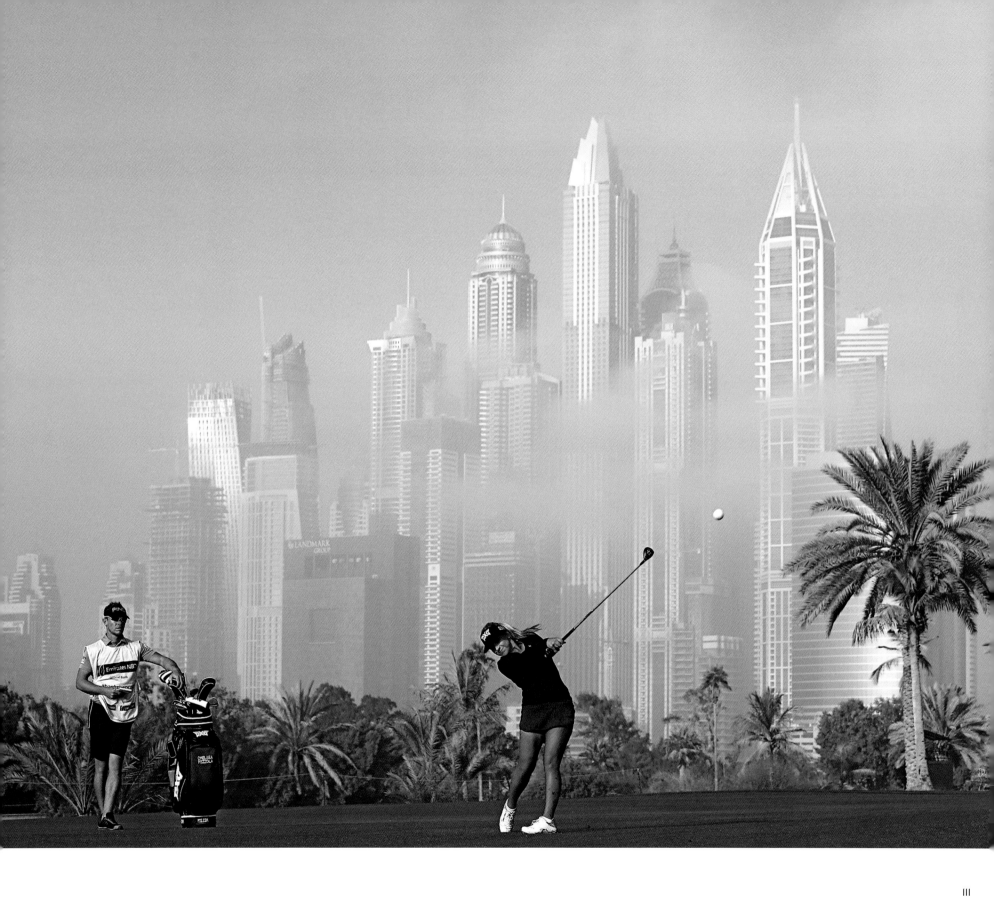

Manele Golf Course

Four Seasons Resort, Lanai, Hawaii, USA

Coastal courses are by their nature characterised by the salt water which laps sometimes alarmingly close to their fairways and greens. Not all are true links but they share a common peril and penalty should their ball find the sea or ocean.

Manele is no different but what distinguishes it from the vast majority of its coastal cousins is the sheer, terrifying scale of the drop from the green expanses of the course down into the Pacific Ocean. At some points, the fall from the dizzying top of the lava outcrops to Hulopoe Bay below is over 150 feet.

Designed by Jack Nicklaus and built in 1993, the inland front nine of Manele give little hint of the vertigo-inducing nine holes to follow but once the uninitiated reach the green of the 11th, they are left in no doubt of the elevated nature of their surroundings. A monster 589-yard par five, it may take three to make the putting surface but once there, the ocean is unmissable.

The 12th is not as coy from the outset as its predecessor and as players prepare for the tee shot on the 202-yard par three, the eye is inevitably not taken by the flag fluttering in the hole but by the 150-foot carry required to get the ball over the water below.

The 13th, in truth, is not quite as intimidating, the Pacific lurking to the left of the fairway but still close enough to distract the unfocused player, and although the 14th through to 16th retreat back to more solid ground on the course, the 17th is a truly spectacular and hazardous challenge.

From the long tees, the hole plays 444 yards but the more pertinent figure players have in mind is the 220 yards required to get the ball over Hulopoe Bay, which cuts hungrily into the fairway from the right. Manele's 18th is mercifully dry and unremarkable, but it is the memories of the back nine's daunting ocean abyss that linger longest.

BELOW: The 10th to the 13th holes overlook Hulopoe Bay, and the vast drop to the Pacific Ocean.

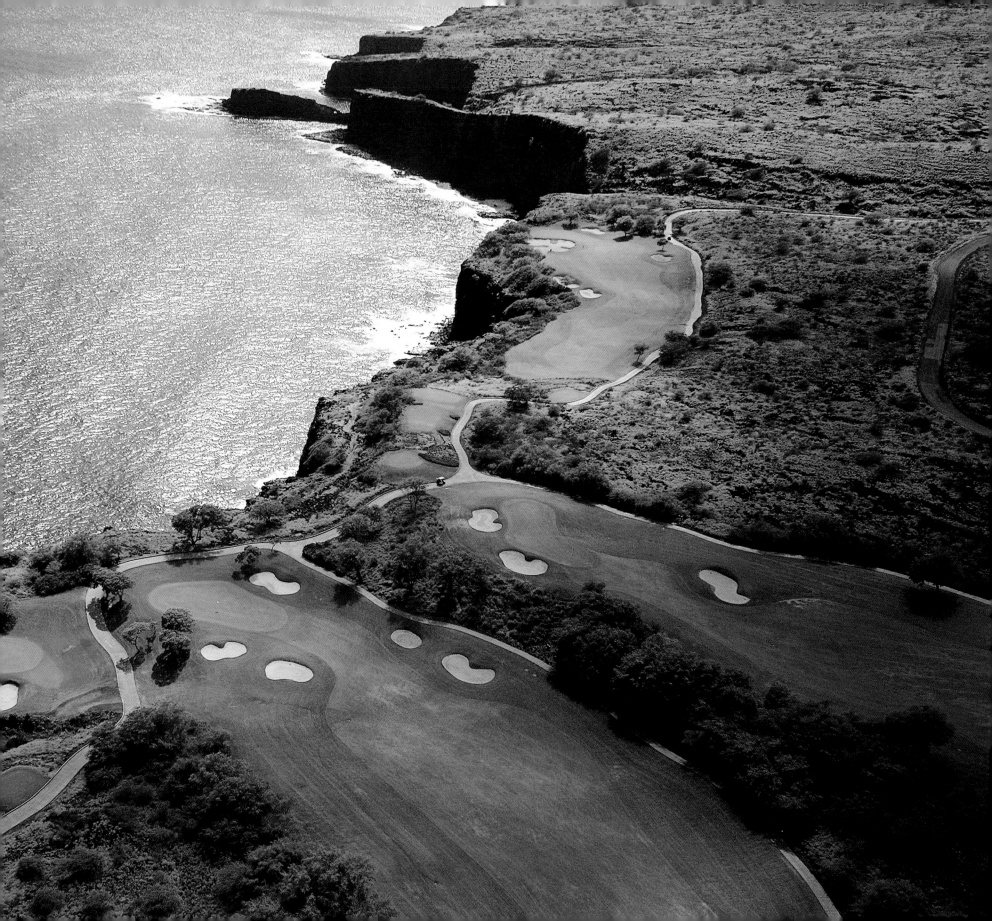

Merapi Golf

Java, Indonesia

Omens are all about how various signs are interpreted. On the day construction of the Merapi golf course started in 1994 the nearby Gunung Merapi (Fire Mountain) gave a sign in the shape of a minor eruption. The more superstitious of the Javanese locals who witnessed the event deemed this a blessing on the new project from the spirit kingdom they believed to lie beneath the volcano. The vulcanologists weren't so persuaded.

The golf club was the idea of Indonesian businessman and engineer Yuwono Kolopaking who wanted to build a course accessible to local people on Java. He commissioned Australian company Thomson, Wolveridge and Perrett to lay out his new course and after deploying an army of Indonesians to undertake the work, Merapi was born.

Sixteen years later, however, Mount Merapi underwent a far more major event, spewing tonnes of ash over the course's ninth, 10th and 17th previously unblemished holes. Local villagers and subsequent heavy rainfall combined to unchoke the course but it was still

closed for a year as the greens and fairways recovered, a graphic reminder of the perils of placing a course in the shadow of an active volcano.

Today the course has been fully restored to its previously pristine condition, and located 800 metres above sea level, it affords panoramic views over the hinterland of Yogyakarta and the Indian Ocean.

BELOW LEFT: A satellite view shows the destruction caused by the eruption of Mount Merapi in November 2010.

BELOW: Indonesian girls play on the golf course in 2006, four years before the fatal eruption that killed 200 and forced 400,000 from their homes.

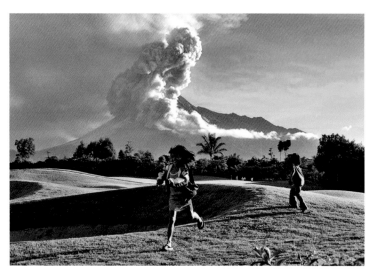

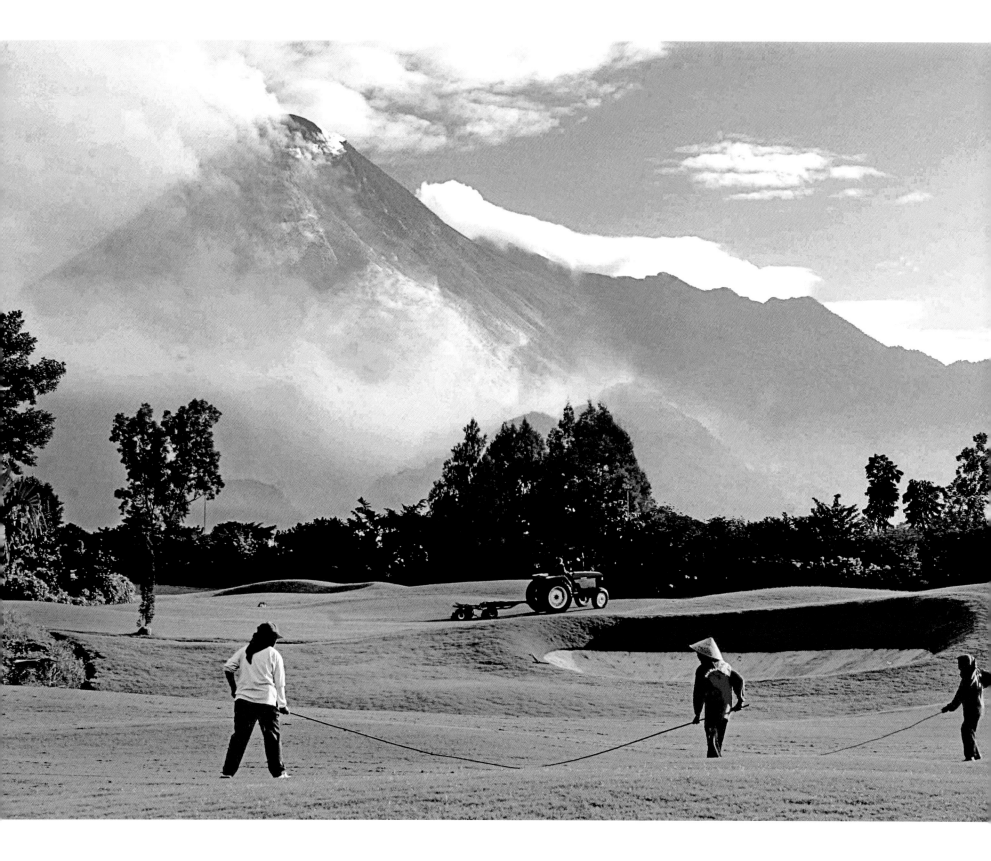

Mission Hills Resort

Shenzhen, China

The People's Republic of China is no stranger to construction on a massive scale and in the Mission Hills Resort and its 12 different courses, the nation boasts a sporting complex that reflects the national ambition for projects with impact.

Golf was banned in China in the 1940s by the ruling Communist Party because it was deemed too bourgeois and it was not until the 1980s, after Mao's death, that the long-standing prohibition on building new facilities was lifted. The country's first course, designed by Arnold Palmer, was opened in 1984 in the city of Zhongshan, but it was the Mission Hills project that spearheaded the explosion in construction. By 2017 there were a reported 683 courses in the People's Republic but none on quite such a grandiose scale as the giant Guinness World Record holder.

Built on what was formerly wasteland between the cities of Shenzhen and Dongguan in the south-east of the country, near Hong Kong, Mission Hills opened its first driving range in 1993. The creation of its array of 18-hole courses quickly followed and in 2006 Guinness World Records confirmed the site as the largest golf facility anywhere on the planet, surpassing the Pinehurst Resort in North Carolina and its nine courses.

It had already attained international recognition in 1995 when it was chosen to host the World Cup of Golf for the first time – the American pair of Fred Couples and Davis Love III beating their Australian rivals Robert Allenby and Steve Elkington – and has gone on to stage the event on three further occasions. The 12 courses were designed by some of the game's biggest names including Nick Faldo, Vijay Singh, Greg Norman, Ernie Els and José María Olazábal, while China's Zhang Lian-Wei and Japan's Masashi 'Jumbo' Ozaki also helped create new, 18-hole courses.

RIGHT: A view of the 15th hole on the Olazábal course at the Mission Hills Resort.

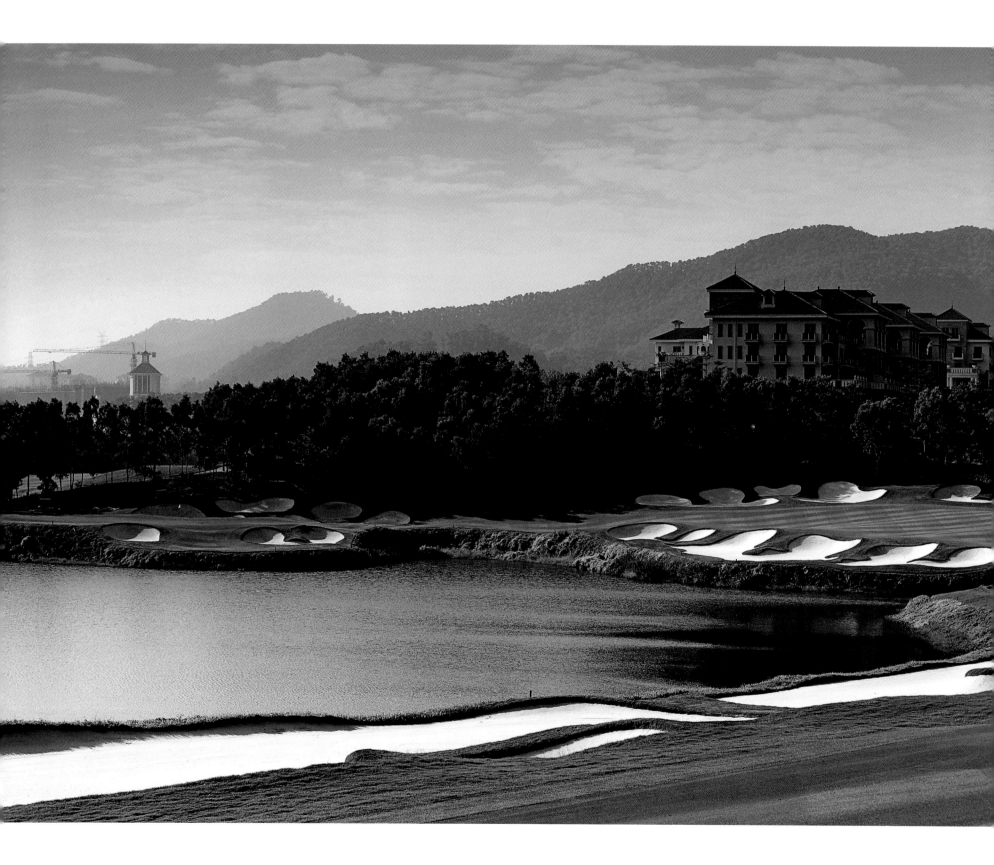

TOP LEFT: Mission Hills has its own night course, where golf can be played on floodlit fairways.

TOP: The architects' gallery, outlining the golfing achievements of their esteemed course designers. With Jack Nicklaus they had just about enough space.

ABOVE: One of Pete Dye's American courses, reclaimed from the mining industry, has old ore carts as a reminder of the site's past use. Old railway sleepers have long been used on British and American courses (where they're known as ties), but at Mission Hills Dye went one step further and incorporated old railway cars alongside the 18th hole.

LEFT: The ninth hole of the Greg Norman course.

RIGHT: The 16th green of the Nick Faldo course.

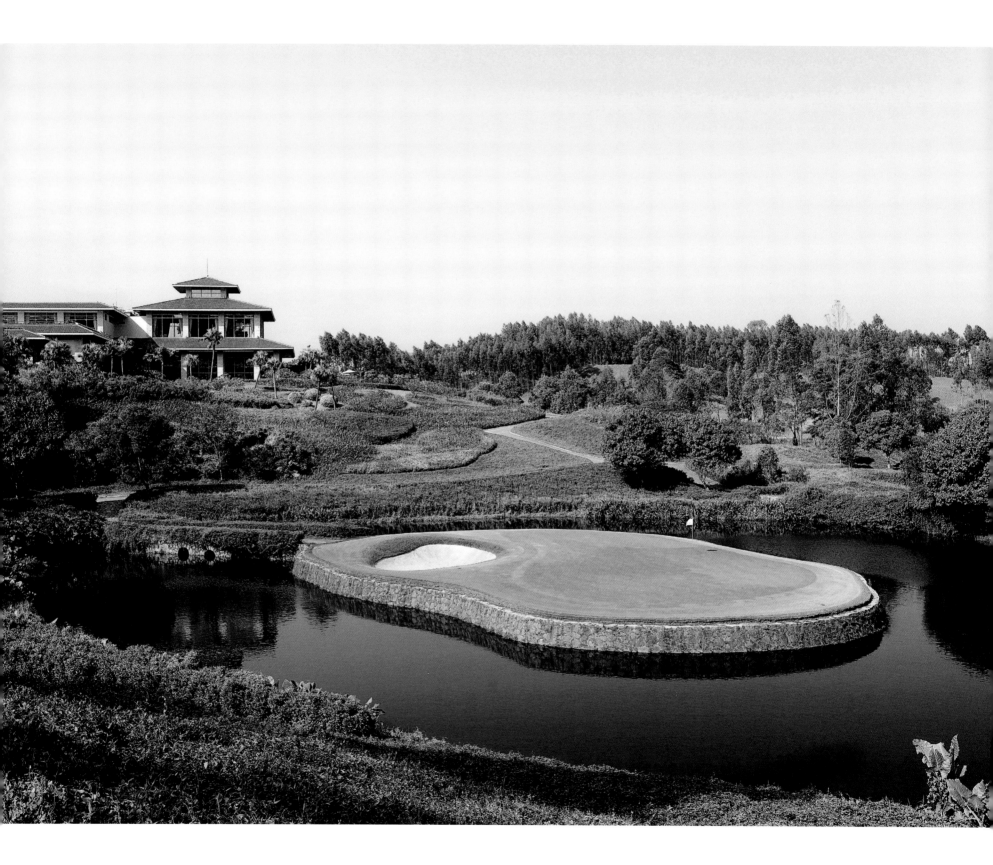

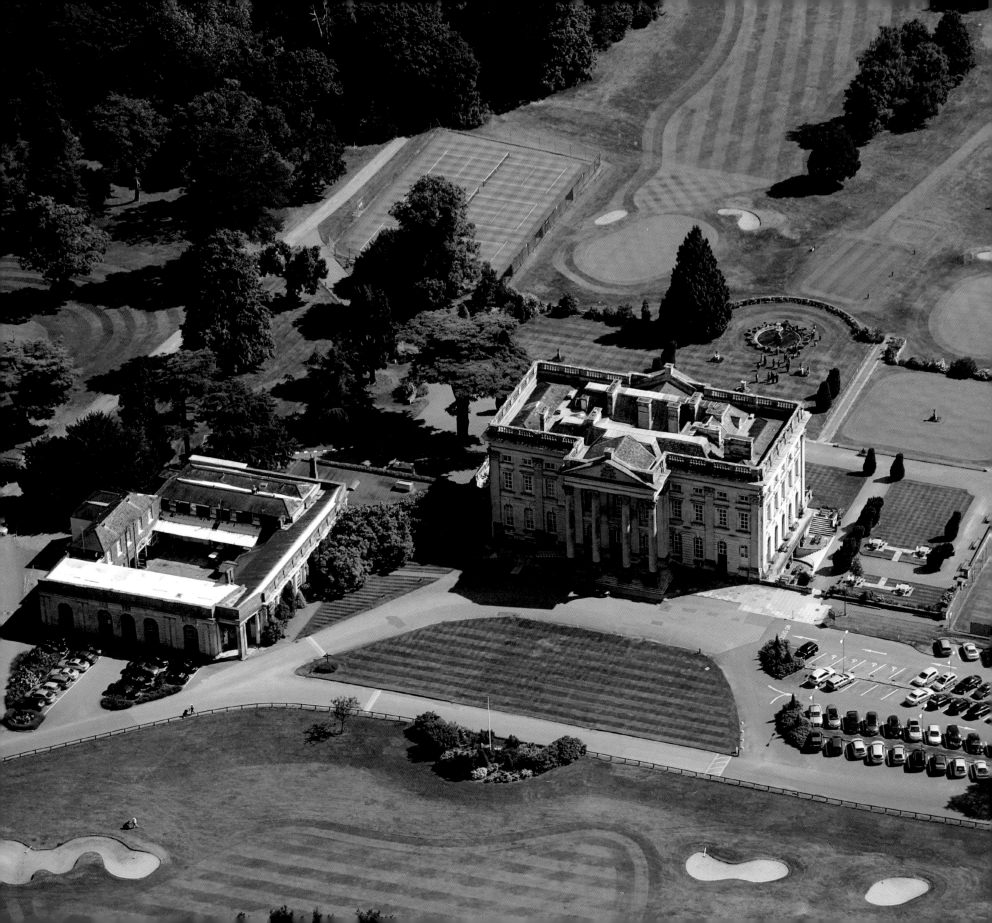

Moor Park Golf Club

Hertfordshire, England

The architecture of a golf course should rarely be eclipsed by the clubhouse which stands within its grounds but Moor Park's seventeenth century, Grade One listed Palladian mansion is one stunning exception to the rule which towers unapologetically above its sporting surroundings.

Built in around 1617 for the Third Earl of Bedford, Moor Park mansion was significantly remodelled in the 1720s when its signature Portland stone Corinthian portico was added to the south frontage of the house.

During the Second World War the building was requisitioned by the Army, serving as the headquarters of the 1st Airborne Corps. It was here that Operation Market Garden, the abortive mission to capture the bridges of the Lower Rhine in Germany in 1944, was planned. The room in which the operation was devised is now called 'The Arnhem Room'.

The Moor Park Golf Club bought the freehold to the mansion from the local district council in 1994 and have since undertaken a complete refurbishment of the historic building under the auspices of the National Association of Decorative and Fine Arts Societies.

Set amidst 300 acres of mature woodland, the club's High and West Courses were both designed by Harry Colt on the instruction of the industrialist and politician Lord Leverhulme after his acquisition of the estate. They opened in 1923.

The High Course is the more prestigious of the two courses and in 1935 was the scene for the inaugural Carris Trophy competition, the annual English Boys' Open Stroke Play Championship which has been won over the years by the likes of Sandy Lyle and Justin Rose. The tournament is now staged on a rotational basis across the country but returns to Moor Park every so often in recognition of its founding.

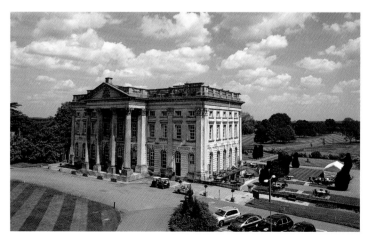

ABOVE RIGHT: Moor Park was a familiar venue for competitions in the 1930s. This photo from 1934.

RIGHT: The venue has changed little in the intervening years, but the vehicles have changed a lot.

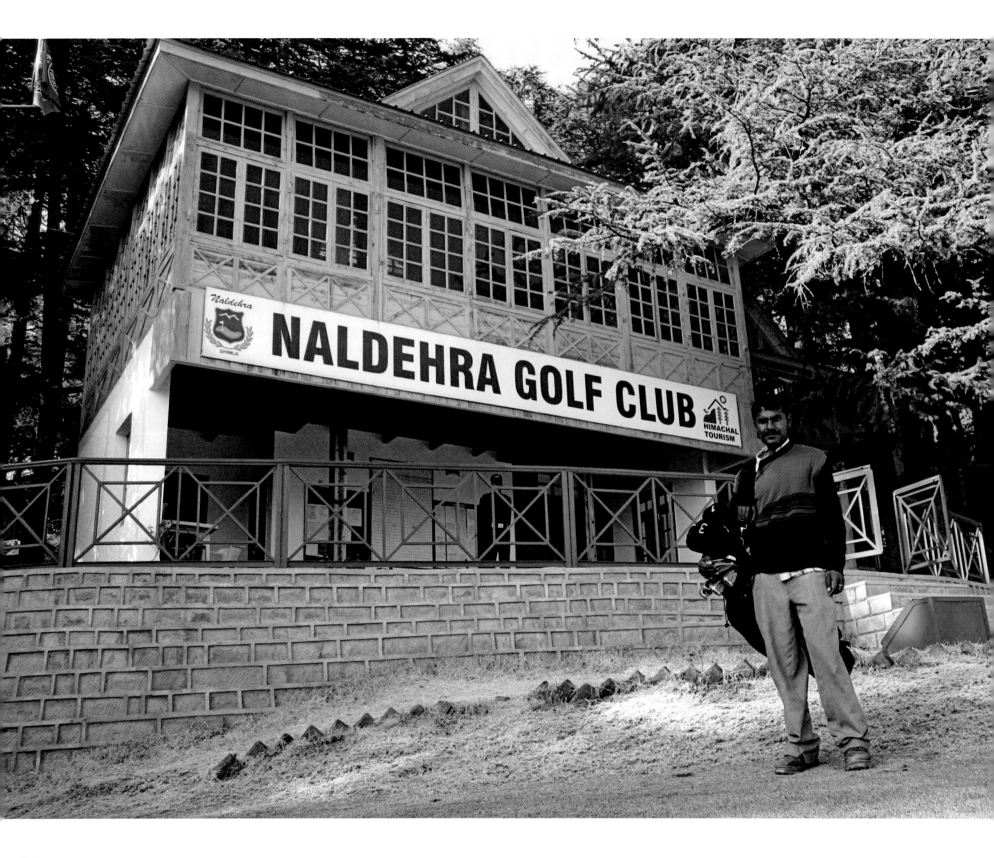

Naldehra Golf Club

Himachal Pradesh, India

In China the expansion of golf and investment in new courses and resorts has gone hand in hand with the growing economic strength of the country. It cannot be long before India joins in the rush, but there is still one hidden gem, one vestige of old empire located high in the hills of Himachal Pradesh province near Shimla.

The Naldehra Golf Club is situated on uphill pasture that was once the site of a great vision of a dancing snake. When told of this vision by the local Turi (singing bard) who witnessed it, the villagers named the god 'Nal Deo' and the area became known as Naldehra, with a temple erected near the site of the vision. Fast forward to a time near the end of the British Raj. Viceroy of India Lord Curzon, like so many of the British administrators, escaped the intense heat of the Delhi summers by heading north to Shimla in the foothills of the Himalayas. He and his family enjoyed camping in the woodland at Naldehra, around 20 miles from Shimla (in fact the Viceroy liked it so much he named his daughter Naldehra) and whilst strolling the upland pastures was struck that this would make a topping site for a golf course.

A nine-hole course was opened in 1905, carved amongst mature Himalayan cedars, deodars, and the course was subsequently expanded to 18 holes, although not necessarily 18 fairways, with some holes sharing a fairway before bifurcating off to their own green. If St Andrews can share greens why shouldn't Naldehra share fairways.

The course is a compact 4,372 yards par 66 and given that it is the highest golf course in India at 7,200 feet above sea level enabling balls to fly further in the thin air, and with no hole longer than 400 yards, it is clearly a course that rewards the short game.

While some of the Scottish golf courses represent fantastic value for money if you rate them at cost of round/breathtaking scenery, none can match Naldehra's rates. You can play at this beautiful mountain course for a monthly fee of 200 rupees – that's £2.40 or $3. What's more, Lord Curzon's original nine holes are exactly as he laid them out.

The vision of the snake god has not been forgotten either. Similar to St Enodoc's church in Cornwall, which is entirely surrounded by a golf course, the old temple to Nal Deo rests within the golf course and those wishing to commune with the spirits must negotiate the fairways to get there.

TOP RIGHT: The Curzons enjoyed camping in the woods around Naldehra so much they gave their daughter the name. Not many girls sent back to boarding school in Edwardian England had a name that meant Indian snake god.

ABOVE RIGHT: The Nal Deo temple.

RIGHT: Should you wish to have a delicious fruit chat while out on the course then your needs are catered for at Naldehra.

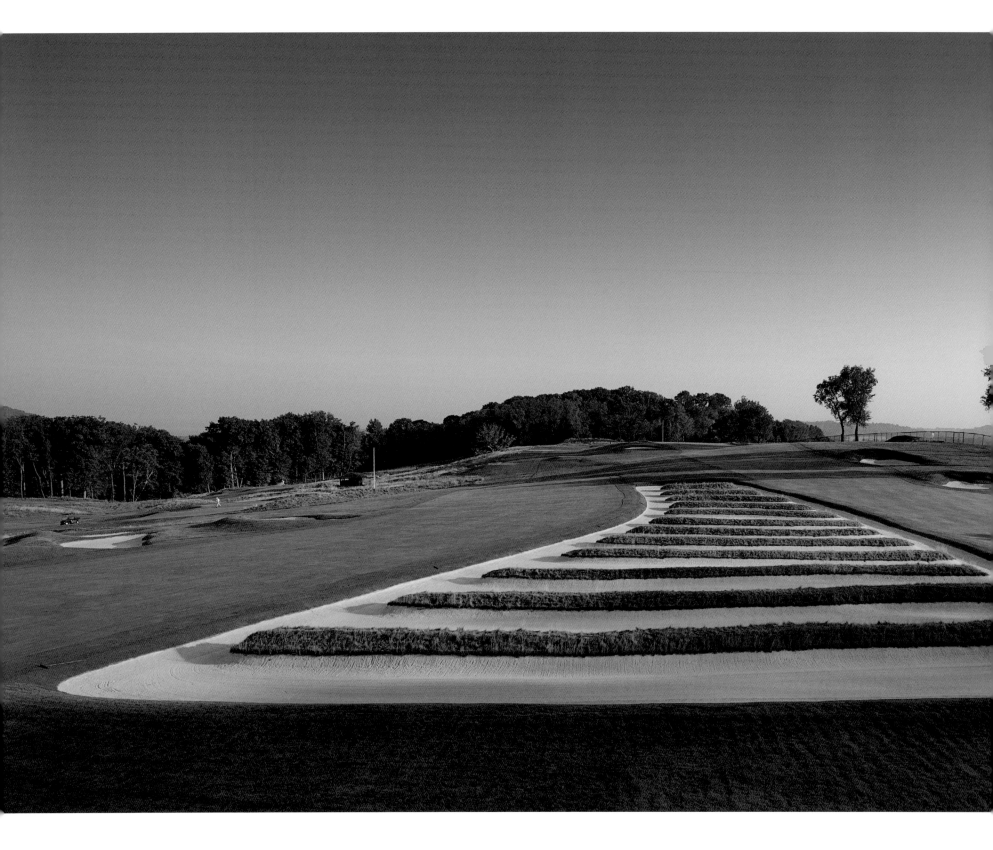

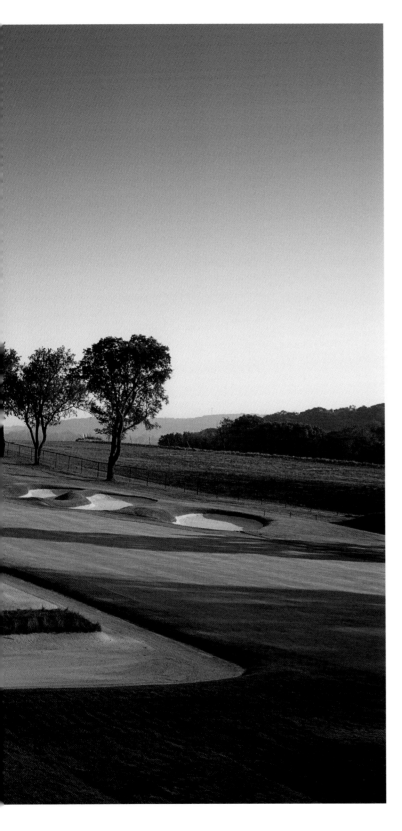

Oakmont

Pennsylvania, USA

"Golf without bunkers and hazards would be tame and monotonous," argued the twentieth century American journalist B. C. Forbes and founder of the financial magazine which still boasts his name today. "So would life."

Many who have found themselves mired in a particularly maddening sand trap might disagree but bunkers remain an occupational hazard for players of every ability and a course without sand is one which would lack a frisson of danger.

Of course they come in a variety of different shapes and sizes, but one of the most famous and feared is the 'Church Pews' bunker at Oakmont, a beautiful but hungry hazard which sits menacingly by the side of both the third and fourth fairways.

Oakmont was designed by Henry Fownes, built on farmland and opened in 1904. In the early years there was no 'Church Pews' bunker but when the club president and superintendent sat down in the 1920s to remodel the course and reduce the number of sand traps, they decided to consolidate the eight separate bunkers that sat between the third and fourth holes into one single, imposing hazard. The result was the 'Church Pews' bunker, named because its trademark grass strips amidst the sand resembled rows of ecclesiastical seating.

The feature originally had eight long, thin grass islands but that increased to 12 when Tom Fazio

was drafted in for a remodelling job in 2005. Overall the unique bunker measures 300 feet by 121, with the turf strips on average three feet high.

From the third tee the 'Church Pews' awaits the errant driver on the left of the fairway. Five small, separate bunkers are adjacent on the left and only a straight shot will suffice. On the longer par five fourth, the Pews is once again a hazard to avoid, but since the hole is played in the opposite direction to the third, the narrower end of the bunker is closest to the tee.

It's not clear which is worst: to land in the sand or on top of the grass strips. Both scenarios frequently produce awkward lies and require uncomfortable stances and a humble sideways hack rather than a full-blooded escape is often the wisest option. The club, however, have allowed the grass strips to grow longer in recent years, prompting some to argue the sand is now the lesser of two evils.

In total, Oakmont has 210 deep bunkers, including a second, smaller 'Church Pews' on the 15th with eight grass tramlines, and the proliferation of sand traps combined with its hard, slick and sloping greens and tight fairways have earned the course the reputation as one of the most challenging in America.

The course made history in 2016 when it hosted the U.S. Open for a record-breaking ninth time

but it was the 1973 edition of the tournament at Oakmont which produced one of the game's most memorable moments as American Johnny Miller was dramatically crowned champion.

He began his final round a full six shots adrift of joint leaders that included Arnold Palmer. Miller proceeded to birdie the opening four holes. Three pars followed and although he three-putted for bogey on the eighth, another birdie on the ninth saw him out in four under par.

The back nine yielded four more birdies and five pars and as his rivals faltered. Miller had

registered a remarkable 63 to win the U.S. Open. His display at Oakmont has been described as the "greatest round of the twentieth century" and to put his achievement into context, his 63 remains the joint lowest ever score in a major.

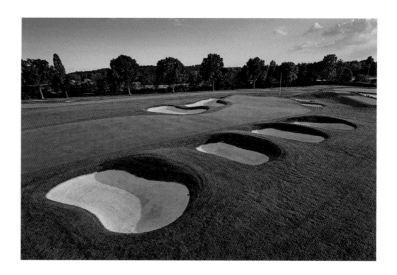

RIGHT: The shark's-gill-like bunkers at the approach to the par five fourth hole at Oakmont. They both bite.

BELOW: Andrew Landry of the United States plays a shot from the 'Church Pews' bunker on the fourth hole during the final round of the U.S. Open in 2016.

OPPOSITE: The clubhouse beyond the 18th green at Oakmont.

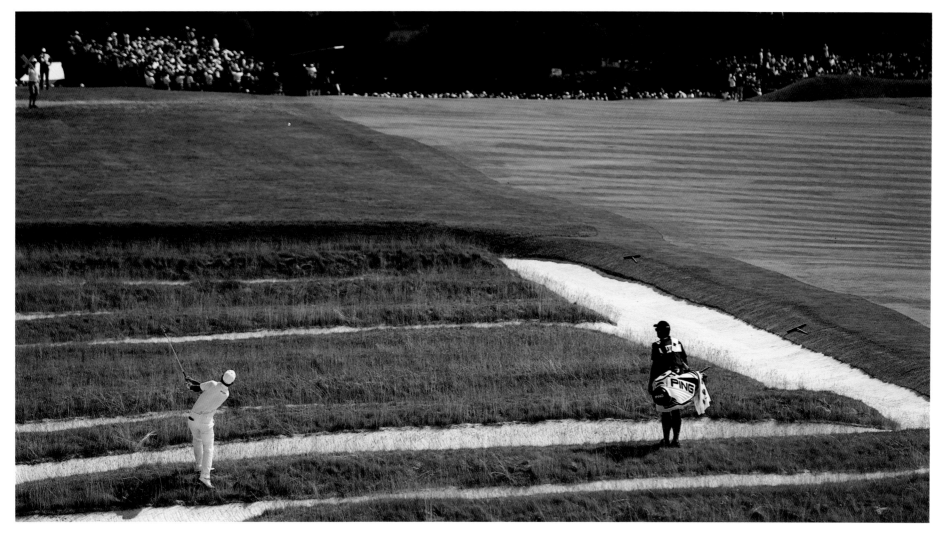

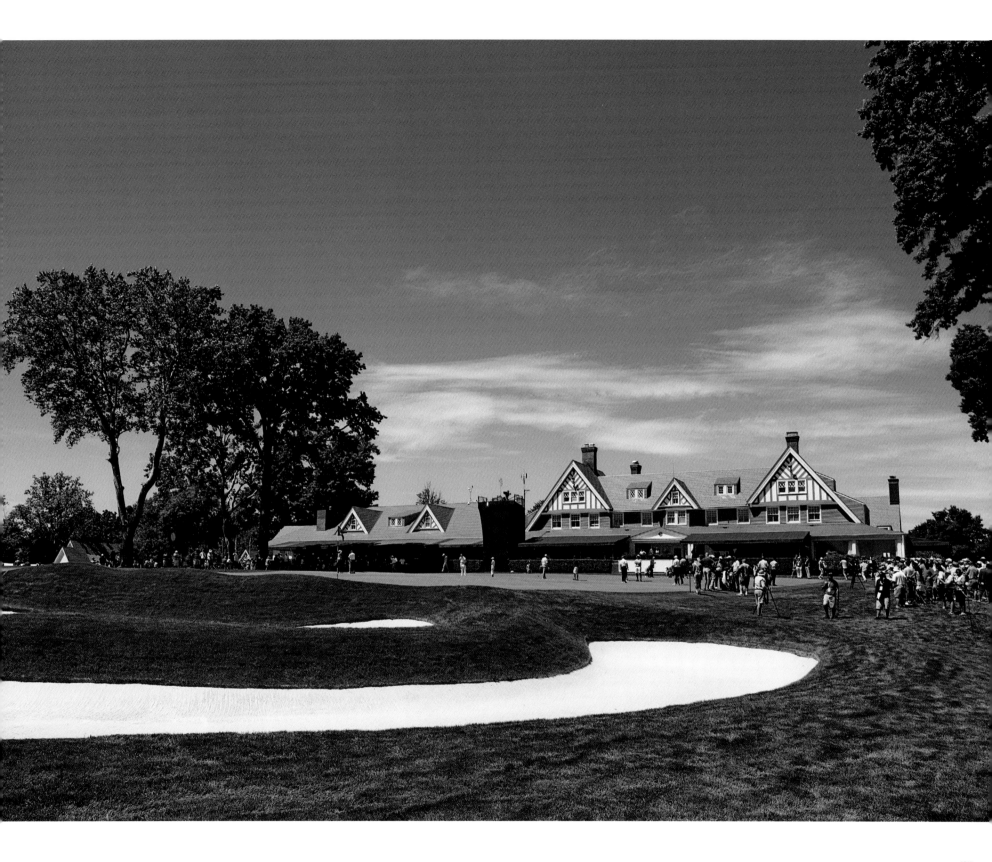

The Ocean Course

Kiawah Island, South Carolina, USA

Golf architect Pete Dye initially planned to site the Ocean Course behind the substantial dunes of Kiawah Island but when his wife and long-time collaborator Alice suggested raising up the entire course, affording more panoramic views of the Atlantic Ocean, her husband ceded to her vision.

The result was what many consider the finest links in America, featuring 10 holes alongside the ocean, more, the club claim, than any other course in the northern hemisphere. The wind, which almost perpetually buffets the course, is neither gentle nor predictable, inflicting up to an eight-club difference on any given hole depending on the strength and direction of the breeze. Which all makes for a serious challenge for those who venture to South Carolina to tackle the Dyes' creation.

Forbes named it one of the five toughest courses in the USA in 2016 while the 17th is regularly rated as the most fiendish of the 18. "The tee shot is all carry over water," said Dye of the penultimate hole. "A very demanding par three and my favorite here."

An interesting footnote in the story of the Ocean Course is provided by the Ryder Cup and the 1991 clash between the USA and Europe. Surprisingly, the course was selected to stage the 29th instalment of golf's greatest international fixture *before* work had even started on the new course. Construction was completed on schedule and the world's finest players proceeded to produce a match that will never be forgotten.

Ill feeling between the two teams and at times over-exuberant interventions from some of the fans helped give the match the nickname 'the War on the Shore' but bad behaviour could not eclipse a truly dramatic denouement, Hale Irwin halving on the 18th hole in Sunday's final singles match after Bernhard Langer missed a six-foot putt for victory. Irwin's priceless half point gave the USA a famous 14.5 to 13.5 victory and after three successive defeats to Europe, their first Ryder Cup success in eight years.

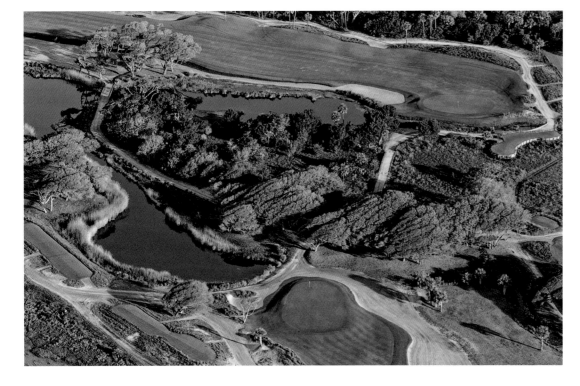

LEFT: The first green is at the top of the picture, as the course heads out from left of picture to right, along the shoreline. Below it is the eighth green as the course heads back. There is a remarkable 900 yards, as the crow flies, between the ninth green and the 10th tee.

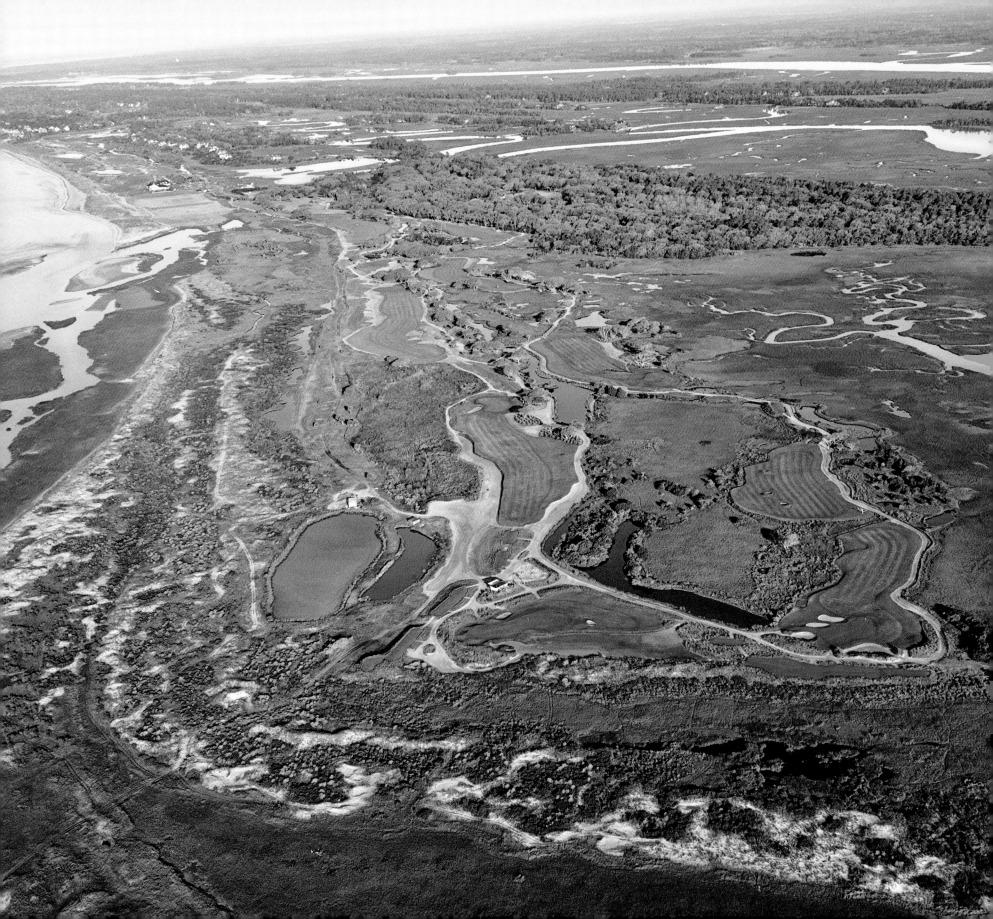

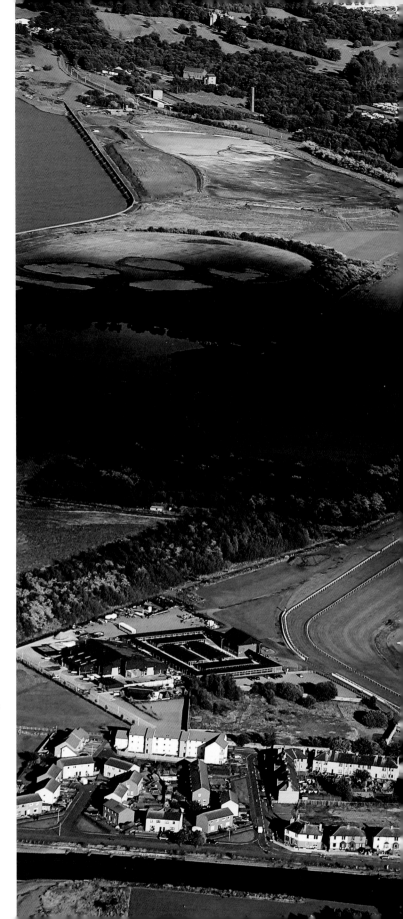

The Old Course

Musselburgh Links, East Lothian, Scotland

The game of golf's foundations were almost certainly laid in the face of unforgiving North Sea winds in East Lothian in the seventeenth century. Scotland may boast many famous aged courses but none can conclusively trace their history further back than the Old Course in Musselburgh.

Today an unprepossessing nine holes to the east of the River Esk and entirely surrounded by the town's racecourse, it was originally a mere seven holes but its relative lack of stature did not preclude it playing a central role in the game's development north of the border.

Legend has it that Mary Stuart, Queen of Scots, played golf in Musselburgh as early as 1567. The documentary evidence for the claim is sketchy, deriving from a charge made by the Earl of Moray that a less-than-grief-stricken Mary had ventured out into the town with her clubs only days after the grisly murder of her second husband Lord Darnley in Edinburgh, but it is unclear exactly where in Musselburgh she played.

There is, however, proof positive of the flight of balls on the Old Course in the early 1670s. The source is the account book of a prominent Edinburgh lawyer Sir John Foulis of Ravelston who kept extensive records of his golfing exploits, and on March 2, 1672, committed to paper the details of a round he had played with two friends. "Lost at Golfe at Musselboorgh," Sir John wrote, "with Gosford and Lyon etc... £3 5s 0d."

Foulis' account might yet have been lost to the dustbin of history had it not been for the efforts of a clergyman called John Kerr, who published a tome called *The Golf Book of East Lothian* in 1896 which included Sir John's writings. It may be an unremarkable diary entry but significant nonetheless because it is those few fleeting words which afforded Musselburgh the historical edge over other courses claiming to pre-date it and in 2009 Guinness World Records acknowledged the town as the proud site of the world's oldest course.

An eighth hole was added in 1838 and the ninth in 1870 and it was in the late nineteenth century

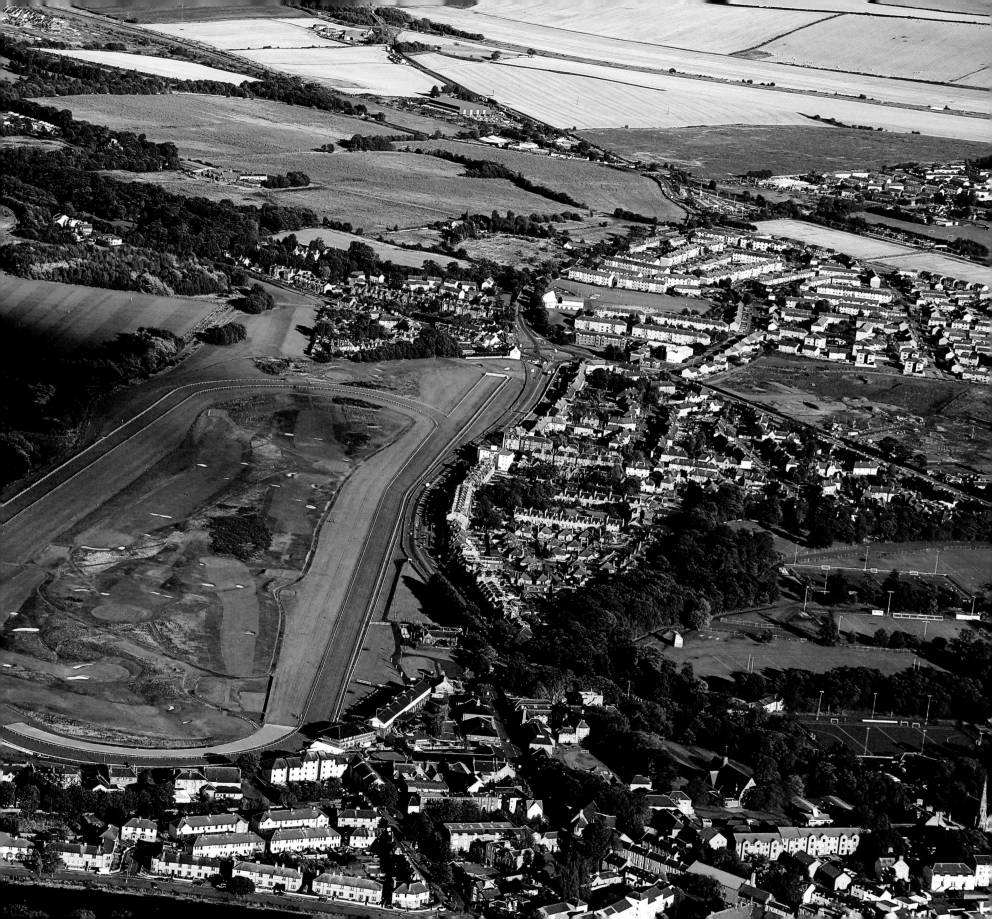

that the course enjoyed its heyday, hosting the Open six times in total before Muirfield was built 15 miles along the coast and Musselburgh was dropped from the Championship rota.

The town's first Open was in 1874 when Mungo Park Sr. shot 159 at the age of 38 to win the tournament for the only time in his career, while Musselburgh-born Willie Park Jr. was champion for a second time in 1889, the last time the Old Course was chosen as the host venue. Park's victorious total of 155 was the lowest Open score witnessed in the town.

The rich history of the Old Course does not end there. In 1829 the club commissioned local blacksmith Robert Gay to manufacture an implement for cutting holes on the greens and for the princely sum of one pound he produced a four-and-a-quarter inch diameter device. How many years of service the club enjoyed from Gay's cutter is unclear but in 1893 the Royal and Ancient adopted the Musselburgh man's dimensions as the standard size for all holes.

The course today is a par 34 and begins with 'The Short Hole' off the first tee towards an

elevated green. The second, a par four, features two hidden bunkers on the fairway and is dubbed 'The Graves', a nod to the legend that soldiers who were killed at the Battle of Pinkie in 1547, a catastrophic and bloody defeat for the local Scottish forces against the Duke of Somerset's English army, lie buried beneath.

BELOW LEFT: A stone plaque on the Musselburgh Old Course Golf Club building commemorates the five winners of the Open Championship held at the Old Course.

Musselburgh's only par five is the 457-yard seventh, known as 'The Bathing Coach', which exposes players to the perils of the town's ubiquitous coastal winds, while a round is completed after tackling the par four ninth, 'The Gas', which is protected by nine bunkers.

BELOW: The 'new' clubhouse sited just beyond the rails of the racecourse. Apart from its great lineage, Musselburgh also has the remarkable distinction of being a golf course sited within a racecourse where the golf course was there first.

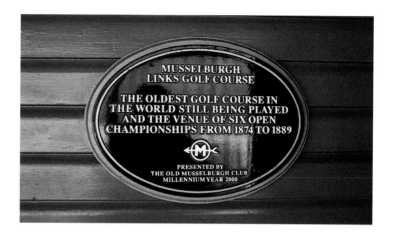

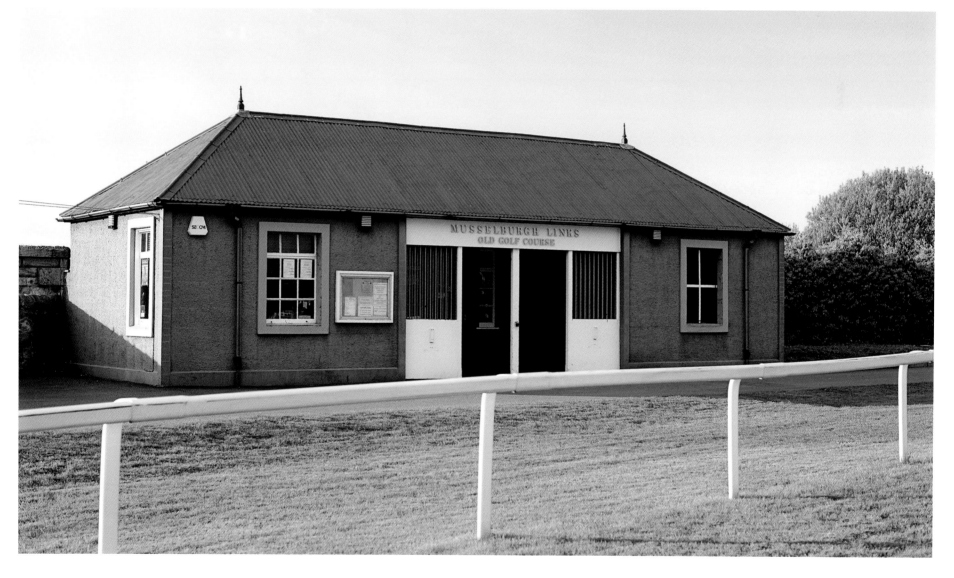

The Old Course

Royal Troon, Ayrshire, Scotland

Some nicknames attach themselves to their subjects straight away. Others take longer to stick, such is the case for Troon Old Course's world-renowned eighth hole, famed as the shortest hole anywhere on the Open Championship roster.

Today the eighth is affectionately known as the 'Postage Stamp' on account of its diminutive dimensions; the hole measures a mere 123 yards long while the green is a meagre 2,635 square feet. But while the nickname was first coined in 1922, it would be more than 30 years before that the title was recognised by the club.

Troon was founded in 1878 but the eighth was only built in 1909 and in its early days it was dubbed 'Ailsa' after the rocky island Ailsa Craig in the Firth of Clyde, which is visible from the elevated tee. In 1922, in readiness for the Open the following year, the hole's dreaded 'Coffin Bunker' was carved into the base of the sandhill that abuts the green and when sports writer William Park was in Scotland and espied the eighth's minute putting surface, he described it in his subsequent article for *Golf Illustrated* as "a pitching surface skimmed down to the size of a Postage Stamp".

The name quickly caught on among local players but the club's committee were reluctant to rename the hole and it was only in the 1950s that they finally relented and the 'Postage Stamp' was officially born. Since then the eighth's reputation has preceded it and the par three's proudest boast is that there really isn't a risk-free way to approach it. The tee shot from up on high is played over a gully to the narrow, minuscule green, but danger lurks on all sides in the shape of two bunkers on the left, the 'Coffin Bunker' at the front right, and two more bunkers with near vertical faces on the right.

The Stamp's list of victims reads like a *Who's Who* of Golf. When Greg Norman set the course record at Troon with a dazzling 64 in the 1989 Open, the only hole he bogeyed was the eighth, while Tiger Woods' Open debut in 1997 saw him tangle with the 'Postage Stamp' and emerge with a triple bogey six.

In the 2016 Open Jordan Spieth was condemned to a demoralising double bogey, while a hapless German amateur by the name of Hermann Tissies signed for a 15 in the 1950 Open. On a brighter note, the 71-year-old Gene Sarazen scored a hole in one during the 1973 Open Championship at the 'Postage Stamp', making him the oldest golfer to achieve that feat in a major.

ABOVE RIGHT: If the shot into the 'Postage Stamp' wasn't tricky enough already, players on the eighth tee have to contend with jets landing at nearby Prestwick Airport. Troon's Old Course and Prestwick Golf Club sit side by side on the Ayrshire coast

RIGHT: A view of the 422-yard ninth hole 'The Monk'.

OPPOSITE: The eighth hole 'Postage Stamp'. In a practice round for the 2016 Open, Rory McIlroy took six shots to get out of the hole's 'Coffin Bunker'.

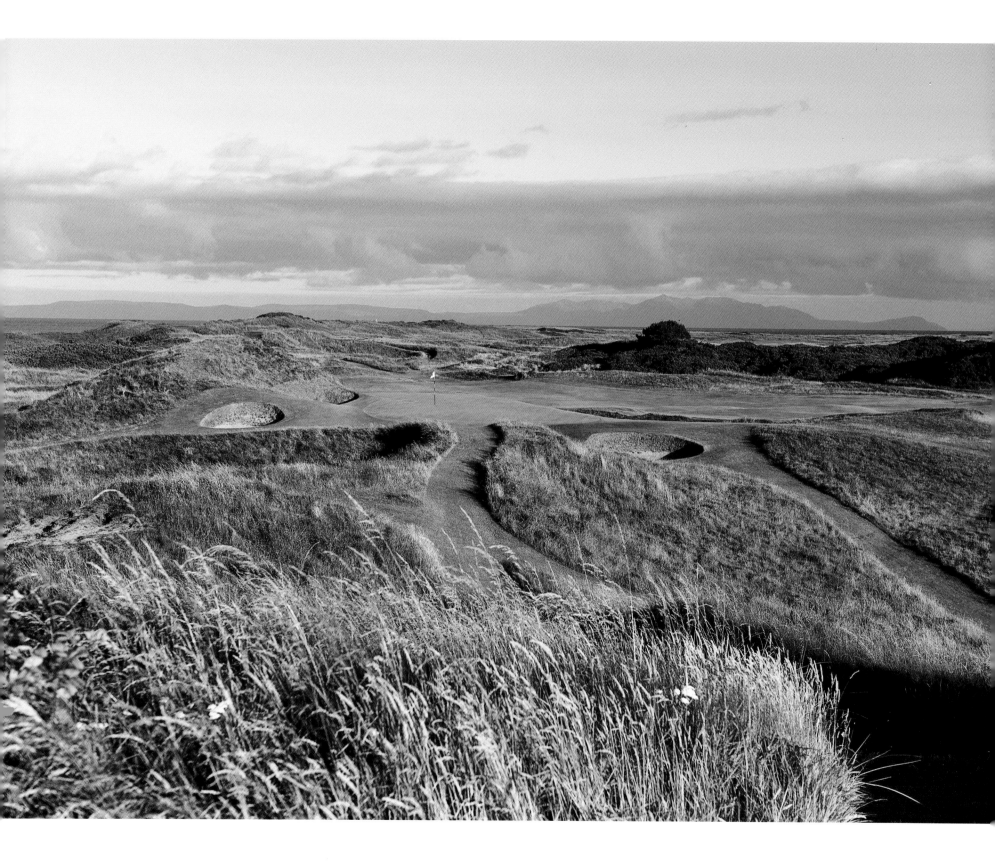

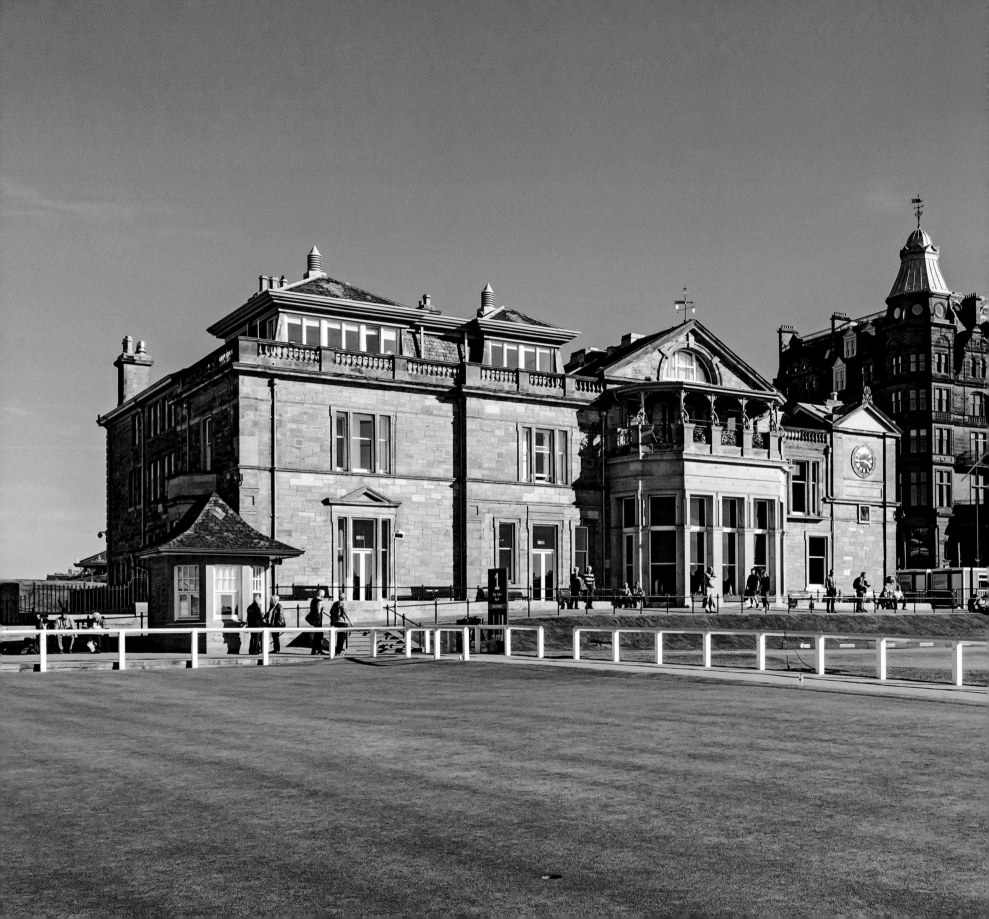

The Old Course

St Andrews, Fife, Scotland

There are records of a form of golf being played along St Andrews Bay as early as the fifteenth century but the early pioneers of the game were temporarily frustrated when King James II of Scotland banned the sport, reputedly wanting the young men of the country to focus on their archery skills rather than such frivolous, non-lethal pursuits.

King James IV reversed the edict and in 1552 the Archbishop of St Andrews granted the town's residents the right to once again play the links. In 1754 a group of the great and the good founded the Society of St Andrews Golfers, a precursor of the modern Royal and Ancient Golf Club of St Andrews.

By 1764 the Old Course had 22 holes but there was no formal ownership of the land. In 1797 the club was declared bankrupt and over the next two decades the links turf was shared by golfers and rabbit farmers. The arrangement was finally ended in 1821 when a local player by the name of James Cheape got out his chequebook and bought the site, thus securing the future of the Old Course.

The rest, as they say, is history. The course was subsequently modified by a series of architects over the years, including Old Tom Morris who fashioned the first and 18th holes. By the 1860s the course had been trimmed down to 18 holes, setting the template that all courses have since followed. In 1873 St Andrews hosted the Open for the first time, the start of an enduring relationship between the game's most famous course and its most revered tournament.

The Old Course today is as challenging as ever and the target remains, as it did centuries ago, to stay on the wide fairways and avoid the pot bunkers that lurk around the course unseen, and then find the hole on the expansive greens with their seemingly imperceptible contouring.

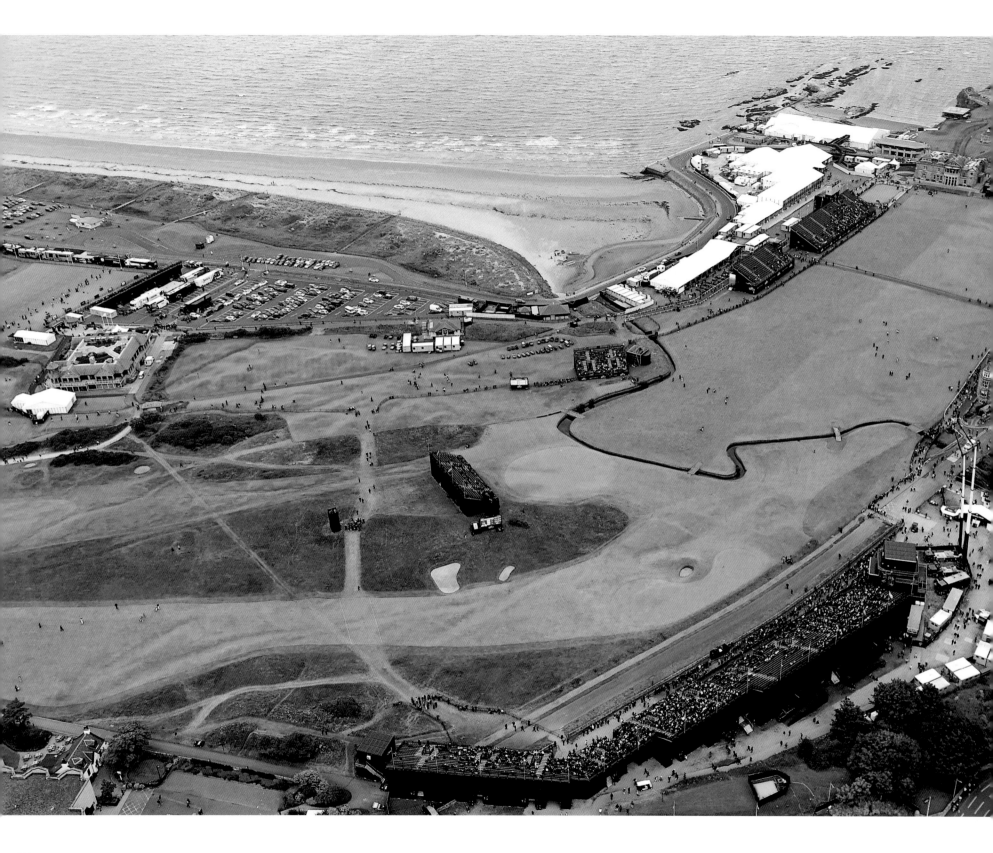

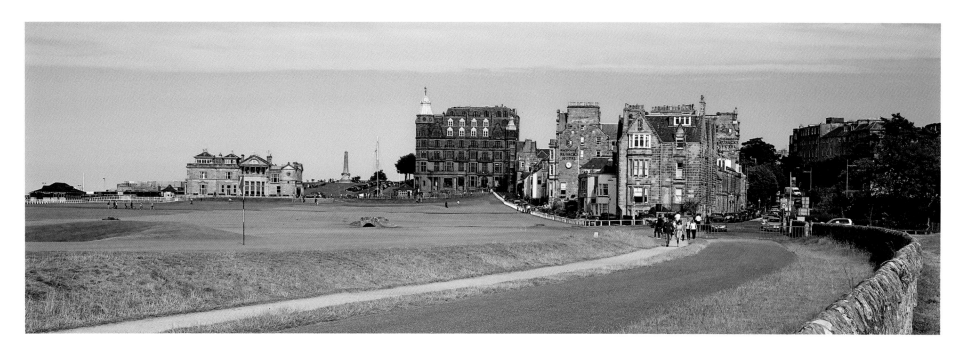

A rare feature of the Old Course is the large double greens shared between holes. Only the first, ninth, 17th and 18th have putting surfaces all of their own, with the 14 remaining holes serviced by seven greens between them, the second and the 16th sharing, the third and 15th, and so on.

Bunkers play a leading role in the Old Course's charm and considerable challenge and of the 112 sand traps which await the unwary the 'Hell' bunker on the par five 14th is one of the most feared, with a 10-foot drop at its deepest recess the punishment for an errant shot.

The 'Deacon Sime' bunker on the 16th is another noteworthy hazard and is named after a local preacher and keen, if limited, golfer who stated that on his death he should like his ashes to be

TOP: The road and wall behind the 17th 'Road Hole'.

RIGHT: Jack Nicklaus tees off on the 17th during a practice round for the 134th Open. In 2010 the tee was controversially moved back a further 40 yards to make it more challenging.

LEFT: An aerial view of the Swilken Burn crossing the first and 18th fairways.

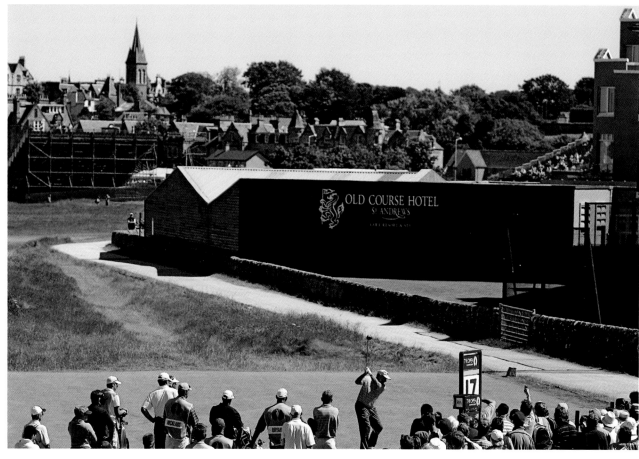

scattered amongst the sand, a fitting resting place, he reasoned, given that he had spent so much time in the bunker whilst alive.

The hole perceived by many as the most difficult on the Old Course is the par four 17th known as the 'Road Hole', even though on the stroke index it is rated five. At 455 yards from the long tees, it is not a monster by modern standards but disaster threatens from the start. There are no other tee shots in the majors that require players to aim their drive over a one-story hotel building, but the Old Course Hotel is the line at the 17th. The instinct is to play with draw to avoid the looming building but that invariably results in finding the rough. Approach shots need to avoid the dreaded 'Road Bunker' to the middle left of the green.

It's a hazard that might initially look innocuous to the untrained eye but the steep, greenside face is a tricky barrier which has defeated many championship ambitions and playing out sideways is often the only practical option.

Further danger lurks beyond the other side of the green, over the eponymous road, in the shape of a five-foot high stone wall. Many players who have found their ball too closely nestled against it, with no room to swing the club, have been reluctantly forced to attempt to bounce the ball against the wall and backwards towards the putting surface.

The list of the Old Course's familiar features, however, does not end with the 'Road Hole' and chief among them is the Swilken Bridge, the small stone construction that spans the Swilken Burn. Built over 700 years ago to help shepherds and their livestock over the water, the modest bridge is no more than 30 feet in length but it is probably golf's most widely recognised structure.

The Royal and Ancient still calls St Andrews home more than 250 years after its formation

and the club has played a pivotal role in the development of the rules of golf. In 1897 the club codified the laws of the game and was subsequently invited to control the running of tournaments beyond St Andrews.

The clubhouse of the Royal and Ancient sits proudly within the grounds of the St Andrews estate, an imposing building adjacent to the first

RIGHT: The 'Hell' bunker on the 14th hole. The hole has the stroke index 1 on the Old Course scorecard.

BELOW: One of the Old Course's vast double greens. The par three eighth hole shares its green with the par four 10th.

tee of the Old Course. Opened in the summer of 1854, the clubhouse has been augmented over the years to meet the changing demands of the membership but still provides an iconic backdrop to the photographs of the players who have lifted the Claret Jug at St Andrews over the years.

TOP LEFT: A seasonal view of golf's most iconic structure.

TOP: The 18th green is often the scene of fond farewells. Tom Watson hugs his caddie, son Michael, after his last round at an Open Championship in 2015.

LEFT: Shadows lengthen across the subtle contours of the 18th green as Eddie Pepperell of England, Raphael Jacquelin of France and David Hearn of Canada finish their second round of the 144th Open Championship in 2015.

Old Head Golf Links

Old Head Of Kinsale, County Cork, Republic of Ireland

A course of staggering natural beauty on the south-west coast of Ireland, the Old Head Golf Links is a sight to behold and were it not for the precarious sliver of land that connects it to the mainland, it would be buffeted by the Atlantic Ocean from all sides.

The distinctive headland was created by erosion of the relatively soft shale which sandwiches the sandstone at the heart of the remarkable 220-acre outcrop and the result is a unique golfing promontory which offers spectacular views out across the ocean and, on nine of the 18 holes, up to a 300-foot drop from clifftop fairways down to the rocks below.

Those natural hazards are millennia old but the Old Head Golf Links itself was born a mere two decades ago when property-developing brothers John and Patrick O'Connor decided to make their vision of a world-class course on the 'Wild Atlantic Way' a reality.

It cost the O'Connors north of £15 million to buy the land. Designers Ron Kirby and Paddy Merrigan were commissioned to shape the course and they were aided and abetted with advice from Irish golfing luminaries Liam Higgins, Eddie Hackett and Dr Joe Carr.

Experts warned that the project was unfeasible. They would, they were told, struggle to grow enough grass on the headland and the 220 acres was not enough space to accommodate 18 holes. Admittedly it took Kirby and his colleagues 54 potential routings before they settled on their final design but they persisted and in 1997 Old Head Golf Links opened for business.

LEFT: The 12th and 13th holes straddle the narrow promontory leading to the Head of Kinsale.

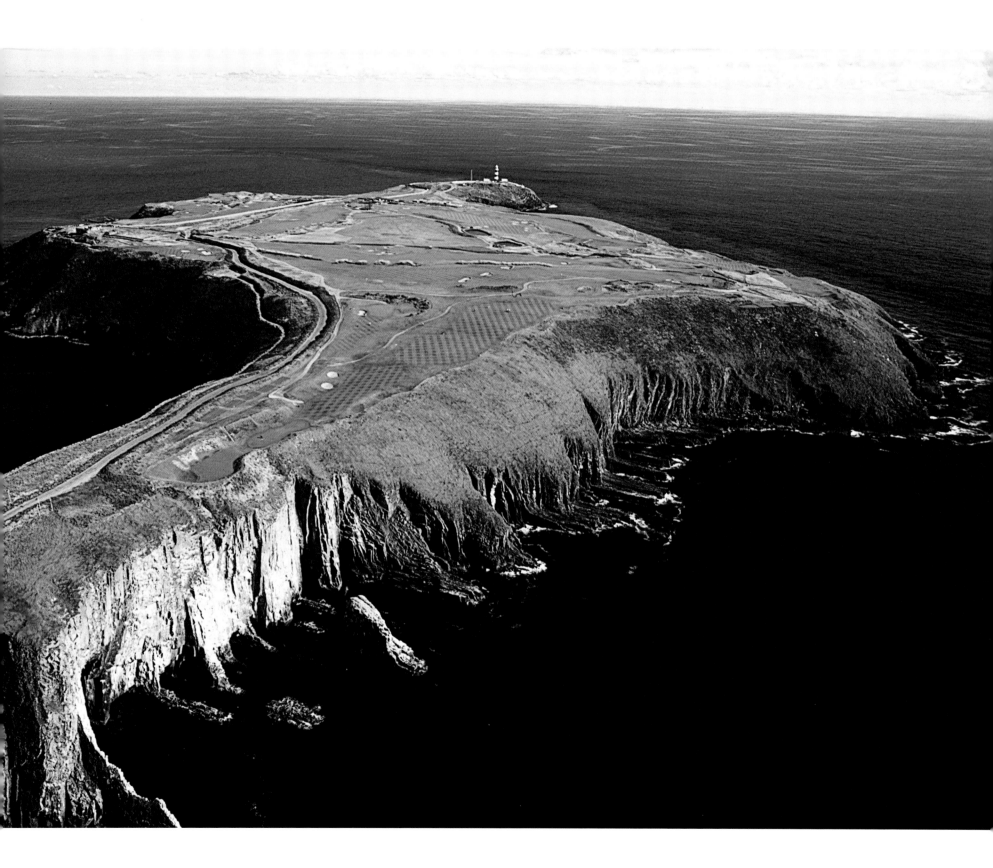

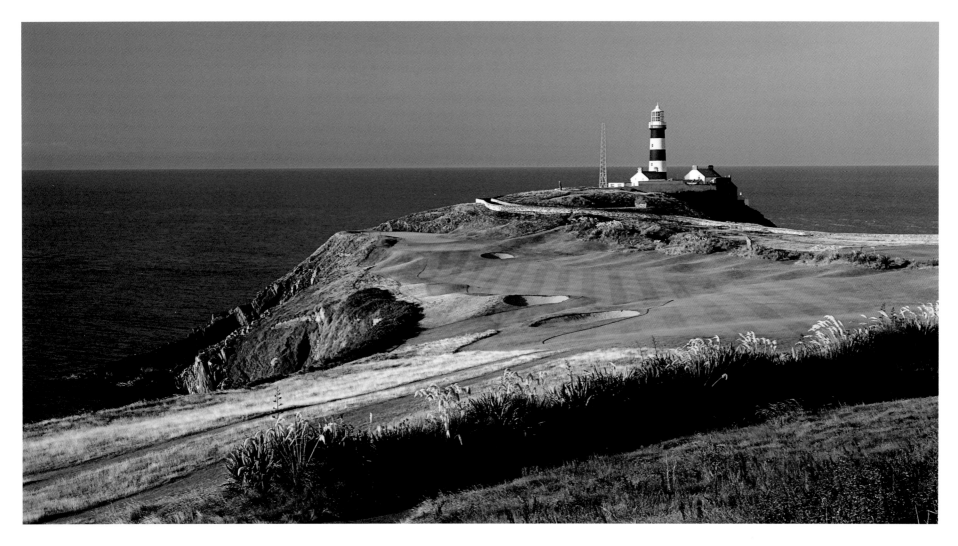

Its reputation has grown globally and three years after completion, Tiger Woods arrived to sample the delights of the par 72 course which plays 7,159 yards off the back tees. In 2012, former U.S. President Bill Clinton made the long journey across the pond to further Old Head's status as a destination venue.

The course's stunning coastal backdrop, however, comes at a price with the omnipresent salt spray and high winds plaguing the playing surface, while one particularly violent winter storm produced an epic wave which scaled the rocks and swept away the green on the par three 16th hole.

ABOVE: A view of the fourth hole stretching towards the Old Head of Kinsale Lighthouse.

RIGHT: An aerial view of the par four, second hole at The Old Head Golf Links .

OPPOSITE: Not surprisingly, the fourth green, closest to the lighthouse, is regularly exposed to a winter battering.

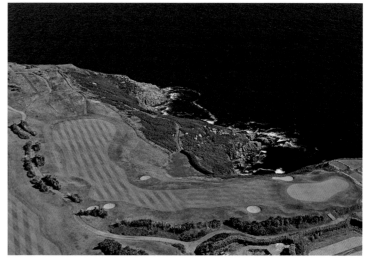

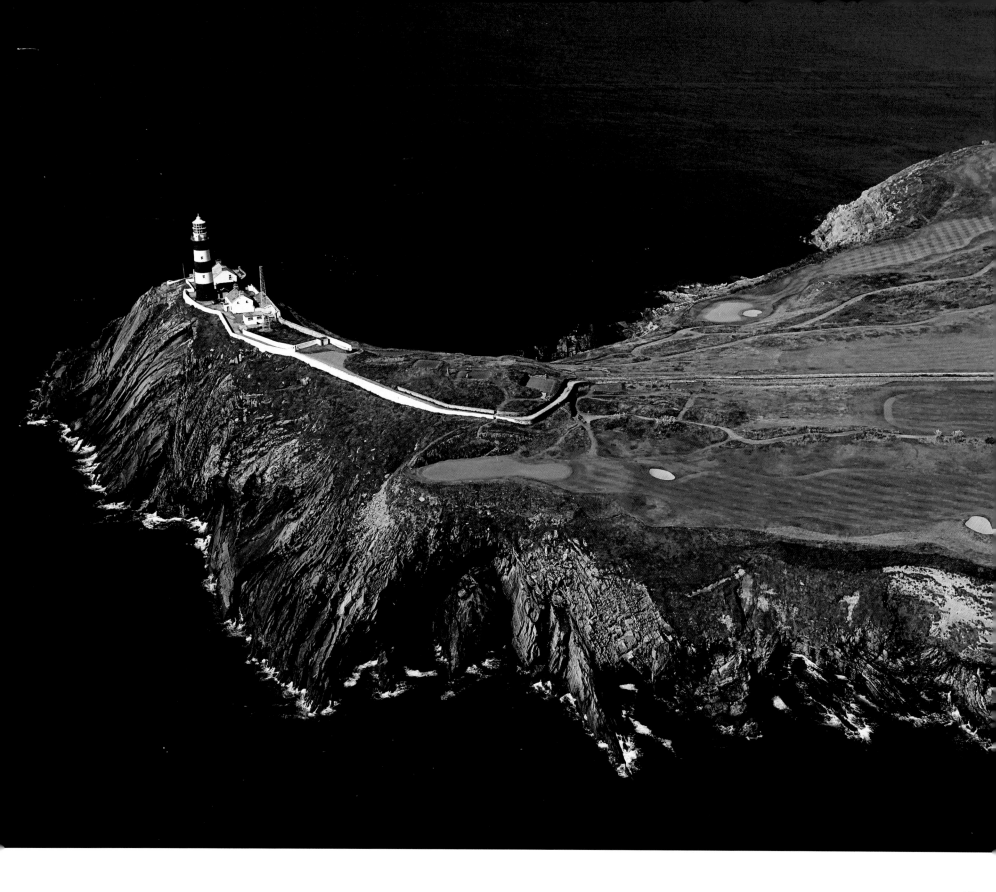

Painswick Golf Club

Gloucestershire, England

Painswick Golf Club in Gloucestershire occupies an elevated, ridge-top position commanding panoramic views of the Severn Valley, the Malvern Hills and Brecon Beacons. Founded in 1891 and designed by the 1886 Open champion, Scotsman David Brown, the club is not the longest. Even from the back tees, the 18 holes play well short of 5,000 yards for its par 67. But what Painswick lacks in length, it

more than makes up for in history. The course utilises ancient natural hazards rather than a host of artificial bunkers, and while it is lovingly maintained, it is not manicured to within an inch of its life due to the restrictions placed on the club by its location within a Site of Special Scientific Interest. The course's signature feature is its 3,000-year-old Bronze-Age hill fort, which encircles Painswick Beacon at the top of the

course. The surviving stone-and-earth ramparts come into play on the fifth, sixth, seventh, 10th and 11th holes. The par three fifth in particular makes good use of the ancient fortification, the mere 114 yards from tee to pin seemingly innocuous enough until the 70-foot rampart is taken into account. The 11th, too, makes use of the history of the site. The well which once watered the fort's original inhabitants is

now employed as a hazard to those who are wayward off the tee. Because the ancient gullies and earthworks cannot be altered thanks to its historic and SSSI status, walking the course at times is a bizarre experience. It is like someone has placed a traditional links course with all its undulations on the top of the Cotswolds (but forgotten the sand). Following the unique fifth hole is the rolling sixth, played from a high

tee right by Painswick Beacon. The great golf commentator Henry Longhurst described it as one of his favourite holes.

RIGHT: The view from the tee of the 114-yard par three fifth hole, 'Castle'. The line to the blind green is to the left of the tree furthest up the slope.

TOP: The panoramic view shows the fifth green nestled behind two Bronze-Age defensive ditches. The fifth tee is far right. The 11th green is visible just beyond the fifth green.

Pebble Beach Golf Links

California, USA

If imitation is indeed the sincerest form of flattery, it is safe to assume that Jack Neville and Douglas Grant were both big fans of Scotland and its abundance of coastal courses. The men who originally designed Pebble Beach in the late 1910s were American but what they crafted on the Californian shoreline was, for many, as close as Uncle Sam has ever come to successfully replicating a classic Scottish links.

Neville said of his creation. "Years before it was built, I could see this place as a golf links. Nature had intended it to be nothing else."

In terms of a true golfing marriage between fairway, green and ocean, it is unsurpassed. *Golf Digest* described it as "the greatest meeting of land and sea in American golf, with nine holes perched immediately above the crashing Pacific surf."

The course opened in February 1919. Neville and Grant had laid out the 18 holes in a figure of eight loop to ensure as many as possible unfolded along the coast and their architectural ingenuity ensured the course was an instant hit with the West Coast golfing fraternity.

Pebble Beach hosted its first major in 1972 when it staged the U.S. Open. In the final round Jack Nicklaus hit the flag from the tee on the spectacular par three 17th hole. His subsequent tap-in for birdie from four inches saw the Golden Bear crowned champion, the 11th of his 18 majors.

Ten years later the U.S. Open was back in town and once again Pebble Beach and the 17th was to become part of golf folklore when Tom Watson, who was tied with Nicklaus in the final round, famously chipped in from the rough to snatch the title.

The spot from which Watson holed out no longer exists, swept away as it was by a Pacific storm the following winter. The sea removed a significant part of the 17th green and the 18th tee, which required a new sea wall to be built and the new infill failed to replicate Watson's mound. Its abrupt disappearance a confirmation that Neville and Grant had pushed their course to the very edge of terra firma.

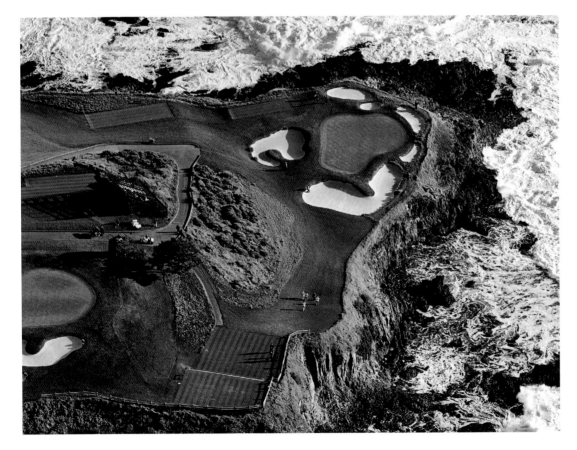

LEFT AND RIGHT: Two views of the more-than-a-bit-bracing par three seventh hole at Pebble Beach.

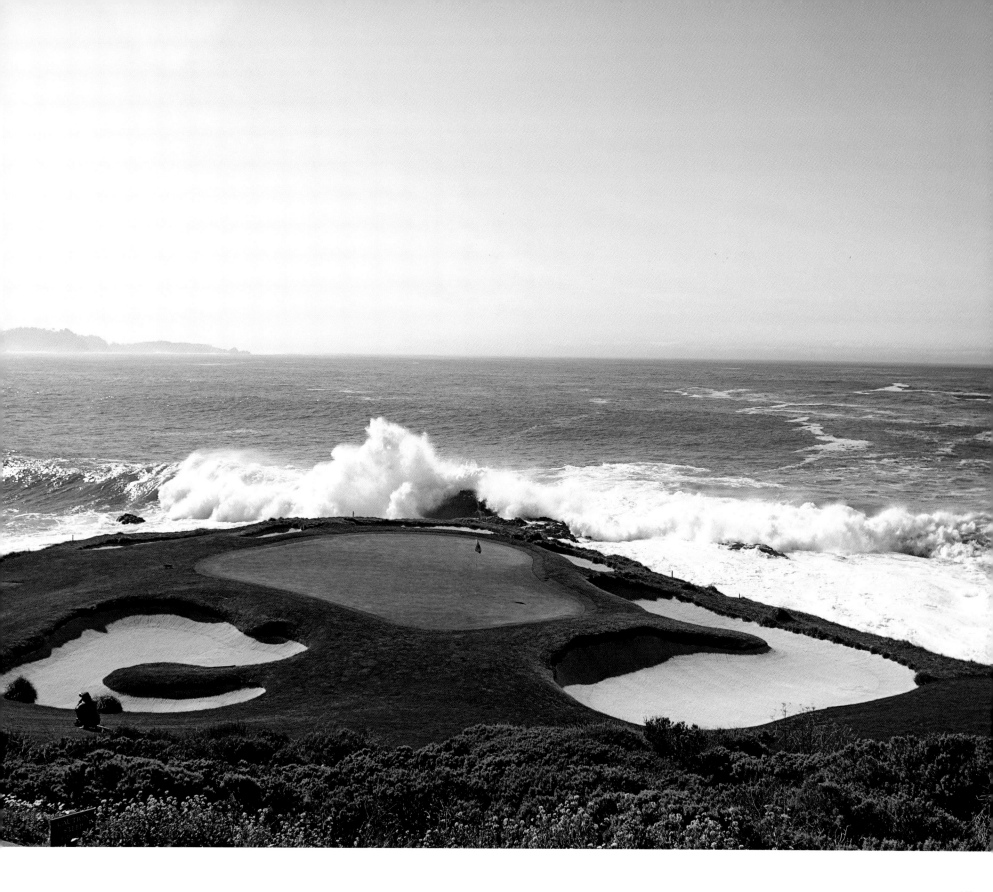

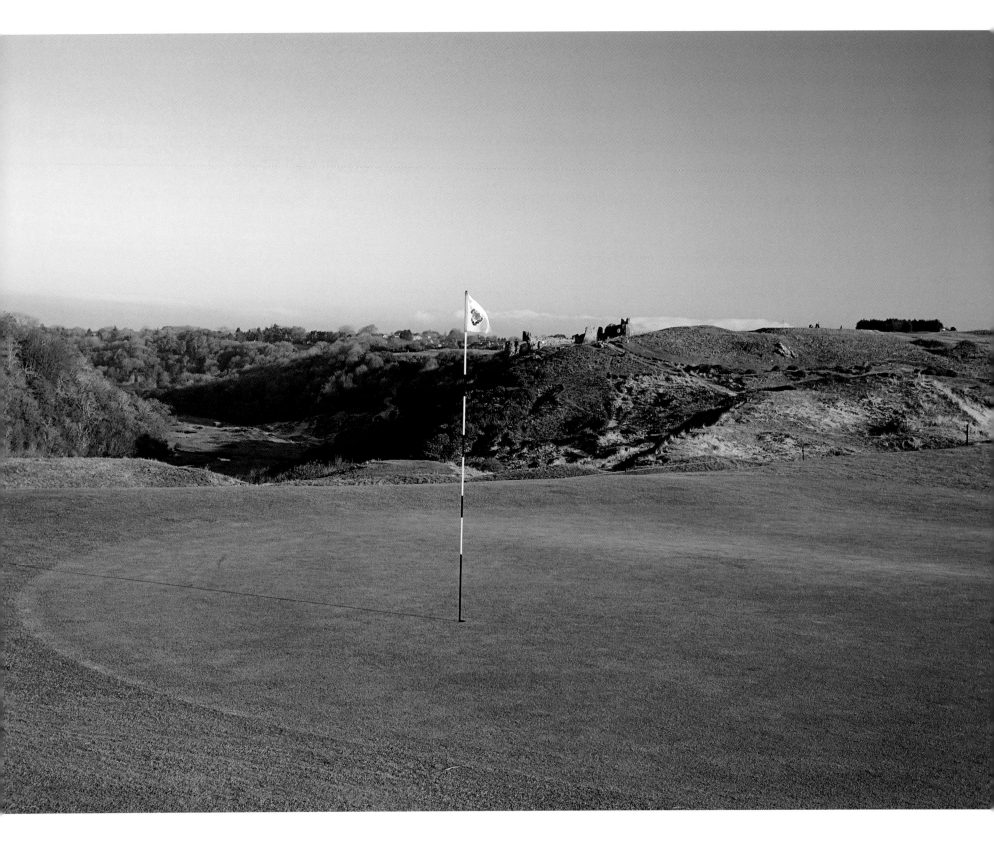

Pennard Golf Club

Swansea, Wales

Many golf courses in Britain are fringed by history, but Pennard in South Wales is one with its own Scheduled Ancient Monument. Pennard Castle was originally built in the twelfth century as part of the Norman conquest of Wales. Henry de Beaumont, Earl of Warwick, took control of the Gower peninsula and established his rule there. The wooden castle he built was gradually replaced by stone structures in the thirteenth and fourteenth centuries but by the late fourteenth century the ever-encroaching sand dunes had become so problematic that the owners abandoned the fortress after cracks started appearing in the outer walls. Its haunting (but stabilised) ruins now stand within the boundaries of the course.

The crumbling castle provides a rather spectacular addition to what is already a stunning links course by the coast, which can trace its own history back to 1896 when the owner of the Pennard Burrows agreed to lease his land to a group of locals to enjoy a spot of golf. In fact initial membership was limited to just 20 until the club was reconstituted in 1908.

It is a classic links course with undulating holes running through the sand dunes and natural hillocks and offering panoramic views over Three Cliffs Bay to Oxwich Bay. But what is not traditional is Pennard's elevated position 200 feet above the sea, earning the course the nickname 'The Links in the Sky'. Such height blesses Pennard's 18 holes with great drainage, meaning it is playable virtually all year round.

The front nine is a classic mix of challenging par threes and fours – the 543-yard fourth hole is the solitary par five heading out – while the back nine provides the more stunning views of the famed Gower coastline below. The 16th is the course's signature hole with the best vantage point to be found at Pennard but players are advised not to be seduced by the scene as the par five is unforgiving with its green exposed to the prevailing wind.

The course closes with the 17th, a second successive par five featuring a dangerous double dogleg, while the narrow fairway of the par four 18th must be successfully navigated before tackling its large, undulating green.

BELOW: The romantic ruins of Pennard Castle on the Gower Coast overlooking Three Cliffs Bay.

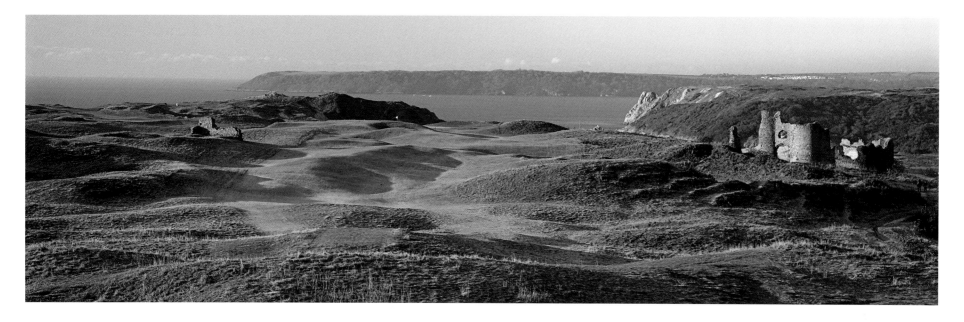

Pine Valley

New Jersey, USA

The overwhelming majority of the game's finest courses are the result of either the vision of one of golf's great architects or sited in superlative landscape, perfectly suited to become an outstanding golf course.

Pine Valley, however, is neither and while there is no disputing its modern status as a stunning challenge, the course's origins rather defied logic, both in terms of the identity of the man charged with its original design and the parcel of land selected for its location.

The architect in question was Philadelphia hotelier George Arthur Crump, who was approached by a group of golfers in the 1910s to lay out a track for them deep in the pinelands of southern New Jersey. Although he had toured Europe to study the continent's best courses, Crump had never designed his own track – Pine Valley would be his one and only, albeit incomplete creation – and he was chosen for the job primarily because he knew the area from hunting expeditions.

Crump's singular vision meant no hole was laid out parallel to the next and no two consecutive holes were to play in the same direction. He also stipulated that members should not be able to see any hole other than the one they were currently playing.

This all required a huge amount of work to make his design a reality and in an era where courses tended to work with the existing landscape,

Crump bucked the trend. The heavily wooded land was hardly an ideal location for a course and it required teams of steam winches along with horse-drawn cables to pull out some 22,000 tree stumps, while huge areas of marshland were drained at considerable expense.

The first 11 holes were unofficially opened in 1914. The project became an obsession for Crump who sold his hotel in Philadelphia to raise further funds, but when he died in 1918, the 12th, 13th, 14th and 15th holes were still incomplete. Little wonder that the course was known by some in the early days as 'Crump's Folly'.

Over the years, however, Crump's design has been modified and refined by others and despite its chaotic, unconventional inception, Pine Valley is today widely recognised as one of the finest but toughest tracks in the USA, every single hole demanding unswerving accuracy.

The list of accolades the course has accrued over the years is lengthy and in early 2017 Pine Valley's reputation was further bolstered when it was named by *Golf Digest* as America's greatest golf course.

RIGHT: Pine Valley is remarkable in many ways. George Crump's view was that a golf course should require a golfer to use every club in the bag. And it is comforting to the amateur golf designer in all of us that the course regularly voted the best in America was designed by neither an architect or a professional golfer.

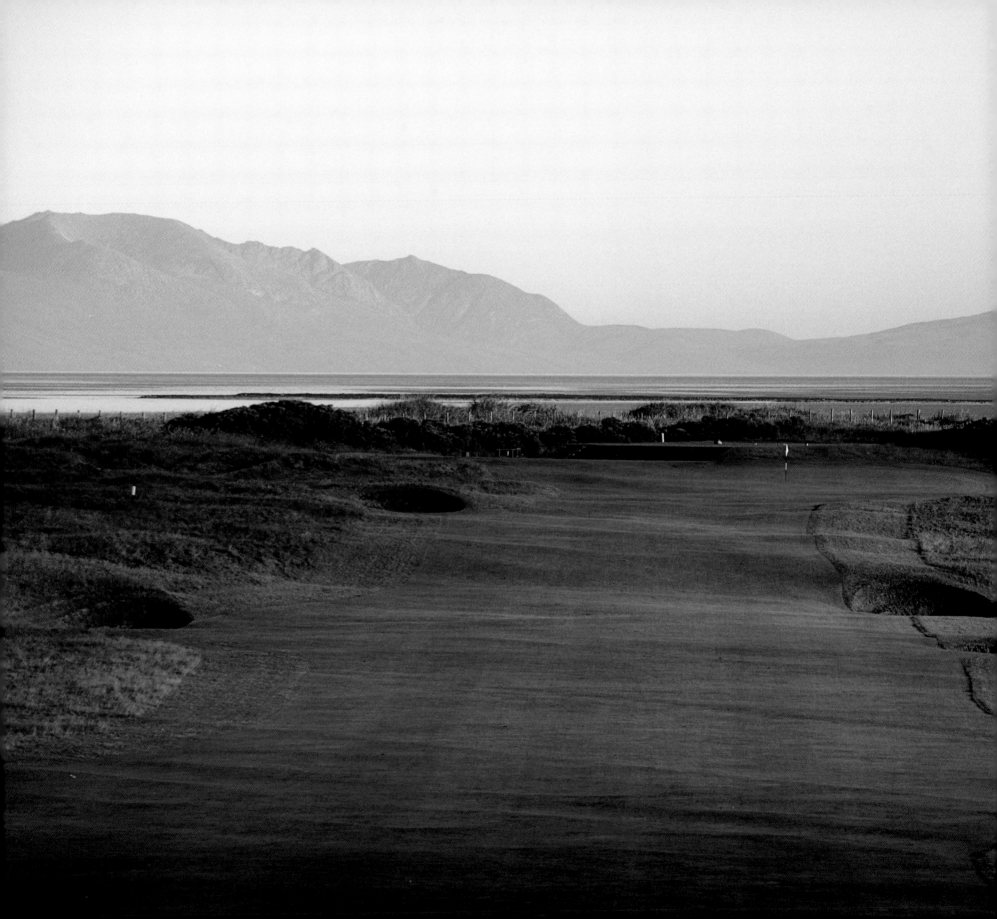

Prestwick Golf Club

Ayrshire, Scotland

Despite the spiritual home of golf being on Scotland's east coast, golf's first major was held on the west. The Open Championship story began back in the mid-nineteenth century in South Ayrshire, when the Prestwick club decided to organise a tournament to determine the identity of the best golfer in the land. It followed the death in 1859 of St Andrews professional Allan Robertson, who was considered the pre-eminent player of the era. Invitations were duly despatched to Blackheath, Perth, Edinburgh, Musselburgh and St Andrews to send their finest, and in October 1860 eight men convened at Prestwick to compete for a red leather Challenge Belt with a silver buckle.

The contenders played Prestwick's then 12-hole course three times in a single day to decide the champion and it was William Park Sr. who eventually emerged victorious, the first ever winner of the Open. Eleven further, consecutive Opens were staged at the club before rotation was adopted, the 1873 edition of the tournament heading east to St Andrews. The over-exuberance of the Prestwick crowd in 1925 meant that year's Open was the 24th and final time golf's greatest competition graced the club.

Prestwick's own story is not one exclusively linked to the Open. The club was founded nine full years before Park Sr. was crowned inaugural champion, with Old Tom Morris the first 'Keeper of the Green, Ball and Club Maker', and it grew from 12 to 18 holes in 1882. Today, six of the original dozen greens and three of the first holes: the second ('Alps'), the fourth ('Cardinal')

and the fifth ('Sea Headrig') have survived the passage of time.

Today's links is still intersected by the River Pow and features a series of large dunes, the tallest of which is Pow Hill, while the standout hole is the par five third, which is the stuff of golfing nightmares.

At 533 yards from the Championship tees, distance is not the issue, but the vast 'Cardinal Bunker', some 230 yards from the tee just before the fairway doglegs dramatically to the right, certainly is. Even if the yawning bunker is avoided, players still have to contend with the out-of-bounds river running to the right of the fairway all the way to the green and the series of hillocks which rise and fall right up to the front edge of the putting surface.

LEFT: The 453-yard 10th hole 'Arran' looking towards the rugged island of Arran beyond.

BELOW: Most of golf's history was made on the east coast of Scotland, but golf's first major belongs to the west.

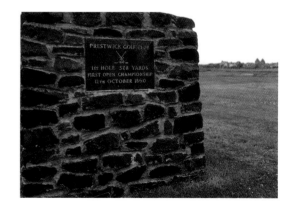

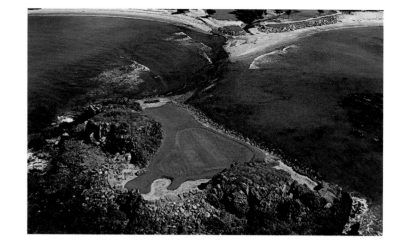

Punta Mita Pacifico Golf Course

Punta Mita, Nayarit, Mexico

The Pacifico is not the only course on the planet from which players can gaze out over the ocean and catch a glimpse of a migrating whale but it is one where the tail of the whale represents an enormous challenge.

The challenge in question is Punta Mita's curiously named hole, 3B. Unsurprisingly it follows 3A on the course map but that is the only vaguely conventional thing about the 194-yard, par three challenge whose green sits incongruously out in the Pacific Ocean on an outcrop of black lava rock. It is one of the few natural island greens in the world (The Himalayan Club can lay similar claim, although its natural island is in the middle of a river).

Nicknamed 'The Tail of the Whale' – both because of its distinctive shape and in recognition of the submerged leviathans that swim beneath the waters nearby – it was the brainchild of Jack Nicklaus, who designed all of the Pacifico's 19 holes ahead of its 1999 opening. Nicklaus has described 3B as the favourite hole he has designed.

Water is in play on the course on eight holes in total with five, including 'The Tail of the Whale',

skirting the Pacific. Two run alongside Banderas Bay and another, the 13th, is watched over by a lake. The course is one of two at the Four Seasons Resort on the Punta Mita Riviera and also offers spectacular views of the nearby Sierra Madre Mountains. The 200-acre site is dotted throughout with palms and flowering trees.

The yardage of the Pacifico is of course something of a moot point given that 'The Tail of the Whale' is not accessible if the ocean is in a particularly belligerent mood. On a calm day, tackling the full 19, it plays 7,014 yards while an 'abridged' round of 18 is officially measured by the club at 7,001 yards.

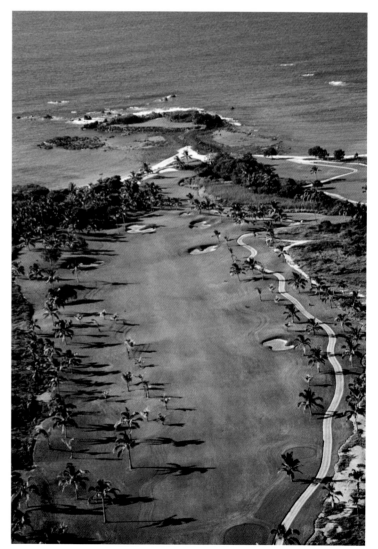

TOP: An aerial view of water lapping the causeway leading to 3B 'Tail of the Whale'. Jean Van de Velde could still get to it.

RIGHT: The much-photographed 3B is promoted as the 'largest natural island green in the world'. However there are serious contenders in Iceland and Nepal.

Real Club Valderrama

Sotogrande, Andalusia, Spain

Spain's golfing history is long and illustrious. Its oldest club, the Royal Las Palmas Golf Club, was founded back in 1891 and for more than a century the Iberian peninsula has produced some of the game's greatest players and courses.

Valderrama is perhaps the most prestigious of the latter and although it is relatively young, opened as recently as the 1970s, it holds the historic distinction as the first course outside England, Scotland or America to stage the Ryder Cup. The ground-breaking match took place in 1997 when Valderrama was selected to stage the 32nd edition of the famous Transatlantic tussle. Never before in its 70 previous years had the Ryder Cup ventured to mainland Europe and, with the world watching, southern Spain did not disappoint as Seve Ballesteros' Europe side emerged victorious by a single point.

Valderrama's rise to prominence began in 1975 with the construction of the original course designed by Robert Trent Jones Sr. The site also had to accommodate a new housing development and Jones' course, originally called 'Sotogrande New', was rather unsatisfactorily constrained as a result. A decade later a new owner, Jaime Ortiz-Patiño, was able to acquire more land in order to expand and elongate. Jones was recalled to finesse his first plans and the course which was to make Ryder Cup history was born.

Set in gently rolling parkland with a number of tight doglegs, Valderrama is famed for its profusion of cork trees. The ancient forest represents a significant hazard for all those who inadvertently stray from the fairway while, with the exception of the greens on the 15th and 17th holes, the putting surfaces are notoriously small and difficult to locate on approach.

The signature hole is the fourth, known as 'La Cascada', a par five which features a long, narrow fairway bordered by the ubiquitous cork trees. There is a large lake to the right of a two-tiered green and although it is just 516 metres (564 yards) long from the back tee, all but the best are happy to escape with par.

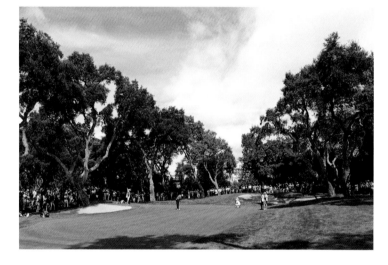

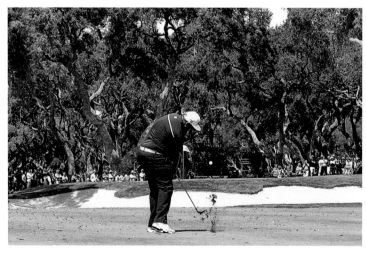

ABOVE RIGHT: Sergio Garcia putts out on the first green.

RIGHT: Andrew 'Beef' Johnston of England plays his second shot from the eighth fairway at the 2016 Open de Espana.

OPPOSITE: A wide view of the sixth green.

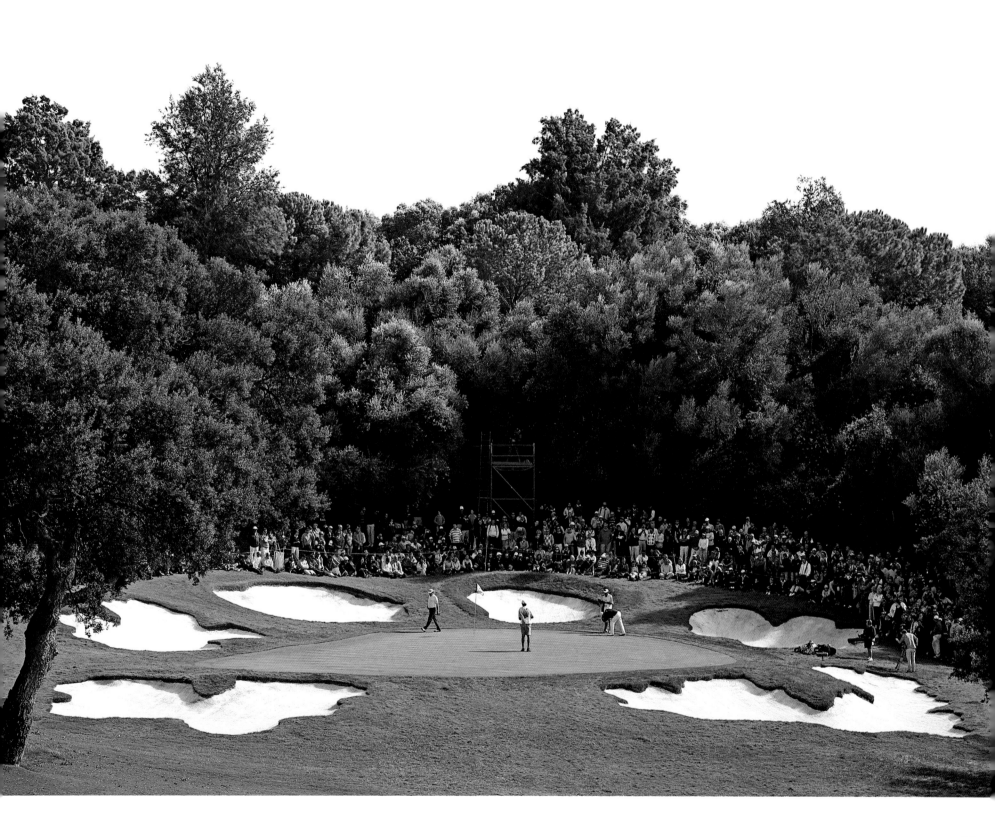

The Rise

Vernon, British Columbia, Canada

Canada has in excess of 30,000 sizeable lakes and it reflects the abundance of them that Okanagan Lake in British Columbia, a full 80 miles (130 kilometres) long, doesn't even make the Canadian Top 50 in terms of size.

Its northern tip does provide a stunning backdrop to The Rise which sits 1,000 feet above lakeside and with 12 of the club's 18 holes blessed with views of the water below, the course is a spectacular proposition.

Its elevated location is certainly striking and occasionally affords players the unusual experience of standing on a tee and being able to see below them in the distance planes taking off from and landing at the small airport at nearby Vernon.

Designed by 1992 Masters champion Fred Couples in conjunction with Gene Bates and opened in 2008, The Rise incorporates natural wetlands and indigenous Douglas firs over its 250-acre site and measures in at 6,843 yards from the long tees. Couples was given the honour of playing the first, ceremonial round of the course but the American struggled to tame his own creation, losing four balls. "We have a lot of hay out there to give to the farmers," he joked after hacking through the thick rough in a fruitless search for his errant shots.

The notoriously unforgiving Canadian winter means The Rise is a seasonal course with the club opening for business in May before closing its doors in mid October.

The course's best holes are to be found on the back nine and the par four 15th is regarded as The Rise's signature hole, the two longest tee boxes offer spectacular views of Vernon and the lake. Taking a driver is ill advised on the 415-yarder because water comes into play further down the fairway and those in the know play short from the tee and then attack the island green with a long second shot.

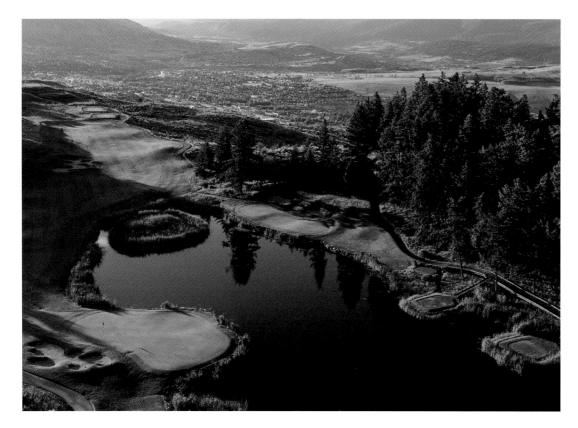

LEFT: The tee for the par four 15th hole is at top left with the green bottom left; while at right are two of the forward tees for the par three 16th, with the green in the centre of the photo.

RIGHT: The fourth hole comes in at under 300 yards and is one of the perfect vantage points to see the northern arm of Lake Okanagan.

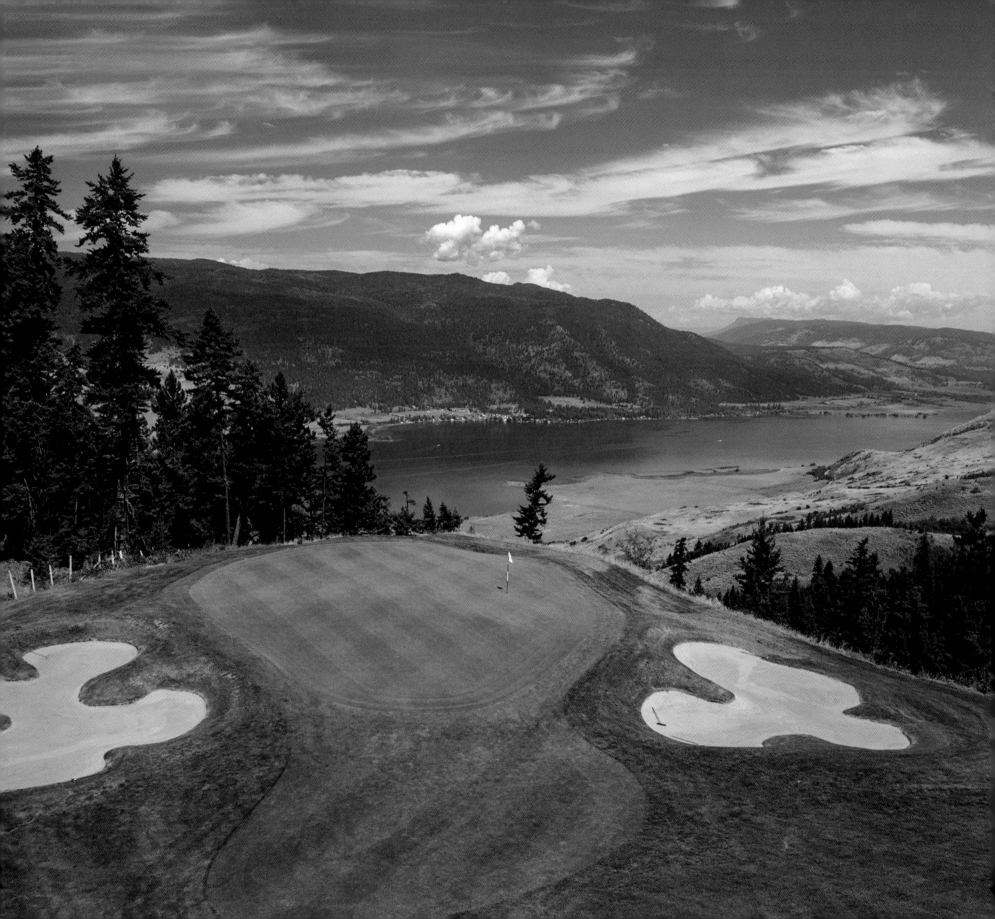

Royal Haagsche Golf and Country Club

The Hague, Netherlands

Royal Haagsche holds the distinction as the oldest club in the Netherlands, founded in 1893. According to a controversial 2002 paper by a German academic, Holland and not Scotland is the home of golf. A sports historian at Bonn University, Dr Heiner Gillmeister, claimed that the game derived its name from 'kolve', the Dutch for a shepherd's crook, and that golf was played in the Low Countries from the middle of the fifteenth century. If that is indeed the case, they took a long time to build their first permanent course.

The original course at the Hague is gone. It suffered extensive damage by bombing during the Second World War, leaving the club temporarily homeless. Fortunately for Royal Hague a Dutch businessman by the name of Daniel Wolf had commissioned Harry Colt to design for him his own private course in 1938. Wolf originally intended the new course to be his own exclusive retreat, but members of Royal Hague persuaded him to sell it to them in the 1940s and the club once again had a home.

The course has retained much of Colt and his design associate Charles Alison's imprint through the years, although 2008 did see Dutch designer Frank Pont commissioned to renovate all 18 of Royal Hague's greens that had been built on clay and were struggling to drain after 70 years in use.

The surprises of the course are twofold. Firstly, it is a full two miles from the North Sea yet features a sandy dune terrain typically associated with a true links track located right by the sea. Secondly, in a country world renowned for its flat topography, the whole course is remarkably undulating, making the Royal Hague an 18-hole geographical contradiction.

TOP: Sam Torrance of Scotland drives from the 13th tee during the Van Lanschot Senior Open in 2012.

RIGHT: Steve Van Vuuren of South Africa plays a recovery shot from near a gnome at the 2011 Van Lanschot Senior Open at Royal Haagsche Golf and Country Club. There was no sign of an accompanying windmill.

RIGHT: The unusual thatched clubhouse beyond the 18th green.

Royal Melbourne Golf Club

Black Rock, Melbourne, Victoria, Australia

Founded in 1891 and garnering its royal prefix four years later, Royal Melbourne boasts two 18-hole courses, known as 'West' and 'East', and is Australia's oldest extant golf club. Unlike many other multiple-course venues, however, where courses are distinct entities within a perceived pecking order, the twain does indeed meet in the form of Royal Melbourne's acclaimed 'Composite Course'.

Featuring 12 holes from the West Course and six from the East, the combined 18 was first played in 1959 when Royal Melbourne was chosen to stage the Canada Cup, latterly known as the World Cup, and the innovation was so successful that it has been in play for major tournaments in Melbourne ever since.

The selection of holes constituting the Composite Course has changed slightly over the years – 21 in total have made the cut – but the amalgamation of the best of the West and East have to offer has proved enduringly popular.

Royal Melbourne is renowned for both the speed of its greens and the intricate shape and size of its myriad of bunkers. The West Course is the slightly longer of the two courses from the back tees at 6,077 metres (6,645 yards) against 6,007 metres (6,569 yards) and is a par 71 compared to 72 for the East Course.

The sand traps on both courses are infinitely eye-catching. The most ornate on West is the bunkering on the par three fifth, five separate curved hazards jostling around the green, while the par three 16th on East is equally arresting with no less than seven distinct bunkers surrounding the putting surface.

The club began life in the early 1890s on a site near the city centre but by the mid 1920s the increasing urbanisation of Melbourne and encroaching building work prompted members to consider relocating. A plot on the Melbourne Sandbelt south of the city was identified and by the end of the decade the club had moved to its new home. Designed by Englishman Alister Mackenzie, the West Course was opened for play in 1931, while the East was laid out by Alex Russell, a former winner of the Australian Open, the following year.

BELOW: The 18th hole on the East Course at Royal Melbourne Golf Club, which also plays as the 18th hole on the tournament Composite Course.

Royal North Devon Golf Club,

Westward Ho! Devon, England

The honour of the title of the oldest course established in England belongs to the Royal North Devon club, a links which dates back to 1864. There are grander, more refined courses in the country but none with such a long and rich history. It started out in life as The Burrows of Northam, 18 named holes that could be played as a round of 17 or 22 holes. The Reverend Isaac H. Gosset, Vicar of Northam, was so enthused about the suitability of the area for golf that he invited Old Tom Morris for a month's visit in 1860 to advise on laying out a new course. His 1864 course largely survives today.

As befits a links course, Royal North Devon is littered with its fair share of bunkers and none are more intimidating than the wooden escarpment that Old Tom created on the fairway of the 349-yard, par four fourth hole. Dubbed the 'Cape Bunker', it's a monstrously wide and deep prospect as players look out apprehensively from the tee, needing to drive 170 yards in the direction of a helpful arrow to avoid the hazard. In the era of pot bunkers on links courses it was reputedly the largest bunker in the world.

Located on common land between the villages of Northam and Westward Ho! (as the club is sometimes known), the course boasts spectacular views over Bideford Bay. It was granted its royal prefix by the Prince of Wales in 1867 – the first outside Scotland to receive the honour - and hosted The Amateur Championship in 1912, 1925 and 1931.

Many of the game's early pioneers played at Royal North Devon and the greatest of them was John Henry (J. H.) Taylor, born in nearby Northam, who began his career as a caddie and labourer. He turned professional as a teenager in 1890 and famously went on to win five Open Championships. He was named Club President in 1957, his portrait still hangs in the clubhouse today.

RIGHT: The green of the par four sixth hole stands out as an island of 'flat' in a sea of highly contoured fairways.

LEFT: The monster 'Cape Bunker' needs to be cleared by a drive on the fourth hole. The view here is looking over the 16th green. The tee for the fourth is to the left of photo.

RTJ Golf Club

Gainesville, Virginia, USA

Robert Trent Jones Sr. designed or redesigned more than 500 courses during his glittering career but none, in his own opinion, could rival the 18 holes he created by the shores of Lake Manassas in Virginia, which opened in 1991.

The revered Anglo-American designer identified the parcel of land 30 miles outside Washington, D.C. on which his course now sits by accident, flying over the area en route to conduct an aerial survey for a separate project. But he was immediately struck by the "aesthetically perfect" terrain and determined to lay out a course by the side of the 770-acre reservoir. The result is a stunning par 72 course which plays 7,425 yards from the long tees and one on which, surprisingly given its lakeside setting, a succession of sand traps rather than water are the principal hazard to the unsuspecting golfer.

The RTJ's reputation as one of the USA's elite tracks was cemented in 1994 when it was selected to host the inaugural Presidents Cup match between America and the Rest of the World, minus Europe, and it has staged the tournament three subsequent times, most recently in 2005.

Two holes – the ninth and 11th – vie for the title as the RTJ's signature hole. The ninth is a 200-yard par three from the back of the tee towards an ominously narrow putting surface and danger

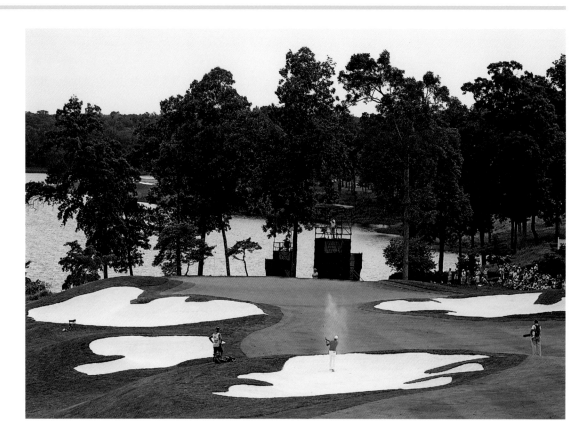

lurks twice to the left of the green first in the shape of a large, ornate bunker and then water further back.

The 11th is also a par three featuring a green on a peninsula. At 215 yards, it's slightly longer than its rival (and arguably prettier) and players must be wary of the steep slope that fronts the putting

surface and threatens to send balls that come up short mercilessly towards the water of Lake Manassas.

ABOVE: Rickie Fowler hits from a sand trap at the 10th hole during the Quicken Loans National at RTJ in 2015.

RIGHT: The tricky, roll-friendly 11th hole.

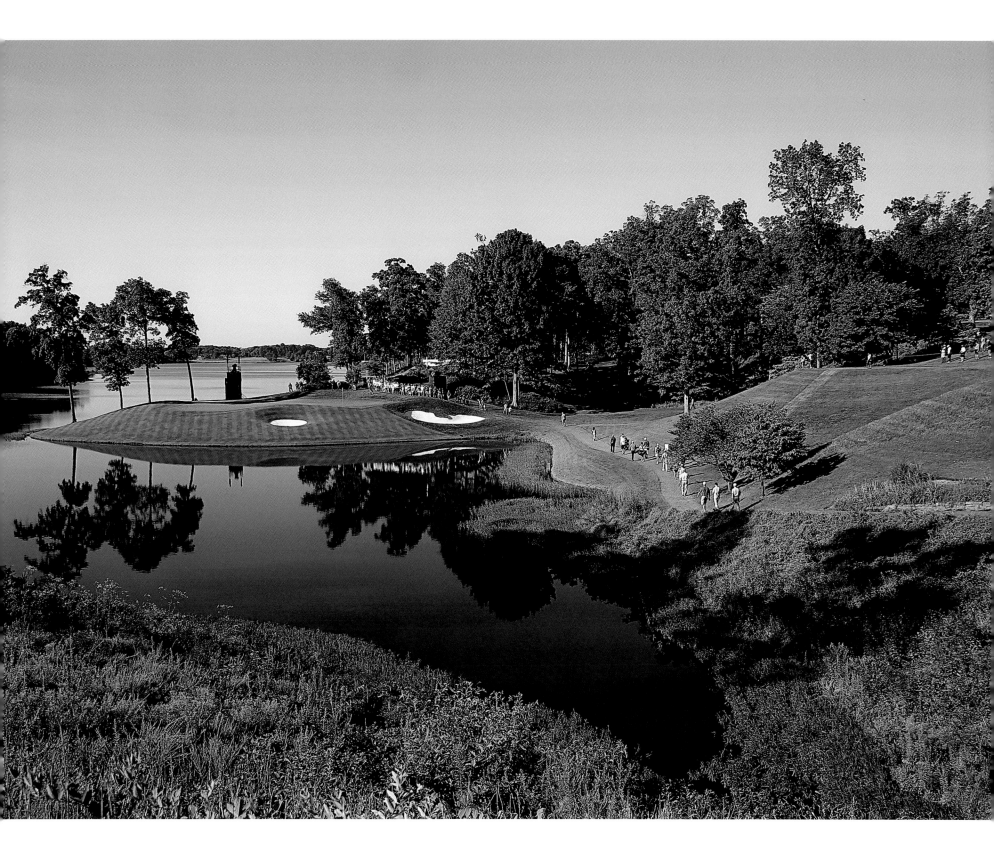

Rye Golf Club

East Sussex, England

The master craftsman of tomorrow is today's apprentice. All leading practitioners of their profession must hone their skills and for Harry Colt, widely regarded as the greatest English course designer, it was at Rye that he first cut his teeth.

Colt would work on over 300 courses during his career, 115 of them solo projects. He was but a 25-year-old solicitor in 1895 when he was elected as captain of the newly-founded Rye Golf Club in East Sussex and asked to lay out 18 holes for the members. It was a request which changed the course of his life.

His first canvas was the Camber Sands dunes and Colt produced a course which made full use of the natural coastal terrain. It was an immediate success. By the end of the nineteenth century the membership exceeded 250, including the Prime Minister, A. J. Balfour, while in 1906 the famous golf writer Bernard Darwin succeeded Colt as club captain. "Surely there can nowhere be anything appreciably better than the golf to be had at this truly divine spot," he wrote of Colt's creation in his 1910 book, *The Golf Courses of the British Isles*.

The course underwent alterations in 1932 and again six years later without sacrificing Colt's

original vision, but it was during the Second World War that Rye acquired some rather striking additions to the site which endure today in the shape of the concrete pillboxes constructed on the front nine in anticipation of an imminent German invasion.

Rye's long-standing reputation as one of England's finest clubs has been enhanced over the years with the staging of the President's Putter tournament, an annual event which sees current and former golf Blues from Oxford and Cambridge Universities do battle by the sea.

First held in 1920, the Varsity match is a scratch matchplay format and takes its name from the tradition that the victorious player exchanges the ball with which they make their winning putt for a silver medal. This ball is then attached by a silver band and chain to the eponymous President's Putter to commemorate their triumph. After almost a century of competition there are a trio of putters bedecked with balls in existence, all three of which are now on display in the Rye clubhouse.

RIGHT: Three President's Putters are displayed in a cabinet in the Rye clubhouse. The influential English golfer Henry Cotton was once an assistant professional at the club.

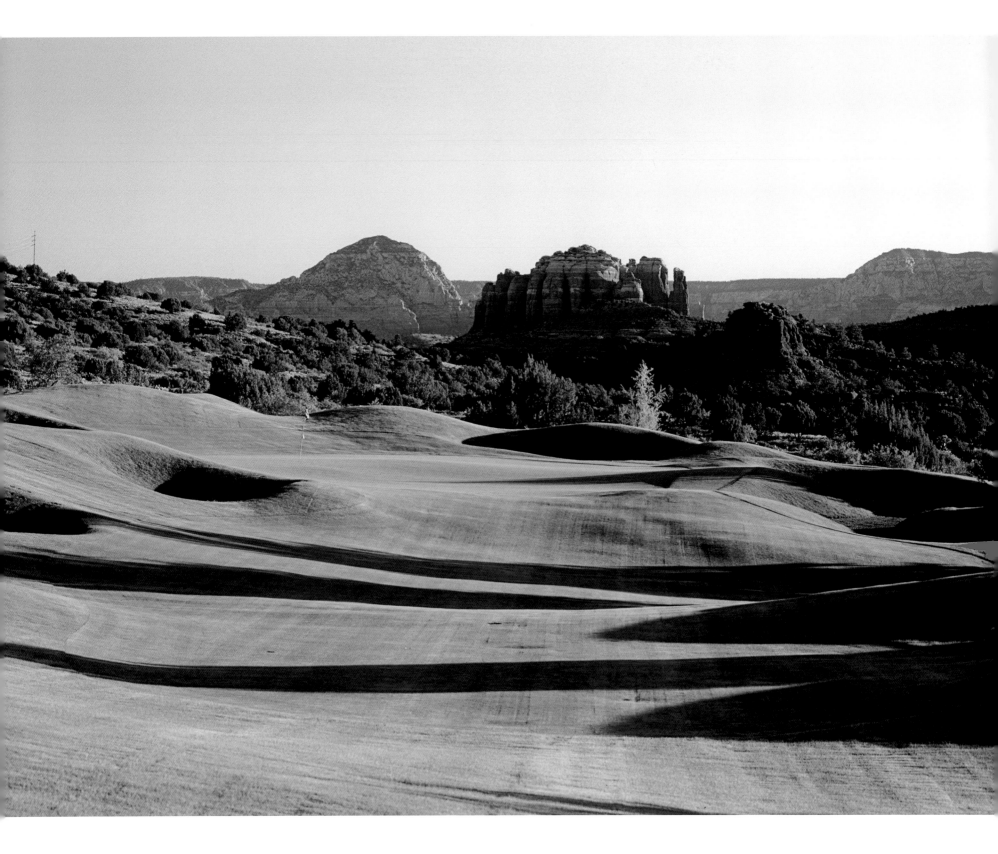

Sedona Golf Resort

Arizona, USA

Even the most mild-mannered player has on occasion seen red out on the golf course, but with the epic landscape surrounding Sedona Golf Resort, and its neighbour Seven Canyons, it's inescapable.

For those playing Sedona red is not the colour of anger but rather the haunting hue of the famous sandstone formations that encircle the course, enhanced by the rising or setting sun hitting the imposing rock to create incredible scenes of reflected light. Players have been enjoying the majestic sight of the red rocks in the early morning or late evenings since the course opened in 1988 but the Sedona Golf Resort course is much more than a natural wonder and it is ill advised to stare too long at the sandstone spectacle if you want to make par.

Measuring 6,646 yards from the back tees, the par 71 track is a stern challenge as it winds through junipers, water features with elevation changes starting at 4,050 feet but rising in parts to over 4,300 feet. It features an unusual front and back nine layout with three par fives on the way out and just one on the way home.

The monster 623-yard fifth is a number one handicap examination of power and accuracy with a fairway that is as narrow as it is straight. The front nine concludes with another par five which doglegs to the right and climaxes with the smallest green of the whole course.

The back nine is no less entertaining and water comes into play for the first time on the par four 13th with a lake nestled to the left of the latter portions of the fairway and the front of the green. There's water again on the right of the 16th fairway, but the wet stuff is really in evidence on the 17th and 18th holes. The penultimate hole is a par three, a mere 155 yards from the long tees, but its green is protected by a long, ravenous bunker at the front right, a preferable fate than the water that lurks expansively further right.

The closer is a par four and while the tee shot is relatively routine, the second shot is all about staying straight and an impromptu hook will see the ball fly inexorably towards the water at the front left of the green.

OPPOSITE: The 10th hole at the Sedona Golf Resort. The course was designed by Gary Panks.

BELOW: The 12th hole at the nearby Seven Canyons Golf Club in Sedona, which shares the stunning sandstone backdrop.

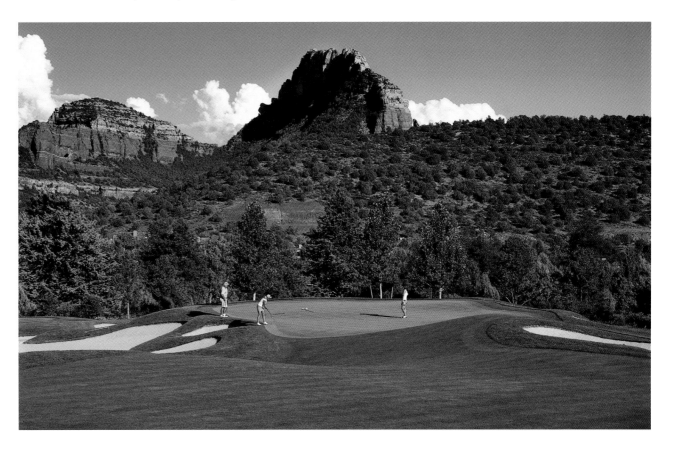

The Severiano Ballesteros Course

Golf Club Crans-sur-Sierre, Valais, Switzerland

There are golf courses all over the world which bear the names of famous players. In the case of the Severiano Ballesteros Course, perched high in the Swiss Alps and overlooked by the Matterhorn and Mount Blanc, the connection goes far beyond a mere design credit.

The late, great Spaniard did indeed help reconfigure Crans-sur-Sierre in the 1990s. He also conquered its 18 Alpine holes on three separate occasions to win the coveted European Masters in the 70s and 80s, but the great entertainer's real legacy on the scenic course was established in 1993 when he produced a trademark moment of magic after his ball landed behind an eight-foot high concrete wall which hid, of all things, a swimming pool. The Spaniard's almost impossible recovery shot is now commemorated by a metal plaque mounted on a large stone from the unassuming and obscure spot where his ball landed. Two years later Seve was called in to redesign the course, while in 2002 the club decided to honour the Spaniard by naming the course after him.

The history of the club dates back more than a century to 1906 when the original 18 holes were laid down. The outbreak of the First World War saw the course temporarily abandoned, but it was revived in 1924 and its burgeoning reputation as one of Europe's finest courses was cemented in 1939 when it staged the European Masters, a competition which still makes its way to the Swiss Alps in September each year.

The course's elevated location, some 5,000 feet above sea level, affords players spectacular views with the seventh hole widely regarded as the most panoramic on the course. A short walk through pine trees from the sixth green briefly hides the vista to follow, but once out of the woodland, the par four, 303-metre (331 yards) hole dramatically unfolds with mountain tops behind the tee and a plunging valley to the right. The green is no less breathtaking with uninterrupted views across to the 'Weisshorn' (or White Mountain), the fourth highest peak in the Alps.

LEFT: Seve hit a pitching wedge almost vertically through a small gap between the wall and the trees onto the apron of the green and then chipped in for a birdie.

OPPOSITE: Michael Hoey of Northern Ireland plays a shot during the second round of the Omega European Masters at Crans-sur-Sierre Golf Club in Crans-Montana, Switzerland.

ABOVE: Edoardo Molinari of Italy escapes out of a bunker with the Alps as a backdrop.

LEFT: In 2016 Omega Watches sponsored a hickory challenge at Crans-sur-Sierre. Lee Westwood, Danny Willett, and Miguel Angel Jimenez donned period costume and toted their own small canvas golf bags full of hickory-shafted clubs. Westwood claimed the title and the 'Turn Back Time' cowbell after beating fellow Englishman Willett in a chip-off. That cowbell's certainly going to jostle for pride of place in the Westwood trophy cabinet.

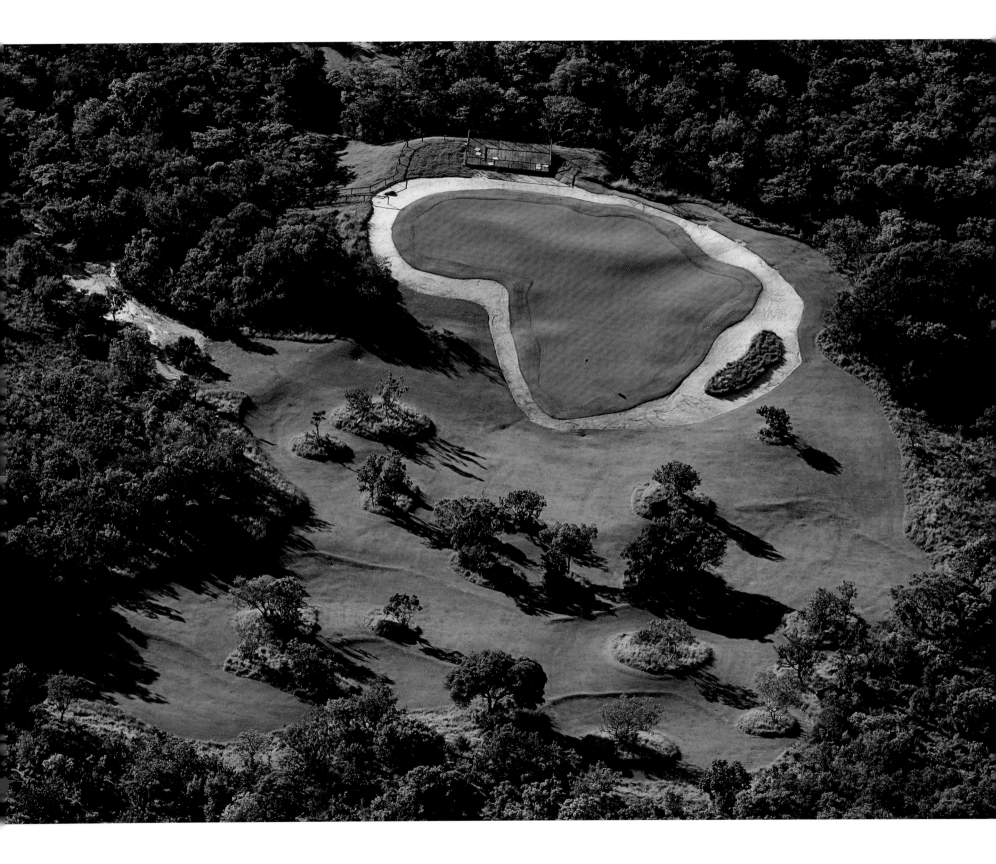

Signature Course

Legend Golf & Safari Resort, Lympopo, Sterkrivier, South Africa

Courses designed by current and former professional players are an increasingly common occurrence in golf. The association with one of the game's leading lights is good for business and lends a new course a potentially lucrative sense of credibility.

A celebrity endorsement was very much at the forefront of the thinking when plans were being drawn up for the Legend Golf & Safari Resort within Big Five Entabeni Safari Conservancy but they decided that one big name on the marketing material just wasn't enough. The ambitious resort wanted rather more.

The result is the Signature Course, opened in 2009, which has 18 holes each individually designed by a different golfing luminary and made a reality amongst the open grasslands and dense bush that sit in the shadows of the Waterberg Mountains.

The first hole, for example, is the work of South Africa's own Trevor Immelman, while the first par three of the course, the fourth, was created by Bernhard Langer. The sixth is the vision of Scotland's Colin Montgomerie, while former Masters champion Ian Woosnam came up with the 12th hole. The Signature Course concludes with a 494-yard, par five which was designed by another South African, Retief Goosen. Former major winners Jim Furyk, Justin Rose and Vijay Singh were also involved in the project.

The combined golfing wisdom of 18 of the sport's greatest players undoubtedly makes for a top-class course but the Legend Golf & Safari Resort has another, giddying trick up its sleeve which has allowed it to claim a place in the game's record books.

The feature in question is known as the 'Extreme 19th' and the optional, additional hole is worthy of its title, nestled as it is some 1,300 feet high up on Hanglip Mountain. The tee of the sublime par three is only accessible by a short flight in the resort's own helicopter and it is only once players have disembarked that the scale of the 19th hole's considerable challenge becomes apparent. The green, sculpted in the shape of the African continent, is a full 631 metres (690 yards) away, making it the longest par three by some margin. The vertigo-inducing drop of 400 metres (437 yards) down to the putting surface

LEFT: The tee of the extreme 19th hole looking down on the green below. The pin is in the tricky Zimbabwe position. Note: Mozambique not to scale.

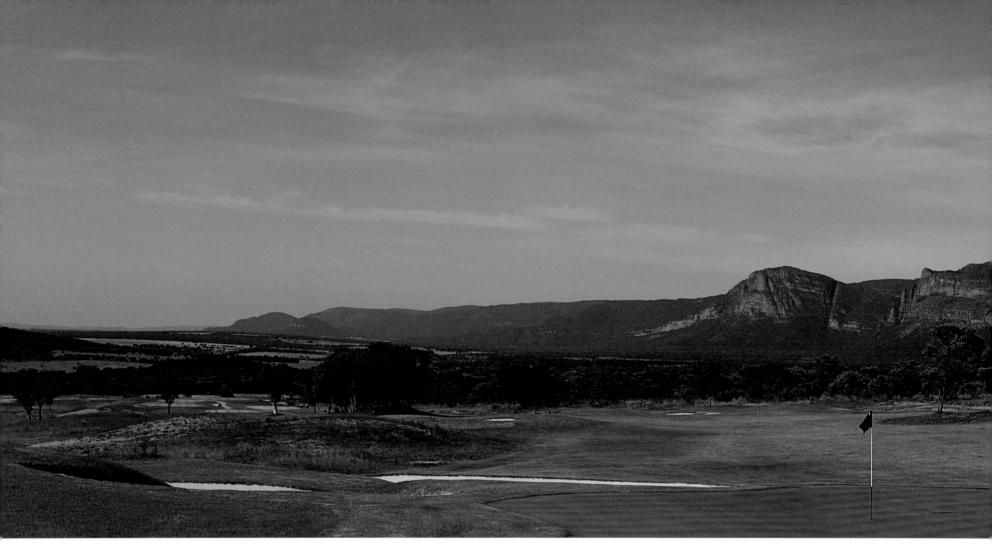

may mean the distance from tee to hole is not as demanding as it initially sounds but it is devilishly difficult to accurately gauge the flight of the ball from such an elevated position.

There is a $1million prize on offer for anyone brilliant or lucky enough to register a hole-in-one, so confident is the resort that the Extreme 19th is unconquerable. Many of course have tried and failed to tame the hole with a single blow and according to the club's own official scorecard of May 2016, only 14 players had ever registered a birdie two. Ireland's Padraig Harrington, who designed the Signature Course's 10th hole, became the first professional ever to make par on the 19th in 2009. A South African gentleman by the name of Ivan Roux meanwhile

is listed as having taken a demoralising 76 to complete the unique hole, the worst attempt listed, while many other have avoided such ignominy by not having their scores recorded.

Since it takes a tee shot around 30 seconds to descend down onto the green, losing sight of the ball is something of an occupational hazard and to combat the problem players are provided with six balls fitted with tracking devices, while there are four separate cameras in position to follow the flight of the plummeting balls. A high percentage unsurprisingly fail to even find the 19th hole's putting surface. The resort's chequebook has remained resolutely closed to date despite thousands rising literally and metaphorically to the challenge on Hanglip

Mountain and the suspicion is it will take more than a million-to-one shot for anyone to become an instant millionaire.

ABOVE: A view of the 13th hole, designed by Luke Donald at the Legend Golf Course on the Entabeni Safari Reserve.

FAR LEFT: Hanglip Mountain is silhouetted between the gatehouse buildings.

LEFT: Each hole at the Legend course has been designed by a well-known golfer. Impala graze on Colin Montgomerie's sixth hole. He's not going to like that, is he.

Stadium Course

Bro Hof Slott Golf Club, Sweden

A breathtaking venue which showcases the most spectacular of Scandinavian scenery, Bro Hof Slott is a relatively young course set on the banks of Lake Mälaren in southern Sweden and although it may lack heritage, it is already regarded as one the best 18 holes in the world.

Opened as recently as 2007 to the north-west of Stockholm, Bro Hof Slott is a seriously long course measuring an intimidating 7,357 metres

(8,046 yards) long from the black tees. Some 70,000 tons of sand were imported during construction to afford it the feel of a links course while, rather indulgently, the bunkers boast crushed marble mixed with sand.

The lavish attention to detail saw the reputation of the venue rise rapidly and by 2011 it was named the 10th best course in Continental Europe by *Golf World* magazine, while it now

regularly makes the top 100 of greatest courses on the planet.

The pristine waters of Lake Mälaren are never far from view but many rate the 17th as the most eye-catching of all, a deceptively short par three that requires players to pitch 118 metres (130 yards) over water to an island green which is only accessible by a narrow pathway.

The lakeside setting is rivalled by the stunning clubhouse, the renovated Bro Hof Castle which, unlike the surrounding fairways and greens, is far from a recent arrival. Sitting on the site of an earlier building, the castle was built in the grounds in 1888 by Count Johan Sparre in the Baroque style and over the years was home to many of Sweden's grandest families. By 2002 it had endured many years of neglect and fallen into a state of some disrepair.

Entrepreneur Björn Örås bought it and ordered a painstaking restoration of the castle to restore to its former glory. The result is a striking white edifice which now serves as a breathtaking centrepiece to Bro Hof Slott.

ABOVE LEFT: Scott Henry putts out on the 17th at the 2016 Nordea Masters. That island-hole-in-a-lake looks familiar...

RIGHT: Lee Westwood putts on the 10th green with the Baroque Bro Hof Castle beyond.

Stadium Course

PGA Catalunya Resort, Girona, Spain

The Transatlantic golfing rivalry between Europe and the USA may be embodied by the Ryder Cup but it also manifests itself in the infrastructure arms race that is top course construction and was the catalyst for the magnificent Stadium Course at the PGA Catalunya.

It was back in 1980 that the Tournament Players Club at Sawgrass in Florida was opened. The acclaimed home of the PGA in America quickly earned a reputation as one of the finest golf challenges around, and the European Tour sought to emulate the success of Sawgrass. After a decade of meticulous planning and design, the opening of Catalunya in 1999 was Europe's riposte in all its glory. The Stadium Course is now consistently ranked as one of the continent's top 10 tracks.

The beauty of the course, framed by the Pyrenees in the distance, however, belies its considerable teeth and with trees consistently in play along the fairways, water a factor on seven holes and disconcertingly rapid greens, it is an examination of even the finest players.

The exacting tone is set on the opening tee. A 398-metre (435 yards) par four, the fairway doglegs from right to left amidst an avenue of pine trees and with water waiting at the front left of the green, the first is a hole which demands pinpoint accuracy. The sixth is a dry hole but features another significant dogleg along the ascending fairway before players must safely negotiate the battery of five bunkers located front right and left of the green.

Catalunya's best-looking par three is the 11th. The par four 18th provides a fittingly difficult finale with bunkers left and right of the fairway.

The second shot is uphill and anything but a straight approach to the green will see the ball find sand.

RIGHT: You get a great view of the Catalan countryside from the par four 13th tee, that's if you're not concentrating so hard on getting your European Tour card as Anirban Lahiri of India was doing in 2014. The green is between the two lakes.

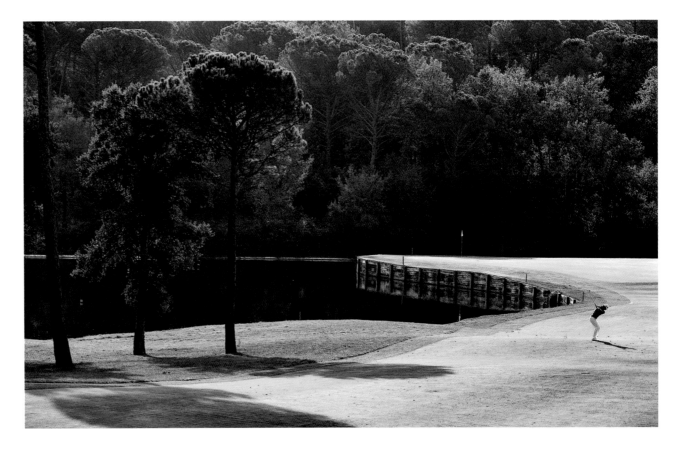

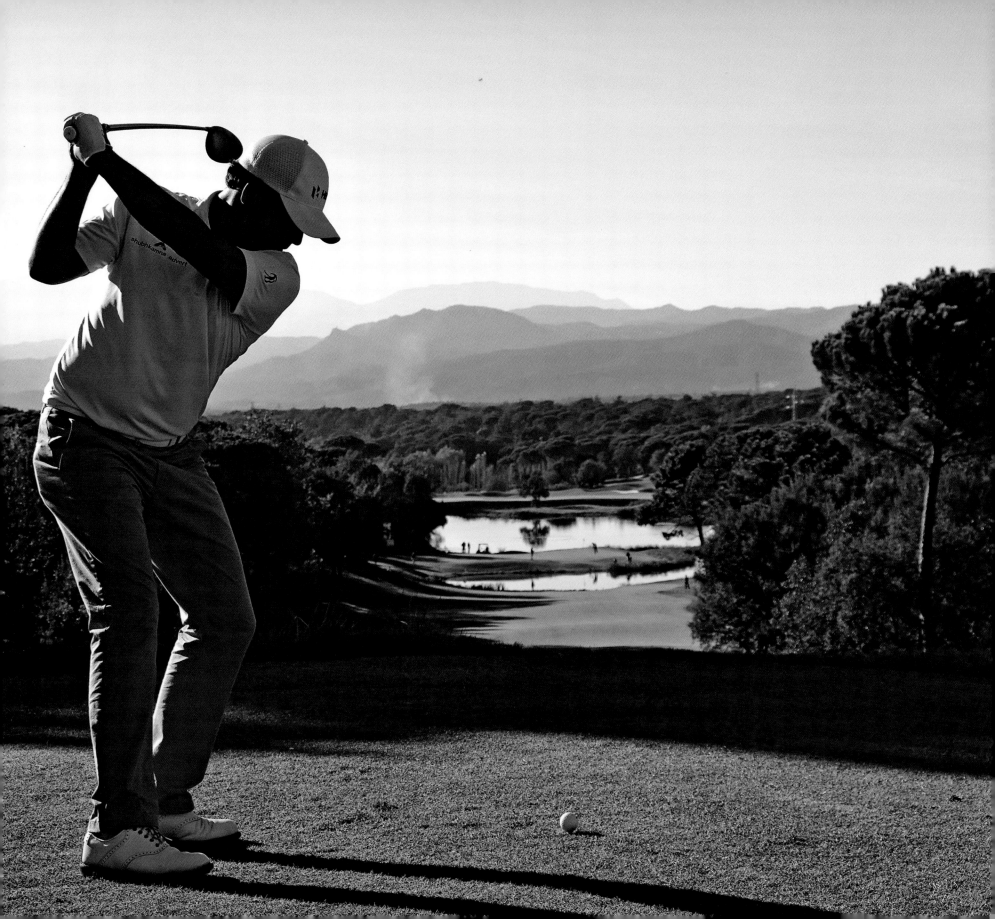

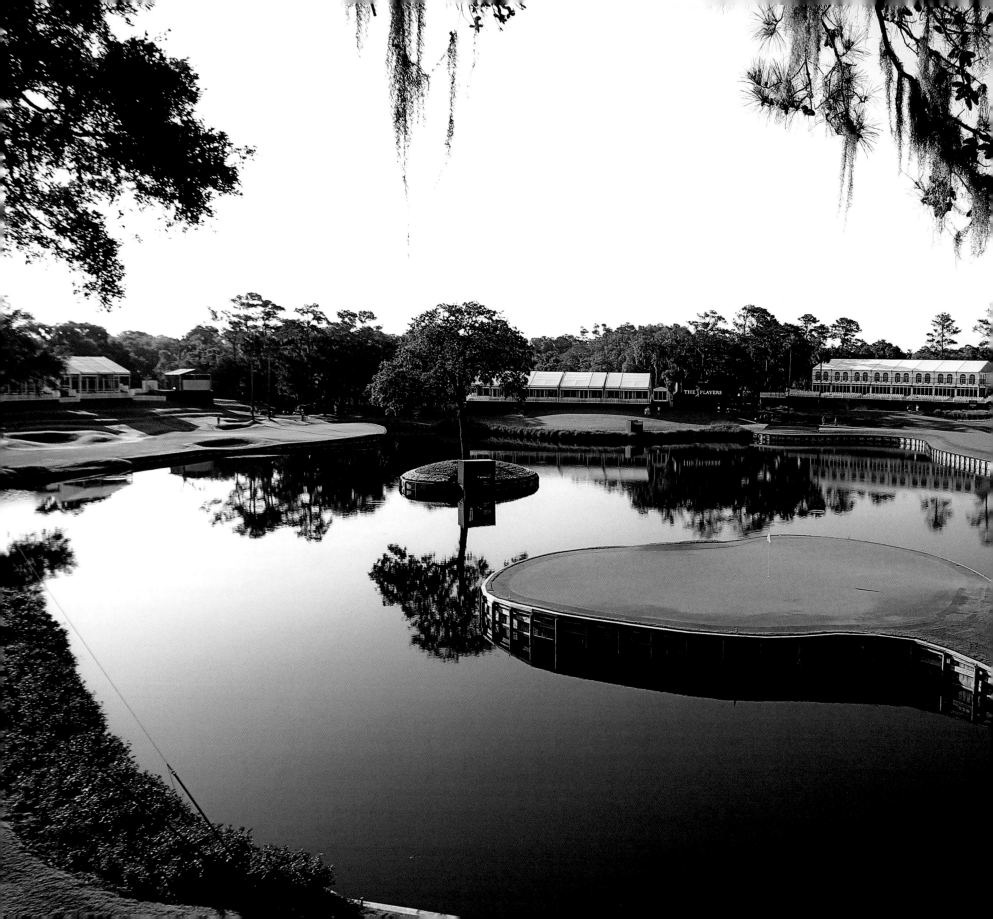

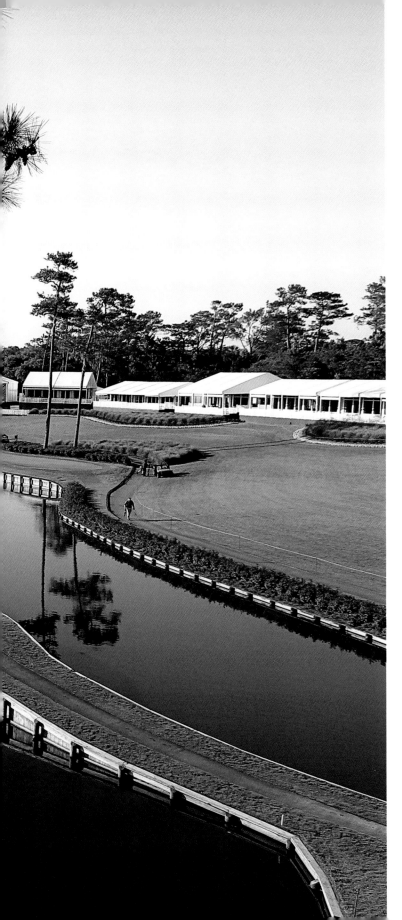

Stadium Course

TPC Sawgrass, Ponte Vedra Beach, Florida, USA

Unveiling a brand new course is inevitably an anxious time for those behind the project. The Stadium Course at Sawgrass opened in the early 1980s and the initial reaction to what is today a widely acclaimed course was far from complimentary.

The course was envisaged by former PGA Tour Commissioner Deane Beman and designed by revered architect Pete Dye, but when it staged its first major tournament, the Players Championship in 1982, the aforementioned players were deeply unimpressed to say the least. "It's 90% horse manure," remarked American J. C. Snead, "and 10% luck." Dye was promptly recalled to slow up the lightning fast greens and replace some of the unforgiving deep pot bunkers which had so offended the pros and after his alterations were complete, the Stadium Course's reputation as a top-class track began to grow in America and beyond.

Built on 415 acres of Florida swampland, the course is now characterised by narrow fairways, obstructive palm trees, marsh hazards and the bunkers that survived Dye's cull. Although the greens remain relatively rapid, it is considered a true test of all abilities rather than something more akin to a lottery.

As the Stadium Course's name suggests, Beman's vision was to build a venue accessible to as many golf fans as possible and to achieve this, Dye located the key points of the course adjacent to large, sloped areas which serve as natural vantage points for spectators. The innovation has proved hugely successful and in 2013 Sawgrass welcomed a record 173,946 people for that year's edition of the Players Championship.

There is no doubt which is the course's signature hole, the 137-yard par three 17th, dubbed the 'Island Green' which, although it is technically sited on an artificial peninsula accessed by a narrow walkway, is nonetheless one of the most famous holes in golf.

The 17th was born by accident. Dye had already laid out the green, which was to be partially surrounded by a lake. But by the time sand excavations around the putting surface had been used on other parts of the course they were left with a big crater where a bunker should be. Dye's wife Alice (a former amateur champion) suggested making a virtue of adversity and the cavernous hole was transformed into extra lake.

An estimate 100,000 balls are lost to the water on the Island Green each year but it was the local birdlife that proved problematic to Steve Lowery at the 1998 Players Championship, when a seagull swooped down, picked up his ball from the green and struggling to control its prize as it flapped away, promptly dropped it into the lake.

LEFT: The par three 17th at Sawgrass has influenced many course designers. The tees are directly above the pin in this photo.

BELOW: A view from behind the green on the par five 11th.

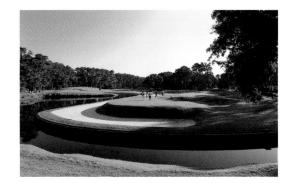

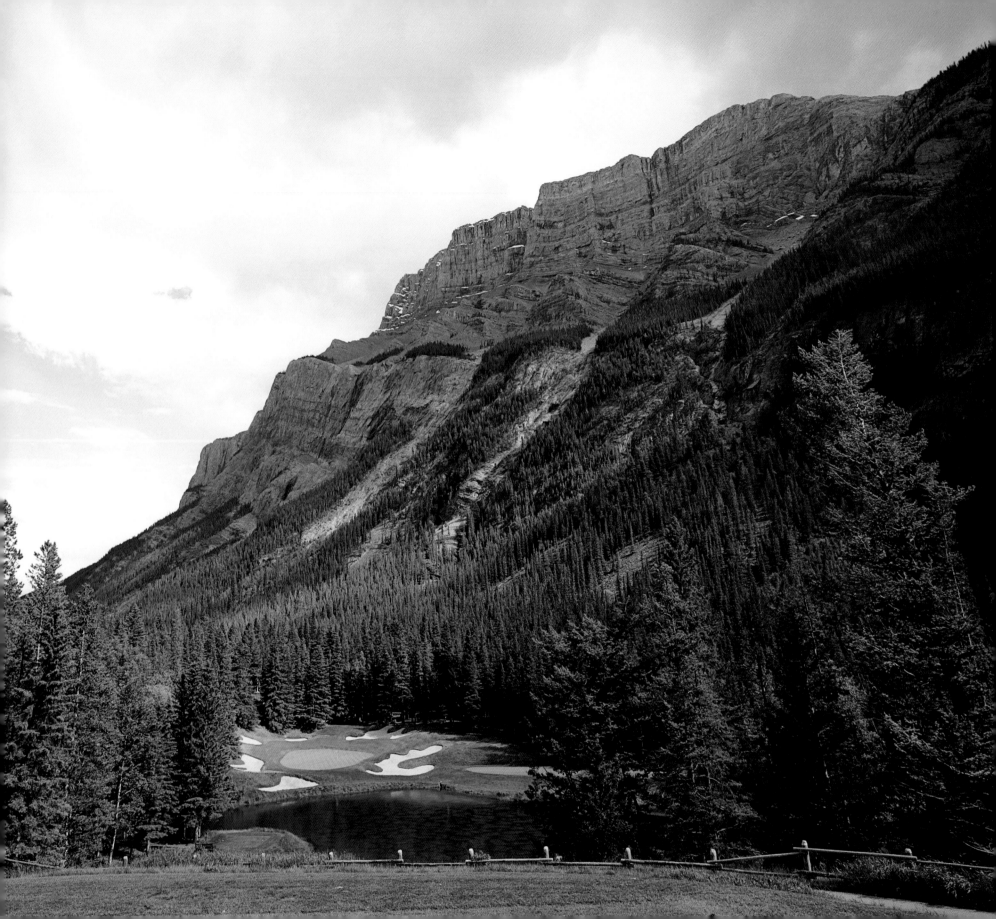

Stanley Thompson Eighteen

Banff Springs Golf Resort, Alberta, Canada

There is an old saying that you get what you pay for. Quality doesn't come cheap and those fortunate to have played the Stanley Thompson Eighteen at Banff Springs would probably agree that the unprecedented level of investment on the course almost a century ago was indeed money well spent.

Opened in 1928, the course was commissioned by the Canadian Pacific Railway and the company engaged acclaimed architect Stanley Thompson to create what they insisted would be a stunning 18 holes. The budget for the project was a generous $1million, making Banff Springs the first course in the history of the game to break the seven-figure ceiling in its construction.

Thompson spent much of the railway's money on hundreds of men, horses and mules to help sculpt the Canadian Rockies into what is regarded today as one of the best courses in the country. The dynamite required to blast certain sections into shape was another significant expense.

Flanked by Mount Rundle, Sulphur Mountain and Tunnel Mountain, the course sits in unquestionable natural splendour but it is a manmade structure – the remarkable Fairmont Banff Springs Hotel – which really catches the eye from the fairway as it rises above the tree line.

Constructed in the style of an imposing Scottish baronial palace, the hotel was built on the orders of Canadian Pacific Railway boss William Van Horne and opened in the summer of 1888. "Since we can't export the scenery," Van Horne reasoned, "we'll have to import the tourists." Guests over the years have included Princess Elizabeth, Winston Churchill, Marilyn Monroe, who was filming *River of No Return,* and baseball legend Joe DiMaggio who played a round with the club's resident pro.

The course's most celebrated hole is the par three fourth known as the 'Devil's Cauldron'. The tee shot is taken from up high on a natural granite shelf, over a lake and down onto a bowled green – hence the 'cauldron' moniker.

ABOVE RIGHT: The ninth green on the Stanley Thompson course.

RIGHT: The imposing structure of the Fairmont, a top destination since the 1920s.

LEFT: The 'Devil's Cauldron' fourth hole on the Stanley Thompson Eighteen course at Banff.

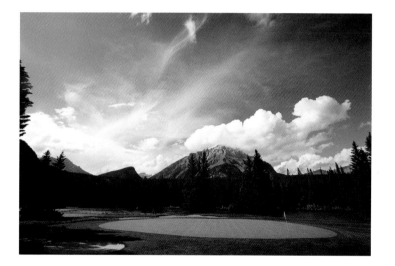

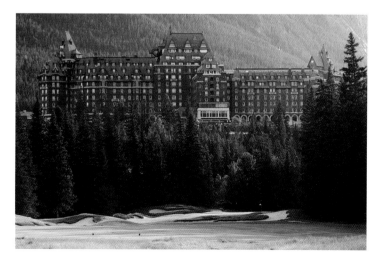

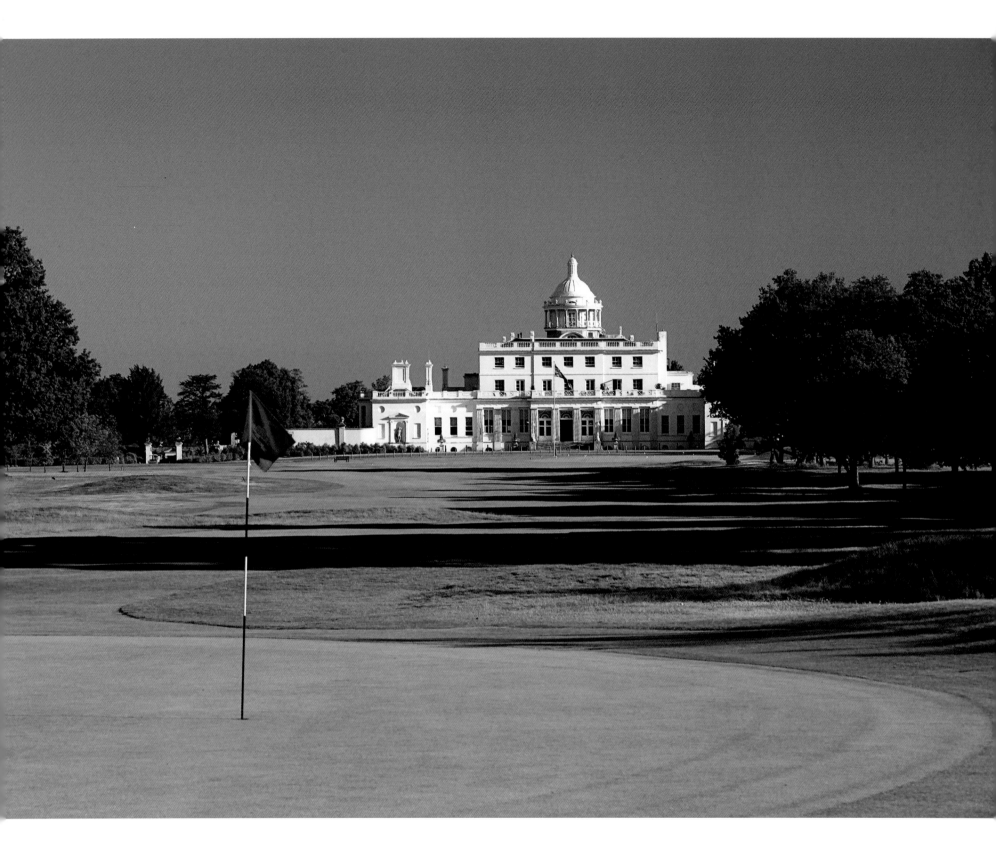

Stoke Park

Buckinghamshire, England

A century before James Braid, Old Tom Morris and Willie Park Jr. were plying their trade laying out golf courses in Victorian Britain, two other great landscape architects were at work. Lancelot 'Capability' Brown and Humphry Repton were responsible for creating some of the classic parkland landscapes surrounding the great houses of England.

And their work can be appreciated by golfers today at Stoke Park along with an eighteenth century Palladian mansion, one of the oldest and most architecturally exquisite buildings to be used as a clubhouse, rivalling Moor Park.

It is not only golfers, architecture and landscape architecture students who have made the pilgrimage to Stoke Park over the years. The beautiful backdrops have also made it popular with filmmakers (especially as it is so close to Pinewood Studios) and in 1964 the club was the location for one of the most memorable golf scenes in the history of the big screen as Sean Connery in his third outing as James Bond crossed clubs with the eponymous villain in *Goldfinger*.

The Bond connection does not end there. Segments of the 1997 instalment in the franchise, *Tomorrow Never Dies*, were filmed inside the Grade I listed mansion, while the 2004 film *Layer Cake* starring Daniel Craig was partially shot at the club two years before he assumed the mantle of 007.

Golf remains Stoke Park's principal claim to fame. It was designed in 1908 by Harry Colt, the leading architectural light of his generation and the man who subsequently laid out Wentworth, Sunningdale, Muirfield and Royal Portrush. Unusually it has 27 holes within the confines of the 300-acre estate. These consist of three courses of nine holes, instead of the standard 18.

The trio of truncated courses are named 'Colt' after its creator, 'Alison' after his design collaborator Charles Hugh Alison, and the more recent 'Jackson' after the club's founder, the journalist and sporting philanthropist Nick Lane Jackson.

The clubhouse is the undisputed centrepiece of Stoke Park. Designed as a private house by James Wyatt, architect to King George III, the building was completed in 1795 and subsequently bought by Lane and leaves an enduring impression on all those who encounter it. "The clubhouse is a gorgeous palace," wrote Bernard Darwin in his 1910 book *The Golf Courses of the British Isles*. "A dazzling vision of white stone, of steps and terraces and cupolas, with a lake in front and imposing trees in every direction."

ABOVE RIGHT: Despite his Scottish heritage Sean Connery had never played golf until his role in *Goldfinger* demanded that he look an accomplished golfer. He was given lessons at a club near Pinewood and from that point onwards he was hooked.

The Straits Course at Whistling Straits

Wisconsin, USA

The overwhelming majority of golf clubs take their names from their geographical location. It's a simple if rather prosaic convention but for every rule there must be exceptions and a cursory glance at any map will confirm there is nowhere called Whistling Straits in Wisconsin. The course got its evocative name in the late 1990s courtesy of local billionaire and founder Herb Kohler. It was still under construction as Kohler strolled around the site and was hit by a northerly wind which whistled along the rocky shoreline – the straits – of Lake Michigan.

Whistling Straits was christened, opening in 1998, and having hosted three PGA Championships it is also scheduled to welcome the Ryder Cup for the first time in 2020 – the course is now regarded as one of the finest links-style challenges in the States.

Built on what was once farmland and more recently a U.S. Army anti-aircraft training base, the Straits was designed by Pete Dye. A million cubic tons of earth were excavated and 13,216 truckloads of sand brought in to help create the bewildering number of bunkers which guard the 18 holes. Elevated greens and three stone bridges, aided and abetted by the wind sweeping in off the lake, all add to the quintessential British links feel.

The final flourish, though, is the flock of Scottish Blackface sheep imported by Kohler to give his course that extra sense of authenticity. The sheep are not quite as resident as they seem, wintering as they do away from the course and also moving out to accommodate major tournaments. Sadly the flock was reduced by one in 2004 when Dye returned to Whistling Straits to map out a new access road and his dog chased one of the ewes into the lake.

The ubiquitous bunkers are Whistling Straits' trademark feature. The fluid nature of the layout makes it impossible to put an exact number of sand traps but at any one time there are roughly 1,000 of them. The most populated hole is the eighth with 102 bunkers, closely followed by the 18th with 96.

LEFT: Bunkers, bunkers everywhere on the enormous 520-yard par four 18th hole, justifying its given name 'Dyeabolical'.

BELOW: The par four 494-yard fourth hole 'Glory' isn't preceded by 'Death' or followed by 'Allelulah'.

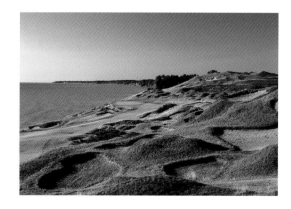

Streamsong Red, Streamsong Blue

Bowling Green, Florida, USA

The land is littered with physical reminders of bygone eras and at Streamsong players frequently stumble across some very ancient natural artefacts indeed. The objects in question are sharks' teeth, a striking reminder that this particular part of Florida was once, millions of years ago, an ocean. The land has long since conquered the water here but it is not every day a round can be interrupted by the discovery of the tooth of a long forgotten apex predator.

Streamsong's more recent history has had a greater impact on its design. The site is a former phosphate mine, first pressed into service in the late 1800s, the sandy spoils from the excavation now form the dune-like mounds that give the course its distinctive, undulating appearance. The excavated depressions have filled with water to create additional peril and with Bermuda Grass now resplendent on the fairways, the seemingly natural scene is one which belies the course's essentially artificial origins.

There are two 18-hole courses at the resort, Blue and Red, which both opened in 2012 thanks to a trio of architects working side-by-side to complete the construction. Blue is the work of Tom Doak who created a course characterised by multiple changes in elevation throughout, while Red is the creation of Ben Crenshaw and Bill Coore and winds through dunes, lakes and natural bunkers.

"This is such a good piece of land for golf," Doak said of the location for his course. "The variety of contours created by the mining process is unique for a project in Florida or anywhere in the Southeast."

At 7,176 yards from the back tees, Blue is a mere 28 longer than its neighbour but Red has stolen an early march in terms of public recognition since opening, named the 10th Best Public Access Course in America in 2016-17, compared to a ranking of 14th for Blue.

Unusually for Florida, both of Streamsong's courses are specifically designed to be walked and between January 1 and April 15, players are only allowed on Red or Blue on foot. Buggies are permitted later in the year as the temperatures in Florida in the summer months rise.

RIGHT: The 203-yard par three seventh hole at Streamsong Blue is regarded by many as its signature hole.

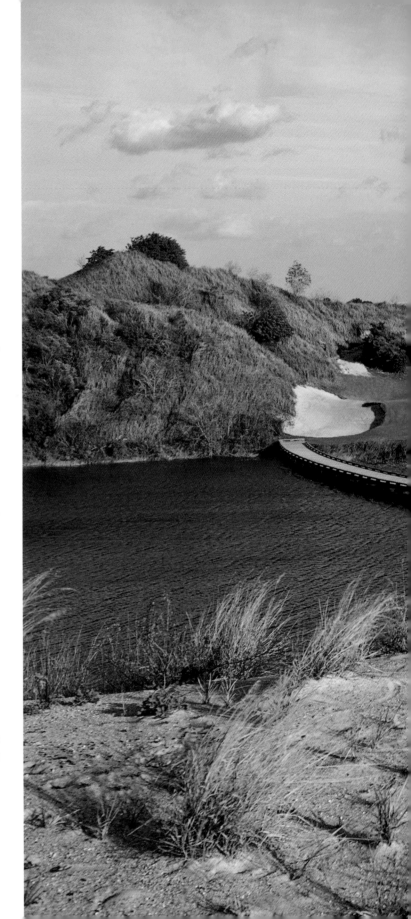

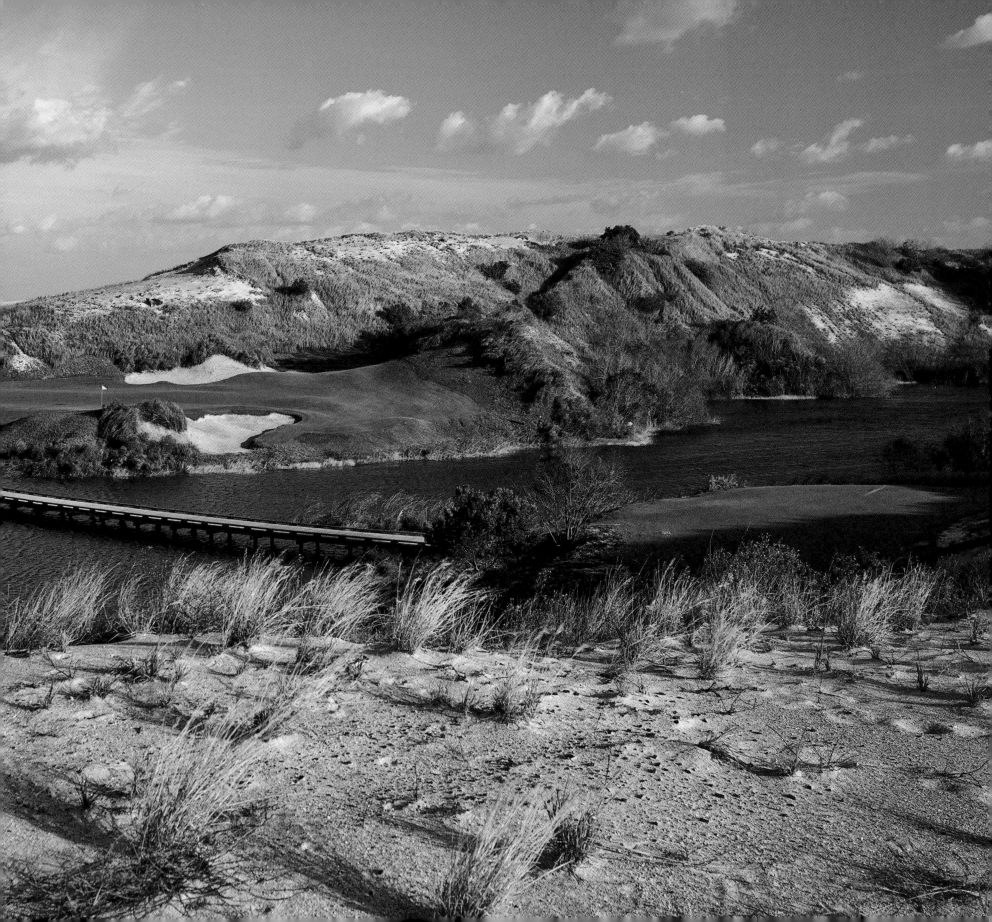

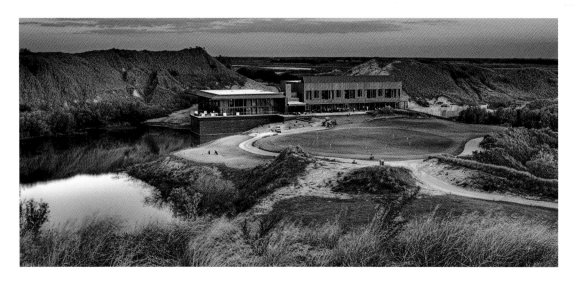

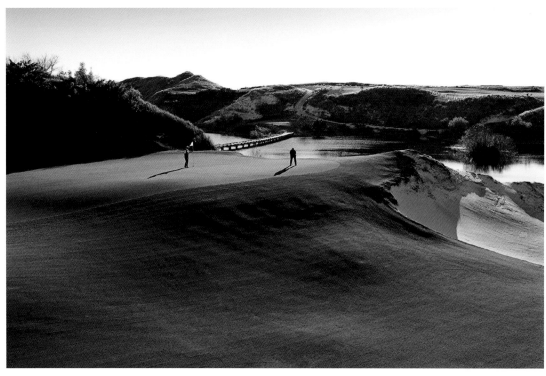

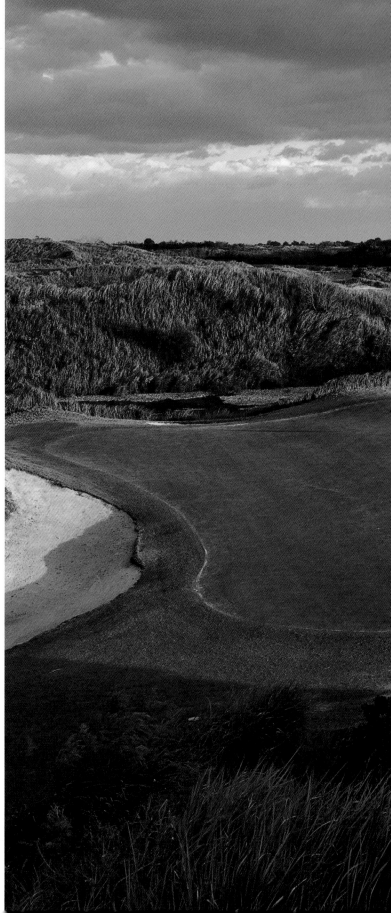

TOP: The stylish Streamsong clubhouse designed by Alberto Alfonso contains 12 guest suites as well as the usual dining and retail experiences.

ABOVE: The 16th green on the Red course. Water is never far away at both courses. An aerial photo of the area looks like a wallpaper pattern with vertical stripes and horizontal stripes where the land has been mined and replaced with water.

RIGHT: The sixth hole at Streamsong Red.

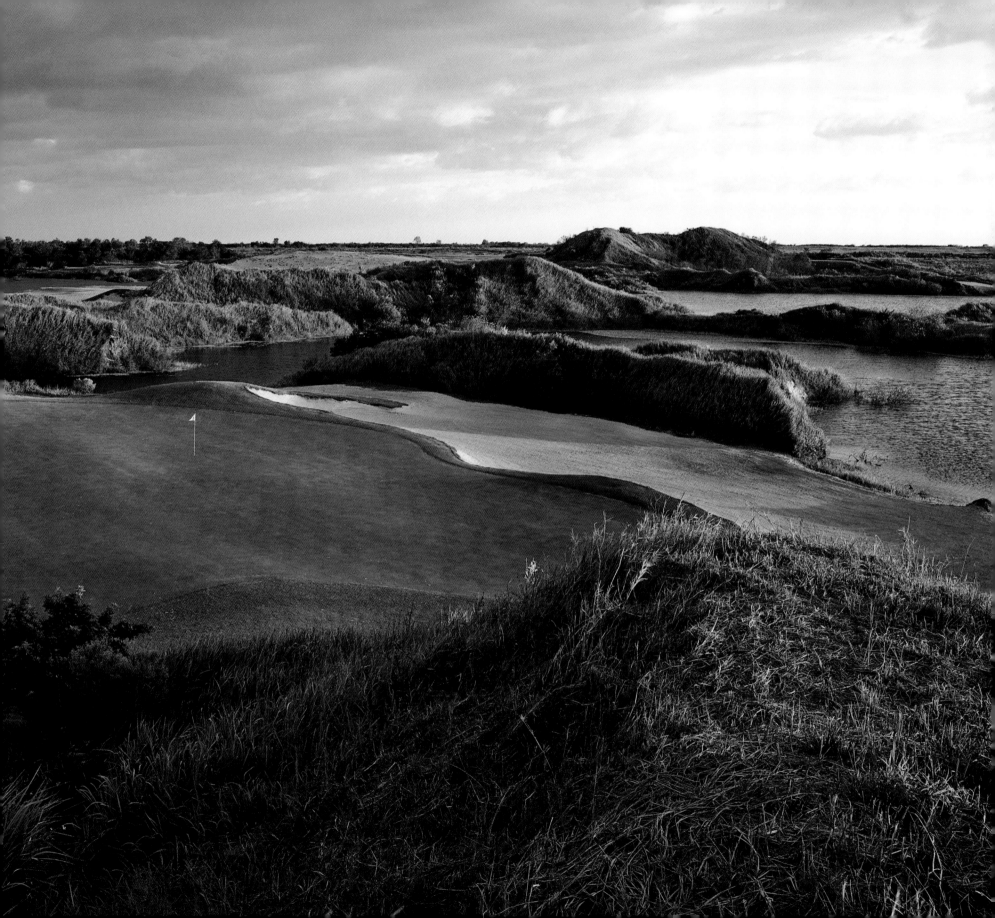

Taiheiyo Club Gotemba Course

Shizuoka, Japan

On a clear day Mount Fuji can been seen from the Japanese capital Tokyo, some 60 miles away. At 12,139 feet tall, the country's tallest mountain is nothing if not imposing and for those fortunate enough to play Gotemba, the shadow of the iconic, conical volcano is inescapable.

The par 72 course which measures 7,246 yards from the championship tees was designed by the Japanese Shunsuke Kato and opened in 1977. Gotemba is sited 1,600 feet above sea level and encased by an array of cedars and local cypress trees. The front nine of the course are characterised by significant changes in elevation while the back nine takes players through flatter woodland, the challenge coming on the undulating greens.

Since its construction it has been consistently ranked among the top 20 courses in Japan but in 2001 it was showcased to a global audience when it hosted the 47th edition of the World Cup, a tournament won by the South African pair of Ernie Els and Retief Goosen after a dramatic play-off featuring Denmark, New Zealand and the USA. It is also the current home of the Mitsui Sumitomo Visa-Taiheiyo Masters.

The two longest holes on the course are the third, which measures a monster 556 yards, and the slightly shorter sixth hole, a 540-yard challenge. Gotemba has one solitary hole that comes in under 200 yards, the 178-yard seventh. The most challenging hole is arguably the par

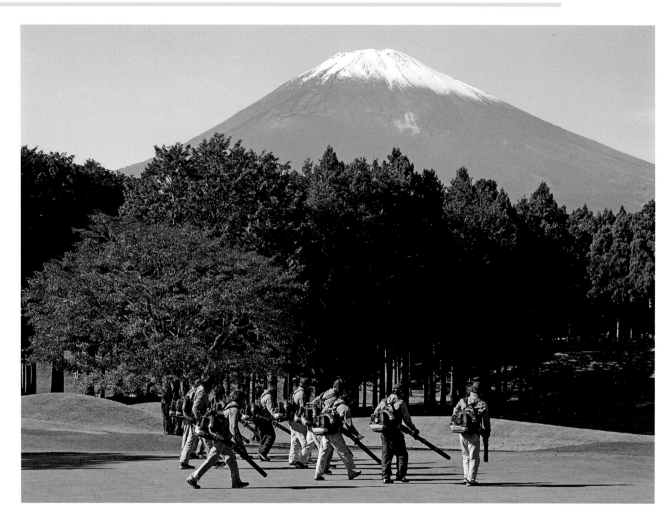

four 16th which features a significant dog leg from left to right and an approach shot to a green protected by bunkers front and back.

ABOVE: A course with remarkable attention to detail from the greenkeeping staff. Here, 11 leaf blowers are employed to manicure the 13th hole.

RIGHT: The green on the 517-yard par five 18th hole at the Taiheiyo Club Gotemba.

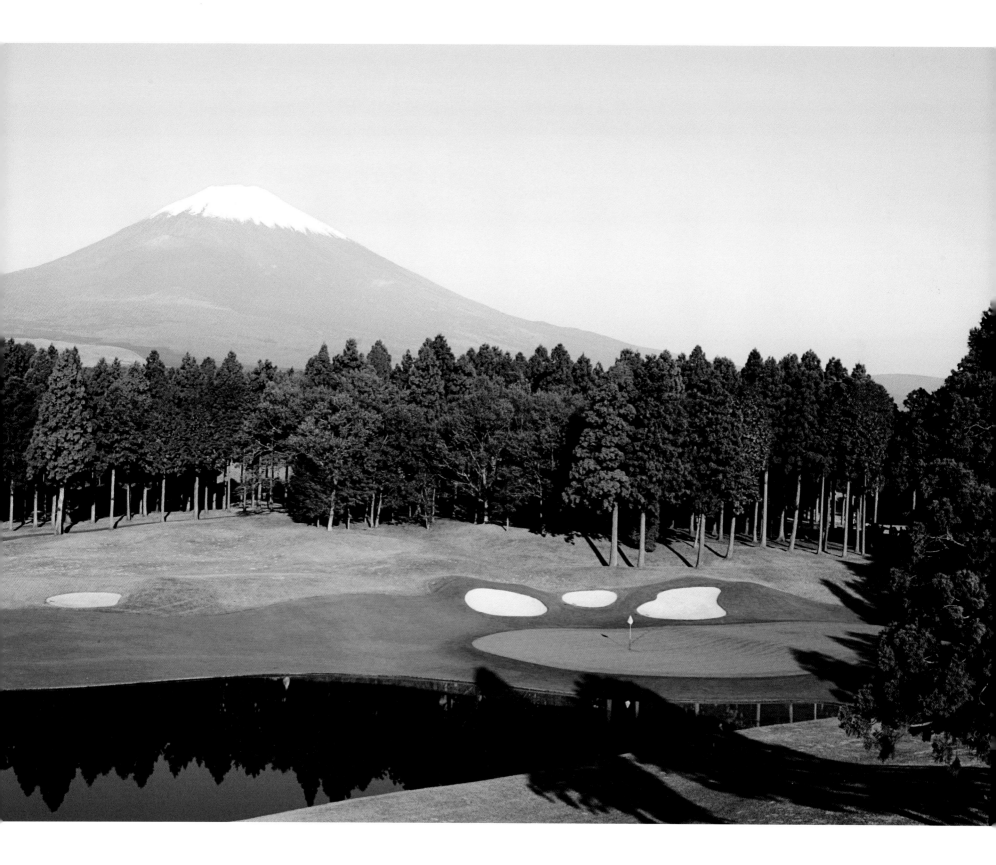

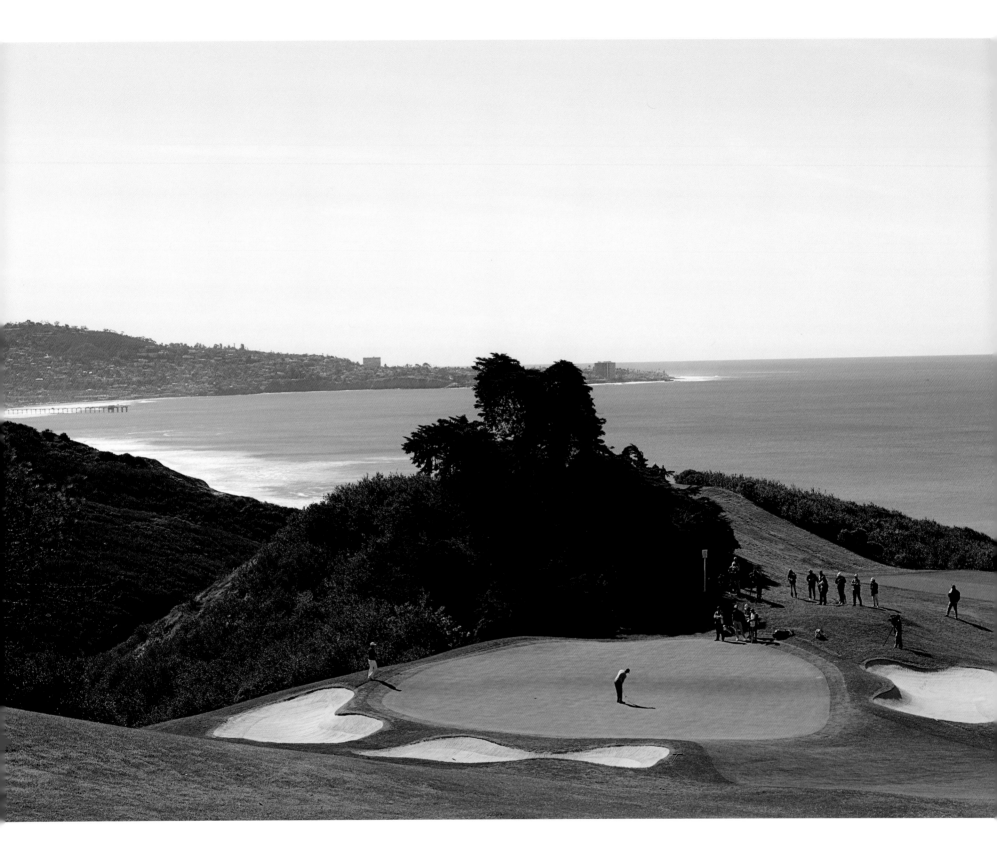

Torrey Pines Golf Club

La Jolla, California, USA

Built on the site of a former army base and opened in 1957, Torrey Pines takes its name from the trees that stand alongside its two 18-hole courses. The club is a municipal one and to ensure that the public can indeed play, Torrey Pines operates an egalitarian but fatigue-inducing admissions system.

The club has a first-come, first-served policy at the weekend. The first tee times are 7.30 in the morning but such is the popularity of the two courses – North and South – that queuing for a coveted booking begins in the early, early hours of the morning. Some golfers are so determined to play Torrey Pines that they arrive outside the night before to begin their wait.

Few are disappointed when their patience is rewarded with a round. Torrey Pines is stunningly sited along cliffs looking out over the Pacific Ocean and with its wealth of natural and dramatic ravines, elevated location and fiendish greens, it is a championship quality venue despite its municipal status.

The South Course underwent major renovations in 2001 under the watchful eye of Rees Jones and now measures a monster 7,707 yards from the back tees, including the eye-watering 614-yard ninth hole, while the North Course is a slightly less daunting 7,258 yards.

The overhaul of the South Course was undertaken in preparation of Torrey Pines hosting the US Open in 2008 and in terms of unforgettable drama, the competition certainly lived up to expectations as Tiger Woods won his 14th and possibly final major.

Woods was a wreck at Torrey Pines, suffering from residual cartilage problems, a cruciate knee ligament injury and two stress fractures of his left tibia, but after 72 punishing holes, the American found himself tied with compatriot Rocco Mediate in first place. The pair were required to play 18 more to settle their differences and after Woods had hobbled his way around the South Course in obvious pain once again, there was still nothing separating the two protagonists.

Woods looked on the verge of a physical breakdown as the pair headed to the 17th for a sudden death play-off but the former champion found enough reserves of energy to muster par on the 520-yard par five while Mediate registered a bogey and Woods was the winner of the U.S. Open for a third time.

ABOVE RIGHT: Charles Howell III plays his shot from the second tee overlooked by one of the remaining pine trees.

LEFT: Tiger Woods putts at Torrey Pines during Friday play at the Farmers Insurance Open in January 2017.

Tralee Golf Club

West Barrow, Ardfert, Kerry, Republic of Ireland

The Tralee Golf Club has both a long history and a long history of moving about. Formed in October 1896, the club's current course in Barrow is a majestic 18-hole links designed by Arnold Palmer overlooking Tralee Bay out towards the Atlantic. It was opened in late 1984 and such is the beauty of its location that only the forces of nature will move it this time.

Back in the late nineteenth century, club members initially played on a nine-hole course in Tralee believed to have been sited where the town's sports field now sits, but just 12 short months later the membership were on the move with the construction of a new nine-hole course in Fenit, on the south-western side of Barrow Harbour. By the early 1920s, however,

the club's wanderlust resurfaced and a Captain Lionel Hewson was instructed to lay out a new course in Oakpark which opened for play in 1921. They moved again to a nine-hole course at Mounthawk, but once they had obtained the land at Barrow in 1980, their moving days were over. With sufficient funds in place and Arnold Palmer on board as course designer, Tralee's

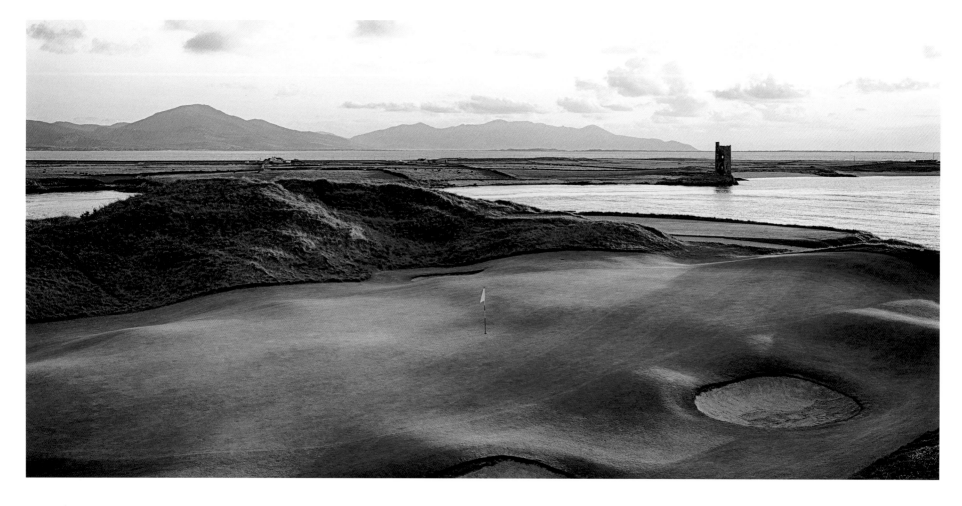

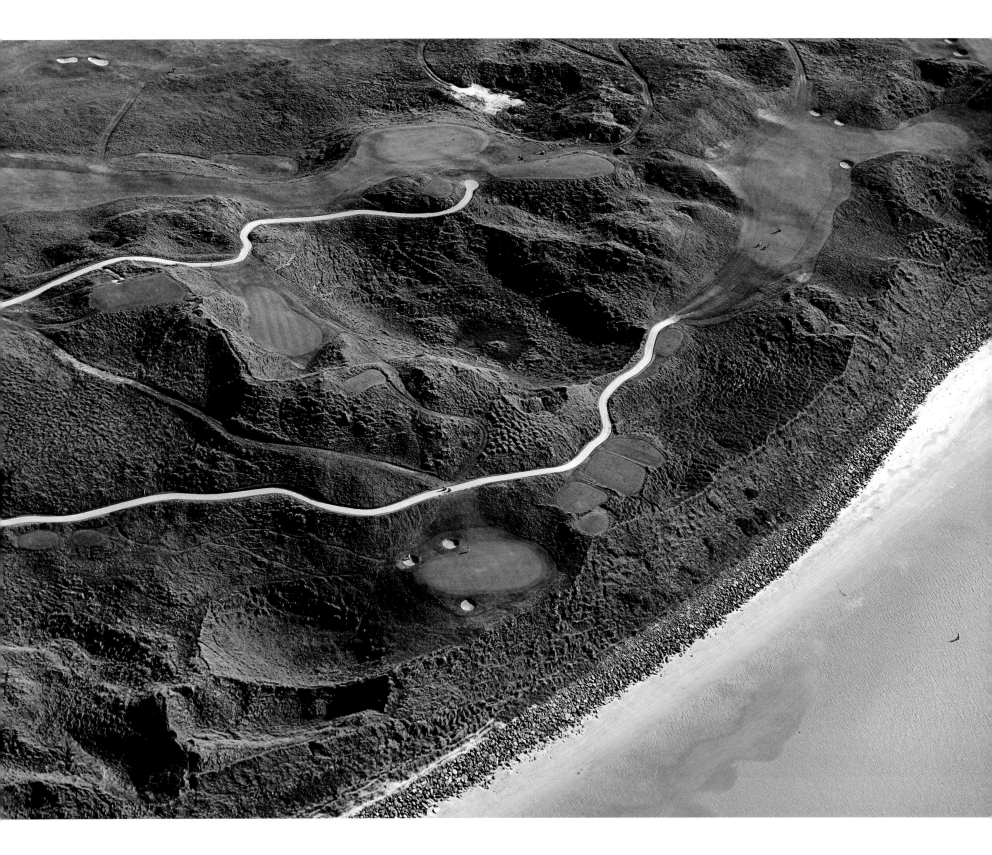

future was set. With the majority of Palmer's front nine hugging the coastline on elevated ground and the back nine running through mountainous dunes crisscrossed by ravines, it's a classic links offering tough golf and spectacular views.

The par three third is Tralee's signature hole. At 194 yards long, it needs no more than an iron to reach the green but the shot is complicated by the ever present threat of the rocks and the sea down the right-hand side and the distracting sight of the fourteenth century castle which stands impassively to the back of the putting surface.

The 16th has been dubbed 'The Shipwreck'. It's another par three that runs along a sandy beach but beneath the waves lurk rocks which have done for more than one passing vessel over the years, including one unfortunate ship from the Spanish Armada of 1588, which ran aground after being forced to return to Spain via Scotland and Ireland.

The 17th at Tralee, a par four measuring 361 yards, is known as 'Ryan's Daughter' courtesy of its unadulterated view of the beach below where scenes for the acclaimed 1970 film of the same name were shot, a movie which won the Academy Award for Best Cinematography the following year.

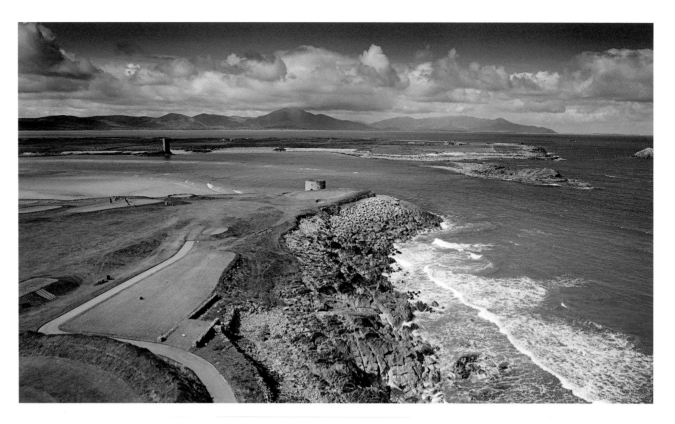

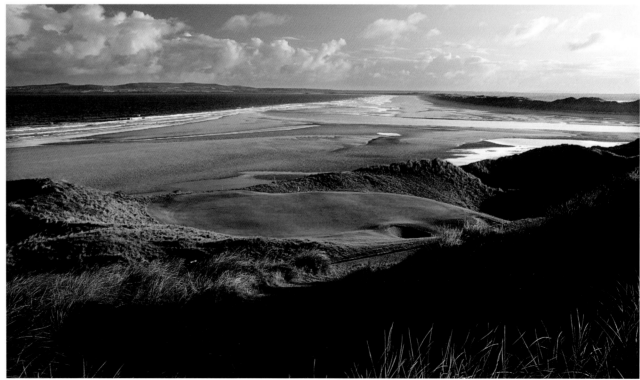

ABOVE RIGHT: A hole for *Game of Thrones* fans, the stone tower behind the short third hole dates from the fourteenth century and inside is a stone staircase and the "murdering hole" overhead from which intruders were bombarded with rocks and boiling oil. Good local advice is, "pay your green fees".

RIGHT: The par three, 16th hole, 'Shipwreck'.

OPPOSITE: The par four 15th hole, 'Poulgorm', is a tricky 300-yard uphill dogleg with the tee at the bottom left of the picture.

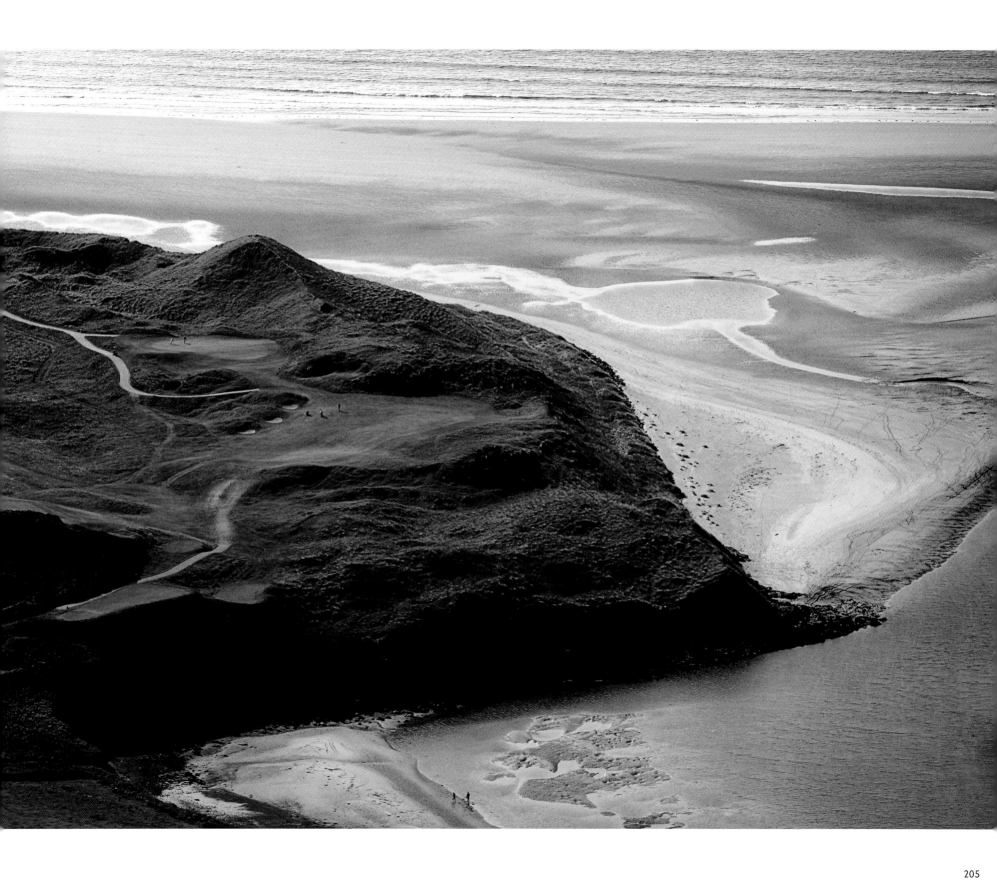

Tromsø Golf Club

Breivikeidet, Tromsø, Norway

Golf is not usually classified as a winter sport but the hardy souls who play at Tromsø, the northernmost 18-hole course to be found anywhere on the planet, may be inclined to argue the toss given its location inside the Arctic Circle. The work of Swedish architect Jan Sederholm it was opened in 1996. Tromsø is sited in the foothills of the Lyngen Alps in the north of Norway but while this provides a stunning backdrop for golf, its extreme latitude does present significant challenges, particularly in the harsh winter months.

Snow, surprisingly, is not the issue. It is the inevitable accumulation of ice on the greens that occurs when temperatures plunge well below zero. To ensure the grass below is not killed off, grounds staff have to regularly chip away the ice to prevent the precious putting surface beneath being killed off. In 2006 the winter was particularly unforgiving and the entire course had to be reseeded in the spring.

Tromsø is only open from May through to October when the elements are a little kinder and in June the club benefits from the perpetual Arctic daylight which allows around-the-clock play as in the Lofoten Islands and Iceland. Temperatures in June around Tromsø can reach a relatively balmy 12 °C and subsequently rise to a sweltering 15°C in July.

A curious local rule applied by the club concerns the unfenced gardens that border the course. In many places such areas would be deemed out of bounds but at Tromsø players are able to simply chip their balls back onto the fairway without penalty and continue their round.

BELOW: A breathtaking view of the Lyngen Alps. Golf is all about numbers and distance, and for those golfers who like big latitude, Tromsø cards a 69° 39' 30". The club is a 35-minute drive from the centre of Tromsø and also provides a nine-hole par three course for beginners.

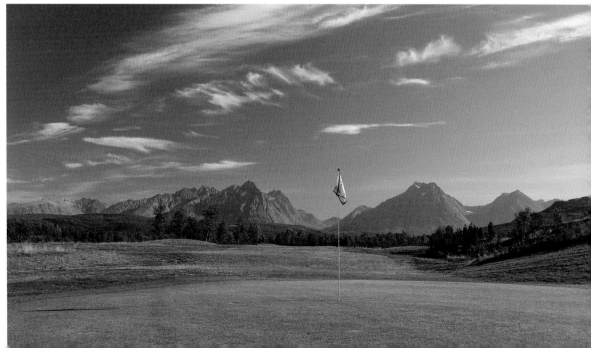

Upper Course

Whisper Rock, Arizona, USA

If the owners of Whisper Rock ever found themselves in dire financial straits, they could try hiring the place out as a movie set. The cacti-lined course with a backdrop of boulders is redolent of silver screen cowboys from the golden era of the genre and although the surprisingly lush greens may be slightly incongruous, Whisper Rock is otherwise the picture of the Wild West.

Whisper Rock has two 18-hole courses. The Lower is the older of the pair, designed by Phil Mickelson in collaboration with Gary Stephenson in 2001, while the Upper was laid out by Tom Fazio four years later. Both enjoy a fearsome reputation and both attract more than their fair share of leading amateurs and tour professionals alike. Mickelson himself is a member and frequent visitor and such is Whisper Rock's status as a players' course that, at the last time of counting, the club had 20 PGA pros on its books while more than 200 of its 550-plus membership boasted handicaps of five or better. It's certainly a venue with few fripperies – there's no swimming pool, no tennis courts and no social membership – and as befits the rugged, untamed scenery which surrounds it, the place prides itself on its no-nonsense approach to the game.

This reputation was only further enhanced when the club instituted an annual tournament which it ominously dubbed 'The Battle of Attrition'. A four-player event held in January,

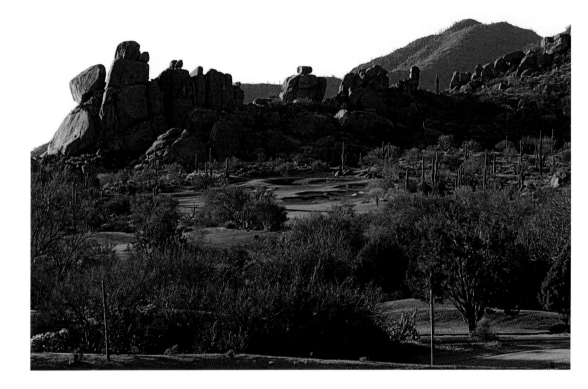

the competition certainly reflected the perceived strength in depth of the membership as the tees were pushed back to 7,417 yards and merciless pin placements deployed on the viciously sloping greens.

In 2006, for example, former Masters champion Fred Couples embraced the Battle of Attrition but after nearly four hours in the unrelenting Arizona sun, the American had failed to even threaten par and posted a rather underwhelming round of 79. Couples had to be persuaded not to

quit after shooting a dismal 45 on the front nine but after the day's play was over it transpired his modest score was in fact enough to share the winner's trophy with Englishman Paul Casey, who went on to win the European Tour Player of the Year Award later that year.

ABOVE: The epic 561-yard par five, 16th hole viewed from the clubhouse. Although the geology is very different, and there are far more cacti, the course resembles the Stone Forest in Kunming, China.

RIGHT: In the foreground is the green for the 169-yard par three, 14th hole.

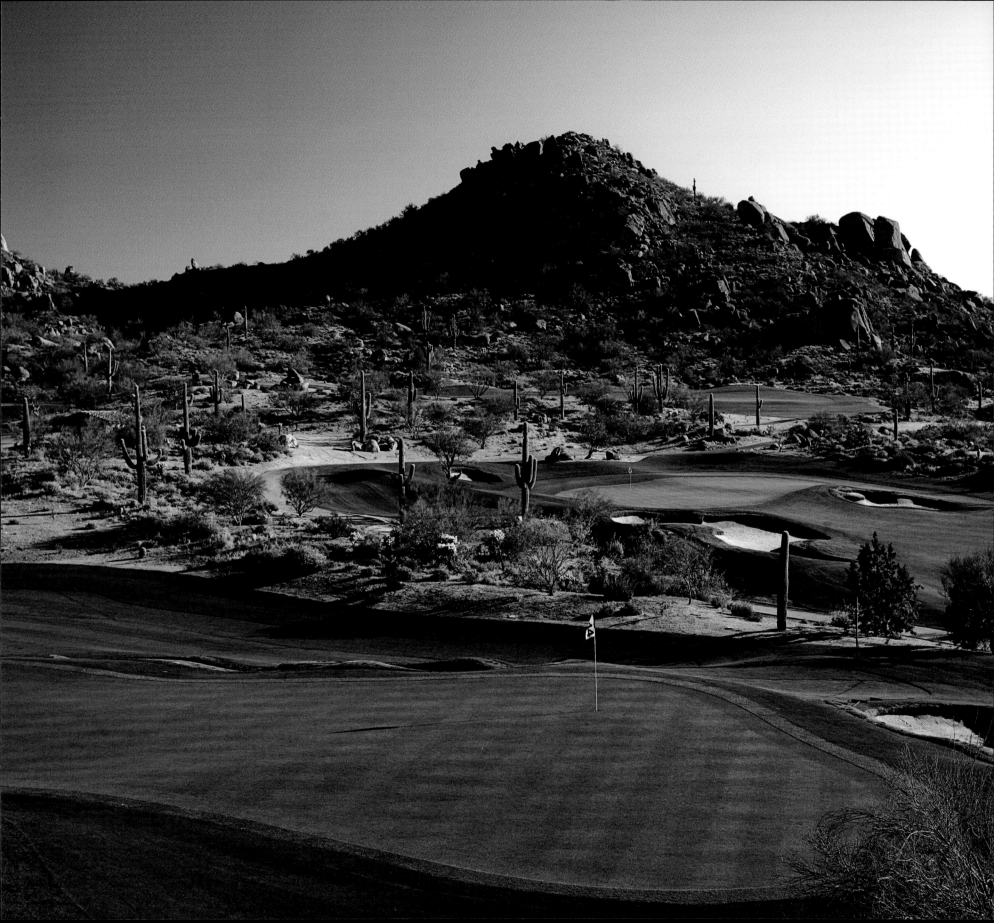

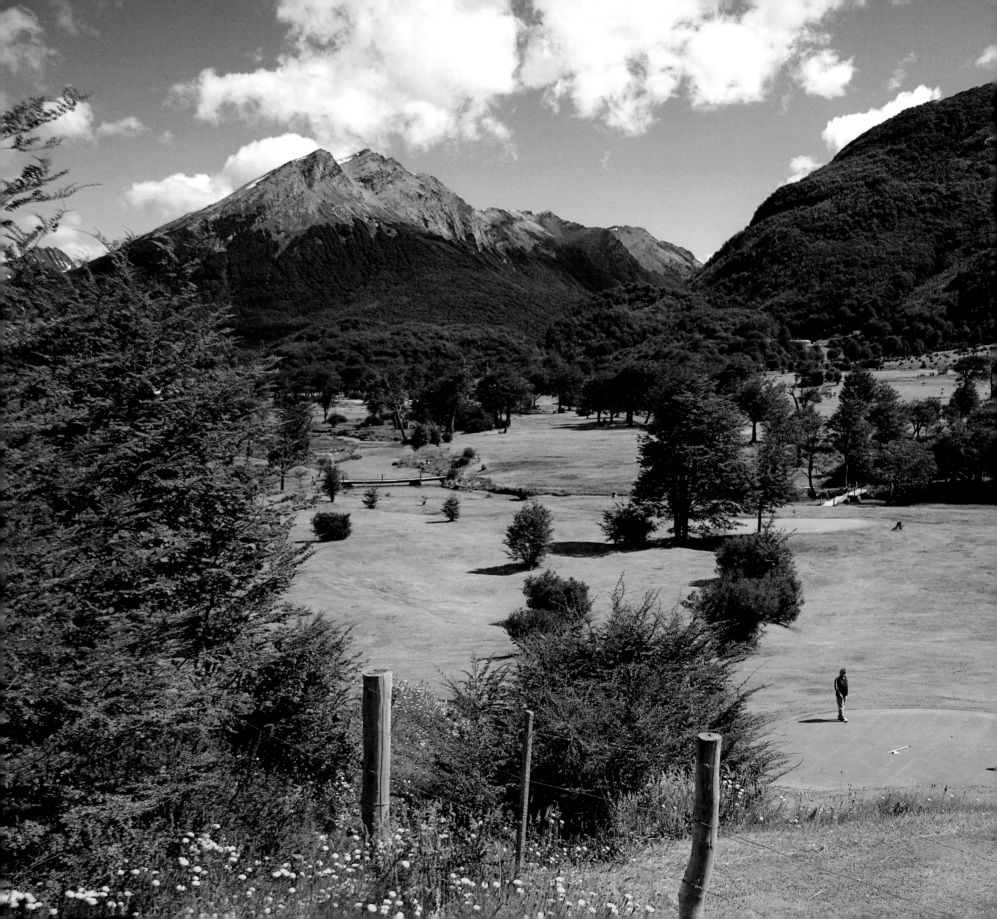

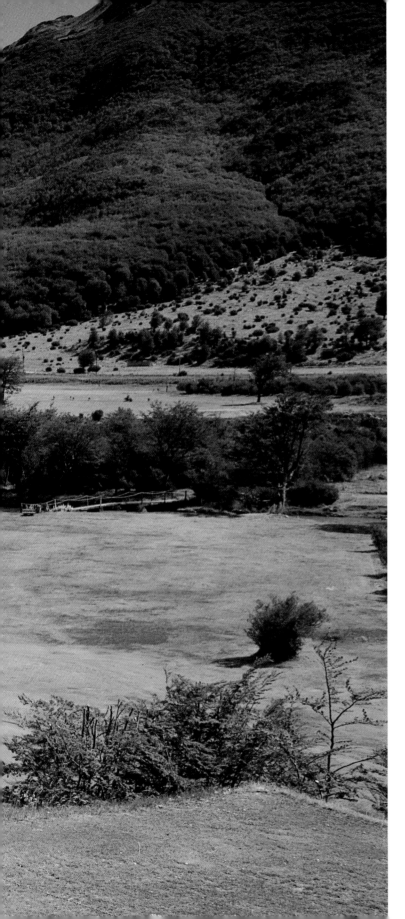

Ushuaia Golf Club

Tierra del Fuego, Argentina

It is not unknown for unhappy golfers to feel like it's the end of the world following a particularly error-strewn round. But for those who venture far enough south to play Ushuaia in the 'land of fire', they can be confident they are literally at the end of the world.

Located on the Argentinian island of Tierra del Fuego, there is nothing beyond Ushuaia other than the freezing waters of the South Atlantic and Antarctica, making the nine-hole course that shares its name with the island's capital, the southernmost golf course in the world. Even the Falkland Islands are more northerly.

Built in 1992, Ushuaia is a rough and ready but charming course close to the Lapataia National Park. Sunken embankments, a proliferation of small trees and the river Rio Pipo all combine to form an impressive array of natural hazards, while the wind coming in off the nearby Beagle Channel and the frequently plummeting temperatures all add to the unique challenge at the tip of the South American continent.

The river comes into play at Ushuaia on five of its nine holes and the eighth is generally regarded as the course's signature hole, a significant par five challenge which measures 508 yards from the back tees and features an abrupt bend in the Rio Pipo across the fairway which demands players must carry the cold, flowing water twice en route to the green.

Ushuaia's remote southerly location also means it does not get dark until midnight in December and January, affording members and intrepid visitors alike extended playing hours, but with temperatures rarely getting above 9°C even at the warmest time of the year, it is advised to wrap up exceedingly warm before venturing out.

LEFT: Playing conditions along the Rio Pipo valley look unusually benign in our photograph. For most of the year the mountains are snow-capped and the small clubhouse has the ever-popular fried penguin on the menu.

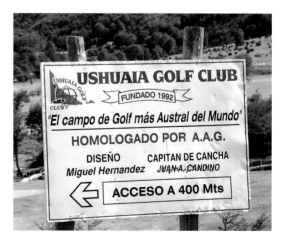

Victoria National

Newburgh, Indiana, USA

Victoria National was the lifelong vision of Terry Friedman. A successful Indiana businessman, Friedman's dream was to build a championship course fit to stage the U.S. Open. In 1998 he bought 418 acres of land formerly owned by the Peabody Coal Company and turned to his friend Tom Fazio to lay out the 18 holes which he one day hoped would host a major. The course was an immediate success when it opened in 1999.

Friedman sadly never saw his ultimate dream become a reality. He died in 2004, just 24 hours after playing a round of Victoria, and although his course is still patiently waiting to welcome the U.S. Open, Friedman's enduring legacy is a superb course which is consistently rated among the 50 finest in the States.

Few inland courses in America or beyond can compete with Victoria in terms of water. Twelve of its 18 holes have water in play in varying degrees and the area owes its many signature lakes to the mining activity that preceded the golf, the digging process eventually reaching natural underground springs, which in course filled the manmade holes.

The water and the significant undulations along the length of the course make for a true championship challenge and Victoria's quartet of

par threes are particularly noteworthy. The first is the 212-yard fifth which features water to the left of its triangle-shaped green, while the seventh is the shortest of the four at 183 yards and although there is no water hazard to factor in, a long narrow bunker to the left of the two-tiered putting surface (pictured above) lies in wait.

The 233-yard 11th demands an enormous, double carry over the same lake, while the 16th

is arguably the pièce de résistance of Victoria's short holes, a beguiling mosaic of water, rough and bunkers en route to a green with the wet stuff front and left, the only dry area off the putting surface protected by a substantial, steeply-inclined bunker.

ABOVE: Players approach the seventh green during the United Leasing Championship held in 2015.

RIGHT: The perilous drive on the 374-yard second hole.

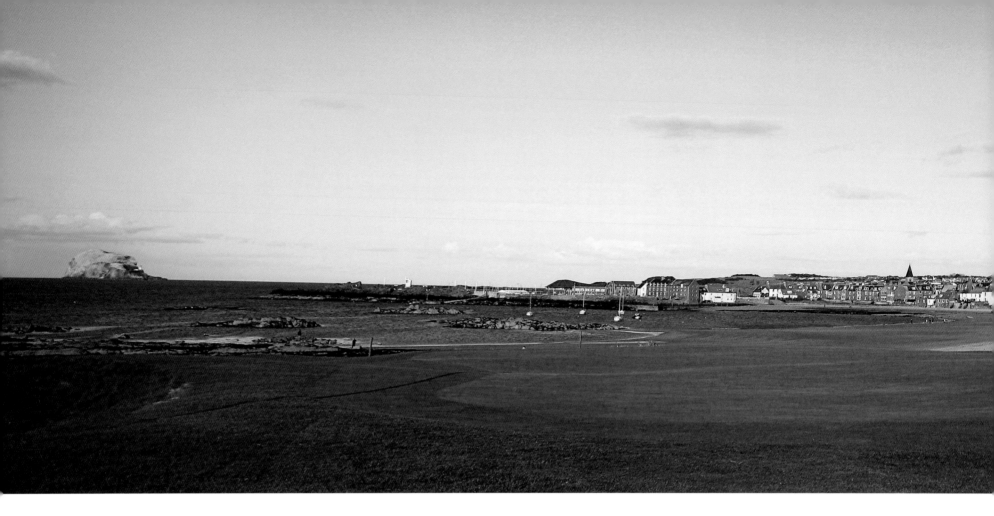

West Links

North Berwick Golf Club, East Lothian, Scotland

The West Links course looks ideally sited on the edge of the Firth of Forth, with its stunning views of the islands of Bass Rock, Craigleith, Lamb and Fidra, but the story of how the 18 holes were brought to life is one which begins with a decidedly cramped opening chapter.

North Berwick was founded in 1832 and when the new club turned its attention to acquiring land for a course by the coast, they were restricted to an unsatisfactorily small plot by the sea, encircled by common grazing land, which could only accommodate six holes.

A seventh hole was somehow squeezed in some years later but it was not until 1868 that significant expansion was made possible when one of the club's members, the Right Hon. John Nisbet-Hamilton, made some of his land available and although one of the original seven holes was lost, three new ones were added and North Berwick was now a nine-hole course.

Eleven years later the club once again appealed to the generosity of the Nisbet-Hamilton family, who freed up more of their property, and the club was finally able to lay down the nine additional holes they had yearned for. At 4,841

yards in length, it was by any measure a modest challenge, but 45 years after the club's formation, North Berwick finally had the full complement of 18 holes.

Today the West Links is a more challenging, 6,506 yards in total from the back tees – the last major alterations were made to the course in the 1930s – and it is widely regarded as one of

RIGHT: Ah, what it was to be a Victorian gent playing golf with a caddie and one's own ballmarker. The 'Then and Now' pairing shows how little has changed on the West Links in a hundred and twenty years, not even the raffish trousers.

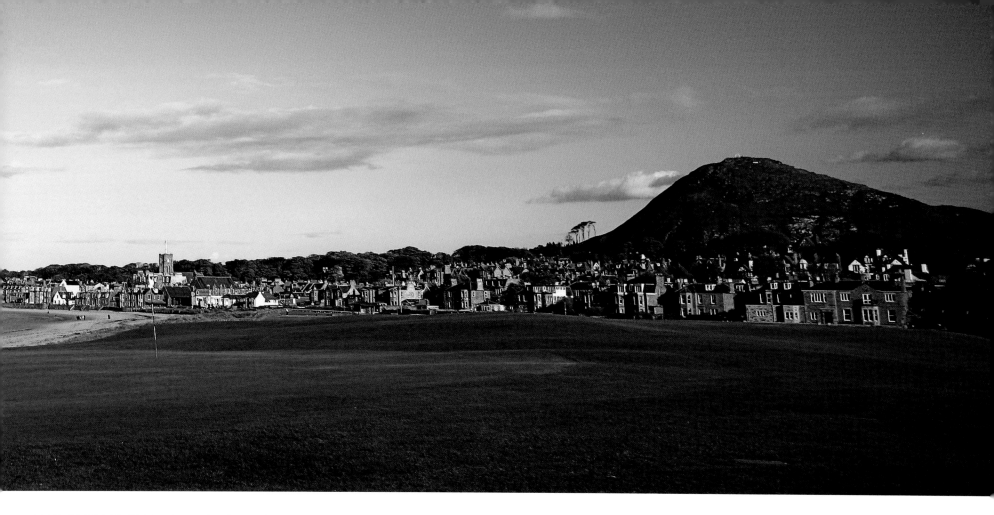

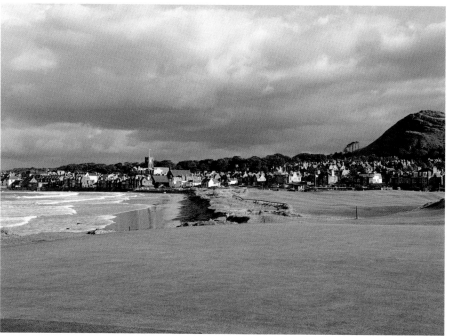

the finest examples of a classic Scottish Links to be found with the sea in play on six holes, the front nine winding their way out along the Forth of Firth, the back nine heading back to the club house in the opposite direction.

The 13th through to 15th holes are the best on the course. The 13th, known as the 'Pit', is a short par four featuring a sunken green hidden behind a stone wall, while the 14th, 'Perfection', is so christened because its requires two perfect shots to land on the green of the par four, 374-yard challenge. The 15th is the 'Redan', a par three which boasts a steeply sloping green with an enormous, hidden gully to the right front of the putting surface.

BELOW: The 16th green on the right and the second green on the left.

BOTTOM AND RIGHT: Two views of the par four 13th hole 'The Pit' with the ancient stone wall guarding the green.

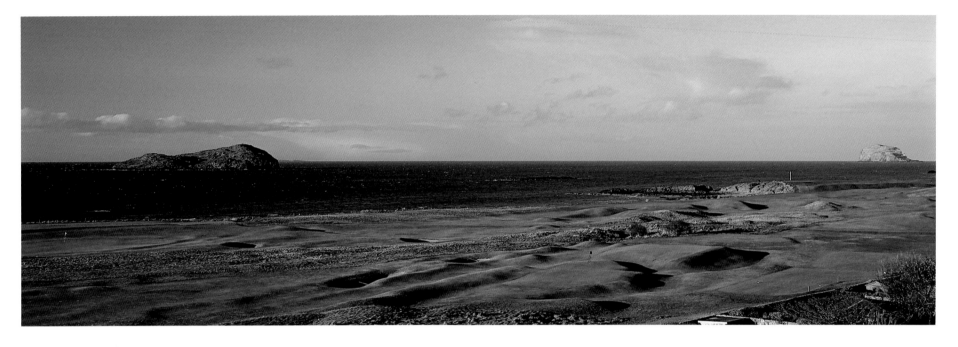

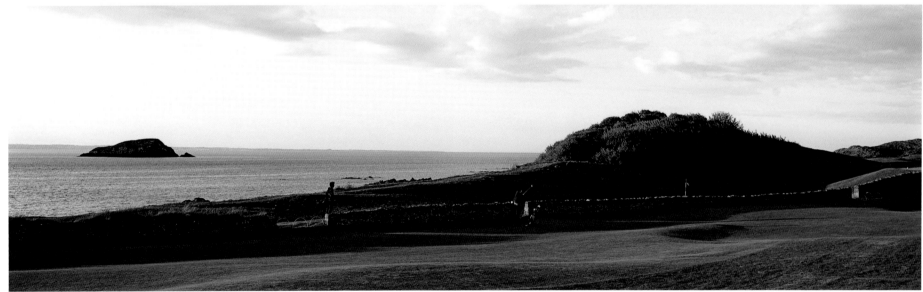

West Course

Wentworth, Virginia Water, England

Built in 1926 and designed by the renowned Harry Colt, the West Course at Wentworth is the long-time home to the prestigious PGA Championship. But despite its reputation as one of England's classic courses, sited on a stretch of natural Surrey heathland and framed by pine, oak and birch trees, the owners have refused to rest on their reputation.

The course was originally owned by a builder who wanted to sell the houses that fringe the course. Colt's original vision endured relatively unscathed for almost 80 years but in 2005 the club decided modern golf technology had rendered much of the layout outdated and Ernie Els, himself a Wentworth resident and a five-time winner of the World Matchplay Championship on the course, was commissioned to give the revered 18 holes some more teeth.

The South African extended the course by 310 yards. He added 30 new bunkers, new greens and when the dust settled only the 14th hole was untouched in the ambitious redesign. The West Course was reborn and now presented a distinctly sterner challenge to players of all abilities. The most talked about of the modifications was on the signature par five 18th hole. A sweeping dogleg from left to right, Wentworth's famous closing hole acquired a broad stream in front of the green as part of the extensive overhaul.

In 2016, however, the club decided to recall the diggers and Els to once again significantly change the course. It was no small project with all 18 putting surfaces stripped and reseeded, the eighth, 11th, 14th and 16th holes having their greens completely rebuilt in the process. The team also decided to remove 29 sand traps in an attempt to return the West Course to something that Harry Colt could recognize.

"We've improved the greens and taken bunkers out, and restored holes to their former glory," Els said. "Some holes won't even have bunkers on them any more. The crowds will enjoy it and so will the players. Their bad shots will get punished, but not as badly as before."

While most of the changes have been admired, the *Daily Telegraph*'s Martin Reason lamented the damage done at 18. "A perfectly good par five has been turned into a bash, a lay-up and a pitch across water. It might as well be a par three. They spent half a million quid on an aquatic folly." Though he did like the rest of the course.

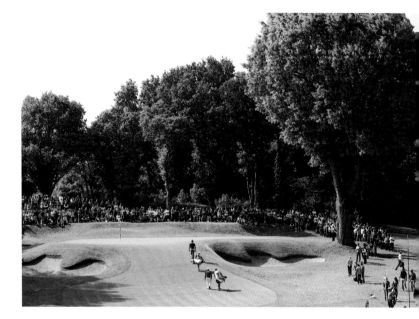

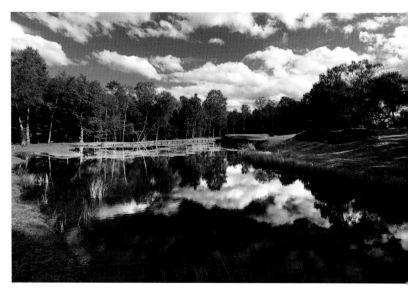

ABOVE RIGHT: Martin Kaymer of Germany and Andy Sullivan of England ascend the second green during the 2015 BMW PGA Championship.

RIGHT: The par four eighth hole.

OPPOSITE: The scene of so much drama in the World Matchplay Championship, the par five 18th hole has been transformed with a water hazard that negates any chance of a long-running second shot to make the green in two.

Wolf Creek

Mesquite, Nevada, USA

Golf course architects can either work with the natural contours of the land or bring in earth-moving machinery. Wolf Creek is a stunning example of the natural world firmly calling the shots. The course is undeniably spectacular but the great mystery is exactly how father-and-son design team of Dennis and John Rider successfully incorporated 18 holes in between the sandstone outcrops that dominate the area. Taking an aerial view, their creation looks like something akin to architectural contortion with fairways and greens nestled snugly amongst the myriad of rock promontories.

Opened in 2000, Wolf Creek was an instant hit, voted 'America's Best New Course' by *Golf Digest* in 2002, and its combination of dramatic changes in elevation, wandering desert canyons and wetland areas have ensured its reputation as one of the country's most challenging courses remains unblemished.

There is still some argument over which is Wolf Creek's signature hole, with the eighth and 17th both attracting considerable support. The former is a par three playing a sizeable 248 yards from the long tees but the real attraction is the view from the tee, the green visible some 100 feet below. Distance is an issue but so too is the sandstone ridge to the right of the green and the brook to the left.

The 17th, a par five, is arguably even more breathtaking. The tee this time is a full 200 feet above the fairway, perched on a rock precipice, and although big hitters can reach the green in two, the putting surface is encircled by a lake along three quarters of its circumference.

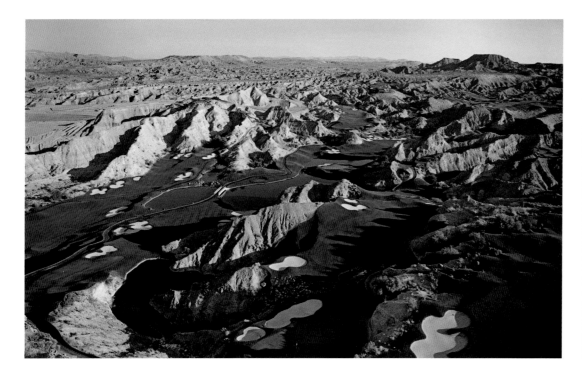

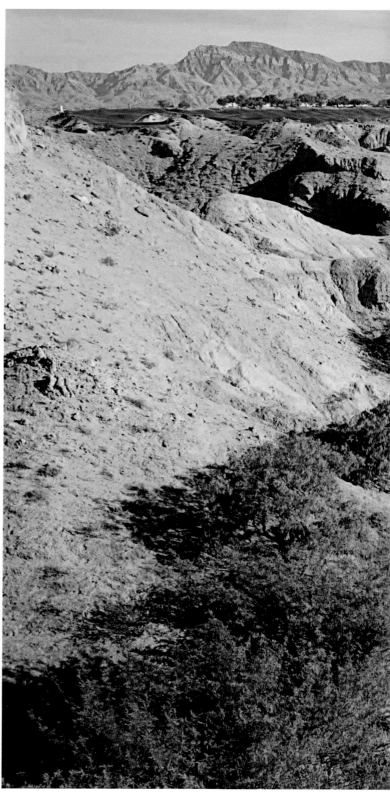

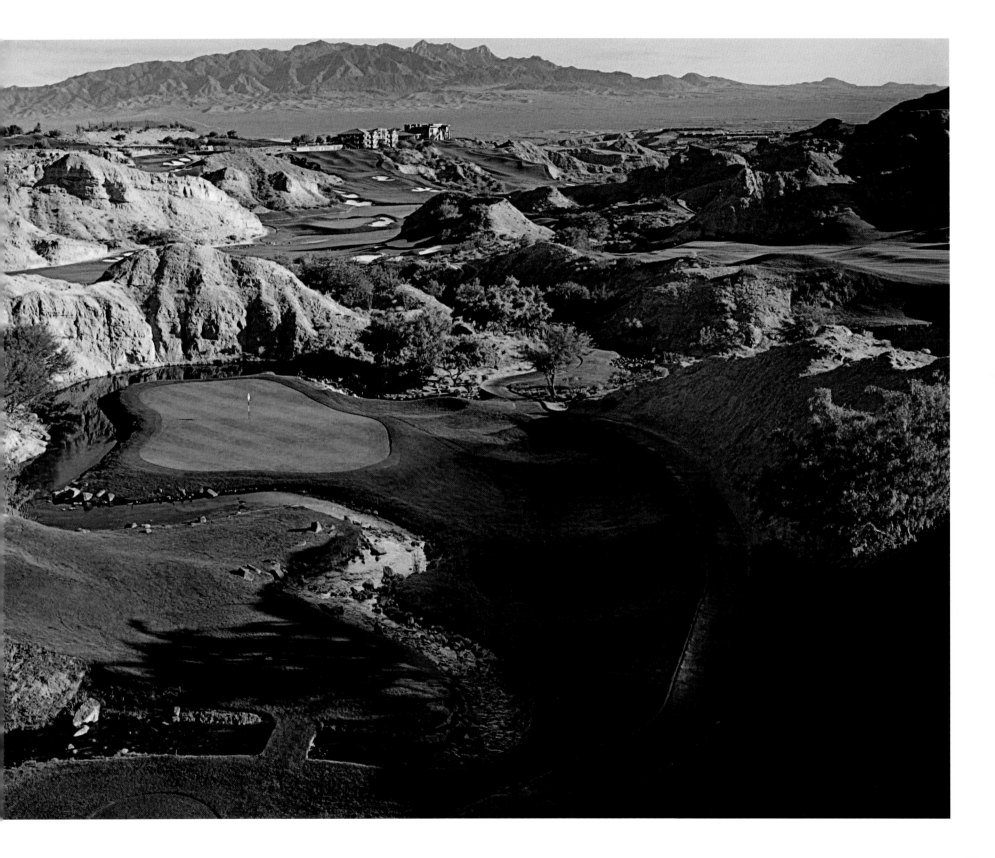

Index

Abercromby, J. F. 17
Abu Dhabi Golf Club 14–15
Addington Golf Club 8, 16–17
Ailsa Championship Course 13, 18–19
Akureyri Golf Club 78, 79
Alison, Charles 162, 191
Allenby, Robert 116
Alliss, Peter 34
Argentina
 Ushuaia Golf Course 8, 210–11
Arikikapakapa 20–1
Arrowhead Golf Club 22–3
Augusta National Golf Club 24–7
Australia
 Barnbougle 28–31
 Royal Melbourne Golf Club 164–5
Baillie, Lady 99
Balfour, A. J. 170
Ballesteros, Seve 110, 158, 174, 175
Banff Springs Golf Resort 188–9
Barbados
 Green Monkey Golf Course 13, 70–1
 Sandy Lane Resort 13, 70–1
Barnbougle 28–31
Barra Golf Club 32–3
Bates, Gene 160
Beaumont, Henry de 151
Belfry Hotel & Resort 34–5
Bell, William F. 68
Beman, Deane 187
Berckmans, Louis 24
Betjeman, Sir John 8, 52, 54
Blair, Tony 99
Bolivia
 La Paz Golf Club 10, 92–3
Brabazon, The 34–5
Braid, James 52
Bro Hof Slott Golf Club 182–3
Brocket, Lord 'Charlie' 36
Brocket Hall Golf & Country Club 36–7
Brown, David 146
Brown, Lancelot 'Capability' 191
Bush, George W. 99
Campbell, Sir Guy 99
Canada

Banff Springs Golf Resort 188–9
 The Rise 160–1
 Stanley Thompson Eighteen 188–9
Cape Kidnappers Golf Course 38–9
Carnoustie Golf Links 41–3
Carr, Joe 142
Casey, Paul 208
Championship Course (Carnoustie Golf Links) 40–3
Championship Course (Machrihanish Golf Club) 44–5
Championship Course (Royal County Down) 46–9
Charles, Sir Bob 65
Cheape, James 137
Chicago Golf Club 50–1
China
 Jade Dragon Snow Mountain Golf Club 8, 86–7
 Leaders Peak 94–7
 Mission Hills Resort 116–19
Church Course 8, 9, 52–5
Clayton, Mike 28
Clearview Golf Club 56–7
Clinton, Bill 144
Club de Golf Alcanada 58–9
Cobb, Henry 72
Coeur d'Alene Resort Golf Course 60–1
Colt, Harry 46, 162, 170, 191, 219
Connery, Sean 191
Coore, Bill 31, 194
Cotton, Henry 170
Couples, Fred 116, 160, 208
Crenshaw, Ben 194
Crump, George Arthur 152
Curley, Brian 94, 96
Curzon, Lord 123
Cypress Point Club 62–3
Darwin, Bernard 170, 191
Dayan, Moshe 99
Devil's Golf Course 10, 68
Doak, Tom 28, 39, 194
Dubai
 Majlis Course 110–11
Dubai Desert Classic 110
Dunes Golf Course 28, 31
Dunes Golf Resort 64–6

Dye, Alice 128, 187
Dye, Perry 67
Dye, Peter 67, 72, 118, 128, 187, 193
Elkington, Steve 116
Els, Ernie 110, 116, 198, 219
England
 Addington Golf Club 8, 16–17
 The Brabazon 34–5
 Brocket Hall Golf & Country Club 36–7
 Church Course (St Enodoc Golf Club) 8, 9, 52–5
 Leeds Castle Golf Course 98–9
 Llanymynech Golf Club 106–7
 Moor Park Golf Club 120–1
 Painswick Golf Club 10, 146–7
 Royal North Devon Golf Club 166–7
 Rye Golf Club 170–1
 St Enodoc Golf Club 8, 9, 52–5
 Stoke Park 190–1
 Worcestershire Golf Club 6
English Boys' Open Stroke Play Championship 121
Faldo, Nick 75, 116, 119
Fazio, Tom 70, 208, 212
Fernie, William 19
Fleetwood, Tommy 48
Forbes, B. C. 125
Foulis, Sir John 130
Fowler, Rickie 168
Fownes, Henry 125
Francis I'i Brown Golf Course 12
Friedman, Terry 212
Fuego Maya 66–7
Furnace Creek Resort 68–9
Furyk, Jim 34, 179
Gallacher, Bernard 34
Garcia, Sergio 26, 42, 110, 158
Gay, Robert 132
George VI, King 17
Gillmeister, Heiner 162
Goldfinger 191
Green Monkey Golf Course 70–1
Golf Club Q 6–7
Goosen, Retief 179, 198
Gosset, Isaac H. 166
Grace, Branden 72
Grant, Douglas 148
Groom, Arthur Hesketh 90
Guatemala
 Fuego Maya 66–7
Hackett, Eddie 142

Hagadone, Duane 60
Harbour Town Links 72–3
Harradine, Peter 14
Harrington, Padraig 42, 48, 180
Haworth, Neil 87
Hearn, David 141
Henry, Scott 182
Hewson, Lionel 202
Higgins, Liam 142
Himalayan Golf Club 6, 156
Hoey, Michael 176–7
Hope, Bob 62
Hornafjörður Golf Club 78, 80–1
Horowitz, Oliver 78
Hosoishi, Kenji 100
Howell III, Charles 201
Iceland
 Akureyri Golf Club 78, 79
 Hornafjörður Golf Club 78, 80–1
 Ness Golf Club 77
 Vestmannaeyar Golf Course 77
Ile Aux Cerfs 82–3
Immelman, Trevor 179
India
 The Lodhi 100–1
 Naldehra Golf Club 122–3
Indonesia
 Merapi Golf 114–15
International Golf Club 8
Ireland
 Old Head Golf Links 142–5
 Tralee Golf Club 202–5
Irwin, Hale 128
Isle of Harris Golf Club 74–5
Jacklin, Tony 34
Jack's Point 84–5
Jackson, Nick Lane 191
Jacquelin, Raphael 141
Jade Dragon Snow Mountain Golf Club 8, 86–7
James VI, King 137
Japan
 Kobe Golf Club 90–1
 Satsuki Golf Course 8
 Taiheiyo Club Gotemba Course 198–9
Jimenez, Miguel Angel 177
Johnston, Andrew 'Beef' 158
Jones, Bobby 24
Jones, Rees 201
Jones, Robert Trent Jr. 22, 59
Jones, Robert Trent Sr. 22, 158, 168

Karmel, Mohammed Ibrahim 99
Kato, Shunsuke 198
Kaymer, Martin 219
Kennedy, Archibald 19
Kerr, John 130
Kjeldsen, Soren 100
Kohler, Herb 193
Kolopaking, Yuwono 114
Kirby, Ron 142
Kobe Golf Club 90–1
Ko'olau Golf Club 88–9
La Paz Golf Club 10, 92–3
Lahiri, Anirban 185
Lamb, Caroline 36
Landry, Andrew 126
Langer, Bernhard 83, 128, 179
Layer Cake 191
Lawrie, Paul 42
Leaders Peak 94–7
Leeds Castle Golf Course 98–9
Legend Golf & Safari Resort 8, 178–81
Leonard, Justin 42
Lian-Wei, Zhang 116
Litten, Karl 110
Llanymynech Golf Club 106–7
Lodhi, The 100–1
Lofoten Links 8, 102–3
Longhurst, Henry 17, 147
Lord, Gareth 15
Lost City Golf Course 104–5
Lost Farm Golf Course 28–31
Love III, Davis 116
Lundin Ladies Golf Club 108–9
Lyle, Sandy 121
MacDonald, Charles Blair 51
Machrihanish Golf Club 44–5
MacKenzie, Alister 62, 165
MacKinnon, Murdoch 33
Majlis Course 110–11
Mamani, Marta 93
Manele Golf Course 112–13
Mary, Queen of Scots 130
Mauritius
 Ile Aux Cerfs 82–3
McGinley, Paul 34
McIlroy, Rory 46, 49, 110, 134
Melbourne, Lord 36
Melbourne Golf Course (Brocket Hall Golf & Country Club) 36–7
Merapi Golf 114–15
Merrigan, Paddy 142
Mexico
 Pacifico Golf Course 156–7

Mickelson, Phil 208
Miller, James 19
Miller, Johnny 126
Mission Hills Resort 116–19
Molinari, Edoardo 177
Montgomerie, Colin 179, 181
Moor Park Golf Club 120–1
Morris, Old Tom 10, 44, 46, 137, 155, 166
Naldehra Golf Club 122–3
National Course 10
Nelson, Robin 87
Nepal
 Himalayan Golf Club 6, 156
Ness Golf Club 77
Netherlands
 Royal Haagsche Golf and Country Club 162–3
Neville, Jack 148
New Zealand
 Arikikapakapa 20–1
 Cape Kidnappers Golf Course 38–9
 Dunes Golf Resort 64–6
 Jack's Point 84–5
 Rotorua Golf Club 20–1
Nicklaus, Jack 19, 112, 118, 139, 148, 156
Nisbet-Hamilton, John 214
Norman, Greg 116, 118, 134
Northern Ireland
 Championship Course 46–9
 Royal County Down Golf Club 46–9
Norway
 Lofoten Links 8, 102–3
 Tromsø Golf Course 8, 206–7
Nugent, Dick 88
Oakmont 124–7
Ocean Course, The 128–9
O'Connor, John 142
O'Connor, Patrick 142
Olazábal, José María 116
Old Course (Musselburgh Links) 10, 130–3
Old Course (Royal Troon) 10, 13, 134–5
Old Course (St Andrews) 10, 10–11, 136–41
Old Head Golf Links 142–5
Open Championship 19, 41, 42, 132, 133, 134, 137, 141, 155, 166
Örås, Björn 182
Ortiz-Patino, Jaime 158

Ozaki, Masashi 'Jumbo' 116
Pacifico Golf Course 156–7
Padgham, Alf 17
Painswick Golf Club 10, 146–7
Palmer, Arnold 116, 126, 202
Palmerstone Golf Course 36–7
Panks, Gary 173
Park, Mungo Sr. 132, 155
Park, Willie Jr. 132, 134
Peach, Stan 100
Pebble Beach Golf Links 148–9
Pennard Golf Club 10, 150–1
Pepperell, Eddie 141
Persse, Henry 22
Pezzola, Chelsea 111
PGA Catalunya Resort 184–5
PGA Championships 193, 219
Pine Valley 152–3
Pines, The 87
Player, Gary 104
Players Championship 187
Pont, Frank 162
Powell, William 'Bill' 57
Punta Mita 156–7
President's Putter tournament 170
Prestwick Golf Club 10–11, 154–5
Real Club Valderrama 158–9
Reason, Martin 219
Repton, Humphry 191
Rider, Dennis 220
Rider, John 220
Rise, The 160–1
Roald, Edwin 78–9
Robertson, Allan 155
Rose, Justin 26, 121, 179
Ross, Mackenzie 19
Rotorua Golf Club 20–1
Roux, Ivan 180
Royal County Down Golf Club 46–9
Royal Haagsche Golf and Country Club 162–3
Royal Melbourne Golf Club 164–5
Royal North Devon Golf Club 166–7
Royal Troon Golf Club 10, 13, 134–5
RTJ Golf Club 168–9
Russell, Alex 165
Ryder Cup 34, 107, 128, 158, 184, 193
Rye Golf Club 170–1
St Enodoc Golf Club 8, 9, 52–5

Sandy Lane Resort 13, 70–1
Sarazen, Gene 134
Satsuki Golf Course 8
Scotland
 Ailsa Championship Course 13, 18–19
 Barra Golf Club 32–3
 Carnoustie Golf Links 40–3
 Championship Course (Machrihanish Golf Club) 44–5
 Isle of Harris Golf Club 74–5
 Lundin Ladies Golf Club 108–9
 Machrihanish Golf Club 44–5
 Old Course (Musselburgh Links) 10, 130–3
 Old Course (Royal Troon) 10, 13, 134–5
 Old Course (St Andrews) 10, 10–11, 136–41
 Prestwick Golf Club 10–11, 154–5
 Royal Troon Golf Club 10, 13, 134–5
 Trump Turnberry Golf Club 18–19
 West Links, (North Berwick) 214–17
Sederholm, Jan 207
Sedona Golf Resort 172–3
Seven Canyons Golf Club 172–3
Severiano Ballesteros Course, The 174–7
Signature Course (Legend Golf & Safari Resort) 8, 178–81
Singh, Vijay 116, 179
Snead, J. C. 187
South Africa
 Legend Golf & Safari Resort 8, 178–81
 Lost City Golf Course 104–5
 Signature Course 8, 178–81
South Korea
 Golf Club Q 6–7
Spain
 Club de Golf Alcanada 58–9
 Real Club Valderrama 158–9
 Stadium Course (PGA Catalunya Resort) 184–5
Spieth, Jordan 26, 27, 134
Stadium Course (Bro Hof Slott Golf Club) 182–3
Stadium Course (PGA Catalunya Resort) 184–5
Stadium Course (TPC Sawgrass)

186–7
Stanley Thompson Eighteen 188–9
Steel, Donald 36
Stenson, Henrik 15
Stephenson, Gary 208
Stoke Park 190–1
Streamsong Blue 194–7
Streamsong Red 194–7
Sullivan, Andy 219
Sweden
 Stadium Course (Bro Hof Slott Golf Club) 182–3
Switzerland
 The Severiano Ballesteros Course 174–7
Taft, William 19
Taiheiyo Club Gotemba Course 198–9
Taylor, John Henry 166
Tewa, Jack 84
Thomas, Dave 34
Thompson, Stanley 189
Tissies, Hermann 134
Tomorrow Never Dies 191
Torrance, Sam 34, 162
TPC Sawgrass 186–7
Torrey Pines Golf Club 200–1
Tralee Golf Club 202–5
Trevino, Lee 60
Tromsø Golf Course 8, 206–7
Trump, Donald 19
Trump Turnberry Golf Club 18–19
United Arab Emirates
 Abu Dhabi Golf Club 14–15
United States
 Arrowhead Golf Club 22–3
 Augusta National Golf Club 24–77
 Chicago Golf Club 50–1
 Clearview Golf Club 56–7
 Coeur d'Alene Resort Golf Course 60–1
 Cypress Point Club 62–3
 Devil's Golf Course 10, 68
 Francis I'i Brown Golf Course 12
 Furnace Creek Resort 68–9
 Harbour Town Links 72–3
 International Golf Club 8
 Ko'olau Golf Club 88–9
 Manele Golf Course 112–13
 Oakmont 124–7
 The Ocean Course 128–9

Pebble Beach Golf Links 148–9
Pine Valley 152–3
The Pines 87
RTJ Golf Club 168–9
Sedona Golf Resort 172–3
Seven Canyons Golf Club 172–3
Stadium Course 186–7
Streamsong Blue 194–7
Streamsong Red 194–7
Torrey Pines Golf Club 200–1
TPC Sawgrass 186–7
Upper Course (Whisper Rock) 208–9
Victoria National 212–13
Whisper Rock Golf Club 10
Whistling Straits 192–3
Wolf Creek 220–1
U.S. Open 24, 51, 126, 148, 201
Ushuaia Golf Course 8, 210–11
Van de Velde, Jean 41–2
Van Horne, William 189
Van Vuuren, Steve 162
Vestmannaeyar Golf Course 77
Victoria National 212–13
Wales
 Llanymynech Golf Club 106–7
 Pennard Golf Club 10, 150–1
Walker Cup 51
Watson, Tom 19, 34, 141, 148
West Course 218–19
West Links 214–17
Westwood, Lee 34, 177, 183
Whisper Rock Golf Club 10
Whistling Straits 192–3
Willett, Danny 26, 177
Wind, Herbert Warren 26
Wodehouse, P. G. 8, 17
Wolf, Daniel 162
Wolf Creek 220–1
Women's British Open 42
Woods, Tiger 110, 134, 144, 200, 201
Woosnam, Ian 107, 179
Worcestershire Golf Club 6
World Cup of Golf 116, 165, 198
World Matchplay Championship 219
Wyatt, James 191

Footnote

In researching this book we referenced many golf clubs, but none could match the remarkable advice handed out by one Indian golf club for their Stableford competitions.

Code of Conduct:

• Keeping the above in view, our tournament committee has formulated certain norms which will be mandatory for the members to observe. The Committee gives assurance of fair play without any favouritism. Members must play at the Golf Course minimum twice a month failing which right to be part of the Golf Club team in a tournament will get diluted. Repeated or long absence from events may compel the management to initiate sterner action.

• On a tournament day, kindly do not embarrass the organisers by demanding preferential treatment of starting and finishing order.

• Members are humbly requested to be punctual on the tournament days.

• All games are played by gentleman. Golf too seeks divine messengers. Say no to orchestration; do not bring bad temper to the course, be the epitome of sporting ethos.

• Avoid forcing last-minute changes on the organisation, especially through emotional blackmail.

• Suggestions are welcome provided you join hands to implement them.

• Be polite to the ground staff and caddies.

• Kindly, do not patronise a particular caddy. The practice engenders infective depravity.

About the Authors

Iain Spragg is a sports journalist and author with 20 years experience. He has written for a wide range of national newspapers including the *Daily Mirror* and *The Daily Telegraph*, while his book credits include *Twickenham:100 Years of Rugby's HQ*, *The World Cup in 100 Objects*, and *Cycling's Strangest Tales*.

Frank Hopkinson is the author of *Golf: Those Were The Days* and *The Grumpy Golfer's Handbook*. He was the Junior Champion at the Worcestershire Golf Club in 1976, and his prowess at the sport has been in steep decline ever since.

Picture Credits